Theatres of Immanence

THE UNIVERSITY OF
WINCHESTER

Martial Rose Library
Tel: 01962 827306

D1513743

To be returned on or before the day marked above, subject to recall.

LIBRARY

Theatres of Immanence

Deleuze and the Ethics of Performance

Laura Cull Ó Maoilearca

First published 2012
First published in paperback 2015 by
PALGRAVE MACMILLAN

Palgrave Macmillan in the UK is an imprint of Macmillan Publishers Limited, registered in England, company number 785998, of Houndmills, Basingstoke, Hampshire RG21 6XS.

Palgrave Macmillan in the US is a division of St Martin's Press LLC, 175 Fifth Avenue, New York, NY 10010.

Palgrave Macmillan is the global academic imprint of the above companies and has companies and representatives throughout the world.

Palgrave® and Macmillan® are registered trademarks in the United States, the United Kingdom, Europe and other countries.

ISBN 978–0–230–31952–3 hardback
ISBN 978–1–137–51959–7 paperback

This book is printed on paper suitable for recycling and made from fully managed and sustained forest sources. Logging, pulping and manufacturing processes are expected to conform to the environmental regulations of the country of origin.

A catalogue record for this book is available from the British Library.

A catalog record for this book is available from the Library of Congress.

Typeset by MPS Limited, Chennai, India.

To John & James

Contents

List of Illustrations

Acknowledgements

The preparatory work for this book has been undertaken over a number of years, informed and supported by a great many people – colleagues, friends and family – whom I would like to take this opportunity to thank. Firstly, I would like to thank Nick Kaye, for his diligent readings of my work in its earliest stages and his on-going professional advice. I would also like to thank Alice Barnaby, my colleague at the University of Exeter, for her friendship and support over the years; and Alan Read, for his generous readings and provocative questioning of my work, as well as his on-going enthusiasm for the wider Performance & Philosophy projects with which I've been involved over the last few years. Matthew Goulish and Lin Hixson, too, have played an absolutely vital part in shaping my ideas and practices; and I would like to thank them, as well as Karen Christopher, Bryan Saner and Stephen Bottoms, for their openness and encouragement in relation to my work on Goat Island. Thanks must also go to Jon Erickson – an always thought provoking correspondent; to Steven Connor and Susan Best for their willingness to share their important research with me; to Erin Hurley, Sara Warner and Nicholas Ridout for their valuable comments on my work on animals and affect; and to Carl Lavery for helping me to clarify my work on Bene and Lavaudant. From the Performance & Philosophy working group, I would also very much like to thank Freddie Rokem for all his wise advice over the years and his tireless support of my research; as well as Esa Kirkkopelto, Will Daddario, Alice Lagaay and Karoline Gritzner for the philosophical expertise and friendship. Thanks to Karoline and Richard Gough at Aberystwyth University, Craig Smith at the University of Florida, Tony Fisher and Shaun May at Central School of Speech and Drama, Charlotte de Mille at the Courtauld, Dunja Njaradi at Chester, and Margherita Laera at Queen Mary for inviting me to present on this book in its various nascent forms at their respective institutions. And thanks to Jane Arnfield, Nobuko Anan, Peter Hutchings and Craig Richardson at Northumbria University, as well as to my PhD student, Daniel Koczy, who continues to inspire and teach me with his work on Deleuze and Beckett.

I am also extremely grateful to the following people for assisting me with the reproduction of images by the artists discussed in the book: Eikoh Hosoe, for his generous donation of his extraordinary photographs of Hijikata Tatsumi; Fabiane Moraes at 'O Mundo de Lygia Clark'; Tamara Bloomberg at the Kaprow Estate; and Miles Thurlow, Paul Moss and Chris Morgan at the Workplace Gallery, who represent Marcus Coates. I am also very grateful to Juliette Caron from the archives at the Théâtre National de

l'Odéon in Paris for providing me with the video documentation of Georges Lavaudant's 2004 performance of *La Rose et la hache*. I would also like to thank Paula Kennedy and Ben Doyle at Palgrave for their patience and support throughout the process of producing this monograph.

My parents, Ann Smyth and Roger Cull, my step-parents, John Smyth and Liz Cull, and my sister, Gillian Cull, have also provided undinting support for my work – thank you all. Likewise, I am grateful to my stepson James for his tolerance of too many weekends spent with me at my laptop! Above all, though, I want to thank my husband, John Mullarkey, who has encouraged me in my work on this book from start to finish, giving me confidence in my ideas and acting as an attentive 'outside eye' to my writing. He has always known, intuitively, when it is time for confirmation or challenges, and remains my most vital source of both intellectual and emotional support. Never too busy to discuss a particular conceptual problem or help me to envisage 'the whole', I could not have asked for a better companion through this process, or indeed through life.

Introduction

This book is an attempt to explore the implications of the concept of immanence for theatre and performance.[1] In particular, it is an effort to conceive what we might call a 'theatre of immanence' or 'immanent theatre' by way of an exploration of the philosophy of Gilles Deleuze (1925–95) in conjunction with the work of a group of core practitioners who, I propose, think immanence *in* and *as* performance: the Living Theatre (1947–), John Cage (1912–92) and Goat Island (1987–2009) in Chapter 1; Antonin Artaud (1896–1948), Carmelo Bene (1937–2002), Robert Wilson (1941–) and Georges Lavaudant (1947–) in Chapter 2; Hijikata Tatsumi (1928–86) and Marcus Coates (1968–) in Chapter 3; Allan Kaprow (1927–2006) and Lygia Clark (1920–88) in Chapter 4; and finally, back to Goat Island and Robert Wilson again in Chapter 5. In each of these five chapters, this book will also pay particular attention to the ethical dimensions of theatres of immanence, questioning what 'good' an immanent theatre might be and on what grounds that 'goodness' might be evaluated.

A contemporary of Jacques Derrida and Michel Foucault, Deleuze has, over the last 15 years, proved to be an extremely popular and productive thinker for scholars across the disciplines, albeit not one whose thought has been taken up by theatre and performance researchers until relatively recently. And yet, despite the surge of Deleuzian scholarship and the rapid growth of the interdisciplinary sub-field of Deleuze Studies,[2] 'We still don't quite know what the name "Deleuze" stands for, or the place we ought to give it in the history of thought' (de Beistegui 2010: 1). Deleuze wrote 25 books during the 40 years from 1953 to 1993 that constituted the core of his working life, most famously the two volumes of Capitalism and Schizophrenia: *Anti-Oedipus* (1972) and *A Thousand Plateaus* (1980), which were written in collaboration with the experimental psychoanalyst and political activist, Félix Guattari. And as we attempt to survey these works, we soon appreciate that there is not one Deleuze, but many: a structuralist Deleuze and a post-structuralist one, Deleuze the careful historian of philosophy and Deleuze the anti-historical visionary, Deleuze the pure metaphysician and Deleuze

1

the engaged transdisciplinary commentator on the arts, science and politics. Fortunately, it is not the goal of this book to represent some putative essence of Deleuze's thought (whatever that might be), nor indeed to reproduce faithfully its supposed 'unity and inner consistency' (de Beistegui 2010: 2). As such, we will not try to conceal the partisan nature of our exploration – as we emphasize certain aspects of Deleuze's thought (while de-emphasizing others) for our own ends.

As such, I hope that this book might make a contribution to a number of different overlapping contexts, fields and sub-fields. In the first instance, it might be understood as an expression of what we might call 'a philosophical turn' in the international field of theatre and performance research: an intensification of its long-standing interest in and engagement with philosophy, as a source of diverse concepts, plural methods and multiple ontologies that can be productively explored in relation to performance. Simon Bayly's *A Pathognomy of Performance* (2011), Martin Puchner's *The Drama of Ideas* (2010), Freddie Rokem's *Philosophers and Thespians* (2010) and Michael Witmore's *Shakespearean Metaphysics* (2008) are only four recent publications that one could cite as evidence of such a turn, along with the emergence of international working groups dedicated to 'performance and philosophy' within a number of the field's professional associations.[3] This turn differs from the so-called theory explosion that took place in US and European Theatre and Performance Studies, and indeed across the humanities at large during the 1970s and 1980s, in terms of the philosophical material that it includes.[4] That is, while Janelle Reinelt and Joseph Roach argue that the theory explosion 'returned the humanities [including performance] to philosophy' (Reinelt and Roach 1992: 5), I would argue that it returned performance to *some* philosophies, but not to others – to Jacques Derrida and J. L. Austin, for instance, but not to Henri Bergson or Gilles Deleuze, who remain under-theorized in theatre and performance publications.

In 2005, when I first began to work on Deleuze in relation to performance, there seemed to be little existing publishing explicitly addressing this relationship. That is, while Deleuze Studies was flourishing, and there were countless books addressing Deleuze's relationship to other art forms such as cinema and visual art, there was a very limited amount of commentary on Deleuze with respect to theatre and performance. However, a growing number of performance practitioners have referenced Deleuze as a philosophical stimulus for their practice, suggesting the particular suitability of his materialist, processual thought for thinking through the embodied, durational art of performance.[5] Likewise, at the 2009 Performance Studies International #15 conference in Zagreb, a delegate noted the ubiquity of Deleuzian vocabularies, such as the notion of 'the body without organs', at the Performance Studies department at NYU, suggesting that there is a groundswell of interest in and engagement with Deleuze's thought in Performance Studies that is yet to manifest itself significantly in extended

discussions of Deleuze in publishing – bar a few examples, including my own edited collection, *Deleuze and Performance* (2009).[6]

Perhaps it should not be surprising that it is in the field of dance research where the reception of Deleuze, and Guattari, has been most enthusiastic. Given Deleuze's emphasis on movement, rhythm, duration and temporality, the body and the nonrepresentational powers of art, it is little wonder that his philosophy has proved productive for researchers in dance, including Valerie Briginshaw and Ramsay Burt (2009), André Lepecki (2004a), Jonathan Burrows and Jan Ritsema (see Bleeker 2004). Yet a sustained engagement with Deleuze's thought, including by critics as well as by enthusiasts, is becoming more apparent in other areas of performance research too; for instance, in the work of Martin Puchner (2002, 2010), Simon Bayly (2011), David Fancy (2011) and James Thompson (2009). Or again, during what will no doubt come to be some very important research, the emerging French scholar Flore Garcin-Marrou has uncovered six humorous and satirical plays written by Guattari 'between 1980 and 1990' (Garcin-Marrou 2011: 4). According to Garcin-Marrou, the plays were inspired both by Alfred Jarry's *Ubu* and by the various 'theatrical experiments of [the] Dadaists and Surrealists'; and they are plays in which 'Guattari satirizes and mocks the patrons and icons of psychoanalysis (Sigmund Freud, Melanie Klein, Carl Gustav Jung) and of philosophy (Socrates, Lucretius)' (Garcin-Marrou 2011).

For many, Deleuze's thought perhaps offers a welcome alternative tenor to what Alan Read calls 'the current morbidity of performance studies' that often allows itself to revel in the aesthetic deaths and disappearances of performance, which for Read have little if anything to do with the actual deaths and disappearances going on in the world (Read 2008: 66). First and foremost, that is, we might characterize Deleuze as a philosopher of *life* – where, as we shall see, life is variously conceived as ceaseless creativity and change, as the production of difference or novelty, as a proliferation of encounters between differing forces of affect, as a multiplicity of presents; in a word, as immanence.

In particular, this book starts from the premise that Deleuze's thought provides us with the resources to rethink performance *itself* as a kind of philosophy. That is, this book will attempt to consider the nature of what we might call *Performance-Philosophy*, beyond the tendency of both disciplines merely to *apply* philosophy to performance, to treat performance as the illustration of pre-existing philosophical thought, rather than as its own kind of thinking. The notion that performance is thinking may already be a 'given' for many, especially on account of the growth and increasing institutional acceptance of 'practice as research' (PaR) in performance, at least in the United Kingdom. However, 'research' is only way one to construe how performance thinks; we need to keep our definition of research open, in order to include the new ways that performance finds to perform it. Secondly, concepts from Deleuze can support our proposition: it is not

only because it is made by 'reflective practitioners' that performance counts as thinking. The human maker is not the only one doing the thinking in the creation of performance; rather, Deleuze's definition of thought as creation allows us to suggest that *everything* thinks – including the nonhuman aspects of performance – because every 'thing' is immanent to the creativity of life, an expression of how life thinks itself in and as the creation of different 'things'.

This renewed notion of performance practice as research will not be an explicit topic within the chapters that follow, but the field of PaR nevertheless informs the project as a whole, as does Deleuze Studies – a field that, despite its recent expansion, still includes relatively little work on Deleuze's relationship to theatre and performance. In part, this may simply be a reflection of the fact that Deleuze wrote very little about actual theatre and performance, in contrast to the extensive attention he paid to cinema, literature and painting. Nevertheless, though, and as Puchner argues in *The Drama of Ideas*, the relationship between theatre and philosophy is 'a driving concern in Deleuze's writing'; and, indeed, 'Deleuze is the twentieth-century philosopher who comes closest to recognizing a specifically theatrical strain within modern philosophy' – particularly within *Difference and Repetition* (Puchner 2010: 166). However, Puchner also argues that while Deleuze has much to say about the theatre of philosophy (philosophy's theatricality and so forth), his actual conception of the theatre itself 'remains vague' and 'schematic', such that it must be made more specific by relating it to 'the existing theatres by which ... [it was] variously inspired and repulsed' (Puchner 2010: 169).

This lack of engagement in performance can be interpreted in any number of ways. For his part, Jon Erickson has argued:

> In the working out of their theories Deleuze and Guattari have little to say about the performative situation, even while two of their emblematic figures are men of the theater – Kleist and Artaud. Kleist's play *Penthesilea* is read for its content ('becoming-woman,' 'becoming-animal') like any work of prose fiction, and Artaud is read almost entirely in relation to his biography, with little if any attention at all paid to his theater works. Perhaps this evasion or ignoring of performance has to do with the degree to which the performance situation cannot escape the problems of representation and mimesis (something Artaud was certainly concerned about) that they are so reactive against. (Erickson 1999: 19)

Nevertheless, as Simon Bayly makes clear, it is too simple and, indeed, mistaken to understand Deleuze as simply an 'anti-representational' thinker or, correlatively, as a critic of 'representational theatre' (whatever that might be) (Bayly 2011: 15). As we shall see, any binarism of 'reality' and 'image', or 'original' and 'copy', cannot be sustained by Deleuze as a thinker of

immanence; for instance, 'the real' is always considered as that which also involves 'the powers of the false', as that which ceaselessly differs from itself rather than as any self-same presence that is doomed to be distorted in mimetic activity. However, Deleuze does extend the notion of how the real differs from itself beyond the arguably anthropocentric notion of representation, and likewise he dehumanizes thought to include a strain that he calls 'encounter', which is not 'bound up with representation' (Bayly 2011: 16) but still differentiates and is differentiated by that which it encounters.

For our part, we will suggest that Deleuze is concerned with rethinking representation rather than rejecting it, and with reconsidering presence as a mutually transformative encounter between the different, rather than as an instance of recognition, identification, communication, communion or coincidence between a subject and an object. To represent some 'thing' – which is always more fundamentally a process, for Deleuze – is neither to imitate it, nor to embark on a doomed project to be present to 'things themselves' (an enterprise guaranteed to fail on account of the mediation of a representing consciousness). Deleuze rejects both the idea of thought as a truthful representation of the world, and the notion that the stable categories of representation determine thought in a manner that necessarily separates us from the movement of the world. Thought is not simply 'true' (or rational) in a representational sense, but nor can it simply be 'false', because the world is not the same as itself, it is not an object of representation that keeps its truth hidden from thought. Representation is real creation, not a second-order mode of being, forever detached from and inadequate to some 'thing' that is represented. And likewise, performance's production of images, texts, events and movements involves entering into a becoming that changes both the work and the world as *re*presentation or differential repetition. Theatre's bodies are not only mediated by the values embedded in systems of representation, but were always already differentiated in their own way – as what Deleuze variously conceives of as affect, becoming and duration.

However, before we go much further with this discussion, we need to provide some kind of opening definition of immanence. That is, while this book in its entirety tries to enrich our understanding of what immanence is and how it works, I want to begin by sketching an outline of this concept, as well as giving an initial indication of why I think it matters for performance.

The magic formula – PLURALISM = MONISM: An introduction to immanence

The concept of 'immanence' has been very much at the forefront of continental philosophy over recent years, most notably in publications such as John Mullarkey's *Post-Continental Philosophy* (2006), Leonard Lawlor's *The Implications of Immanence* (2006), Christian Kerslake's *Immanence and*

the Vertigo of Philosophy (2009) and Miguel de Beistegui's *Immanence: Deleuze and Philosophy* (2010) – each of which engages with Deleuze's philosophy, but alongside others who think immanence differently. 'Immanence is every-where,' Mullarkey notes, but at the same time he argues that 'its meaning is completely open' (Mullarkey 2006: 7). For his part, de Beistegui describes immanence as an 'evasive quasi-concept' in a manner that recalls Derrida's characterization of *différance*; and yet he also proposes that we can think of immanence in Deleuze as 'nothing other than reality in the making' (de Beistegui 2010: 192).

Etmyologically speaking, we can say that the word 'immanence' originates from the Latin *immanere*, which might be translated as 'to dwell within'. Or, as Mullarkey puts it,

'Existing or remaining within'; being 'inherent'; being restricted entirely to some 'inside'; existing and acting 'within the physical world': these lexical definitions of immanence play out in all four of our philosophies of immanence in both literal and figurative ways. Most often, though, the equivocity of immanence is linked to the question of ontological monism: if there is nothing 'beyond' the world, no *'arrière-monde'*, then there can be no duality, no two-worlds view. (Mullarkey 2006)

As Mullarkey implies, then, our opening definition of immanence might be formed on the basis of a contrast with the idea of transcendence, where the transcendent is that which 'stands outside or above' the physical world. An extreme transcendent perspective posits a 'two worlds view' in which it is possible for some being or mode of existence to occupy a realm outside the material world. These two realms may participate in or interact with one another, but they are nevertheless distinct and usually understood as being of differing value. According to Todd May, philosophies of transcend-ence are committed both to dualism – the idea of Being as composed of two, interactive types of substance such as 'mind' and 'matter' – and to the idea of the primacy of one of these ontological substances over the other (May 2005: 28–9). As May has discussed, 'it is the transcendence of God that forms the longest legacy' in the history of transcendent thinking in philosophy. 'But it is not the only one' (May 2005: 27). We might also think of the way in which Plato positions the 'Ideal forms' outside experience, or of how the seventeenth-century philosopher René Descartes insists on the independence of mind from body. However, it is particularly after Kant that this notion of the transcendence of human subjectivity takes hold, with the figure of 'the Subject' taking over from God as the originator or necessary condition of creativity and meaning in the world that we construct for ourselves.

As we shall discuss further in a number of the chapters that follow, Deleuze sometimes frames this transcendent concept of 'the Subject' as an

oppressive force operating at the level of the body as well as at the level of the social, and as an organizing force that invites us to operate as if we were really separate from (and, in some cases, superior to) the other bodies populating the world. To develop this perspective, Deleuze works through the history of philosophy seeking out renegade, immanent thinkers – such as Baruch Spinoza, another seventeenth-century thinker who was, in his time, classed as a heretic for his insistence on the idea of an immanent God, manifest in nature, and his rejection of the 'anthropomorphic, intentional God' of the established theism that dominated the Dutch Republic at the time (Lord 2010: 4). Deleuze dedicated two books to Spinoza: *Expressionism in Philosophy: Spinoza* (1968) and *Spinoza, Practical Philosophy* (1970), in both of which Spinoza's posthumously published volume *Ethics* – which Deleuze calls 'a voyage in immanence' (Deleuze 1988b: 29) – plays a central role. Here and elsewhere in his work, Deleuze argues that Spinoza enacts an ontology of immanence partly though his embrace of the notion of 'univocal Being': the idea that 'Being is said in a single and the same sense of everything of which it is said' (Deleuze 1994: 36). Or again, to take a quote from Deleuze's second book on Spinoza, the idea that there is 'one Nature for all bodies, one Nature for all individuals, a Nature that is itself an individual varying in an infinite number of ways' (Deleuze 1988b: 122). And finally, 'Pure immanence requires as a principle the equality of being, or the positing of equal Being: not only is being equal in itself, but it is seen to be equally present in all things' (Deleuze 1990: 173).

These fragments begin to give us a sense of the 'Oneness' associated with the idea of immanence. However, no sooner have we grasped this than we must go further and make clear that this univocal or one-voiced nature of Being is not a question of uniting all the apparent differences of the world within a greater sameness. Neither Spinoza nor Deleuze is saying that immanence means that there is a fundamental identity that unites all things. Rather, Deleuze continues his definition of univocity as follows: 'Being is said in a single and the same sense of everything of which it is said, *but that of which it is said differs: it is said of difference itself*' (Deleuze 1994: 36, emphasis added). So, for Deleuze, univocity or immanence means that there is only *one* kind of thing or being in reality, and as such no fundamental separation or hierarchy between the nature of words and things, body and mind, subject and object, representation and the real, theory and practice and so forth. Nevertheless, we should not be misled into thinking that this philosophy somehow involves homogenizing the world or denying 'the very possibility of difference' (May 2005: 36). The '*one* kind of thing' we have evoked is not one *thing* at all, but process, change or difference. Deleuze is a philosopher of 'difference' who, like Derrida, wants to retrieve the notion of difference from its lowly position in the Western philosophical tradition, which has tended to conceive of it derivatively as opposition and negation in relation to a primary identity or sameness (as the mere difference between

'things'). The critical phrase in the definition of univocity that we have just given is the one that states: that of which Being is said *differs*. There may be one Nature to which we all belong, but what characterizes Nature is its autonomous power to differentiate itself or differ from itself in an infinite number of ways. In turn, this difference or creativity of Nature (or what Spinoza also called 'substance') is immanent to us; it is 'involved in what expresses it' (Deleuze 1990: 16).

This differential nature of univocal Being is essential to an understanding of Deleuze's thought. Specifically, it is essential to understanding why Deleuze is not a 'thinker of the One' (as Badiou has argued), nor does his philosophy does not seek to take us 'out of this world' according to a hierarchized duality of the material and the ideal (as Peter Hallward has argued). That is, an emphasis on the fundamental processuality of Nature is what prevents us from falling into a dualistic thinking that would constitute a return to transcendence. Indeed, throughout this book we will have reason to remind ourselves of this ubiquity of process in order to avoid reinserting dualisms into our thinking. For instance, the chapters that follow will take up many of the key conceptual pairings that Deleuze and Guattari develop, including major/minor, molar/molecular, the organism and the body-without-organs, and, of course, the transcendence/immanence dyad. Most straightforwardly explained, the former term of each dyad names a phenomenon of stabilization, organization and fixity, while the latter is associated with movement and ontological instability; the former confirms notions of self-present and fixed Being, while the latter affirms the mobility of Being as becoming. But how can Deleuze and Guattari claim to be against the two-worlds view of transcendence, at the same time as they invent their own, new dualisms? What is the difference between evoking a 'beyond' in relation to the physical world and evoking a distinction between the molar and the molecular, or the tree and the rhizome, and so forth?

Despite appearances at times, Deleuze and Guattari argue that 'there is no dualism' here:

> no ontological dualism between here and there, no axiological dualism between good and bad ... We invoke one dualism only in order to challenge another. We employ a dualism of models only in order to arrive at a process that challenges all models. Each time, mental correctives are necessary to undo the dualisms we had no wish to construct but through which we pass. Arrive at the magic formula we all seek – PLURALISM = MONISM – via all the dualisms that are the enemy, an entirely necessary enemy, the furniture we are forever rearranging. (Deleuze and Guattari 1988: 20)

Here, Deleuze and Guattari argue that the role of their own dualities is, firstly, to provide an alternative to an existing duality. But secondly, and more importantly, they argue that their dualisms ultimately refer to a

duality of process; they are a temporary and necessary measure within an effort to think through this complex process that is both One *and* Many, univocal *and* differential, a monism *and* a pluralism. 'Immanence' is one name that they give to this fundamental process. And as Christian Kerslake (2009) has discussed, one reason why Deleuze and Guattari speak of 'the vertigo of immanence' is because of the disorienting and destabilizing effect (for immanent thought) of the fact that immanence always differs from itself (Deleuze and Guattari 1994: 48). We will never feel grounded when immanence is the starting point for our thinking. Indeed, the sense of a constantly shifting ground is precisely what characterizes the project to think immanence, to live immanently, whether we approach that project as 'philosophy', 'performance' or, simply, 'life'. As we shall see in what follows, a primary basis for this book's choice of practitioners is a sense that their work in some way constitutes a response to the call to create – to think, to live – alongside this creativity of life as immanence (of immanence as life).

While the specific concept of immanence has not been a particular concern for much of Theatre and Performance Studies, we might wish to note its importance to Witmore's *Shakespearean Metaphysics*, which is informed by the immanent philosophies of Spinoza, Bergson and Alfred North Whitehead. Here, Witmore argues that:

> Shakespeare favoured a view of the world in which order and change are seen to emerge holistically from things themselves (immanence) rather than being localized in certain metaphysically isolated pockets of the universe (punctualism) ... Shakespeare valued immanence as a way of thinking about the very nature of being. (Witmore 2008: 1–2)

For Witmore, the notion of immanence 'best captures' Shakespeare's metaphysics as one that is not, or at least not *only*, articulated by Shakespeare's characters, Witmore argues, but emerges from 'what the plays *do* and *are*' (Witmore 2008: 2, emphasis in original). Like us, Witmore opens his account of immanence by differentiating it from transcendence, characterizing 'immanent reality' as:

> One that lacks an 'outside' or numinous 'other place' that subtends or generates its immediate characteristics, just as it forbids local zones of 'transcendence' where the dynamics of worldly interaction are suspended or cancelled ... An immanent reality is one in which the actual world carries the burden of its own transformations, often through a dynamic process of change whose origins cannot be pinpointed in a single place or time. (Witmore 2008: 12)

Interestingly for us, while Witmore acknowledges the influence of Deleuze on his account of immanence, he argues that Deleuze 'ultimately takes the

concept of immanence in a direction that is not naturally suited to the study of Shakespearean metaphysics'. In particular, Witmore construes this as a 'post-human' direction, but one that he specifically characterizes as a move to 'dissolve the human body' (Witmore 2008: 13). And no doubt, Deleuze is interested in the notion of immanence as an impersonal and pre-subjective power of life, particularly in his last work, *Pure Immanence: Essays on a Life*. Here, Deleuze argues that immanence is *a* life rather than 'my' life or *the* life of Deleuze; it is life as preceded by 'the indefinite article as an index of the *transcendental*' but not of *transcendence* (Deleuze 2001: 28).[7] That is, Deleuze argues that immanence is distorted when it is 'defined by a subject or an object that is able to contain it' (Deleuze 2001: 27), but this is not the same as saying that immanence is somehow beyond our worldly experience. Immanence is a resolutely *immanent* excess, a vital power that can overwhelm individual subjects when unleashed in large quantities, but can also pass unnoticed on account of our tendency to think in terms of a personal life that belongs to 'me'. There is nothing 'wrong' with exploring the specifically human experience of immanence, but Deleuze insists that we should not mistake this for an account of immanence per se, of life as a(n open) whole.

Crucially, though, this book will insist that Deleuze's immanence is not premised on a call to self-dissolution, as Witmore implies, if by the latter we mean to allude to some kind of process of dematerialization in which the human body (or any 'body') becomes the empty vessel for the passage of a pure and abstract thought (as Hallward argues). Rather, and indeed more in line with Shakespeare's metaphysics as Witmore conceives them, Deleuze's immanence precisely concerns the participation, multiplication and exten-sion of the human body – understood as that which is produced by relations of force and encounters with the affects of other bodies. Our sense of *where* and *when* the human body 'is' may be dispersed in this model, but it is less a matter of us losing sight of 'the human' as it disappears into 'a world of intensity flows' and more a question of gaining a sense of humanness as an *open* quality: as an alterable and perpetually altering set of powers to act and be acted upon by other, nonhuman bodies.

Despite these differing accounts of Deleuze, Witmore's book remains an important resource for us, not least on the very basic level of allowing us to make clear that Shakespeare can be understood as a theatre of imma-nence too, as can all other forms of drama and proscenium arch theatre. The architecture of the proscenium arch theatre may well appear to be the most visible manifestation of a 'two-worlds view' within performance, but as Grotowski knew, we cannot assume that spatial distance or separation has any necessary relationship to ontological separation.[8] Of course, David Wiles is right to emphasize the mutual influence of theatre and philosophy on one another with respect to the emerging construction of the passified audience and the increasing influence of Descartes' theatricalized account of

the mind/body relationship. It was Descartes, Wiles argues, who 'cultivated the detached scientific gaze: reality viewed from a non-place somewhere on the margins', in a manner that makes way for 'the Cartesian theatrical dichotomy' between active actor and passive spectator (Wiles 2003: 4). Descartes conceived of the mind as somewhat like a 'miniature theatre' in which an ego or self 'could contemplate reality and decide how to deal with it, before sending appropriate messages down ... to the body' (Wiles 2003). Human thought was not understood as *in* the world, or as *part of* the world, but as a separate representative system that produced and responded to its own images of reality (Wiles 2003: 7).

Likewise, the theatre came to be conceived of as a Cartesian space in which the passive spectator could view the on-stage reality at a remove, with their gaze directed by 'the focalizing lens created by a proscenium arch'. In this way, the spectator's gaze was 'directed towards a stage and via the perspectival décor towards a Euclidian infinity' (Wiles 2003: 8); or, as Mike Pearson has argued more recently, the proscenium arch theatre can be thought of as a 'spatial machine' that positioned the spectator as the transcendent observer of the performance as object (Pearson in Wiles 2003: 2). As is well known, 'the passive audience really only came into being in the 19th century, as theatre began its division into artistic and entertainment forms' (Kattwinkel 2003: ix) – an audience whose alteration of the work on stage was significantly less noticeable than that of their eighteenth-century counterparts. In the eighteenth century, as Judith W. Fisher reports,

The town's displeasure with a manager's decision, or a dramatist's script, or a player's performance or nonappearance, could result in varying degrees of disruptive behaviour, from full-scale rioting and pelting the stage with fruit and other objects to hissing players and demanding apologies. The theatre-goers' pleasure could be equally disruptive: they might call for several encores of a particular speech or song, or cheer so loudly that ... the actors could not be heard. (Fisher in Kattwinkel 2003: 56)

As such, Descartes can be seen as a 'seminal figure in the history of western theatre', particularly with regard to its spatial organization. Within this 'ocular space', Wiles explains:

The invisible ego not only views the action but also quells the actor with the controlling power of its gaze. It does not submit to any embodied immersion in space – space as apprehended through kinetics, smell, sonic vibrations or an osmosis running through packed shoulders. (Wiles 2003: 7)

However, this does not mean that theatres of immanence must be an explicitly immersive, multisensory experience. Or, rather, I will argue that *theatre always*

is an immersive, multisensory experience anyway, not just when such formal qual-
ities are specifically sought out. That is, while we might see how the Cartesian
subject and the passive theatrical spectator are reciprocally informed by one
another, neither has any natural hold on the nature of the experience that we
might have in a 'traditional' proscenium arch space. The proscenium arch may
originally have been designed to organize our perception in particular ways
that encourage greater amounts of transcendence, but this does not preclude
the disorganization of that perception (then and now) – whether through the
work of theatre makers or audience members themselves.

In this sense, it is not that there are immanent theatres that can be
opposed to other transcendent ones, nor is it that theatres of immanence
are necessarily experimental or 'postdramatic'. After all, such an opposition
would be transcendent in itself, implying a fundamental split at the heart of
things – between the immanent and the transcendent – and reproducing the
very dualistic thinking from which immanence is said to depart. Or again, to
think in terms of immanent theatres as opposed to transcendent ones would
also be to suggest that theatres are stable 'things' rather than processes in
themselves. Further, though, in order to avoid introducing a new duality of
things/processes, we will have to say that theatres are 'not not-things' either,
precisely because they are processes that may become more and less thing-
like at any one time. A tendency towards the appearance of dualities is one
dimension of what life, as the differential process of immanence, can do.

As we shall see, at times Deleuze does straightforwardly reject transcend-
ent concepts, such as imitation and representation. However, such bald
statements are usually subsequently qualified in ways that complicate our
understanding of immanence and its relationship to what appears to differ
from it. And this notion of *appearance* will be key, although again, caution is
required. To think in terms of the appearance of transcendence is not to say
that it is simply an illusion; in other words, I do not want to use the concept
of appearance in the Platonic sense in which it is contrasted with reality.
Rather, I will suggest that we need to embody, physicalize and temporal-
ize appearance such that it becomes a matter of the nature of appearing,
which will include the consideration of related processes such as sensation,
attention, perception, observation and so forth. That things appear to us as
things, that the processes of performance appear to us as signs of authorial
intention or representations of ideas, is a real phenomenon. It is real, but it
is also one process among others, even while this one process is often taken
as the only relationship we can have to the world.

And the reality of these appearances, these real worlds of perception,
constitutes another reason why immanence is vertiginous. Immanence is
infinitely plural because it is perspectival rather than substantial; our sense
of what 'it' is and where 'it' is depends on our (real) point of view, which is
a product of immanence in itself, as are all the other differing perspectives
that make up life as a whole. Immanence creates immanence in a ceaseless

production of processes that interfere in one another – encapsulating one another, each within another like a proliferating series of Russian dolls. Yet just when we think that we have found the largest or smallest doll, we see that it is part of another series, in the midst of another expanding and contracting process. Indeed, we might suggest that it is this vertiginous quality that keeps Deleuze returning to the concept of immanence throughout his work; immanence is 'perhaps *the* problem inspiring' Deleuze because we will never cease to find new instances of its expression (Kerslake 2009: 2). Thinking immanence is never complete, not least because we also have to explore the relationship between immanence and thought: Deleuze's thought, our thought, the thought of the practitioners we will discuss. In the exposition we have just provided, for instance, we have inadvertently tended towards a transcendent practice – in attempting to *represent* immanence, to give immanence a fixed definition as a starting point for our investigation (Mullarkey 2009: 9). In contrast, we might suggest that performance practice thinks immanence more immanently. The practitioners we discuss here do not attempt to produce performances that illustrate the concept of immanence in a representational fashion, so much as they try to perform immanence; it is less a matter of trying to show what immanence looks like and more a matter of figuring out how to be inside it and then seeing what comes out of that experience of immanence itself. What counts as a greater degree of immanence to immanence (as 'univocal difference') is indeterminate, by definition. As such, this book cannot hope to be a how-to guide. The best we can do is to take note of what works for Cage, Clark, Goat Island *et al.* and then to use these notes as the starting points for our own experiments (with the same sense of both necessity and contingency that we must take to our starting definition of immanence).

However, we cannot go much further with this line of thought for now: to look down into the vertigo of immanence as it expresses itself in performance is the project of this book as a whole. As such, then, I want to continue then, I want to continue by providing a necessarily brief introduction to Deleuze's thought in general, to situate his discussions of the concept of immanence within his wider project and briefly to introduce some of its key ideas. In particular, I want to make clear that the Deleuze presented here is only one Deleuze among others, only one perspective on the implications of Deleuze's thought for performance. Once this introduction is in place, I will then provide parallel introductions to our focal practitioners before going on to address the complex question of Deleuze's relationship to identity politics.

Which Deleuze?

As John Protevi suggests, Deleuze's work can be broadly divided into three different periods, beginning with 'an early phase of scholarly works that

examine individual philosophers, including studies of Baruch Spinoza, Friedrich Nietzsche and Henri Bergson' (Protevi 2005: 132) – none of whom would have been considered 'proper philosophers' by his former teachers at the Sorbonne, an institution 'steeped in the rationalist tradition' of figures such as Hegel, as well as in the phenomenology of Husserl and the early Heidegger (Bogue 1989: 2). Secondly, there is the period characterized by the publication of *Difference and Repetition* (1968) and *The Logic of Sense* (1969), which Protevi describes as the phase in which 'Deleuze achieved a genuine independence of thought and no longer expressed himself vicariously through commentary' (Protevi 2005: 132).

It is this period that has recently come to be validated as the most important of Deleuze's career, at the expense of the more experimental collaborative texts (with Guattari) that define the third phase in Protevi's schema and, indeed, provide many of this book's theoretical resources.[9] James Williams, for example, refers to *Difference and Repetition* as 'Deleuze's masterwork' and 'the keystone of Deleuze's work as a whole' (Williams 2003: 1–2). Likewise, theatre scholar Jon Erickson is not alone in thinking that 'Deleuze was better off without Guattari, who basically tried to make a political theory out of what wasn't really political in Deleuze's thinking' (Erickson 2007: n.p.). In this regard, Alain Badiou's critique of Deleuze in *Deleuze: The Clamor of Being* (1997) has been influential, since here Badiou suggests that we ought to 'dismiss the works co-authored with Félix Guattari, beginning with the *Anti-Oedipus'* (Alliez 2004: n.p.).[10]

However, even if the second-period works are the key texts for those who want to keep Deleuze as a philosophers' philosopher, and away from the 'diversions' of politics, the two volumes of Capitalism and Schizophrenia remain the primary texts for many interdisciplinary engagements with Deleuze, and for practitioners – not least because these experimental texts call out to be tested and tried out in practice. Though less accessible for certain kinds of readers (and therefore more valued by some), *Difference and Repetition* and *The Logic of Sense* still harbour the traces of transcendence in their disembodied conceptions of the virtual. Or, as Dan Smith helpfully summarizes, the transition between *The Logic of Sense* and *Anti-Oedipus* is one from Deleuze's thinking of 'the event' as an effect akin to something like the irruption of the Lacanian Real into material reality, towards thinking the event as (desiring-) production or becoming. For Badiou (and Žižek), this is a negative development that turns Deleuze into a thinker of 'the One' rather than of multiplicity, whereas, for us, this is a positive change that, in fact, emphasizes the multiplicity of actuality (Smith 2004: 635).

The choice to focus on immanence here necessarily constitutes a selective and partial reading of Deleuze. There are many Deleuzes, and I have chosen to emphasize the immanent, actualist Deleuze and to de-emphasize his purported 'virtualism', while also bracketing off structuralist aspects of some texts (again, *Logic of Sense* and *Difference and Repetition* – these

ironically being the ones championed by his defenders and exploited by his detractors). In the same way, of course, we might note that there are many Artauds, many Kaprows: a Gnostic Artaud who always thinks in terms of a dualistic struggle between mind and body, thought and matter, in contrast to the immanent Artaud I will conceive here; the transcendental Kaprow whose encounter with Zen Buddhism leads him to propose meditative Activities to escape our selves and the world versus the immanent Kaprow who is only ever concerned to increase our attention to *this* world. And the reason for these selective readings is that, in the end, it is a concern with the notion of a theatre of immanence that drives our study.

Which theatres of immanence?

As we have seen, while other practices will have their cameos, this book is primarily focused on the work of 11 practitioners and companies: Artaud, Cage, Kaprow, Clark, Hijikata, Bene, The Living Theatre, Lavaudant, Coates, Goat Island and Wilson. And although there are clearly issues with this line-up (not least the predominance of white Western men), there are also multiple reasons why these practices have been chosen. In the first instance, all 11 are broadly sympathetic broadly sympathetic to an immanent perspective and, as such, both lend themselves to, and benefit from, a Deleuzian engagement with their work at the same time as they benefit our understanding of immanence in general and Deleuze's account of immanence in particular.[11] That is, I hope that what follows, at a minimum, sets up a *two*-way flow of ideas, creating a concept of immanent theatre through a balanced engagement with performance and philosophy, with each one accorded equal status as a kind of thinking. My intention is not simply to apply Deleuze to performance – although, no doubt, traces of this transcendent tendency will remain here despite my best efforts. Rather, I hope to facilitate a series of mutually transformative encounters, where Deleuzian immanence meets the enactment of immanence in theatre and performance practice. 'We do not listen closely enough to what painters have to say,' Deleuze once said (Deleuze 2004: 99).

And just as these practitioners are all broadly sympathetic to an immanent ontology, they are also sympathetic to one another, overlapping with and influencing one another in a variety of ways. For instance, Artaud's influence on a number of the other practitioners featured here is already well known, an influence largely enabled by the translation and dissemination of *The Theatre and Its Double*. For instance, Douglas Kahn reports that Mary Caroline Richards – who produced the best known and most influential English translation of *The Theatre and Its Double* – 'had in fact sent Julian Beck and Judith Malina, the founders of The Living Theater, a prepublication manuscript in 1958'. Kahn adds: 'but it was not until 1963 with their production of *The Brig* that they openly incorporated Artaud's ideas into

their work' (Kahn 1999: 325). In contrast, Kimberly Jannarone has argued that 'The Living Theatre was the first American company to base production work on Artaud's ideas' – citing *The Connection* (1959) as the primary instance of this (Jannarone 2010: 14).[12]

Less well known, though, might be Artaud's influence on John Cage via David Tudor. Cage was reading Artaud in French in 1951 and was inspired by his ideas when making works such as *Music of Changes* and the *Untitled Event* of 1952 at Black Mountain College, which has subsequently been dubbed the first 'Happening' (Kahn 1999: 328–9) – and in which Mary Caroline Richards performed. In turn, *The Theatre and Its Double* was also translated into Japanese in 1965, fuelling what would become Hijikata's lifelong interest in and influence by Artaud (Moore 2006; Scheer 2009). According to Stephen Barber, Hijikata had already taken inspiration from the notion of a 'Theatre of Cruelty' – 'by word of mouth rather than from a comprehensive reading of Artaud's work' (Barber 2010: 31). But Hijikata would also go on to use Artaud's work on Heliogabalus as a key stimulus for his final solo, *Revolt of the Flesh* (1968); to write a short essay on Artaud, called 'Artaud's Slipper', in 1972; and to use a recording of Artaud's *To have done with the judgment of god* as the soundtrack for a 1984 dance he choreographed for Min Tanaka (who, as we know, would go on to dance at the experimental psychiatric clinic where Guattari worked – La Borde – in 1986; Barber 2010: 31–2). We also know that Cage and Tudor visited Hijikata in Japan (Barber 2010: 99). And with the same playful seriousness (or serious playfulness) that characterizes much of his writing, Matthew Goulish reports that, in 1987, Goat Island invited Hijikata to join their company. 'His death in 1986 made him available. He accepted, and he often visited our rehearsals in the form of a ghost, taking part in discussions, delicately responding to our starting point' (Goulish 2000a: 10).

That said, there are, of course, an unlimited number of examples of theatre and performance that I might have discussed here. Indeed, given the ontological claims that Deleuze makes for his philosophy, it must be the case that *every* theatre is a theatre of immanence to some degree – however top-down its approach might appear to be, however much the performance appears to invoke transcendent relationships between subject and object, mind and body, representation and presence, and so forth. For now, though, rather than exposing immanence where we might least expect it, I have chosen to focus on those practices that, I will argue, express immanence to a greater degree than others. I will not suggest that we can 'measure' or 'calculate' these degrees of immanence in some kind of scientific or mathematical fashion; indeed, we will see how the degree to which a theatre is an immanent one will always be a matter of perspective, not in the sense of 'mere' *doxa* or impression, but literally and physically, a product of perception as well as that which produces new ways of seeing and participating in the world.

That leaves us with the persistent problem of the predominantly masculine and Western nature of the book's focal practices (and philosophies) and, indeed, with the broader tension between Deleuze's postidentitarian philosophy of difference and Performance Studies' ongoing commitment to identity politics and, correlatively, to notions of 'the subject'. As we have already seen, like many other disciplines in the arts and humanities, Theatre and Performance Studies had its own 'theory explosion': a sudden growth of engagement with critical theories, from semiotics to postcolonialism, that allowed scholars to question the complex ways in which performance participates in the politics of representation, functions as a site of power/knowledge practices, and both perpetuates and contests dominant representations of difference. And, clearly, given the continuing performance of violence (both literal and symbolic) on ethnic, sexual and class difference, it is not a question of theory having had its 'moment' or of suggesting that we are somehow 'post-' identity politics. Rather, Deleuze has a complex but not entirely irreconcilable relationship to identity politics that I will not be able to address in full here. However, I do want to make some brief remarks regarding his relationship to feminism and interculturalism before we move on.

So first, feminism. As Alice Jardine noted in 1984, Deleuze and Guattari were 'publicly supportive of the feminist movement' (Jardine 1984: 47) and their collaborative works participated in 'denaturalizing sexuality and especially its polarized genders' (Jardine 1984: 49), construing the two sexes as secondary organizations of 'a microscopic transsexuality'. However, they also infuriated feminists with their concept of 'becoming-woman' – a specific form of affect or becoming that has seemingly little if 'anything to do with women *per se*' – begging the question of why the term 'woman' is appropriate here at all (Jardine 1984: 53). Rather, they argue that women as well as men must enter into a becoming-woman (Deleuze and Guattari 1988: 134) and that becoming-woman does not involve 'any recognition of, identification with or imitation of woman' or what Deleuze and Guattari call 'molar entities' (Grosz in Genosko 2001: 1458). As they explain, 'What we term a molar entity is, for example, the woman as defined by her form, endowed with organs and functions, and assigned as a subject' (Deleuze and Guattari 1988: 275). Furthermore, they give the impression that men's becoming is dependent on women 'going first' when they state, 'Woman as a molar entity *must become woman*, so that man as well may become one or is then able to become one' (Deleuze and Guattari 1988: 339).

But if becoming-woman is not about identifying with actual women or pretending to be a woman – if you are not one already – then what does it really involve? For Grosz, becoming-woman involves different things for the two sexes:

For men, it implies a de- and restructuring of male sexuality, the bringing into play of microfemininities, of behaviors, impulses, and

actions that may have been repressed or blocked in their development, but exactly what it means for women remains unspecified. (Grosz in Genosko 2001: 1460)

Most problematic of all, though, was both the argument and the misguided language used in the following passage from *A Thousand Plateaus*:

It is certainly indispensable that women engage in molar politics, in terms of a conquest which they conduct from their organization ...: "We as women..." then appears as the subject of the enunciation. But it is dangerous to fall back upon such a subject, which cannot function without *drying up a spring or stopping a flood*. (Deleuze and Guattari 1988: 339, emphasis added)

Clearly, and as many generations of feminists have already explored, there are multiple problems here. For Grosz, this passage serves as a reminder that 'formulas in which the "liberation of women" is merely a stage or stepping stone in a broader struggle, must be viewed with great suspicion' (Grosz in Genosko 2001: 1461). Subsequently, Claire Colebrook rephrased this question, asking: 'Should the women's movement really be told that it must be 'molar' or concerned with identity only for a moment on the way to a 'molecular' becoming?' (Colebrook in Colebrook and Buchanan 2001: 2). In turn, for Jardine, the implication is that 'Man [capital M] is always the subject of any becoming' (Jardine 1984: 54); it is the metamorphosis of specifically male (and, we might add, white, Western, middle-class) bodies that is of concern in Deleuze and Guattari's theory of becoming; a male experience of desire comes to stand for desire per se. Likewise for Grosz, writing in 1993, Deleuze and Guattari

exhibit a certain blindness to feminine subjectivity, a feminist point of view and the role of women in their characterizations of the world ... They fail to notice that the process of becoming-marginal or becoming-woman means nothing if one is already marginal or a woman. (Grosz in Genosko 2001: 1440)

Ultimately, though, Grosz, and other important feminist thinkers like Rosi Braidotti, have found value in 'a (provisional, guarded) alliance' of feminism with Deleuzian thought on the basis of 'a common target – the reversal of Platonism' as that which includes a problematization of any ontological opposition, including of man and woman (Grosz in Genosko 2001: 1444). In this sense, his immanent project is allied with any form of feminism that rejects an eternal or given notion of 'woman'. Deleuze's insistence on the univocity of being posits relationality as prior to the secondary operations of 'binary machines of social classes; of sexes, man-woman; of ages,

child-adult' etc. (Deleuze and Parnet 1987: 128). In turn, immanence invites us to rethink ethico-political concerns on the level of difference and process, including attending to how ethics and politics operate on the molecular level of affect as well as on the molar level of organizations, political bodies and so forth. It is not a question of doing away with 'woman' or 'the feminine' as a category of identity – either for strategic, political reasons or ontological ones. Rather, an immanent view proposes that such pure categories are ideal and transcendent, while actual bodies are always a mixture of tendencies: variable and varying degrees of sedimented gender identity and mobile transgenderings, different and differing amounts of biological determination and genetic creation.

Secondly, with respect to Deleuze's relationship to interculturalism and Occidentalism, we might look to Gayatri Chakravorty Spivak's massively influential essay, 'Can the Subaltern Speak?' (1988). Here, Spivak focuses on 'Intellectuals and Power', the documented conversation between Deleuze and Michel Foucault, arguing that their critique of the subject merely 'gives an illusion of undermining subjective sovereignty' while covertly conserving 'the subject of the West, or the West as subject' (Spivak in Nelson and Grossberg 1988: 271–2). Ironically celebrated as 'prophets of heterogeneity' by some, Spivak finds both Deleuze and Foucault guilty of effacing intercultural differences within ideologically driven generalizations of 'the oppressed'; for instance, when she accuses Deleuze of disavowing 'the international division of labour' in his invocation of '*the* workers' struggle'. In a recent commentary, Andrew Robinson and Simon Tormey argue that Spivak

> demolishes the pretensions of Deleuze and Foucault to offer an escape from the universalizing ambitions of post – Enlightenment thought, demonstrating how their admonition to give up representing the oppressed ends up enacting the very same logic of subordination to the Western 'global – local' they claimed to confront in their own work. (Robinson and Tormey 2010: 32)

That is, for Spivak, Deleuze makes the mistake of thinking that his specifically Western theorizations have a more general, global application.

However, Robinson and Tormey then go on to argue that Spivak has failed to engage with Deleuze's oeuvre as a whole, and particularly his work with Guattari: 'Far from a position that reinforces or supports an occidental or Eurocentric perspective', Deleuze and Guattari's analysis 'is not only overtly hostile to the presuppositions of this perspective', they argue, it is also a philosophy 'whose evidential base, points of reference and principal counterexamples are rooted in an array of subaltern, indigenous and minoritarian practices and cultures' (Robinson and Tormey 2010: 37). I will not be able to emulate this intercultural diversity of reference here; however, I would still

argue that the practices with which I engage might be called '*minor* theatre' or, better, *minor uses of or approaches to* theatre and performance, according to Deleuze's definition of 'the minor'.[13] For Deleuze, that is, a minor practice is not necessarily one performed by those identifying or identified as belonging to a 'minority group' as they are conventionally defined. In 'One Less Manifesto', for instance, Deleuze suggests that a minor theatre is one that subjects the different elements of theatre – its language, gestures, costumes and props – to the greatest degree of variation, rather than fixing them into the conventional organizational forms of plot, dialogue, consistent character and so forth.

Likewise, Deleuze insists that a 'minority' is not a question of numbers, but of the subordination of difference to a transcendent measure. Under majority rule, groups such as 'women, children, the South, the third world' (but also nonhuman animals) are, despite their numbers, constituted as subordinate minorities in relation to a standard measure: *the supposedly universal model of Man*, who in fact represents the specifically 'white, Christian, average-male-adult-inhabitant of contemporary American or European cities' (Deleuze 1997: 253–5). According to transcendent ways of thinking, ways of living (speaking, thinking) that differ from this standard constitute 'deviations from a norm'. But from the point of view of Deleuze's philosophy of immanence, it seems that those constituted as minorities tend to be closer to the creative, self-differentiating powers of life (and specific forms of life, such as language) than those who conform to the standardizing model.

However, Deleuze also makes clear that this ideal, universal 'Man' does not really exist, since all actual people already participate in becoming, albeit to varying degrees. In the same way, we will see how a universal, transcendent theatre does not exist either; there can be no 'state theatre' that does not also harbour its own immanent mutations, no context in which theatre constitutes a 'state' rather than a process at all (no matter what particular nation states might like us to think). Indeed, through this book I will insist that there is no pure state of immanence or transcendence. Rather, we must think in terms of actual tendencies or movements in the direction of immanence and transcendence as two ideal poles. Of course, the material effects of the domination of Man as an ideal value are certainly real, in and as the 'unimaginable sufferings' of minorities at the hands of the majority.

But Deleuze and Guattari do not define minorities by their suffering, or at least not by suffering alone; rather, they argue that minorities also have in common 'their resistance to death, to servitude, to the intolerable, to shame, and to the present' (Deleuze and Guattari 1994: 110). And Deleuze suggests that theatre and performance can express varying degrees of solidarity with this resistance to transcendent measure – a resistance that is not a secondary reaction, but a primary creativity from which the majority itself derives. An ethico-political theatre, for Deleuze, would not be one that aims to *represent* minorities, or to represent *conflicts* between 'men' and 'women',

or the 'first' and 'third worlds'. Rather, he suggests that the revolutionary nature of a minor usage of theatre lies in its affirmation of the primacy of cross-categorical mutations, its emphasis on the tendency of life perpetually to differ from itself, alongside its tendency to congeal into recognizable or categorizable identities. Theatre might stand alongside actual minority experience, Deleuze suggests, if it is able 'to construct in some way, a figure of the minority consciousness as each one's potential' (Deleuze 1997: 254). An immanent potential though, to be sure – since we are all deviations from 'Man,' even the white Western men whose work dominates this book.

We will explore this notion of the minor in more detail with respect to the use of voice and language in performance in Chapter 2. However, I hope that these brief comments have gone some way to suggest that this book is not only defensible, but positively of interest to those involved in consideration of identity politics with respect to performance. And I hope that this is the case, less because the text includes the important performance work of a number of women (Judith Malina, Goat Island's Lin Hixson and Karen Christopher, Lygia Clark) and a lone but certainly not token non-Westerner (Hijikata Tatsumi), and more because I am able to make clear the ethico-political dimensions of immanence.

This book does not aim to provide a universal and eternal theory of performance, then, nor does it claim to offer a program of action that guarantees immanence. That is, it is not claiming to articulate a global theory that might be applied to all spaces, always. Clearly, it will not *work*, it cannot be useful everywhere nor for all time. In this sense, I am taking up the pragmatic values by which Deleuze argued that we should judge philosophy, following the dismantling of the notion of 'truth'. Without 'truth', how do we judge? Deleuze answers: we ask after the importance and interest of a given theory. Does it work? What does it allow? In terms of space, a universal project falls down when it confronts radically different cultural contexts. In terms of time, it can appear dated in relation to ever-changing times. Clearly, the nature of the forces of organization that theatres of immanence might aim to resist is such that they do not operate in the same way everywhere, and strategies of oppression alter over time. Therefore, the practices that I discuss in this book should not be seen as exemplary models to be reproduced, but as singular solutions to highly specific problems. And yet, at the same time, I would also hope that practitioners might locate resonances or sense commonalities between their own work and the practice under discussion here, such that ways of making and thinking (making as thinking and vice versa) might be transplanted and recreated in new contexts.

1
Immanent Authorship: From the Living Theatre to Cage and Goat Island

I want to begin this chapter by exploring the extent to which the dual notions of immanence and transcendence might be used to differentiate specific approaches to authoring performance. The concept of immanence, I will suggest, has implications for how we think about a variety of forms of authorship, including both collaborative, collective devising and directing. Indeed, I want to propose that immanence provides a productive way to consider the relationship between these authorial modes. Our investigation of immanent authorship will begin with an elaboration of immanence and transcendence as philosophical concepts: conceived by Deleuze as the two ideal poles of a continuum of relation to creative production, with the former tending towards a 'bottom-up' approach in contrast to the top-down tendency of the latter. Secondly, I want to look at the resonance between these ideas and those of the Living Theatre as one company that might be understood to belong to a broader 'collective creation' movement – an emergent tendency within theatre companies, particularly in and around May 1968,[14] towards undoing the hierarchies and divisions of labour that had become the normative mode of organization with respect to theatrical creativity.[15]

Although the company received the greatest critical acclaim for earlier works such as *The Connection* (1959) and *The Brig* (1963), the Living Theatre are best known for *Paradise Now* (1968), a piece that Stephen J. Bottoms refers to as one of the 'countercultural landmarks' of the 1960s (Bottoms 2006: 238). Collectively created while the company were in exile in Europe and subsequently toured around the United States during the politically and socially volatile years of 1968–69, *Paradise Now* is frequently cited by scholars as exemplary of the concern with presence, and the rejection of representational theatre, understood to characterize the American avant-garde theatre (or 'alternative theatre' or 'Off-off Broadway' theatre) of the 1960s. However, as well as ensuring its persistence, the notoriety of *Paradise Now* has arguably also damaged the legacy of the Living Theatre, particularly insofar as the piece tends to be reductively represented as a pure and

simple 'affirmation of live, unmediated *presence'* (Copeland 1990: 28). Much derided in subsequent critiques by Christopher Innes (1981, 1993) and Gerald Rabkin (1984), the company are often construed as vulnerable to deconstruction given their appeals to notions of "truth" and "authenticity"; they act as the 'straw-man' for Derridean performance theory to the extent that they are understood to trust speech over script, and the body over language, as the means to locate an inner self.

Nevertheless, this chapter will suggest that we should be wary of allowing such deconstructive critique to prevent us from seeing the value in the immanent experiments of the Living Theatre, as we know that Deleuze and Guattari did.[16] Such experiments include a range of techniques for desubjectifying performance, including not only collective creation but also improvisation and the use of chance procedures. We will examine each of these in what follows, drawing in insights from the Living Theatre's collaboration with John Cage and contrasting their approach to critiques of collective creation and improvisation by their contemporary, Jerzy Grotowski. In turn, we will move on to explore how immanent authorship is manifest in the work of former Chicago-based company Goat Island, noting from the start how the company affirm the desubjectifying powers of collaboration, but without abandoning the role of the director.

Founded in 1987, Goat Island was a collaborative performance group, directed by Lin Hixson and formed of the core members Matthew Goulish, Bryan Saner, Karen Christopher, Mark Jeffrey and Litó Walkey. During their 20 years of creating work, the company earned both respect and fascination in the field of performance for their commitment to the affective potential of intricate choreographies performed by nonexpert bodies, and the capacity of a slow, genuinely collaborative research and creation process, which starts from a state of not knowing, to generate new thoughts and unexpected sensations. In 2006, Goat Island announced that their ninth performance, *The Lastmaker* (2007), would be the last work they would create as a company before individual members went on to pursue new projects and collaborations, such as Goulish and Hixson's initiative Every House Has a Door.

The connection between Goat Island and Deleuze has already been explored in the writings of founding member Matthew Goulish, as well as in the work of performance scholars such as the company's UK archivist Stephen J. Bottoms, and David Williams. All three have exposed some of the Deleuzian aspects of Goat Island in a range of important observations (see Bottoms 1998; Williams 2005; Cull and Goulish 2007). For instance, in writing about the process of creating the company's eighth performance – *When will the September roses bloom? Last night was only a comedy* (2004) – Goulish evokes notions of 'stuttering' in performance and a 'zone of indiscernibility' between human and animal that clearly evidence an engagement with Deleuze's thought. Likewise, his earlier monograph,

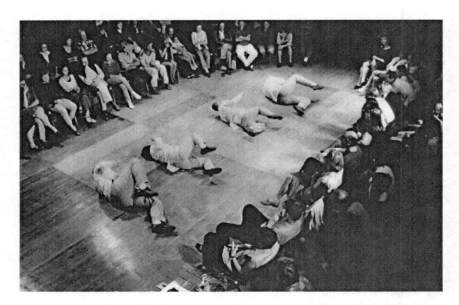

Image 1 Goat Island, *It's Shifting Hank* (1994). Photograph courtesy Belluard Bollwerk International Festival, Fribourg, Switzerland, in performance, 1994. Pictured left to right: Timothy McCain, Karen Christopher, Matthew Goulish, Greg McCain

39 Microlectures: In Proximity of Performance (2000), draws on the concepts of 'deterritorialization', the machinic and differential repetition.[17] As, Bottoms has noted, it is not that Goat Island have 'consciously sought to translate Deleuze and Guattari's ideas into the performance context' (Bottoms 1998: 434), but nevertheless their approach to the creation of performance – as collaboration, as becoming – registers their affinity to the values of Deleuze's ontology.

Here, I want to focus on the approach to collaborative authorship and directing that Goat Island developed over their 20 years of making work. Immanent authorship, the company allow us to make clear, is not a matter of 'freeing' the author from all rules or constraints. In contrast, we find that, for Goat Island at least, immanence is often to be found where we least expect, for instance in modes of authorship that are based on the imposition of rules and constraints, that serve to *preserve* rather than homogenize difference within a process of collaborative authorship. However, before we enter into the practical details of these approaches, I want to go into more depth regarding the philosophical background to the concept of immanence and explore, in particular, its relationship to the notion of 'the subject' and, hence, 'the author'.

To have done with God and the Subject: Immanence in philosophy

As I touched on in the Introduction, immanence and transcendence are distinct modes and different ways of understanding creativity and organization. In some forms of organization – whether we are thinking in terms of ontological, social or artistic processes – creation or the production of form relies on 'a transcendent instance of command': some thing that functions as a leader, director or author from a position outside the process itself (Holland 2006: 195). In turn, we can say that this transcendent 'thing' need not take the form of a person, but could equally be a different kind of body, like an idea. Whatever form it takes, the role of this transcendent figure is 'to guarantee coordination', to impose organization top-down on the chaos of processes or, again, to conceive what to create from the material and to execute that conception (Holland 2006). As Eugene Holland has explained, transcendent modes of creation are those in which the 'modes and principles of ... organization' are external to the activity in question – they are neither part of that activity, nor have they issued from it (Holland 2006). In contrast, immanent modes of organization and creativity allow coordination to emerge bottom-up, and the 'modes and principles of ... organization' to come from within the processes themselves, not from outside them. There is no leader, director, author or transcendent idea that commands coordination and organization from without; rather, 'coordination arises more spontaneously and in a manner immanent to the ... activity' (Holland 2006). The material bodies involved in the creative process do not obey commands issued from a transcendent source, but generate their own rules and forms of creation.

Initially articulated in the context of theological accounts of the nature of the relationship between God and worldly creatures, in Deleuze immanence becomes a secular, ontological principle, which in turn can inform our understanding of creation in an artistic context (indeed, Deleuze will make no distinction between ontology and aesthetics). In *Spinoza: Practical Philosophy*, Deleuze says that his concept of immanence is built up from 'the great theoretical thesis' of the seventeenth-century philosopher Baruch Spinoza; namely, the notion of existence as 'a single substance having an infinity of attributes' and, correlatively, of bodies or 'creatures' as 'modifications of this substance', produced without the intervention of 'a moral, transcendent, creator God' (Deleuze 1988: 17). As Beth Lord has outlined, the established theism that dominated the Dutch Republic at the time was committed to an image of an 'anthropomorphic, intentional God', in contrast to which Spinoza proposed an immanent God, manifest in nature (Lord 2010: 4).

For Deleuze, writing three centuries later, the notion of a transcendent entity that acts as the condition for the creativity of the world persists, but

in the form of human subjectivity rather than a God figure. This is, to a great extent, the legacy of Kant. As Todd May summarizes, Kant inaugurates a philosophical tradition that is

> in thrall to a human subjectivity that abandons God not by overthrowing transcendence but by gradually usurping God's place in it. The primacy of the human subject is not a turn to immanence, not an immersion in the world, but transcendence carried on by other means. (May 2005: 28)

Above all, this transcendent thinking manifests itself in understandings of the relationship between mind and matter; hence its significance for theorizing artistic creativity as well as ontology. After Kant, human subjectivity is construed as that which constitutes the meaning of the material world from a position outside or beyond that materiality. As May makes clear:

> Constitution does not imply creation. It is not as though there was only mental substance and then, by some miracle, physical substance was created from it. What is created is not the *material* but the *world*. The what it is of the material world, its character, is constituted by the mental world, woven from the material world's inert threads into a meaningful complex. (May 2005: 29, emphasis in original)

According to such a perspective, it is the interaction of consciousness, understood as the special and unique substance of human subjectivity, with matter that enables the world to become meaningful. In this way, it is not just that transcendence posits a fundamental dualism, but that this dualism institutes a hierarchy in which the subject becomes sovereign over all that it surveys. In this way, May concludes, the transcendence of the subject ushers in the subordination of difference to which Deleuze and contemporaries like Derrida so strongly object.

> Only that which ... conforms to the conceptual categories of human thought is to be admitted in the arena of the acceptable. Physicality, chaos, difference that cannot be subsumed into categories of identity: all these must deny themselves if they would seek to be recognized in the privileged company of the superior substance. (May 2005: 31)

For Deleuze, this transcendent thinking is a kind of illness; ontological dualism is what he calls a 'philosophical disease', passed on from one generation of philosophers to the next. But some philosophers – such as Spinoza, but also Nietzsche and Bergson – were less susceptible to this disease than others, and become the resources that enable Deleuze to develop an alternative, immanent account of the relationship between subjects and the world, between beings – including human beings – and Being, in the

sense of existence in general. Being, Deleuze says in *Difference and Repetition*, is univocal: 'Being is said in a single and the same sense of everything of which it is said, but that of which it is said differs: it is said of difference itself' (Deleuze 1994: 36). Or again, to take a quote from Deleuze's second book on Spinoza, consider the idea that there is 'one Nature for all bodies, one Nature for all individuals, a Nature that is itself an individual varying in an infinite number of ways' (Deleuze 1988b: 122). Another way to say this might be to say that difference is what all things have in common, for Deleuze; or, further, that because nature differs, what all things have in common is that they are not 'things' at all, but processes of ceaseless variation, change or creativity. And this includes subjects. In *A Thousand Plateaus*, Deleuze and Guattari 'reject dominant "humanist" models of subjectivity focused on the integrity and unity of a single self' (Robinson and Tormey 2010: 23), when they say that 'The self is only a threshold, a door, a becoming between two multiplicities' (Deleuze and Guattari 1988: 249). At times, particularly in his earlier work, Deleuze will even go so far as to suggest that the self is an 'illusion'. For instance, in *Difference and Repetition*, he argues that 'The modern world is one of simulacra ... All identities are only simulated, produced as an optical "effect" by the more profound game [*jeu*] of difference and repetition' (Deleuze 1994: 1, xix). Not just human identity, then, but any appearance of identity or self-sameness is taken to be just that, an appearance or by-product of a more fundamental processuality in which nothing repeats, or, rather, the only thing that repeats is differential (rather than bare) repetition itself.

However, in his work with Guattari, Deleuze frames the transcendent concept of 'the Subject' less as an illusion and more as an oppressive force operating at the level of the body and the social, as an organizing force that invites us to operate as if we were really separate from (and, in some cases, superior to) the other bodies populating the world. In *A Thousand Plateaus*, for example, Deleuze and Guattari characterize instances of subjectification as what they call 'strata': 'acts of capture' (Deleuze and Guattari 1988: 40) or 'phenomenon of sedimentation' that impose organization and stasis on the otherwise mobile, material energy of the world (Deleuze and Guattari 1988: 159). Alongside 'the organism' and 'signifiance', the subject is one of 'the three great strata', each of which attaches to a different aspect of life: the organism to the body, signifiance to the 'soul' (or unconscious) and subjectification to the conscious (Deleuze and Guattari 1988: 160). The strata then come to coordinate our relationship to life, operating like a utilitarian logic or a transcendental point of view that passes moral judgement on differences from their respective representational categories:

> You will be organized, you will be an organism, you will articulate your body – otherwise you're just depraved. You will be signifier and signified, interpreter and interpreted – otherwise you're just a deviant. You will be

a subject, nailed down as one ... otherwise you're just a tramp. (Deleuze and Guattari 1988: 159)

In contrast, Deleuze and Guattari argue that we need to 'tear the conscious away from the subject in order to make it a means of exploration' (Deleuze and Guattari 1988: 160).

For now, a final way of understanding Deleuze's immanence would be in relation to the scientific notions of 'emergence' and complexity theory. In 1969, while Deleuze and Guattari were working on *Anti-Oedipus*, Evelyn Fox Keller and Lee Segel published their seminal research on the behaviour of slime mould – a simple organism that nevertheless demonstrates highly complex behaviour. Now a classic example of 'emergence', Keller and Segel's study of slime mould was one of the first specific accounts of what became known as 'emergent systems': systems that solve problems in a bottom-up rather than top-down manner, or immanently rather than transcendently (Johnson 2001: 14). As Steven Johnson among many others has discussed, slime mould has fascinated generations of scientists on account of its capacity for 'coordinated group behaviour' as well as its ability to oscillate between functioning as 'thousands of distinct single-celled units' and as a 'swarm' (Johnson 2001: 13). But whereas previously this behaviour was assumed to be coordinated by pacemaker cells, Keller and Segel found it to be a biological instance of leaderless organization and 'decentralized thinking' (Johnson 2001: 17).

In turn, many recent Deleuze scholars – from Brian Massumi to John Protevi and Manuel DeLanda – have emphasized the affinity between Deleuze's work and the sciences of emergence. Protevi, for example, sees Deleuze as producing 'the ontology of a world able to yield the results forthcoming in complexity theory' (Protevi 2006: 19), while Massumi argues that Deleuze, along with Bergson and Spinoza, can be

profitably read together with recent theories of complexity and chaos. It is all a question of emergence, which is precisely the focus of the various science-derived theories that converge around the notion of self-organization (the spontaneous production of a level of reality having its own rules of formation and order of connection). (Massumi 2002b: 32)

And certainly, Deleuze's emphasis on the processual and metamorphic nature of materiality constitutes a critique of *hylomorphism*: 'the doctrine that production is the result of an ... imposition of a transcendent form on a chaotic and/or passive matter' (Protevi 2001: 8). In contrast, and thus in line with writing in the field of emergence, Deleuze's thought 'emphasizes the self-organizing properties of "matter-energy"' (Marks 2006: 4), which Deleuze conceives of as the difference or line of variation running through all things.[18] In this sense, one way in which Deleuze's immanence manifests

itself is as a specific understanding of how new forms are created, with an emphasis on the ways in which material bodies organize themselves rather than being construed as moulded into an organized form by an external force.

To have done with authors, directors and intention: Immanence in performance

Transferring such philosophical and scientific concepts of the distinction between immanence and transcendence to the domain of performance might enable us to generate contrasts between top-down and bottom-up tendencies in authorship, as well as to distinguish between different kinds of artistic organizations. Indeed, Deleuzian scholar Eugene Holland has already done precisely this with regard to music. In his 2006 essay, Holland not only wishes to provide an introduction to Deleuze's concepts of immanence and transcendence, but to demonstrate the value of this distinction for analysing differences between modes of creative practice, in his case between the examples of classical symphony performance and jazz. For example, Holland argues:

> The classical symphony orchestra requires a transcendent instance of command in the figure of the conductor to guarantee coordination, whereas coordination arises more spontaneously and in a manner immanent to the group activity in jazz. Classical music entails a social division of labour whereby some merely execute what others (composers and conductors) conceive and command. (Holland 2006: 195)

Or again, Holland goes on to link an immanent mode of organization with Deleuze and Guattari's concept of 'nomadism', contending that nomadism

> designates forms of activity where the modes and principles of social organisation are immanent to the activity itself, not imposed by a transcendent instance from above; where itinerant following and group creation prevail over the issuing and obeying of commands. (Holland 2006: 195)

With the reference to notions of imposition, commanding and obeying, Holland evokes the politicization of immanence and transcendence, according greater political value to immanent modes of organization insofar as they break with some of the traditional hierarchies that might be understood as blocking equality of access to creativity. Holland represents classical music as less democratic than jazz, because it assigns creative labour only to the elite few. In this way, Holland's article emphasizes the social nature of cultural activities, the ways in which activities like music or theatre 'induce

a certain division of labour' or style of social organization that contributes to the wider organization of the social field (Holland 2006: 195). In this sense, it is not merely that theatre can function as a macrocosm of the social in the event of performance. Rather, theatre can be understood to have a socio-political dimension in terms of the style of organization manifested in its creative processes.

And the collective creation movement of the 1960s and 1970s was only too aware of this. While the origins of the *practice* of collective creation are difficult to determine, we do know that Meyerhold used the *term* 'collective creation' in 1906 to describe the experimental work in which he and Stanislavsky had been involved in their first Studio Theatre (Syssoyeva 2012: n.p.). Other key figures in the early history of collective creation include Jacques Copeau, Viola Spolin and Erwin Piscator, all of whom contributed to the flourishing of collective creation during the 1920s. Thus collective creation was not born in the 1960s, so much as reinvented with a strongly political emphasis by practitioners like the Living Theatre. That is, this period stands out as one in which the projects of theatre companies allied with workers' committees and student protesters during the events of May 1968, coalescing around the common concern to break apart 'the hierarchical organization and strict division of labor that plagued both heavy industry and the culture industry' (Calder in Syssoyeva 2012: n.p.).

Likewise, as Theodor Shank discusses in his key article on collective creation, the 'new theatre organizations' of the 1960s and 1970s, like the Living Theatre, can be seen as reflections of other counter-cultural visions 'of the alternative society' (Shank 1972: 3). Specifically, Shank suggests, the new theatres shape themselves as alternatives to a mainstream theatre that is as competitive and specialized as mainstream society. Such theatres have a strict division of labour in which actor, director and playwright all play distinct roles. From this perspective we might say that the Living Theatre's processes of collective creation suggest a 'social ideal' of bottom-up rather than top-down organization and the integration of difference into group production. Indeed, Rabkin suggests that this might be the best way to understand *Paradise Now* and the transformation of the Living Theatre as a company during the 'exile period':

> It was no longer a theatre in the formal sense; it was a tribe, a commune. The new performers on stage ... were not primarily artists sharing in a collective effort, but members of a family cultivating alternative modes of living. And ... why not? The violent, polarized society we lived in then demanded new strategies. (Rabkin 1984: 13)

Like Deleuze, the Living Theatre sought to explore whether it was possible to create an organization 'which is not modelled on the apparatus of the State, even to prefigure the State to come' (Deleuze and Parnet 1987: 146).

In turn, we might suggest that the collective creation movement of the 1960s and 1970s was precisely a rebellion against the theatrical equivalent of the classical symphony orchestra, insofar as the collectives rejected the transcendent command of a director. In the same way, rather than risking becoming subordinate to the intentions of an author and subject to the notion of 'fidelity to the text', collectives like the Living Theatre produced new work through a combination of improvisation and group discussion (processes that have since been confirmed as staple methodologies of contemporary 'collaborative devising'). That is, in addition to the structure of the company itself, the Living Theatre experimented with a wide range of approaches to authoring performance that can be understood as attempts to undo the organization of performance *either* by the transcendent author, director and subjective intention *or,* alternatively, as an attempt to make what we might call *self-organizing theatre.*

As Kimberley Jannarone has discussed, the figure of the modern theatre director only took 'definite form in the late nineteenth century' (Jannarone 2010: 133), at which point the role was understood to involve unifying the disparate elements of performance as well as interpreting, controlling and organizing every last aspect of the theatrical elements on stage in order to place them at the service of communicating the playwright's vision; that is, before the director's own vision became paramount (Jannarone 2010: 136). Here and in the early twentieth century, Jannarone suggests, 'the director was not always a dictator, but he was a missionary figure with unusual skills in manipulating crowds of people' (Jannarone 2010: 135). But even if the notion of directing is now increasingly understood as a specific, but not necessarily privileged, skill within the collective process of creating performance, it does still tend to be associated with externality and transcendence, as evidenced in the familiar but arguably ill-defined notion of 'the outside eye'. As Paul Allain and Jen Harvie have discussed:

> In rehearsal, the director works almost as a proxy audience, reflecting the actor's work back to him or her and providing what is often described as an 'outside eye'. Work that is made without such an outside eye, in theatre collectives, for example, has often been criticized for being indulgent or shapeless, perhaps indicating through this absence crucial aspects of the director's job. (Allain and Harvie 2006: 147)

And perhaps Allain and Harvie have groups precisely like the Living Theatre in mind here, given their conception of collective creation as a means for performance to create itself as a self-organizing system, to generate its own unpredictable form without need of a transcendent design or directorial vision. The company actively appropriated the label 'collective creation' for a number of their works made during the 1960s. For instance, Marianne DeKoven has suggested that the company used the term in relation to their

best known work – *Paradise Now* (1968) – because they wanted to connote a repudiation of 'all traditional theatrical structures that establish hierarchies of separated functions and entities: play, playwright, producer, director, actors, crew, performance' (DeKoven 2004: 144). That is, just as the May 1968 strikes often centred around calls to dismantle the hierarchies that had sedimented with the division of labour, theatre companies also sought to deviate from the 'two-process method' of 'traditional theatre' – as that which involved 'a playwright writing a script in isolation and other artists staging it' (Shank 1972: 4) – where the latter process of creation is subordinated to, or understood to be derivative of, the former. Although clearly influenced by the wider context of May 1968 in many ways, the Living Theatre had already begun to create collectively prior to the strikes and the emergence of collective creation in French companies such as Théâtre du Soleil and Le Folidrome. Appropriately, Beck and Malina claim that the Living Theatre found themselves working on a collective creation *almost by accident* in 1964, in the development of *Mysteries and Smaller Pieces,* the first original production undertaken in their 'exile' period. According to Beck, 'Mysteries had no director' – a shift in the nature of the company's creative process that he presents as accidental, as something that happened to the company without them knowing or planning it (Beck 1972: n.p.). However, though collective creation might have happened to the Living Theatre unintentionally, by 1969 Beck was arguing that 'the real work of the director in the modern theatre is to eliminate himself' (Beck in Shank 2002: 36).

So, whereas in previous productions the company had tended to use an authored script as the basis for performance (for example in their staging of *Many Loves* by William Carlos Williams in 1959), *Mysteries* was conceived as an opportunity for all company members to engage in the process of authorship, beyond the form of improvisation in the performance event itself that had taken place in works like *The Brig.* That is, although the company had, from their beginnings, tended to choose plays by authors who were definitively outside conventional repetoire, they still wanted to experiment with relieving themselves of the transcendent author altogether. Primarily, group authorship took the form of lengthy, multiple discussions that the Living Theatre refer to as their 'rehearsals'. In turn, published notes concerning *Paradise Now* document only the first five of one hundred general discussions in which all company members participated. In collective creation, Beck suggests,

a group of people comes together. There is no author to rest on who wrests the creative impulse from you … We sit around for months talking, absorbing, discarding, making an atmosphere in which we not only inspire each other but in which each one feels free to say whatever he or she wants to say … In the process a form presents itself. (Beck 1972: n.p.)

Beck also suggests that the final work will always be more than the sum of its parts and therefore cannot be quantified in terms of individual contributions. Indeed, he suggests that contributions as such cannot be measured:

> The person who talks least may be the one who inspires the one who talks most. At the end no one knows who was really responsible for what, the individual ego drifts into darkness ... everyone has greater personal satisfaction than the satisfaction of the lonely 'I'. (Beck 1972: n.p.)

According to Beck, discussions such as these became 'an integral part' of the company's 'working method, and were the source material out of which *Mysteries, Frankenstein, Paradise Now*, and the mise-en-scène for *Antigone* were created' (Living Theatre 1969: 90). As Bradford Martin has suggested, in this way the Living Theatre's affirmation of such a self-organizing process 'echoed the New Left's ethos of participatory democracy, giving decision-making power to individuals, as well as the SNCC's [Student Nonviolent Coordinating Committee] attempts to function as a leaderless, grass-roots organization' (Martin in Bloom 2001: 178). 'For the Living Theatre specifically,' Martin goes on to suggest, 'collective creation constituted a practical experiment in the type of anarchist society the company envisioned politically' (Bloom 2001: 178).

As Guattari remarked regarding the group discussions of the political collectives he was involved in, 'It's not a question of creating agreement; on the contrary, the less we agree, the more we create an area, a field of vitality' (Guattari 1998: 196). Likewise with the Living Theatre, the company's rehearsal notes indicate that their participatory discussions did not tend to lead to instances of 'absolute communion' between the actors, as much as disagreements and debates – demonstrating the difficulty involved, in practice, in dissociating authorship from the individual subject or 'destratifying' the creative process. For instance, there are the divergent opinions of company members around the question of how social change happens, the relation between social and individual repression, and the role that theatre might play in undoing these repressions.[19] So, collective creation was often a lengthy and somewhat painful process for the Living Theatre given their diverse backgrounds and differing views, allowing Bradford Martin to suggest that

> the often frustrating tedium of collective creation parallels the New Left's experiences with consensus-based decision-making in trying to constitute a process of working that reflected the egalitarian sentiments of participatory democracy. (Martin 2004: 68)

Yet if what matters most is the participation of all company members in the process of *creating* a work, then there is no reason to position 'agreement'

or 'consensus' as the goal of that process. Company member Henry Howard once remarked, 'The whole company has thirty political ideologies and there has to come out of it one front – not one mind because the thirty of us are never going to agree' (Martin 2004: 69).[20]

However, as the Living Theatre knew, it was not enough to use discussion as a means simply to shift the focus from individual to collective creation, since this could allow the collective to remain, simply, a group of individuals. As Ric Knowles's contribution to Bruce Barton's collection discusses, Foucault's preface to *Anti-Oedipus* operated like 'a kind of structural and political touchstone' for collective creation as it manifested itself during this time. In particular, Knowles argues, collective creation constitutes one practical response to Foucault's argument that

> What is needed is to 'de-individualize' by means of multiplication and displacement, diverse combinations. The group must not be the organic bond uniting hierarchized individuals, but a constant generator of de-individualization. (Foucault in Knowles 2008: 100)

Being a group or a collective is not enough, then; what matters is *how* the group conceives and assembles its constituent parts. In particular, Foucault suggests that the group should not be conceived as merely a collection of individuals, since 'the individual is the product of power'.

Each one is already several: Collective creation in the context of the differential self

In a similar fashion, Beck and Malina's contemporary, Jerzy Grotowski, remained suspicious of the emancipatory claims made by some proponents of collective creation, arguing that the new movement merely exchanged the dictatorship of the director for a dictatorship of the group. In his 1972 text 'Holiday [Swieto]: The day that is holy', Grotowski argues that

> the idea of a group as a collective person must have been a reaction to the dictatorship of the director, i.e., someone who dictates to others what they are to do, despoiling them of themselves. Hence the idea of 'collective creation'. However, 'collective creation' is nothing but a collective director; that is to say, dictatorship exercised by the group. And there is no essential difference whether an actor cannot reveal himself – as he is – through the fault of the director, or the group director. For if the group directs, it interferes with the work of every one of its members, in a barren, fruitless way – it oscillates between caprices, chance and compromise of different tendencies and results in half-measures. (Grotowski in Wolford and Schechner 2001: 224)

Nevertheless, Grotowski's position should not be read as one that simply rejects collective creation; rather, his writings and statements are full of interrogations of the relationship between creativity and control, in ways that are extremely useful for the consideration of collective creation. For instance, in an earlier interview, Grotowski in fact used the term 'collective creation' to describe the nature of theatre, but by this he meant that the theatre was a site in which 'we are controlled by many people and working during hours that are imposed on us'. For Grotowski, one of the fundamental questions for the actor is 'how to create while one is controlled by others, how to create without the security of creation, how to find a security which is inevitable if we want to express ourselves' (Grotowski in Wolford and Schechner 2001: 41).

As such, the Living Theatre experimented with a range of de-individualizing strategies with a specific focus on finding ways to bypass the operations of conscious intention. In this way, we might insist that their critique of the individual and their interest in collective creation were not simply based on a notion of the self-present subject. Writing in the late 1990s, Patrice Pavis argued:

> The cause of the current crisis in collective creation is not only a return to the playwright, the text and the establishment after the collective euphoria of 1968. It is also attributable to the fact that the individual artistic subject is never unified and autonomous in any case. (Pavis 1998: 63)

But those who participated in 1968 already knew this. Individual presence was always already differentiated, for both Deleuze and the Living Theatre in terms of conscious and unconscious thought. Indeed, it is precisely *because* the 'individual is also a group' that Deleuze argues that the self or subject is 'one more thing we ought to dissolve, under the combined assault of political and analytical' (and we might add 'theatrical') forces (Deleuze 2004b: 193).

Given their immersion in the context of 1968, we might not be surprised to learn that some of these experiments were based on an interest in the perception-altering power of drugs and, particularly, the capacity of hallucinogenic drugs to destabilize the role of conscious thought as the transcendent 'director' of the subject/author/actor's experience. In an interview with Pierre Biner, Beck bemoans that most contemporary actor training remains on 'the level of conscious interpretation'; the actor tends to draw only on his conscious experiences. As Biner reports, the Living Theatre reproaches the popularized and highly selective version of Stanislavski propounded by the 'Method' in particular 'for its total reliance on rationality and psychology and upholds the premise that life unfolds on various, diverse levels that are intricately interconnected and also simultaneous' (Biner 1972: 97); 'The world of conscious experience is not enough' (Beck 1972: n.p.). In turn, Beck

argued that one could access unconscious levels of perception through the use of drugs:

I believe that the bourgeois government have forbidden [drugs] … because they are afraid and want everybody to remain in the prison in which we live permanently. Perhaps what one learns with drugs is more real than what one learns with the drug of education, of politics, of language, of words. (Beck in Biner 1972: 93)

Likewise in another text, Beck 'proposes the systematic use of psychedelic drugs to "enable one to begin to associate differently in the head, remember differently, learn time differently"' (Beck in Innes 1981: 272).

This idea of drugs as a way to access unconscious modes of perception, and to bring thought and experience into a more immanent relation with the movement of the world, is also addressed in *A Thousand Plateaus*. Here, Deleuze and Guattari report on the experiences of Artaud and the Beat poets that drugs can facilitate the leap from what they call 'the plane of organization' – characterized by the perception of discrete 'things' – to that of 'consistency' or 'immanence' – characterized by the perception of a primary relationality prior to 'things'. For Deleuze and Guattari, drugs provide one means to perceive presence as movement and, as such, they can act as an agent of becoming. All drugs, they say, whether 'hallucinatory or nonhallucinatory, hard or soft', allow the imperceptible to be perceived, the direct investment of desire in perception and the perceived, and render perception molecular (Deleuze and Guattari 1988: 282). In other words, 'drugs eliminate forms and persons', the molar entities that shape our perception as long as we occupy the transcendent plane of organization. In contrast, molecular perception perceives the world immanently, as 'speeds and slownesses without form, without subject, without a face', which Deleuze and Guattari describe as 'the moment when desire and perception meld' and in which the 'unconscious as such is given' (Deleuze and Guattari 1988: 283).

However, the Living Theatre also explored the possibilities of improvisation to function as a technique for de-individualization, as an alternative to merely executing what another author had already created, and as a means to author performance material without the transcendence of conscious intention. Rather than allowing creative processes to be transcendently organized by a predetermined idea, improvisation generally aspires to allow new ideas to emerge immanently, from within the process of action and interaction.

Malina has suggested that the Living Theatre's real commitment to improvisation emerged with their production of *The Brig*, which the company first performed in May 1963. 'A great deal of *The Brig* is improvisatory,' she states. 'Every time an actor playing a prisoner steps on a line there is an improvisation, every time an actor playing a prisoner has an open button

there is an improvisation' (Malina *et al.* 1964: 212). And after *The Brig*, Beck argues, 'It would never again be possible for us not to improvise. We would have to construct plays with forms loose enough so that we could continue to find out how to create life rather than merely repeat it' (Beck 1972: n.p.). In particular, the company were interested in improvisation as a way to construe the event of performance, less as a representation of prior creativity and more as an act of creation in its own right. In this way, although the Living Theatre devoted a great deal of time to discussion in the preparation of *Paradise Now*, it is important not to over-emphasize the role of 'talk' in the company's methodology. Equally important were physical exercises, improvisations and experiments that allow the body to introduce new ideas during the rehearsal process; we know that they thought in terms of the body doing its own kind of thinking. Correlatively, though the company are known for their 'willful disregard for actor training' and particularly for their rejection of the acting conventions associated with the then dominant 'Method' school (Aronson 2000: 60), it would be a mistake to think that they were uninterested in the knowledge and indeed the 'unknowing' of the actor's performing body. Echoing the Spinozist mantra oft repeated by Deleuze – 'we do not yet know what a body can do' – Beck argues that the theatre can help people 'to find out what it is to have a body, and to begin to use and make joy with it' (Beck 1972: n.p.). Indeed, for Deleuze, following Spinoza, the affect of 'joy' involves the increase of the body's lived power or power to act; joy is the intensification of life as creativity.

The important point here is that the Living Theatre saw the body as a site of creation, in Deleuze's sense; that is, as the locus of the new or unthought, not because it is made meaningful by a transcendent subject but because the body itself has powers of differentiation, the body itself has the power to differ from itself. This perspective is often echoed in remarks made by Beck about the Living Theatre's rehearsal processes; for instance, his comment that 'Whenever we work physically we find things that we could never find if we did nothing but think'. Or again: 'Exercise should not be used to train the body to express the banal. We want things not yet known to the controlled consciousness which is ruining us' (Beck 1972: n.p.). A further, more specific example comes from the Rite of Rung VII in *Paradise Now*, in which the actors are described as reaching

> as far as they can toward the creation of new sounds and new sound relationships. They listen closely to one another; they experiment in the use of their vocal chords and voice boxes in creating sounds and sound relationships which are, so far as they are consciously aware, not in their usual range of sounds. (Beck and Malina 1971: 122)

The creation of new sound was also an element of *Mysteries and Smaller Pieces*, during a section of which 'The actors began to play an organ that was

in the theatre and to create sounds with every element and part of the theatre they could' (Aronson 2000: 72). The actors experiment in order to find out what the body of the theatre building can do – in becoming-musical-instrument rather than being a house of representation.

In contrast, theatre theorists like Christopher Innes have insisted on a fundamental 'incompatibility of improvisation and art', insofar as 'Art' is understood as a separate sphere of conscious, mindful creation that operates independently of the accidental, chaotic process of improvisation (Innes 1981: 198). However, as Holland suggests, improvisation need not be conceived as the embrace of chaos over order, but can be viewed as a process that allows *self-organized order* to emerge, rather than being imposed from without. Indeed, both performance and complexity theorists have already framed theatrical improvisation as an example of an emergent system. For instance, in a 1999 article, Keith Sawyer has spoken in terms of *collaborative emergence* in relation to an improvisational theatre ensemble, emphasizing the extent to which improvised performance is irreducible to the contributions of any one individual performer. Sawyer notes:

> Collaborative emergent phenomena are those that result from the collective activity of social groups. Although collaborative emergence results from the interactions of individuals, these phenomena cannot be understood by simply analyzing the members of the group individually. For example, in an improvisational theater performance – where the actors create dialogue on stage without a script – the performance that results is truly a collaborative creation; the performance cannot be understood by trying to reduce it to a study of the psychology of individual actors. (Sawyer 1999: 450)

Beyond application: Residual transcendence in collective creation and improvisation

However, can we simply *apply* these related notions of transcendence and immanence (or hylomorphism and emergence) to specific instances of theatrical practice such as the Living Theatre's collective creations? While helpful from the point of view of providing an introductory account of the difference between immanence and transcendence as concepts, we might suggest that Holland's essay exhibits the tendency of much philosophy to use art practice, including performance, as a mere example to which philosophical concepts can be applied.[21] Application itself implies a top-down process in which 'theory' is detached from 'practice', thinking from doing, in ways that resonate with the very transcendent notion of the author that we are trying to problematize here. For instance, anyone who has ever played in a 'classical symphony orchestra' or is familiar with jazz will no doubt have squirmed on reading Holland's prompt relegation of musicians

in the former to mere executors and the elevation of the latter to bastions of spontaneity. *Which* symphony orchestra and *which* jazz ensemble are we discussing, one might ask. But it is not the generalization of practice per se that is the problem here, at least for me, given that I would be willing to say that *whichever* specific practice we attend to, we can find both the transcendent and the immanent at work. Neither jazz nor the classical orchestra is a pure instance of one force or the other. Even the most overbearing conductor or theatre director cannot fully manipulate the complex material processes involved in symphonic performance or theatre (including spectatorship) to comply with his or her own singular intention. The most seemingly top-down system of organization is 'always shot through with processes it cannot control' (de Beistigui 2010: 194). Likewise, no matter how fully a jazz ensemble or theatre collective might embrace the idea that they cannot, and do not want to, occupy a God's eye view outside their creative process, they inevitably have to arrive at a point in that process where they must at least *stage* an occupation of such a position: in order to edit and organize their material, in order to arrive at a 'finished' work, in order to perform the 'same' show more than once.

This is certainly the case with respect to the Living Theatre's arguably failed attempts to remove the figure of the director. For instance, the company have been accused of working less collectively, or more under the specific influence of Beck and Malina, than they were willing to admit. Despite the frequent affirmations of collective creation in the writings of the Living Theatre, it has been suggested that Beck and Malina played a perpetually central role in the composition of works, albeit against their best intentions. That is, we might say, despite the Living Theatre's attempts to create collectively, genuinely to collaborate in the absence of the judgement of a director, traces of transcendence remained. For example, although Beck describes *Frankenstein* (1965) as a collective creation in an interview with Biner, he also acknowledges that during 'the last five or six weeks' before its performance in Venice, he and Malina broke off from the rest of the company to work on the piece's overall structure. 'It was no longer possible to have twenty-five directors on stage. The pieces of the puzzle had to be assembled. Judith and I were holed up in the hotel room' (Beck in Biner 1972: 160).

Beck goes on to say that the same situation occurred before *Paradise Now*, and many commentators have since argued that the company's operations were less decentralized than they were claimed to be. Robert K. Sarlós, for example, argues that in the case of *Paradise*, Beck and Malina 'ended up dominating and manipulating the anarchistic collective' (Sarlós 1982: 167). Similarly, in relation to the 1970s period when the Living Theatre split into four separate 'cells', Rabkin argues that 'the disappearance of the non-Beckian cells after the 1970 declaration' exactly confirms the unequal importance of Beck and Malina in relation to the other company members (Rabkin 1984: 18). Even a sympathetic commentator like Paul Ryder Ryan

made similar remarks in relation to the rehearsals for the play cycle *The Legacy of Cain,* inviting us to consider the pragmatics of immanence as collective creation:

> While in theory Malina and Beck have tried to stay in the background and let the collective assume the directing leadership, in practice they find themselves guiding the rehearsals a great deal, mainly because they have more experience than other members of the group. (Ryan 1974: 18)[22]

Yet need we necessarily see this emerging need for direction as some kind of failing in terms of an overall attempt to construct a theatre of immanence rather than transcendence? Above all, Patrice Pavis suggests, collective creation has tended to position itself as an alternative to 'the "tyranny" of the playwright and his/her text and the director, who have tended so far to monopolize the power and to make all aesthetic and ideological decisions' (Pavis 1998: 62). However, beyond this oppositional mode of thinking, the continuum thinking that I am trying to develop here would not frame either collective creation and direction, or immanence and transcendence, as mutually exclusive. Rather, and as I will go on to discuss in more depth in what follows, the 'dictatorship of the director' and pure collective creation constitute two extreme and ideal poles of a continuum of performance processes.

Likewise, there are many arguments and accounts of practical experiences on which we can draw to suggest that both improvisation and drug-induced creation have their limitations as immanent modes of authorship. For example, in contrast to the Living Theatre's embrace of improvisation, John Cage had what might be described as, at the very least, an ambivalent relationship to improvisation. On the one hand, fellow musician Alvin Curran has claimed that 'Cage abhorred improvisation – he shunned the word, concept, and practice all his life' (Curran in Bernstein and Hatch 2001: 178). And certainly, Cage insisted on a distinction between improvisation – as it is commonly understood – and what he called 'indeterminacy'. He argued:

> Improvisation frequently depends not on the work you have to do [i.e. the score one is to perform], but depends more on your likes and dislikes. It doesn't lead you into a new experience, but into something with which you're already familiar, whereas if you have work to do which is suggested but not determined by a notation, if it's indeterminate this simply means that you are to supply the determination of certain things that the composer has not determined. (Cage in Fetterman 1996: 124)

But, arguably, it was less that Cage rejected improvisation altogether, and more that he chose to combine it with chance operations, and used improvisation within very tightly imposed constraints. For instance, in works such

as *Child of Tree* (1975) – 'an eight minute percussion solo, using two to ten plants as instruments' – the performer prepares for the performance by producing a performance score through 'the I Ching coin oracle method', which comes to determine of how many parts the solo consists and which instruments are to be used in each part (Fetterman 1996: 191). Within these constraints, Cage then instructs the performer to improvise.

Correlatively, although Grotowski had initially been attracted by the apparent capacity of improvisation to generate the unpredictable, he later concluded that, in fact, the unforeseeable was, paradoxically, much more likely to be the product of discipline, rigorous training and rehearsal over long periods. In the 1980s, Grotowski abandoned what he called his paratheatrical experiments, in which improvisation had played a large part, because 'He discovered that unstructured contact among random groups of individuals frequently remained at the level of personal or cultural cliché – performing "intimacy" or spontaneity rather than accomplishing an act of disarmament.' The 'experiments in paratheatre convinced him of the necessity for participants to demonstrate a level of "nondilettantism" or artistic competence in order to transcend such behavioural clichés and create a structure within which an authentic meeting could occur' (Wolford in Wolford and Schechner 2001: 11). In other words, losing your 'self', or affirming 'self' as emergence, is no simple task. While Sawyer's improvisation group might produce a new play – in the sense that it is not the product of an existing script – they do not have a methodology in place to circumvent the risk that what they say merely constitutes a repetition of so many social clichés: those phrases and expressions that come immediately to mind when we are put on the spot (indeed, the banality of the passage that Sawyer quotes in his essay suggests that this is exactly what happens). In this way, associating immanent authorship with improvisation comes with its own problems; in particular, the potential assumption that a call to immanent authorship is merely a return to an 'anything goes' attitude to making performance in which improvisation is being mistakenly associated with a kind of instant freedom or easy novelty.

And residual transcendence need not necessarily be condemned; as Deleuze and Guattari put it in *A Thousand Plateaus*:

> Staying stratified – organized, signified, subjected – is not the worst that can happen; the worst that can happen is if you throw the strata into demented or suicidal collapse, which brings them back down on us heavier than ever. (Deleuze and Guattari 1988: 161)

Trying to do away with subjectivity altogether might have worse consequences, including madness or even death. In turn, Deleuze and Guattari have argued that stratification is 'a very important, inevitable phenomenon that is beneficial in many respects' (Deleuze and Guattari 1988: 40).

However, insofar as they acknowledge the *reality* and not merely the practicality of the strata, Deleuze and Guattari also allude to their temporariness and to the perpetual susceptibility of organisms and subjects to being disorganized and reorganized once again.

So, we have discovered that immanence may not be where we expect it to be, and that it is not guaranteed by any one approach. We have seen how residues of transcendence remain in collective creation and improvisation, but we have also acknowledged that this is not necessarily a 'bad' thing, so much as a pragmatic one. Or, further, these residual instances of transcendence might lead us to draw ontological conclusions. As I have already suggested, in its purest form the immanent tendency would correspond to a theatre that is independent of anything outside itself; that is entirely self-organizing rather than appealing to the authority of a text, author or director; and also, perhaps, one that does not measure the value of the worlds that it creates in relation to an external reality. But no such theatre can exist (thankfully perhaps!); rather, as we have already noted, actual theatres are always a mixture of both immanent and transcendent tendencies, and because *theatres are processes*, the balance of this mixture is always changing. Theatre has a tendency to immanence, which we might suggest can be nurtured by means of collective creation (among other means); but it also has a tendency to transcendence that manifests itself in the exertion of authorial control and in the notion of 'truth to the text' (among other theatrical phenomena, such as the frequent reference made to the notion of the director as offering an 'outside eye' on a performance we have already touched upon). Director's theatre differs from collective creation, solo work from collaboration, only in degree rather than kind. In this way, just as we found traces of transcendence in unexpected places, we might also find immanence to be the product of unlikely strategies, such as directing and the imposition of 'chance procedures' and 'creative constraints'.

Where we least expect it... Locating immanence in directing, chance and constraint

Like the Living Theatre, Goat Island affirm the power of collaborative practice to release performance from representing the individual author. They value collaboration, founding member Matthew Goulish suggests, because it offers the chance to

> Escape from ourselves, from the limited perspective of the individual ego ... Who we were, when we met, how we proceeded, what we produced, all seem products of the togetherness, the conjunction ... Escaping our individual limitations was certainly one of our goals – and not only limitations of identity, but also of thought, imagination, history and progress. (Goulish 2000a: 15)

Correlatively, director Lin Hixson has articulated her experience of collaboration as one that involves becoming more than oneself, but not simply through a process of addition:

> I find the word collaboration inadequate to describe what we do but then I would find any single word problematic. In fact, I can't even start with words to describe my experience in Goat Island. I can begin with a physical sensation; my head enlarging to six heads; my legs jumping up and down with twelve feet; my body restricted by five other bodies. (Hixson in Goat Island 1999: n.p.)

In this way, to return to the analogy with emergence, we might compare Hixson's experience with Douglas Hofstadter's classic 1979 description of emergence through the example of the ant colony, in which the ants are said to generate 'emergent behaviour far beyond their individual capacities' (Holland 1998: 5).

Nevertheless, while they affirm collaboration, Goat Island do not reject the director. Likewise, in what follows I will suggest that in the pursuit of immanence, what matters is not so much the presence (or absence) of the director per se, as much as the *approach* to directing taken by a given individual, which can vary from one of dictatorship to one of creative facilitator, with Hixson's approach very much tending towards the latter. In particular, I will note how Goat Island pursue immanent authorship through the unlikely strategy of self-imposed limitations, in the form of what they refer to as 'creative constraints'. One instance of such a constraint is what the company call 'directives': starting points for the process of authoring performance, provided to the company members by Hixson. As Hixson describes it:

> Our process could be described as a series of directives and responses ... I produce a directive. The members of the group present responses to the directive – acts in return. In response to the responses, I produce more directives. (Hixson in Goat Island 2006a: n.p.)

While instructive, the directives are nevertheless articulated in a poetic form that leaves them open to multiple forms of response. 'Create a shivering homage', Hixson instructs (Hixson in Goulish 2000a: 10); 'construct a last performance in the form of a heavy foot that weighs 2 tons and remains in good condition'. Clearly, to respond to such an instruction is not to execute a director's idea or command; there is no fixed and predetermined concept of what a 'shivering homage' might look like to which the performers' response must correspond. In the same way, for Hixson, the unpredictable nature of the performers' responses to her directives allows the final piece to remain surprising, strange and complex rather than being a representation

of her own singular vision. Mutually responsive, there is no clear separation between directive as the creator or as the condition of the creativity of the response; the response creates the directive as much as the other way around, such that no traditional hierarchy of value might emerge to privilege the role of director over that of performers.

Hixson suggests that it was because of her visual art background, at least in part, that she 'never looked at [the director] as privileged over the actor' and never construed directing 'as a hierarchical thing'. As soon as she took on the name 'director', others certainly attributed such values to her, she recalls, but the company itself did not have a 'vertical structure' (Hixson in Bottoms 2006: n.p.). However, Hixson herself does use the language of an 'outside' to describe her experience of directing Goat Island. She says:

> My strength is much more from looking at things from the outside, and working with transitions and putting material together. I think that's from being a sculptor and working visually initially. And then working with sound installation. I've always been outside something and then worked it to try to make it come together. (Hixson in Bottoms 2006: n.p.)

But rather than presume that such evocations of outsideness necessarily involve transcendence, we might ask after the nature of the 'outside' being alluded to here, given that Hixson and other contemporary directors do not accord that position with any necessary privilege. What, if anything, is specific to Hixson's relationship to the material of a given Goat Island performance in relation to those of the performers and the audience? One response would be to suggest that this 'outside' is always a *relative outside*, and also one that enables *the preservation rather than homogenization of difference* – as a kind of immanent or internal outside – within a process of collaborative authorship. In this sense, the 'outsideness' of the immanent director is akin to the plane of immanence, which Deleuze describes as 'the not-external outside and the not-internal inside' of thought (Deleuze and Guattari 1994: 60).

In largely unpublished interviews with Stephen Bottoms, Hixson and Goulish think alongside such issues, with Goulish describing the work of the director as something that involves balancing different durations and instances of 'focus'. Hixson, in turn, speaks in terms of seeking out and then trying to find ways to combine what she calls the 'poignancy' of how individual performers enact specific instances of movement and text (Hixson in Bottoms 2006: n.p.). For the most part, these are movements and texts that the performers rather than Hixson have introduced into the process, and it is in this sense, Hixson says, that 'it's kind of like directing a play'. That is, Hixson does not know the circumstances that have led a member of the group to introduce a specific piece of material into the collaborative process; she is relatively 'outside' the complex of intentional and unconscious

decisions that may have led to that introduction in a manner that enables her to see it anew. Of course, this sense of unfamiliarity may become less likely as collaborations continue; perhaps here, like in long-term relationships, the challenge concerns how to maintain one's outsideness to the other at the same time as remaining open to transformation by them.

While much has been made (and continues to be made) of the ethico-political powers of collective creation and collaboration, Goat Island tend to place an equal emphasis on the value of the director as the one who secures the *nonhierarchical, egalitarian nature* of the stage. Inspired by precedents such as Sam Shepard's one-act plays, the company have always avoided allowing any one performer to become 'the central focus all the time' (Christopher in Bottoms 2006: n.p.), in favour of an approach in which 'each performer has their solo', inviting an even distribution of the audience's attention (Goulish in Bottoms 2006: n.p.). In this instance, the director's 'outsideness' serves to challenge and question attempts by performers to 'hold on' to moments of performance that may serve individual needs, but do not serve those of the performance as a whole. Often, Christopher suggests, these individual needs were precisely those associated with proprietorial attitudes to authorship and ego-driven approaches to performance: the desire to keep an idea within the final show because I see it as 'my idea', or to preserve a particular moment because it 'makes me look good' as a performer (Christopher in Bottoms 2006: n.p.). And this democratic approach extends beyond the performer to the different material elements of the performance itself – each of which must also be given equal time and attention. Hixson's role, for instance, includes ensuring that instances of dance in a Goat Island work do not become 'ornamental' distractions in relation to the real work of the text sections – something that troubles the company about the work of both the Wooster Group and Richard Foreman.

Similarly, equal value seems to be accorded to a whole variety of conscious and unconscious, relatively intentional and unintentional forms of thinking through performance. Goat Island, Hixson says, 'have the objective of making performance works in an agreed atmosphere of trust and support. But the unintentional and intentional sit alongside this desire.' Here the unintentional creeps into the process in myriad ways; it is not only that 'Cars break down. People get ill', but also that 'someone brings in serious material [to rehearsal] but we think it's funny' (Hixson in Goat Island 1999a: n.p.). The implications of this egalitarian attitude to performance making are greater than they might first appear. They seem to me, that is, to concern the ethics of performance and philosophy in terms of the relations that we establish to what we do not know or do not understand. I must give my collaborator 'the benefit of the doubt'; there are no bad ideas or wrong ideas here, only materials for collaboration. Or again, there is a sense of egalitarianism or a 'democratization of thought' at work, to borrow a concept from the contemporary French philosopher François Laruelle. For instance,

Goulish has characterized Goat Island's approach as one that 'values the considered response no more and no less than the seemingly unrelated distraction or the simple mistake' (Goulish in Bailes 2011: 112). The unintended does not merely interrupt to demonstrate its presence within even the most controlled attempts at communication; rather, we are being asked to value the unintended, the passing thought, the misremembered concept as *equal to* the carefully contemplated.

Goat Island show that we can think directing immanently. And the company know that, in the same way, the transcendence of authorial intention cannot simply be dismantled by doing away with a script and by no means is novelty guaranteed by a process of 'making it up as we go along'. As the composer Igor Stravinsky once remarked, and Goat Island might agree: 'The more constraints one imposes, the more one frees oneself of the chains that shackle the spirit ... the arbitrariness of the constraint only serves to better precision of execution' (Stravinsky 2003: 65). That is, Goat Island have sought immanent authorship in the imposition of what they call 'creative constraints', a method that on first hearing sounds very much like a straight instance of transcendence, a top-down imposition of an often arbitrary rule onto creative processes such as writing, as well as the devising of performance material. In this method, the company are inspired not only by similar methods employed by Cage, but also by groups such as Oulipo, a loose collective of mostly French authors co-founded by Raymond Queneau and mathematician François Le Lionnais in the 1960s. Oulipian constraints include 'the S+7 method', in which each noun in a given text, such as a poem, is replaced by the noun to be found seven places away from the original word in a dictionary. Or we might think of lipograms: texts produced from a process in which the writer is assigned the task of writing without using a particular letter of the alphabet, as in Georges Perec's 1969 novel *La Disparition* (translated as *A Void*), which is written without the use of the letter E.

In Goat Island, constraints might be spatial or temporal: create a two-minute dance that can be performed in a one-by-one-metre square; or they might involve the imposition of geometrical or mathematical structures like the Fibonacci sequence, or of literary structures like the palindrome. Or one might be given a precise number of words to write in a constraint-based writing project. But from their beginning, Goat Island have also used appropriation as another kind of constraint, where appropriation is conceived as a means to let the 'outside' into their work. Encountering the found, it seems, is as much a form of collaboration or thinking with others as engaging with the material brought to rehearsal by other company members. That is, the company do not use appropriation in a postmodern fashion, in order to say 'there is nothing new under the sun'; rather, appropriation is like a special kind of constraint that liberates creativity by limiting it (I can write what I like as long as I plagiarize). Influenced by the work of the Wooster Group,

but also by the novels of Kathy Acker, Goulish in particular attributes a creative power to appropriating found texts. As he explains, Acker 'talks about plagiarising texts, but changing them as you're doing it, changing the words you don't like. So it's a combination of your own personal artistic will, and this other thing that you're forcing yourself to use as source material' (Goulish in Bottoms 2006: n.p.). Intention does not (indeed, cannot) fall away entirely, then, but the author moves closer to the pole of immanence when the sense of the author's 'free will' is brought into contact with some kind of restriction (albeit a self-imposed one); creativity flourishes not by removing all the rules or limits, but by imposing a specific framework or set of boundaries within which to act.

Perhaps it is productive to explore this appropriative tendency in Goat Island alongside Deleuze's conceptualization and practice of 'indirect discourse'. As John Marks has discussed:

> Deleuze seeks to work with other thinkers and artists so that his own voice and the voice of the author become indistinct. In this way, he institutes a zone of indiscernibility between himself and the authors with whom he works ... It is a matter of picking up another's arrows and relaunching them. (Marks 1998: 25)

Indeed, this appropriation of other voices is a way for Deleuze to perform his idea that language is, inherently, impersonal. In turn, in *Deleuze: The Clamor of Being*, Alain Badiou suggests that Deleuze's use of 'the free indirect style' produces a 'deliberate undecidability of "who is speaking?"' that constitutes 'a commitment to perspectivism' (Badiou 1997). Of course, Badiou ultimately goes on to argue that Deleuze's thought is 'monotonous' despite this appearance of multiplicity; there is a 'virtuosic variation of names', Badiou accepts, but what is thought, he argues, 'remains essentially identical'.

Text was not the only thing borrowed. Just as Hixson's work with her pre-Goat Island group, Hangers, often involved 'images and gestures lifted from films' (Apple 1991: 30), Goat Island's work has always incorporated borrowed movement, but more because of the challenge that such appropriation presents to conventional notions of the author, than to enfold any hidden referentiality into their work. At this point, it is Pina Bausch rather than the Wooster Group who constitutes a precedent, allowing the body of the dancer to function less as the originary source of a movement (as its author and therefore as the stabilizing ground for its interpretation as expression) and more as what Goulish sometimes describes as a 'vessel' or a 'filter' for the found (Goulish in Bottoms 2006: n.p.). Elsewhere, however, he has also drawn from Deleuze and Guattari to rethink appropriation as 'reciprocal becoming'; arguably a more appropriate way to articulate Goat Island's borrowings, since it is not that the performer acts as the mere container for the passage of some other (character, gesture or phrase) that stays

the same as itself, but rather that both borrower and borrowed are differentiated in the event of appropriation. They do not become one another, though; instead, appropriation as becoming exposes the self-difference that was always already there, the always 'more than' and 'other than' nature of things with respect to their so-called original context.

Finally, we might note the potential of chance operations to function as a form of constraint and as a strategy for de-intentionalizing authorship. Cage is undoubtedly an important figure in terms of a consideration of the relation between authorship and intention, developing a wide range of compositional techniques investigating the introduction of chance, indeterminacy and nonintention to the creation of events. Of course, he was by no means the first artist (composer or performance maker) to employ such techniques. Deleuze, for instance, explores the concept of chance alongside the work of the nineteenth-century French poet Stéphane Mallarmé; we also know that Mozart produced what he called a 'musical dice game', and that Marcel Duchamp engaged in extensive explorations of chance-based art (Fetterman 1996: 139). However, it is Cage's extensive influence on performance, and particularly on Kaprow, as well as the Living Theatre and Goat Island, that largely justifies our focus here.

Indeed, Cage contributed a sound element to the Living Theatre's chance-based work *The Marrying Maiden* (1960). As Pierre Biner explains:

> The Marrying Maiden turned out to be almost entirely different from one performance to the next. The author [Jackson MacLow], drawing on the rules of chance of the hexagrams in the I Ching, constructed six dialogue-and-character scenes. He provided a series of directions for the actors consisting of five degrees of vocal volume and five degrees of tempo in delivery. And, he specified, by means of a hundred adverbs and adverbial phrases, the tone in which certain words or groups of words were to be spoken – with gaiety, sorrow, and other emotions following each other solely by chance. (Biner 1972: 55)

Malina then built on MacLow's explorations of chance, adding a dice thrower into the structure, whose throws determined the sequence of the performance and interjections of a recording created by John Cage. As Biner reports, each time the dice thrower threw a five, 'the tape recorder was activated – Cage's "music" actually consisted of a taped reading of the play, with certain parts electronically distorted by Cage but most of the text remaining audible' (Biner 1972).

In part, Cage's interest in chance can be contextualized with reference to his being influenced by Zen (notions of which we will discuss further in Chapter 4).[23] Sources suggest that Cage discovered Zen in the late 1940s and that it was on the basis of his engagement with Zen that he developed 'a philosophical commitment to "nonintention", the affirmation of life as

it is rather than the desire to improve upon it' (Cox and Warner 2004: 176). Nevertheless, as I will reiterate later in this book, Cage's Zen is not a form of transcendence but a means to affirm the immanence of self and world. This immanent attitude also informs his use of chance:

> Chance operations are not mysterious sources of 'right answers'. They are a means of locating a single one among a multiplicity of answers, and at the same time, of freeing the ego from its taste and memory, its concern for profit and power, of silencing the ego so that the rest of the world has a chance to enter into the ego's own experience. (Cage in Herwitz 1996: 167)

As William Fetterman suggests, Cage follows Mallarmé (though not consciously) in conceiving of chance as 'the way in which nature works', and hence of the operation of chance as a way of (re)connecting art and worldly life (Fetterman 1996: 39). But above all, perhaps, the use of chance is construed as means to expose the ego of the author to the intervention of worldly forces into the art-making process, such that the author is no longer the sole arbiter of events. Cage insists that the playful use of chance operations is

> not an attempt to bring order out of chaos ... but simply a way of waking up to the very life we're living, which is so excellent once one gets one's mind and one's desires out of its way and lets it act of its own accord. (Cage 1978: 12)

Chance, Cage suggests, 'provides a leap out of reach of one's own grasp of oneself' (Cage in Nicholls 2002: 57). In particular, Cage was concerned to remove personal taste from the process of composition, arguing that allowing decisions to come from chance operations 'has the effect of opening me to the possibilities I hadn't considered. Chance-determined answers will open the mind to the world around' (Cage in Fetterman 1996: 41).

As Marjorie Perloff and Charles Junkerman have discussed, Cage's use of chance operations is the aspect of his work 'that has been most subject to ridicule' in the mainstream media, largely because chance has been confused with randomness; what is the point of an artwork where anything can happen, where anything goes (Perloff and Junkerman 1994: 10)? Likewise, academic critics of Cage have often focused on the seeming paradox at the heart of Cage's oeuvre: 'How ... can one *intend* to produce a work that sabotages intention?' (Hayles in Perloff and Junkerman 1994: 230); can we really block the perception of works of art as products of intention, albeit that intention might be to escape intention? For instance, in his 1994 article 'Cage and Philosophy', the analytic philosopher Noël Carroll remains skeptical as to the powers of chance processes to elude the conventional

tendency to interpret works of art as representations or expressions of authorial intentions. He begins by noting that

> Cage appears to believe ... [that] chance operations pre-empt the direct operation of the will on his material. This makes its interpretation in terms of authorial intention impossible, for the artist no longer has the means to express herself or to realize intended purposes. (Carroll 1994: 94)

Carroll gives a balanced response to his analysis of the success of this enterprise, acknowledging that Cage 'did succeed in severing his particular sounds from authorial intention in one sense'. However, Carroll then argues that

> it is not clear that he severed his compositions from intentionality altogether. For his compositions remain situated in a cultural space, one which imbues gestures within it with purposes, and, as we have seen, with semantic content and meanings, at least in a broad sense. The cultural context, that is, provides a matrix of meanings, which carry intentionality – a tradition which both constrains moves within it, and invests genuine actions within it with meaning. (Carroll 1994: 96)

Now, I would agree that Cage's work does not operate in the realm of pure chance (as one ideal pole of a continuum between chance and intent or will), but my account of *why* this might the case will differ from Carroll's. For instance, Carroll seems to me to underestimate the capacity of the audience to deviate from an interpretative relation to the work, neglecting the extent to which cultural contexts are as much the sites of affective and *attentional* (rather than intentional) experiences as they are of semantic ones. Carroll goes on to argue that Cage's sounds are about something because they are framed, and act as symbols or *exemplifications* of ordinary noise rather than actually being ordinary noise that is not framed: 'Cage's noises are, in other words, illustrative. Thus, they have a semantic content or function that the ordinary noises to which they allude lack' (Carroll 1994: 95). That is, Carroll argues, 'despite his polemics to the contrary, the seminal works of Cage and of many of the artists he influenced (especially in the sixties) are symbolic. They are exercises in exemplification' (Carroll 1994).

Ultimately, Carroll presents Cage's thinking as founded on an opposition of simple presence and 'aboutness'; as if to attempt to elude intention and interpretation necessarily means that Cage conceives of sound as self-identical presence. As we shall see in the next chapter on the voice, this is much the same assumption that Jon Erickson seems to make with regard to Artaud: that any resistance to the primacy of signification in the theorization of art must be based on a metaphysically naïve notion of presence. And indeed, one could interpret Cage's concern with 'giving up control so that

sounds can be sounds' (Cage in Nicholls 2002: ix) as a pursuit of presence, an ambition to undo intention in order to reveal sound as a 'thing-in-itself'. But, as N. Katherine Hayles suggests, Cage's chance works are less about trying to escape intention altogether (which we cannot do) than they are concerned with affirming the forces – other than intention – that author works of art. She argues:

> Although Cage's chance operations inevitably bring intentionality back into play, they do so in a context that emphasizes asymmetry. Driving down time's one-way street, his work does more than go with the flow. It also points insistently to the traffic signs indicating more is in play that human intellection alone. (Hayles in Perloff and Junkerman 1994: 233)

The notion of chance also appears across Deleuze's oeuvre, for instance in his repeated evocation of the image of the dice throw in texts such as *Nietzsche and Philosophy* (1962), *Difference and Repetition* (1968) and *The Logic of Sense* (1969), among others. In *Nietzsche and Philosophy*, for example, Deleuze examines the relationship between chance and necessity as a parallel to the relations between becoming and being, multiplicity and unity (Deleuze 2006: 202). The act of throwing the dice once constitutes an affirmation of becoming and of chance, Deleuze argues. But when the dice land in a particular combination, they affirm being and necessity (Deleuze 2006: 26). The game of dice, Deleuze says, is a game with two moments: 'the dice that is thrown and the dice that falls back'. However, we must be clear from the outset that for Deleuze this distinction does not form the basis of a radical distinction, but an immanent differentiation, since they are 'two moments of a single world' (Deleuze 2006: 25).[24]

Deleuze then goes on to suggest that how we take part in a game of chance, such as dice, constitutes an attitude to the chaos of chance – a chaos that some attempt to control, but that others learn to will or desire. Whereas a bad player throws the dice again and again in order to achieve a desired combination that has already been determined in advance, he says, the good player affirms whatever combination emerges as the right one, in a gesture of *amor fati* – or love of fate – which, for Deleuze, constitutes an ethical value. As Ronald Bogue has summarized:

> Most gamblers are bad players who want to control chance. They throw the dice and only affirm the outcome that they like. If they shoot craps, they roll again in an effort to overcome the unlucky roll and erase its consequences. Nietzsche's good players, by contrast, roll only once, and whatever the result, they affirm that result and will its eternal return. In this way, good players avoid the *ressentiment* of finding the world guilty of frustrating their desires, and thereby genuinely affirm the play of the world. (Bogue 2007: 8)

What matters for Deleuze, then, is *how* we relate to chance, *how* we play the game of chance. Deleuze claims that 'man does not know how to play: this is because, even when he is given a situation of chance or multiplicity, he understands his affirmations as destined to impose limits upon it, his decisions as destined to ward off its effects' (Deleuze 2006: 142). We assume that our intervention into the chaos of the world is necessarily a reduction or an exclusion of some kind. But instead of choosing from alternatives (or willing one result of the dice throw over others), we need to find strategies *to choose chance itself*. All the same, this is hard: 'The most difficult thing is to make chance an object of *affirmation*' (Deleuze 1994: 198, emphasis in original). Levi Bryant has suggested that 'Deleuze's incessant return to the metaphor of throwing dice' is due to the fact that he sees this act 'as characteristic of the conditions under which thought takes place' (Bryant in Jun and Smith 2011: 31). 'To think,' Deleuze says, 'is to send out a dice-throw' (Deleuze 2006: 32); the encounter with chaos forces thought, echoing the closing line of Mallarmé's 1895 poem *Un coup de dés*: "All Thought utters Dice Thrown" (Mallarmé in Fetterman 1996: 39). Perhaps, then, the difficult (but not impossible) task to which Deleuze directs us concerns an attitude to thinking (including art as thinking) that affirms its uncontrollability.

For Deleuze, this task has also been taken up by the British painter Francis Bacon, an artist who once described his work as operating on 'a tight-rope between what is called figurative painting and abstraction' (Bacon in de Beistegui 2010: 172). In his 1981 book dedicated to the artist, Deleuze argues that Bacon developed a concept of chance as 'a type of choice', rather than invoking chance according to a more conventional notion of 'art as play' or equating chance with probabilities (Deleuze 2004c: 94). Picturing the 'empty' canvas 'before the painter begins working', Deleuze describes all the places on that canvas as, initially, 'equivalent' or 'equally "probable"', but then as becoming unequal insofar as places become differently privileged depending on 'what the painter wants to do, and what he has in his head ... The painter has a more or less precise idea of what he wants to do, and this prepictorial idea is enough to make the probabilities unequal' (Deleuze 2004c: 93). On the one hand, Deleuze suggests, it is an increasing certainty with regard to the privileged probability that allows the painter to begin; but on the other, this moment also marks the point at which cliché (as another kind of prepictorial idea) can intervene into the process, in a manner that calls on the painter to enact what Deleuze calls '"manipulated" chance' or '"utilized" accident' (Deleuze 2004c: 96), terms that evoke a mixture of chance and intention akin to Bacon's notion of 'the will to lose the will' (Bacon in Deleuze 2004c: 92).

In this sense, the 'empty' canvas is really full; 'It is a mistake to think that the painter works on a white surface,' Deleuze says, because 'clichés are always already on the canvas' (Deleuze 2004c: 86–7). Neither the empty

stage nor the blank canvas is 'a *tabula rasa*, but the space of unconscious visual preconceptions and received conventions of representation' (Bogue 1989: 120) that must be emptied, cleared and cleaned in order to allow *anything but* cliché to emerge, to allow other ways of seeing to be created. In Bacon's case, '"manipulated" chance' or '"utilized" accident' takes the form of 'chance manual marks' (also called 'random' or 'free marks' and 'free manual traits'), which he chooses to introduce onto and integrate into the image being painted in order to deform it and separate it from familiar illustrations. At the same time, Deleuze is clear that such chance procedures must be used with caution and care:

> The violent methods must not be given free reign, and the necessary catastrophe must not submerge the whole ... Not all the figurative givens have to disappear; and above all, a new figuration, that of the Figure, must emerge ... [and make the sensation clear and precise]. (Deleuze 2004c: 110)

Deleuze also warns that, as with any experimental strategy, these chance marks do not guarantee an escape from cliché; they 'could easily add nothing, and definitively botch the painting' (Deleuze 2004c: 96). And nor do they solve the problem of cliché once and for all; rather, Deleuze suggests, the fight against cliché is 'a task' that must be 'perpetually renewed' each time we start to make a new piece of work (Deleuze 2004c). Deleuze presents these clichés or 'givens' as stubbornly resistant things that cannot be removed through parody (Deleuze 2004c: 87), reaction or abstraction (Deleuze 2004c: 89). Indeed, Deleuze goes on to suggest that clichés 'cannot be completely eliminated' (Deleuze 2004c: 97), so perhaps we cannot perform a 'true deformation' of cliché (Deleuze 2004c: 89). What counts as a cliché, after all, is always changing; and, arguably, what appears as clichéd to one audience member may not appear so to another. So if cliché was one of the potential pitfalls of improvisation, then perhaps the intention of both Cage and Bacon to affirm the unintentional as chance provides an alternative strategy to test.

Conclusion: The authority of perpetual variation

Given the observations that this chapter has made, we might be surprised to learn that Deleuze himself seems to embrace the idea of an authoritarian director – particularly in his essay on the work of Carmelo Bene – forcing us to question whether a top-down directorial approach is necessarily at odds with the project of immanent theatre. In 'One Less Manifesto', Deleuze states: 'It is of little consequence that the actor-author-director exerts influence and assumes an authoritarian manner, even a very authoritarian one' (Deleuze 1997: 54). As we saw in the Introduction to this book, the

political function of the minor theatre as Deleuze sets it up is to awaken a 'minority-consciousness' in its audience or to enlist the audience in a 'becoming-minority' by putting all the elements of theatrical representation – character, gesture, enunciation – into variation, by emphasizing the self-difference or self-creating nature of all theatre's materials. If a dominant director is needed to construct such a theatre, then so be it, Deleuze seems to imply; whatever way works. 'This would be the authority of perpetual variation in contrast to the power or despotism of the invariant,' Deleuze argues. 'This would be the authority, the autonomy of the stammerer who has acquired the right to stammer in contrast to the "well-spoken" majority' (Deleuze 1997). As long as the resulting work operates 'for' the minority (in Deleuze's nonrepresentational sense of that expression), it can be produced by any means.

But was Bene simply an authoritarian figure, a prime instance of an artist who saw himself as an autonomous creator? Bogue suggests that 'In many instances, it would be problematic to call Bene the author of his plays, as he himself recognizes in his frequent reference to his productions as "by author x", "according to C.B." (Bogue 2003a: 127), for instance in works such as his *Riccardo III*, which is almost entirely constructed using the text of Shakespeare's original script. Likewise, Deleuze's statements might seem less problematic insofar as they are addressed to practitioners like Bene, who tended to write, direct and star in his own work. That is, Bene's authoritarianism can be tolerated because it is only exacted on himself, rather than suppressing the creativity of others. But then again, Bene did not work entirely alone; and, furthermore, the apparent egoism of any project that involves 'actor-author-director' figures (who remain largely indifferent to the skills of others) might well seem to go against the aspirations to dismantle the notion of the autonomous author that we described at the start.

This is what happens when philosophy encounters performance. As soon as we confront an actual practice, the diagram of tendencies becomes increasingly entangled. If we get lost in these entanglements for too long, we may forget why it matters (and for whom) what Beck and Malina did in that particular hotel room during those days when they extracted themselves from the rest of the company in order to put *Mysteries* together. We get trapped in specificity and untransferability. However, if we fail to allow ourselves to become entangled at all, our performance philosophy will have no purchase for those caught up in the mixtures of actual practice.

We began this chapter with the observation that the dual notions of immanence and transcendence might be used to differentiate specific approaches to authoring performance, allowing us to contrast top-down forms of authorship to bottom-up ones (doing with performance what Holland did with music). From this perspective, we could suggest that directing is top-down, whereas collective creation and collaboration are

bottom-up; the traditional theatre company is organized as a transcendent hierarchy, whereas the collective is immanent and self-organizing. In turn, we could employ the immanence/transcendence dyad to argue that staging a pre-existing script is a top-down approach to creating performance, whereas devising and improvisation are bottom-up.

However, I then went on to argue that a closer inspection of particular performance practices would persuade us that the relations between immanence, transcendence and performance authorship are not so straightforward. The immanence/transcendence dyad cannot simply be mapped onto specific instances of performance, allowing us to separate the bottom-up from the top-down, the good from the bad. Indeed, we have noted that this very gesture would be a kind of transcendence in itself, an application of pre-existing concepts onto performance as if it were a passive and pliant example. In contrast, these investigations revealed residues of transcendence in unexpected places, such as within the apparently immanent processes of collective creation and improvisation. Likewise, our investigations of the kinds of thinking undertaken *through* and *as* performance by Cage, the Living Theatre and Goat Island suggested that we might find immanent authorship where we least expect it; for instance, in the seemingly transcendent imposition of chance procedures and creative constraints onto the materiality of performance, and in the use of a director to coordinate collaboration. In the same way, we saw how Deleuze's own thinking around the nature of the relation between immanence and transcendence does not involve the reinstatement of a dualism, nor does it simply equate immanence with the good and transcendence with the bad, regardless of the context.

In the next chapter, we move on to discuss the idea of an immanent use of language and voice in performance, exploring concepts of a 'minor usage of language' and the 'destratified voice' in relation to the work of Artaud, Carmelo Bene and Georges Lavaudant – three practitioners who could easily fit into Avra Sidiropoulou's account of director-auteurs. Indeed, Sidiropoulou suggests that Artaud is a primary source of inspiration for contemporary auteurs, arguing that, like Edward Gordon Craig, Artaud 'conscientiously dismantled the role of the director as mere *explicator* of the dramatic text' and likewise sought to liberate performance from a subordinate and faithfully representational function (Sidiropoulou 2011: 14). But on this basis, Artaud has come to be associated with the straight rejection of a theatre of the word in favour of one of bodies, while the notion of the 'theatre of cruelty' is conventionally understood to involve some kind of nonverbal assault on the audience. Yet, although one can find evidence that 'Artaud conceived of the world in binary oppositions' (Sidiropoulou 2011: 34) and prioritized 'the power of spectacle over speech' (Sidiropoulou 2011: 41), I would argue that this presents a somewhat reductive picture that neglects to account for the complex relation between thought, language and body

that Artaud constructs elsewhere. That is, while Artaud no doubt objected to the subordination of theatre to literature, this should not be mistaken for an outright rejection of language based on a presumed duality of body and word. Rather, as Deleuze's engagement with him brings out, Artaud is pioneering in terms of his *usage* of language, in his production of a language that speaks the 'body without organs' and the schizophrenic experience of language's performativity.

2
Disorganizing Language, Voicing Minority: From Artaud to Carmelo Bene, Robert Wilson and Georges Lavaudant

This chapter will continue to flesh out the concept of immanence that has been outlined so far, shifting our attention from authorship to the roles of language and voice in performance by way of a consideration of Deleuze's thought alongside that of Antonin Artaud in particular, but also Carmelo Bene, Robert Wilson and Georges Lavaudant – practitioners who have all paid considerable attention to ways of speaking and listening in their work. I want to explore what an immanent approach to language and voice might involve by way of a series of concepts. First, we will consider this approach with reference to the 'schizophrenic use of language' that Deleuze controversially attributes to Artaud in *The Logic of Sense*. Next, we will approach immanence in relation to what I call the 'destratified (or disordered) voice', a concept that builds on both the notion of the body without organs and a 'minor usage of language' as they are developed by Deleuze and Guattari in *A Thousand Plateaus*, as well as in *Kafka: Towards a Minor Literature* and in Deleuze's essay on Bene, 'One Less Manifesto'. We can also hear this destratified voice at work, differently, in Artaud, Bene, Wilson and Lavaudant, I will suggest; again, these vocal performances are not mere illustrations of the concept of destratification so much as thinkings of, philosophies of voice in themselves, that might reciprocally inflect what we hear in Deleuze.

As Kimberley Jannarone reports, 'Artaud entered the public eye in 1923 with a series of letters denouncing the inadequacy of language' – the *Correspondence avec Jacques Rivière* – 'and he exited the world in 1948 doing the same, leaving, in additional to a substantial body of performance and visual art, approximately ten thousand pages of this inadequacy behind' (Jannarone 2010: 3). That is, we might begin by suggesting that Artaud's very articulations of his frustration with the apparent capacity of language to restrict the creativity of thought and theatricality performatively contradict their own claims; or again, that the affective dimensions of his writings (what they do) destabilize their informational aspects (what they say).

By no means a pure 'theorist' of theatre, in the 1920s and 1930s Artaud worked as an actor in a number of French theatres and from '1926–1928

he directed, designed, wrote for, acted in, and produced works in his own Théâtre Alfred Jarry' (Jannarone 2010: 5). During this time, Artaud 'played over twenty roles in French, German, and Italian avant-garde and commercial films' (Jannarone 2010), while between 1931 and 1935 he wrote the essays that would later be compiled as *The Theatre and Its Double*. However, our focus here will be more on Artaud's aborted radio project, *To have done with the judgment of god* (1947). Recorded a year after Artaud finally returned to Paris having been in psychiatric institutions for the previous nine years, *To have done...* was never publicly broadcast before his death in 1948 (at least not in the way that Artaud had hoped; Schumacher 1989: 188).[25] Wladimir Porché, the director general of the radio station who functioned as the God-form on this occasion, judged Artaud's text to be 'studded with violent words' and 'terrible language' that were certain to scandalize the French public and therefore the broadcast of the play was cancelled at the last minute, much to Artaud's frustration (Sontag 1976: 579).

However, I also want to indicate the affinity between this work and subsequent pieces such as Bene's *Riccardo III;* Wilson's *KA MOUNTAIN* and *When We Dead Awaken* and Lavaudant's *La Rose et la hache* (*The Rose and The Axe*), a creative response to Bene's *Riccardo III* that Lavaudant first produced in 1979 and restaged in 2004, apparently as a tribute to Bene who died in 2002.[26] In terms of Deleuze, we will extend the last chapter's exploration of immanence as a 'bottom-up' organizational tendency in order to examine the implications of immanence for our understanding of the relationships between language, voice, thought, bodies, presence and ethics. But again, this will not be a one-way process in which Deleuzian concepts inform readings of performance, without any mutual informing of Deleuze by performance. After all, we know that the very image of a body without organs or a disorganized body – including a destratified voice – came from Artaud in the first place, and that Deleuze draws extensively from Artaud in order to develop his definition of thought as creation and the production of the new. At the same time, we absolutely need the insights of Artaud, Bene, Wilson and Lavaudant in order to enhance our understanding of how an immanent use of language and voice might actually work in practice. However, while we will note how 'methods of stammering, whispering', mumbling and howling might function as ways of disorganizing the voice (Deleuze 1997: 247), we can also be sure that such methods have no guarantees in and of themselves, that there can be no universal or eternal 'methods' that secure greater degrees of immanence. *How* we enhance and increase our apprehension of the affective and creative, rather than informational and representational, powers of language and voice must remain mobile and attentive to the auditory context. Or again, perhaps we might say that the engagement with performance in this chapter teaches us that univocal being is as much about the ways in which immanence is *heard* as about how it is voiced.

Of course, there is nothing new, at least within Artaud Studies if not within Performance Studies at large, in setting up a connection between Artaud and Deleuze. Catherine Dale and Jeffrey Bell, among others, have already explored the Deleuzian elements of Artaud's oeuvre.[27] Indeed, Artaud Studies has been through this conduit and has come out the other side, with theorists like Jane Goodall and Umberto Artioli both arguing that Deleuze's project is distinct from Artaud's in a number of crucial ways. Goodall, for example, accepts that Deleuze and Guattari are close to Artaud 'in their quest for a return to some kind of chora of subjectivity, "the Body without Organs", and in their fascination with becoming, metamorphosis and contagion as processes which rupture paradigmatic understanding'. However, she ultimately insists that

> they hardly qualify as gnostic revolutionaries. Their campaign against stratification is not the same as the aim of Artaudian theatre: '...to make manifest and to plant in us ineradicably the idea of a perpetual conflict and of a seizure in which life is rent at every moment, in which the whole of creation rises up and sets itself against our condition as constituted beings'. (Goodall in Scheer 2004: 75)

Likewise, while Artioli describes Deleuze and Guattari's *Anti-Oedipus* (1972) as 'unthinkable without Artaud's oeuvre', he also frames the book as dissolving the 'persistent dualism' of Artaud's thinking with its positive notion of desire (Artioli in Scheer 2004: 145). Furthermore, Artioli questions Deleuze's description of Artaud as having achieved a 'wonderful breakthrough' that 'knocked down the wall [of the signifier]' (Deleuze 2004: 240). Instead, Artioli suggests, 'If you put the two projects together, Artaud's revolt, far from attaining the miracle of the breakthrough, resonates with the devastating cry of setback' (Artioli in Scheer 2004: 147).

However, despite these particular instances, theatre scholars who have sought out a philosophical perspective to contribute to an exploration of language and voice in performance have tended to turn to Derrida rather than Deleuze, given the former's important and better-known work on the relationship between speech and writing. Specifically too, after Derrida, who insisted on the fundamental impossibility of Artaud's project, it has become commonplace to argue that Artaud failed to achieve in practice what he set out to do in theory, that he could not make manifest his manifestos.[28] In contrast, just as Jannarone has argued that we might see Artaud's *Les Cenci* as 'one attempt' to bring his theatre of cruelty to life (Jannarone 2010: 5), this chapter will explore *To have done with the judgment of god* as a further key instance of actualized performance practice. Secondly, whether through reference to deconstruction or Artaud's own influence by Gnosticism, we are told that Artaud thought in dualisms and thus left himself and his project vulnerable to deconstruction. In contrast again, this chapter will argue that,

although tendencies towards a dualistic way of thinking are apparent in aspects of Artaud's various practices, his overall project can be conceived as tending towards immanence rather than transcendence, and towards 'differential presence' rather than self-presence (see Cull 2009b).

At first, we will emphasize that the theatre of immanence is not conceived as a theatre without words or against language; it is one that affirms language as an immanently varying material body, rather than as that which transcends bodies. However, in later sections we must also address that fact that the specific theatres of Artaud, Bene, Wilson and Lavaudant are not purely performed in stutters and whispers, or breath-words and howls. If Artaud, for instance, is against using the voice as a tool for communication, how do we account for the fact that his voice speaks in terms that we *can* recognize, as well as screaming and stuttering in ways that we cannot? Correlatively, if Deleuze values language as affect rather than information, how can he defend the apparent dependence on language to communicate the ideas of his own philosophy? If language is, fundamentally, affect rather than information, as Deleuze and Guattari seem to suggest, how do we account for the appearance of communication? Or better, since we cannot sustain an affect/information duality from the point of view of immanence, we need to consider what it is *in* the performance of language, *in* vocal performance, that makes one theatre *more* affective and *less* informational than another. If all actual performances involve major and minor uses of language, more or less destratified voices, on what basis might we assign a greater value – philosophically, aesthetically, ethically – to one over another?

More of these questions in due course. Overall, I hope that this chapter will demonstrate that Deleuze, as well as Derrida, has a great deal to contribute to considerations of language and voice (the full details of which we will not cover here): from the invocations of language as the enactment of 'incorporeal transformations' in *The Logic of Sense* to the insistence on a pragmatic rather than linguistic approach to the 'order-words' of language in *Anti-Oedipus* and *A Thousand Plateaus;* from his call to us to make language stutter and to become foreigners in our own tongues, to his lifelong engagement with literature, including dramatic literature. Deleuze is by no means 'anti-language', nor is his philosophy 'opposed to the use of language as a communication tool or as a support for understanding' (Williams 2008: 30). Rather, Deleuze goes against the reduction of language to communication – particularly as it has been construed by structuralist linguistics – and proposes multiple alternative understandings of the nature of the relation between language and the reality to which it is immanent (Williams 2008). Given my concern to emphasize immanence, our interest here will primarily be with the poststructuralist account of language and voice that Deleuze develops in and after *Anti-Oedipus*. That said, though, we cannot ignore the extended discussions of Artaud's use

of language and of the concept of the body without organs in *The Logic of Sense*. However, in both cases we will reread Deleuze's remarks in the light of his subsequent immanence, rather than according to the seemingly more transcendent schema in which the virtual is construed as the condition for the actual.

Voice, likewise, is a theme to which Deleuze frequently returns in his philosophy. To begin, we might note that the idea of voice and voicing is key to Deleuze's articulation of the ontology of immanence, rather than transcendence, through the concept of univocity or one 'voicedness'. 'Being is Voice,' Deleuze declares in *The Logic of Sense*, because Being speaks itself in and as the many different beings of the world: a 'single voice for every hum of voices' (Deleuze 1990: 179). In *Difference and Repetition*, as we have already noted, Deleuze insisted that this singular, univocal ontology is, nevertheless, an ontology of difference, summing up univocity as follows: 'being is said in a single and same sense of everything of which it is said, but that of which it is said *differs: it is said of difference itself*' (Deleuze 1994: 45, emphasis added). In this sense, the univocal in Deleuze means something different to the meaning it is given by Derrida in early works such as *Speech and Phenomena*. With Derrida, univocity is associated with the sense of self-presence or auto-affection that we experience when we hear ourselves speaking, and the denial of equivocity that is introduced in the delay between speaking and hearing, or the distinction between the speaking self and the hearing self. In contrast, what there is for Deleuze is a 'thousand-voiced multiple', but because every voice belongs to the same order of existence (no copies, no echoes, no voice of God), this multiple can be said to speak in 'a single and same voice' (Deleuze 1994: 378). Indeed, we might suggest that this multivoicedness also characterizes Deleuze's notion of language itself, given his suggestion that each apparently individual utterance is always already connected to the collective; each seemingly single voice is many different voices speaking through and as us. Language is not, Deleuze argues, a fixed and rule-bound system that stays the same as itself, but a type of living entity in a ceaseless process of variation.

These multiple contributions from Deleuze do not amount to a single, coherent philosophy of language that one might attempt to summarize. However, there are a number of authors who have already done a good deal of the important work required to collate Deleuze's extensive and heterogeneous thinking on language, including Jean-Jacques Lecercle (2002) and Ronald Bogue (2003a). Given this existing literature, our job here is less to theorize Deleuze's relationship to language and linguistics per se than to explore what an immanent approach to language and voice in performance might involve. To begin, I want to look at the vocabulary and problems of *The Logic of Sense*, before moving on to a discussion of the notion of a destratified voice and the concept of a minor usage of language that Deleuze and Guattari subsequently develop.

Howling from the depths: Artaud's 'schizophrenic use of language'

Deleuzian commentators largely agree that *The Logic of Sense* 'is a structuralist book' (with Lacanian overtones), not only because it is principally focused on the operations of language, but also because it tends towards a conceptualization of language as a 'virtual' structure serving as the condition of possibility for 'actual' knowledge and experience, as commentators like Lecercle have suggested (Lecercle 2002: 105). In Deleuze's case, this virtual structure is articulated in terms of the notion of 'series', such as the 'heterogeneous series' of 'signifying' ('sonorous words') and the 'signified' ('physical bodies') (Deleuze 2004a: 34). In turn, Deleuze argues that 'sense' is a 'secondary organisation' that ensures the separation of signifier and signified, a fragile surface or 'frontier' always under threat from the depths beneath it: a 'formless, fathomless nonsense' (Deleuze 2004a: 28). Nonsense comes first, in other words, sense only latterly and thanks to the organizational operations of the surface.

For the Deleuze of *The Logic of Sense*, at least, Artaud's work presents us with evidence of this fragility of sense. First, Deleuze points to Artaud's 'quasi-translation' of fragments of Lewis Carroll's poem *Jabberwocky* into French, undertaken in the summer of 1943 while he was involuntarily interned in a psychiatric institution in Rodez (Bogue 2003a: 22).[29] Controversially, as we shall see, Deleuze labels Artaud's translation – which includes a number of challenges to conventionally pronounceable words – as exemplary of the distinct operations of the language of schizophrenia[30] (rather than the nonsense language of Carroll); as a product of mental illness, then, rather than artistic intention. Deleuze says:

> Beginning with the last word of the second line, from the third line onward, a sliding is produced, and even a creative, central collapse, causing us to be *in another world* and *in an entirely different language*. With horror, we recognize it easily: it is the language of schizophrenia. (Deleuze 2004a: 29)

He argues that, in his *Jabberwocky*, Artaud's use of language is symptomatic of his specifically schizophrenic experience of language and its relation to bodies, which is qualitatively different from Carroll's. Despite his use of nonsensical elements such as portmanteau words, Carroll's language is still organized on the surface of the two series of signifying and signified, such that 'physical bodies' (signified series) and 'sonorous words' (signifying series) are separated by what Deleuze calls an 'incorporeal frontier' or, simply, 'sense' (Deleuze 2004a: 34). In Artaud's 'schizophrenic' language, in contrast, Deleuze argues that 'there are no longer any series at all; the two series have disappeared' (Deleuze 2004a: 34). In other words, there is no organization

that creates a frontier between signifier and signified, words and bodies. In the absence of surface and series in Artaud's text, Deleuze says, nonsense 'absorbs and engulfs all sense' (Deleuze 2004a). In *Jabberwocky*, Deleuze argues that Artaud is confined to the depths of nonsense (or nonmeaning) on account of his 'schizophrenic' relation to language, while Carroll can move between the surface of sense (or meaning) and the depths of nonsense, which comes prior to sense and always threatens to engulf it. The surface of sense makes the world denote, manifest and signify. 'In this collapse of surface' – that is, the experience of the 'schizophrenic' as Deleuze defines it –

> the entire world loses its meaning. It maintains perhaps a certain amount of *denotation*, but this is experienced as empty. It maintains a certain power of *manifestation*, but this is experienced as indifferent. And it maintains a certain *signification*, experienced as 'false'. (Deleuze 2004a: 31)

Without the virtual structure of signifiers and signifieds, experiences of neither full presence, distinction nor truth seem to be possible. Indeed, in this way it might even seem as if virtual structure transcends actual experience or, again, that it serves as a condition for the production of meaning without itself being produced. Materiality or actuality seems to be construed as dependent on something separate from itself, in order for it to become differentiated as denotation or to appear as manifestations of this or that. However, Deleuze qualifies any duality of surface and depths by insisting that sense and nonsense are not opposed to one another. Rather, he says, 'Even at the surface, we can always find schizoid fragments, since its function is precisely to organize and display elements which have risen from the depth' (Deleuze 2004a: 34).

For his part, as Deleuze acknowledges, Artaud claimed not to like Carroll's original poem. In a letter from 1945, for instance, Artaud wrote:

> *Jabberwocky* has never seemed to me anything but an artifice of style, because the heart is never in it … one cannot write like this, one does not have the right to write like this, a poem that is outside the heart … a poem that has not been *suffered*. (Artaud in Sontag 1979: 447, emphasis in original)

Indeed, Artaud goes as far as to suggest that *Jabberwocky* 'is the work of an opportunist who wanted to feed intellectually on someone else's pain' (Artaud in Sontag 1979: 449). Unlike himself (and Baudelaire, Poe and Nerval), Artaud implies, Carroll did not 'suffer ruin' and hence while his writing takes on the *style* of nonsense, one can differentiate between this stylistic performance and a use of language that derives from suffering. In turn, Artaud ultimately argued that his own 'translation' was not secondary or derivative in relation to Carroll's; rather, Artaud insists that Carroll's *Jabberwocky* is a poor imitation of an experience of suffering (including

the suffering of/by language), such that he can accuse Carroll of a kind of reverse plagiarism (Sontag 1979).

Secondly, *The Logic of Sense* forms the context in which the (in)famous concept of the 'body without organs' first appears in Deleuze's work as that which corresponds to Artaud's triumphant composition of a novel usage of language. As is well known, the image of a body without organs first appears in the conclusion of Artaud's censored radio play *To have done with the judgment of god*, in which in which Artaud declares:

> When you have made him a body without organs, then you will have delivered him from all his automatisms and restored him to his true liberty. Then you will teach him how to dance wrong side out ... and this wrong side out will be his real place. (Artaud in Sontag 1976: 570–71)

Like Spinoza and Nietzsche before him, then, Artaud's text suggests that our mode of construction or existence determines what we are able to think and do. We must remake the sickly anatomy of Man the organism, including the organ of the mind, if we want to think and act alongside and within life, rather than continuing to operate as the living dead, performing 'automatic reactions' scripted by God and, now, by his medical colleagues (Artaud in Sontag 1976: 571).[31]

As a 'new dimension of the schizophrenic body', Deleuze argues that the body without organs does not achieve self-identical expression with its cries, but, rather, feels the 'problem' of language through its suffering: 'namely, the schizophrenic problem of suffering, of death, and of life' (Deleuze 2004a: 30–32). Deleuze suggests that the specifically 'schizophrenic' experience of an absence of distinction between 'things' and 'propositions' draws attention to an ontological capacity of language to *act on* bodies rather than merely represent them (Deleuze 2004a: 31). The 'schizophrenic' appears to sense that language is not a separate kind or level of being that transcends bodies; but how, then, might language be used as a response to this 'problem'? In his discovery of the body without organs as, in part, a relation to language, Artaud breaks free from passively suffering the wounds that 'words without sense' inflict on the schizophrenic body. Having made himself a body without organs, he is not sheltered from language but actively uses it as 'words without articulation', as words that become 'illegible and even unpronounceable, as it transforms them into so many active howls in one continuous breath' (Deleuze 2004a: 33). At first, this may seem to be no more than a simple redirection of the force of language, shifting from occupying the position of one to whom things are done with words to one who uses language to act. But for Artaud this is a relation that must be performed and enacted, just as he did, firstly through writing and poetry and then latterly in performed lectures and his foray into radio, which constitutes a prime example of this new use of language.

Much as the language of schizophrenia lacks the distinction of signifying and signified series, Deleuze states that the schizophrenic body does not experience a distinction between 'things' and 'propositions' (Deleuze 2004a). As such, Deleuze argues, 'body-sieve', 'fragmented body' and 'dissociated body' are 'the three primary dimensions of the schizophrenic body' (Deleuze 2004a). For Deleuze, it seems, bodily experience is directly connected to language usage. Artaud has a qualitatively different experience of the relation between language and the body from Carroll and hence uses language differently. Carroll's language is 'emitted at the surface', at which the incorporeal frontier of sense 'shelters sonorous language from any confusion with the physical body' (Deleuze 2004a: 34). Artaud's language, in contrast, is 'carved into the depth of bodies' (Deleuze 2004a: 29) – not all bodies, but the schizophrenic bodies of his world, which Deleuze describes as 'no longer anything but depth' (Deleuze 2004a: 31). The body is no longer sheltered from confusion with language, nor with other bodies. As we shall see, in his 1985 article, Erickson argues that Artaud aspires to a language of presence that issues from a pure, undivided body. In contrast, Deleuze says that Artaud's language issues from a body that, as 'depth', has no surface to maintain a distinction between 'itself' and other bodies. As Deleuze says: 'A tree, a column, a flower, or a cane grow inside the body; other bodies always penetrate our body and coexist with its parts' (Deleuze 2004a: 31).

Without the distinction between language and body, Deleuze proposes, 'the only duality left' for the schizophrenic 'is that between the actions and the passions of the body' (Deleuze 2004a: 34). In turn, he associates the actions and passions of the body with two different relations to language available to the schizophrenic. On the one hand, the schizophrenic can experience language in the form of what Deleuze calls 'words without sense'. In this scenario, 'The word no longer expresses an attribute of the state of affairs; its fragments merge with unbearable sonorous qualities, invade the body where they form a mixture and a new state of affairs, as if they themselves were a noisy, poisonous food and canned excrement' (Deleuze 2004a: 32). Through this invasion, Deleuze claims, words without sense have the capacity to wound the schizophrenic body. Alternatively, he suggests, the schizophrenic can actively use language in the form of what he calls 'words without articulation'.

Rather than passively suffering wounding words, the schizophrenic actively transforms words into actions by subtracting the difference between the phonetic elements. For Deleuze, Artaud exemplifies this latter active relation to language with his transformation of words into 'a fusion of consonants' (Deleuze 2004a: 33). In this case:

It is a question of transforming the word into an action by rendering it without articulation ... One could say the vowel, once reduced to the soft sign, renders the consonants indissociable from one another, by

palatising them. It leaves them illegible and even unpronounceable, as it transforms them into so many active howls in one continuous breath. (Deleuze 2004a: 33)

Deleuze calls these words breath-words (*mots-souffles*) and howl-words (*mots-cris*) and describes them as a 'triumph' for the schizophrenic (Deleuze 2004a: 32). They are not triumphant because they are meaningful, for Deleuze, since he insists that 'words without articulation' are 'no less beneath sense and far from the surface' (Deleuze 2004a: 33). Rather, they are triumphant because they signal a break with the schizophrenic's suffering from words as wounding, and a move towards the schizophrenic's use of language to act. Deleuze proposes that this language of breath-words and howl-words corresponds to Artaud's concept of the body without organs, which he refers to as a 'new dimension of the schizophrenic body' (Deleuze 2004a: 32), in contrast to the dimensions of the 'body-sieve', 'fragmented body' and 'dissociated body'. Deleuze concludes this series of *The Logic of Sense* with the claim that he 'would not give a page of Artaud for all of Carroll' and argues that 'Artaud is alone in having been an absolute depth in literature, and in having discovered *the vital body and the prodigious language of this body*' (Deleuze 2004a: 35). This 'vital body' is the body without organs and its language is that of breath-words and howl-words. Deleuze concurs with Artaud's own observation that he discovered this new dimension of the schizophrenic body and its language 'through suffering' in ways that Carroll never experienced (Deleuze 2004a).

However, *The Logic of Sense* caused something of a controversy when it was published, insofar as Deleuze was seen by some to be annexing 'Artaud's writing to the realm of the schizophrenic' (Morfee 2005: 108) and thus denying him artistic control or credit for his work. For example, Paule Thévenin – Artaud's friend and collaborator – railed against Deleuze's reading of Artaud in an article called 'Entendre/Voir/Lire'.[32] Here, as Jeffrey Attebury (2000) reports, Thévenin objects to Deleuze's use of existing clinical terminology to categorize Artaud's work, which she suggests makes him complicit with the violence done to Artaud by the medical profession. 'Straight away,' Thévenin argues, 'Deleuze falls into the major trap of identifying Artaud as a schizophrenic' (Thévenin in Attebury 2000: 716).[33] As Attebury notes:

> Whether or not Deleuze here uses the term schizophrenia in a manner that is in strict accordance with clinical practice, he clearly has recourse to the language of psychoanalysis as a means of explicating Artaud's texts, a strategy that would appear to make Artaud's writing into a case study. (Attebury 2000)

In contrast, Thévenin argues 'that Artaud's work must be understood on its own terms, that his language presents a consistent challenge to any analysis

of it according to a codified system, especially that of psychoanalysis' (Attebury 2000: 716).

And indeed, whether or not in response to Thévenin, Deleuze and Guattari do take greater care in their subsequent collaborations to differentiate between their own concepts of 'schizophrenia' and the 'schizophrenic' (or the 'schizo') and the conventional psychiatric definitions of those terms. Likewise, come *Anti-Oedipus*, spatialized notions of the depths of the virtual beneath the surface of the actual, or of underlying structure and emergent experience, are flattened out into an evocation of a singular plane. At this point, we might suggest that Deleuze's overriding concern is to emphasize what language *does* and how it functions, rather than what it represents or signifies, insofar as he will admit no ontological distinction between words and things, no independence of sign and referent. In these works, Deleuze and Guattari continue to develop the notion of the body without organs that Deleuze had introduced in *The Logic of Sense*, expanding the territory of the concept beyond the schizophrenic body such that the body without organs now appears as an ontological plane. In the next section of this chapter, I want to focus on two different conceptual vocabularies for exploring what happens to voice and language within this flattened ontology: the notion of a 'destratified voice', drawing from the concept of the strata from *A Thousand Plateaus* that we introduced in the last chapter; and Deleuze and Guattari's idea of a 'minor' usage of language, as developed in *Kafka: Towards a Minor Literature* (1975), Deleuze's 'One Less Manifesto' (1979) and *A Thousand Plateaus*. In this section our exploration of the vocal performance of language will also expand to address the work of Carmelo Bene and Georges Lavaudant, as well as that of Artaud.

Language is neither communicational nor informational... A destratified voice

Although *The Logic of Sense* has been generally received as a structuralist work, Deleuze clearly had an ambivalent relationship to the domination of philosophy by phenomenology and structuralism, including structuralist linguistics in which language is construed as the condition of possibility for experience and the determination of meaning. Essentially, structuralism extends the structural operations, which it construes as the basis of meaning making with regard to *human* language, to a model for understanding the production of meaning in general. Everything, structuralism suggests, is structured like a language, whether we think of Levi-Strauss's insistence on the universality of a binary structure at work beneath seemingly diverse cultural practices or, more presciently for Deleuze and Guattari, Lacan's account of the unconscious. That is, as much as Deleuze might be seen as part of the linguistic turn in French philosophy in the light of his work

with Guattari on Austin and Searle (as well as his own work in *The Logic of Sense*), Lecercle notes that 'he is also heir of a tradition of, if not downright hostility to language, at least deep distrust' (Lecercle 2002: 20). Or again, Lecercle argues,

> there is in Deleuze a definite desire to move away from the centrality of language. Such a move has to do with Deleuze's ingrained empiricism, as the move away from language fosters an interest in sensation and in thought. (Lecercle 2002: 25)

In particular, Lecercle proposes that Deleuze's distrust of language attests in part to his being influenced by Bergson, who is well known for his 'devaluation of language as frozen, as betraying in its spatial ordering the experience of *durée*' (Lecercle 2002: 29). And indeed, Deleuze refers to his philosophical context as dominated by 'the cult of language' (Deleuze and Parnet 1987: 34) or what he and Guattari also call 'the imperialism of language' (Deleuze and Guattari 1988: 65) and specifically 'the tyranny of the signifier'. Correlatively, just as Deleuze and Guattari propose the destratification or 'deterritorialization' of the subject (as we saw in Chapter 1), we might also note their call to us to deviate from the 'signifier and signified, interpreter and interpreted' and to tear 'the unconscious away from significance and interpretation', just as we were to tear consciousness from subjectification (Deleuze and Guattari 1988).

By the time we reach the two volumes of Capitalism and Schizophrenia – *Anti-Oedipus* and *A Thousand Plateaus* – the body without organs (now called the BwO for short) has become a central concept for Deleuze and Guattari's ontology. Here they distinguish between different types of BwOs, which we find once we have 'sufficiently dismantled our self', and what they call 'the totality of all BwOs' (Deleuze and Guattari 1988: 151, 157). Like the distinction between specific becomings (-animal, -imperceptible) and the fundamental becoming that they affirm, the totality of BwOs has less to do with 'the body' as such, or the schizophrenic body in particular, and more to do with ontology. According to Deleuze and Guattari, once the self is taken apart, what we reach is 'nonstratified, unformed, intense matter' or 'energy'. The BwO is this primary 'glacial reality' on which organisms and subjects form – nothing but these flows of energy, of difference in itself (Deleuze and Guattari 1988: 153). This energy is elusive: 'It's not so much that it pre-exists or comes ready-made,' Deleuze and Guattari argue,

> although in certain respects it is pre-existent. At any rate, you make one, you can't desire without making one. And it awaits you; it is an inevitable exercise or experimentation, already accomplished the moment you undertake it, unaccomplished as long as you don't. (Deleuze and Guattari 1988: 149)

As such, the BwO can be defined multiply. According to their commentators, it is what Deleuze and Guattari refer to elsewhere as a plane of consistency, 'a static plane of immanent creation which Deleuze and Guattari pit against God's transcendentalism' (Dale 2001b: 136n), and it is what Claire Colebrook defines as 'the totality or plane of ... prehuman, prelinguistic and profound differences', which Western thought has tended to consider as deviations or distractions from existing categories of representation (Colebrook 2002a: 16).

What is new in *A Thousand Plateaus*, then, is the articulation of the ontological realm with which the body without organs is associated. The BwO is not associated with the depths of nonsense threatening to disrupt the surface of sense, but with 'the *field of immanence* of desire, the *plane of consistency* specific to desire (with desire here defined as a process of production without reference to any exterior agency, whether it be a lack that hollows it out or a pleasure that fills it)' (Deleuze and Guattari 1988: 154, emphasis in the original). In turn, whereas *The Logic of Sense* emphasizes the suffering involved in the schizophrenic experience of the body, *A Thousand Plateaus* allies the schizophrenic experience with the attempted becomings of artistic, sexual and drug-related experiments, to which Deleuze and Guattari assign creative potential. Having broken down the 'incorporeal frontier' of sense or what Deleuze and Guattari reconceive as the strata inhabiting the BwO, we no longer experience ourselves as a signifying subject (wo/man) in relation to a signified object (e.g. horse). Rather, the BwO of the masochist is an event in which she constructs herself as a body without organs in order to participate in a becoming-horse. Through becomings, then, there is a presence of difference to difference, the perception or affection of one body by another, without the need to pass through processes of imitation or representation. So, the dismantling of the strata of signification is only one part of a two-stage process, of which the second phase is an event of becoming: a circulation of intensities, a transmission of forces and a transformation of bodies by one another.

In the same Plateau, Deleuze and Guattari also associate the organism as a stratum on the BwO with 'the judgment of God'; again borrowing a phrase from Artaud. The judgment of God, they argue,

> is precisely the operation of He who makes ... an organization of the organs called the organism, because He cannot bear the BwO ... The organism is already that, the judgment of God, from which medical doctors benefit and on which they base their power. (Deleuze and Guattari 1988: 159)

Indeed, the judgment of God is equated with the stratification of the BwO. The judgment of God is all the strata, or phenomena of sedimentation, that operate on the intense matter of the BwO put together: 'For many a strata,

and not only an organism, is necessary to make the judgment of God' (Deleuze and Guattari 1988: 159).

The concept of the destratified voice can also be contextualized with reference to the theory of language that Deleuze and Guattari later articulate in *A Thousand Plateaus*, in which they argue – contra linguistics – that language's variability comes from within itself rather than, merely, from external circumstances. Language is not a homogeneous system that acts as theme to the variations performed in instances in speech; rather, they argue, 'it is the variation itself that is systematic' in language (Deleuze and Guattari 1988: 93). And it is this immanent difference of language that Artaud's destratified voice allows us to apprehend, for instance in the fluctuations of pitch in his particular brand of *Sprechgesang*, as one procedure 'in which several voices seem to issue from the same mouth' (Deleuze and Guattari 1988: 97). In this way, the voice is neither the phenomenological medium that allows the presence of self-consciousness to itself nor the mere 'simulation' of presence, as Derrida contends in *Speech and Phenomena* – the response to the threat of the difference that language is said to introduce into self-presence (Derrida 1973: 15). Rather, the destratified voice embraces the potential 'to be a foreigner, *but* in one's own tongue', or to perform the difference in one's own voice, in a gesture that, for Deleuze and Guattari, expresses a solidarity with those minorities who 'work over' a foreign language from within (Deleuze 1997: 247). Indeed, for Deleuze and Guattari, placing the voice in variation is revolutionary, insofar as it both goes against the political enterprise to impose a homogeneous system of language on speakers that they claim is coupled with the study of linguistics (Deleuze and Guattari 1988: 101), and has the capacity to bring forth perpetual variation as 'the essential element of the real beneath the everyday' (Deleuze and Guattari 1988: 110).

In contrast to the elaborate scenic and theatrical effects required by Artaud's first dramatic text, *The Spurt of Blood* (1925).[34] *To have done with the judgment of god* eliminates every aspect of theatre except the voice. Likewise, we might note that it is the variation of language that receives the greatest amount of attention in Deleuze's 'One Less Manifesto'. In both cases, it is important to emphasize the attention paid to language as a means to counter-balance the tendency to conceive of the pursuit of immanent theatre (whether as the theatre without organs, a subtractive theatre of perpetual variation, or the theatre of cruelty) as one that reinstates a dichotomy between language and body (or thought and affect) and falls down heavily in favour of the presence of the latter over the alienating power of the former. All three theatres may well be anti-textual, as Martin Puchner (2002) implies, but only if by 'text' we mean a self-identical script the truth of which must be faithfully reproduced in performance, or a homogenizing force that serves to fix the creativity and variability that Deleuze argues is immanent to language. However, they are by no means anti-literary or uninterested in speech as a theatrical element; on the contrary, 'One Less Manifesto' argues

that 'A public reading of poems by Ghérasim Luca is a complete and marvellous theatrical event' (Deleuze 1997: 247).[35] Correlatively, Artaud describes the purely vocal theatre of *To have done with the judgment of god* as 'providing a small-scale model for what I want to do in the *Theatre of cruelty*' (Artaud in Sontag 1976: 577).

In this way, although Artaud's polemics sometimes suggest otherwise, it is important to acknowledge that the theatre of cruelty is not conceived in terms of the exclusion of words. 'There is no question of abolishing speech in theatre,' Artaud states; rather, Deleuze and Artaud share the notion that language ought to be handled as the 'concrete' entity that it is (Sontag 1976: 123). It is not language itself that is rejected, so much as the codified ways in which it is used. In *The Theatre and Its Double*, for example, Artaud praises the capacity of altered *intonation* or pronunciation to access the 'music' underlying the conventional meanings of words. There is much to be said, he declares,

> about the power of words to create their own music according to the way they are pronounced, distinct from their actual meaning and even running counter to that meaning – to create an undercurrent of impressions, connections and affinities beneath language. (Artaud in Schumacher 1989: 93)

By varying pronunciation, theatrical speech can expose the difference within words that Artaud conceives in terms of an immanent, autonomous musicality.

Since the story of Artaud's censored broadcast of *To have done with the judgment of god* is well known, we will not rehearse it here. Suffice it to say that the occasion of the ban acts as a good example of Deleuze's argument that the strata are perpetually recasting themselves in the BwO. In other words, for Deleuze and Guattari, *To have done with the judgment of god* constitutes an experiment towards making oneself a body without organs that is perceived as a threat to those State bodies that exert political and aesthetic control in order to protect the strata. The starting point for the radio play was a series of short texts, written by Artaud and then performed by Roger Blin, Maria Casarès, Paule Thévenin and Artaud, interrupted by rhythmic passages played on xylophones and drums, 'beating and exchanges' between Blin and Artaud and the latter's 'cry in the stairwell'.

As a theatre without organs, *To have done with the judgment of god* performs its philosophical work in its construction of a 'destratified voice'. In the case of the voice, destratification involves putting elements such as intonation, diction, pitch and meaning into variation. For example, in *Anti-Oedipus*, Deleuze and Guattari argue that the BwO resists the 'torture' of organization partly by way of a particular relation to the phonological aspect of language: 'In order to resist using words composed of articulated phonetic

units, it utters only gasps and cries that are sheer unarticulated blocks of sound' (Deleuze and Guattari 1984: 9). In this respect, the phoneme is like an 'organ' of language that the destratified voice would rather be without.

In *To have done with the judgment of god*, this phonological variation can be most obviously heard in the passages of glossolalia that erupt from the text, and in Artaud's distant, resonating cries from the stairwell. Whereas the stratified voice speaks 'perfectly and soberly' (Deleuze 1997: 247), Artaud's destratified voice speaks too high and too fast to act as the servant of communication. In turn, having torn the voice away from the task of signification, Artaud can then use his voice to enter into a series of becomings. There is a becoming-woman of the voice, for instance, when it becomes impossible to identify the sex of the speaker according to the traditional representational categories of 'man' and 'woman' – the distinction that Deleuze and Guattari call one of 'the great binary aggregates'. There is a becoming-animal of the voice, insofar as we are alerted to uses of the human voice that can be perceived directly by a listener (whether that listener is also the speaker or another body) without the mediation of a linguistic system of differences. Likewise, in the passages where he performs a dialogue with himself, Artaud uses his voice to enact the 'inclusive disjunctions' that Deleuze associates with the schizophrenic: he is mad *and* sane, patient *and* analyst.

'Contrary to popular belief,' Deleuzian commentator Catherine Dale insists, there is 'nothing sloppy' or vague about these cries of the destratified voice. Rather, she says, 'The unlanguage of howls and syncopated rhythms requires utter diligence and determination' (Dale 2002: 92). Such a position is reinforced by the 1994 film about Artaud directed by Gérard Mordillat and Jérôme Prieur, which draws from accounts by Artaud's friends, including Thévenin, to attest to the picture of Artaud as the obsessive director who relentlessly rehearsed his readers to make sure that they were getting the pronunciation of his words 'right'. However, this 'rightness' has nothing to do with the pursuit of a language of presence to present the self truthfully, since, as Dale notes, Artaud 'disapproves of thinking of oneself as a being, as an innate being who is then able to represent/reproduce oneself' (Dale 2002: 89). Rather, perhaps, getting it 'right' concerns the struggle to construct a destratified voice in the first place, to break with the habitual use of the voice as an organ of communication, and to reconfigure the relationships between lips, tongue, palate, breath and vocal chords in order to produce as yet unheard sounds.

A minor usage of language

In 'One Less Manifesto', Deleuze defines a minor theatre as one that places all the different elements of theatre – including its language and voices, but also its gestures, costumes and props – in perpetual variation, through a process of 'subtraction' or 'amputation'. Whereas in much conventional

theatre the tendency is to submit the speeds and slownesses of performance to the organizational forms of plot and dialogue and to emphasize characters over transformative becomings that sweep them away, a minor theatre seeks to affirm the primacy of perpetual variation over the fixed representation of subjects, objects and a coherent fictional world. 'One Less Manifesto' must be read in the light of Deleuze's wider philosophical project, and the notion of the perpetual variations of minor theatre alongside the idea of life as constituted by becomings rather than beings, process rather than substance. However, given his onto-aesthetic position, it is also important to note that there are no *essentially* major or minor theatres for Deleuze, but rather different *usages* of theatre and its elements that we can call major and minor. In the first instance, Deleuze argues that Carmelo Bene's practice constitutes a minor usage of theatre because he employs a tripartite, subtractive method that removes the 'elements of Power' from theatre, eliminating both representations *of* power and representation *as* power in order to set free the movement of difference. This process involves:

(1) deducting the stable elements, (2) placing everything in continuous variation, (3) then transposing everything in minor (this is the role of the company in responding to the notion of the 'smallest' interval). (Deleuze 1997: 246)

This subtraction (or amputation) constitutes what Deleuze calls a process of 'minoration' or 'minorization' – the undoing of the major in order to release the minor, which he defines as a revolutionary practice (Deleuze 1997: 243). In this way, 'One Less Manifesto' shows that performance as much as literature has an important role to play in allowing us 'to be as a stranger *in* one's own language' – perhaps the best known of the many ways in which Deleuze characterizes a minor usage (Deleuze and Guattari 1983: 26). Indeed, Deleuzian commentator Ronald Bogue goes as far as to suggest that the performance of language in Bene provides Deleuze with the 'fullest instance of a minor style' (Bogue 2003a: 141).

In 'One Less Manifesto', Deleuze defines Bene's as a minor theatre because it performs 'minorization' on Shakespeare in particular, but also on the elements that make up theatre more generally, including voice (Deleuze 1997). With this concept Deleuze creates an image of Bene as a director and performer involved in a precise, yet somewhat violent, dissection process that disorganizes the body of theatre, in a manner that releases each of its elements – voice, but also gesture, costume and so forth – from the oppressions of predetermined forms and functions (Deleuze 1997). As a result of a process of disordering or disorganization, Deleuze suggests, each theatrical element is returned to a more primary state of 'ceaseless variation' (rather than stasis), which allows performance more readily to present itself to the audience as a 'nonrepresentative force': resisting recognition, eluding

interpretation and forcing the audience to think in new and unexpected ways (Deleuze 1997). In this way, while Italian critics of the time, like Ennio Flaiano, often accused Bene of refusing 'the demands of the intellect' (Farrell 2004: 290) and of producing irrational works that delighted in their meaninglessness, Deleuze's essay affirms the positively *affective* value of Bene's theatre; affects that are more likely to be attended to when the conventional organizing structures of narrative, character and dialogue are dismantled.

In the particular cases of language and voice, a minor usage might involve the variation of the 'phonological, syntactical, semantical and even stylistical' (Deleuze 1997: 244) elements through 'methods of stammering, whispering' and mumbling (Deleuze 1997: 247), among others. Deleuze argues that Bene's minor usages of language allow us to apprehend 'language's most inherent, creative property': a fundamental variability that tends to be curtailed by everyday usage and by the linguistic and structuralist accounts of language (Deleuze 1997: 245). Whereas the structuralist distinction between *langue* and *parole* suggests that there is an underlying set of rules or constants, in relation to which specific enunciations are understood to be deviations from a norm, Deleuze argues that any given language ought to be understood as 'a multiplicity of semantic worlds' in which infinite differences of meaning can be produced each time they are spoken (Bogue 1989: 147). In this sense, then, we might say that for Deleuze, speech is 'organized voice', suggesting that 'voice is *at first* noise and nonsense' and only latterly sense and signification (Colebrook 2002: 233). In turn, this primacy of nonsense is affirmed by Bene's musical treatment of language, in the performance of stutterings and stammerings that deform words and of shouts and whispers at the limits of audibility.

Deleuze refers positively to a general 'aphasia' in Bene's performances. That is, a term normally used to designate an acquired communication disorder that prevents people from speaking and understanding speech is now transplanted to describe Bene's active transformation of spoken language through the performance of whispers and 'barely audible lines' alongside 'stammers, cries and groans' (Bogue 2007: 24). Whispering, then, is one kind of 'disordered voice'. With this term – the disordered voice – I mean to evoke the idea of voice disorders in a clinical sense, the equation of whispering with misbehaviour in the mythical and religious texts, but also the idea of disorderly voices in a more positive, political sense, in which disorder might be understood as the undoing or dismantling of an existing order, a revaluation of values or the overthrowing of an unwanted system of organization.[36] That is, Deleuze allows us to explore the whispering voice as positivity (not as 'lack') and even, maybe, as somehow *more than* rather than less than what we might consider a normal or everyday voice. Indeed, in 'One Less Manifesto' Deleuze argues that 'whispering does not imply [what he calls] a weak intensity but, on the contrary, an intensity with indefinite pitch'

(Deleuze in Murray 1997: 247); a whisper, he suggests, can be as powerful and unbearable an affect as a scream.

In *A Thousand Plateaus*, it is Robert Wilson, in particular, that Deleuze identifies as using what he calls 'whispering, without definite pitch' as a 'procedure of variation' (Deleuze and Guattari 2004: 108). And indeed, Wilson's exploration of a 'minor usage of language' is evident in his earliest works, including the 168-hour epic *KA MOUNTAIN*, performed as part of the Shiraz Festival in Iran in 1972. In a section of this piece called 'Questions and Answers', for instance, audience members entered a space in which a performer was reading from Melville's *Moby-Dick*, interrupted by what spectator Ossia Trilling describes as 'long, soft, piercing shrieks' from Wilson. Later in the piece Wilson is described as 'whispering almost inaudibly'; as 'rapidly' repeating the words 'be careful' eight times over; and as speaking 'in a high-pitched falsetto' (Trilling 1973: 37). In this and in other early Wilson works, one might suggest that the whisper is one strategy among others that Wilson employs in an attempt to encourage the audience to treat language as but one element, inter alia, in the theatrical assemblage (rather than *the* element that determines their relation to all the others). Much like in Allan Kaprow's early Happenings as well as in Bene's treatments of Shakespeare, language in Wilson's work appears as a material for variation alongside objects, movements and lights, rather than as the stable ground that can secure our interpretation of the piece as a whole.

For Deleuze, what is at stake in a minor usage of language – as I have already suggested – is the revelation of the variable and ceaselessly varying nature of language and speech as material forces over which we should not imagine ourselves to have mastery. But he also argues that language can establish a new relation to thought when it is no longer 'spoken perfectly and soberly' (Deleuze 1997: 247), claiming that asignifying sounds like stammering, stuttering and whispering open out to the creation of new concepts in the event of enunciation rather than the representation of the already known. That is, as Bogue explains, 'Rather than obliterate the relationship between expression and content, a minor usage [of language] reverses the conventional relationship between *dominant* forms of content and *dominated* forms of expression' (Bogue 1989: 119, emphasis added).

Just as this language is not preceded by content to be expressed, neither is it preceded by a subject or, in theatrical terms, by a character who comes before speech. That is, for Deleuze it is not that the subject expresses him- or herself through the voice, but rather that 'the subject is the *effect* of voice' (Colebrook 2005: 230). Speakers are produced, not represented, in vocal events; characters are created, not reproduced, through specific styles of speaking. In both Bene and Wilson's work, we might suggest that the speakers that are produced tend to be differential rather than unified, since there are often multiple styles of speech spoken by one performer and/or the lines of one character are split among several different performers (as is the case

with Ophelia in Wilson and Heiner Muller's *Hamletmachine*, for example). Furthermore, in his short text produced for the program for Bene's perform-ance of *Manfred*, Deleuze argues that in this piece, 'It is no longer the voice which whispers or screams or hammers away in order to express some emotion or other; the whisper itself becomes *a voice*' (Deleuze 2002: 188). Likewise, in his discussion of Bene's film work in *Cinema 2*, Deleuze argues that 'It is no longer the characters who have a voice, it is the voices or rather the vocal modes of the protagonist (whisper, breathing, shout...) which become the sole true characters in the ceremony' (Deleuze 2005: 184).

As we briefly mentioned in the previous chapter, Deleuze proposes that 'all discourse is indirect' (Deleuze and Guattari 1988: 85) and that there are 'all manner of voices in a voice, murmurings, speaking in tongues' (Deleuze and Guattari 1988: 85). Direct discourse, Deleuze argues, is extracted from a more primary indirect discourse; the single voice drawn from a 'constel-lation of voices' that precede it (Deleuze and Guattari 1988: 93). Indeed, Deleuze even refers to this relation between the individual and language in terms of the relationship between 'the cuer and the cued', in a manner that resonates with 'prompting' in a theatrical context (Deleuze and Guattari 1988: 94). In this way, as Philip Goodchild implies, the lived experience of hearing voices might be seen as a figure for Deleuze's understanding of how language operates for all of us. 'Those who hallucinate unindividu-ated voices may report the speech they hear as indirect discourse: "It was said that ..."' (Goodchild 1996: vii). Indeed, Deleuze makes an explicit link between literature and schizophrenic experience, proposing that

> To write is perhaps to ... select the whispering voices, to gather the tribes and secret idioms from which I extract something I call my Self ... A schizophrenic said: 'I heard voices say: he is conscious of life'. In this sense, there is indeed a schizophrenic cogito, but it is a cogito that makes self-consciousness ... a result of indirect discourse. My direct discourse is still the free indirect discourse running through me, coming from other worlds or other planets. That is why so many artists and writers have been tempted by the séance table. (Deleuze and Guattari 1988: 93)

This indirect, impersonal nature of discourse can perhaps be seen from both a positive and a negative perspective from the point of view of Deleuze's affirmation of difference over sameness, novelty over reproduction. On the one hand, it is indirect discourse that turns us into ventriloquists of clichés, like so many of Kafka's narrators who do not speak so much as be *spoken by* a particular style of language. But as the closing sentence of the quote I have just included suggests, the other side to the indirectness of discourse is per-haps the way in which it opens us up to becoming other than our selves, to fleeing from the very word 'I' that attempts to organize embodied experi-ence in particular ways.

Arthur Holmberg's description of the soundscape of Wilson's 1991 adaptation of Ibsen's *When We Dead Awaken* (made in collaboration with the sound artist Hans-Peter Kuhn) implies a transposition of the audience into an experience of being surrounded by desubjectified voices. Holmberg says:

> the mix of live and recorded voices, bombarding the ear from all quarters, gives the voice a strange autonomy. The voice no longer represents a character, no longer utters a speaking subject. The speaking voice is simply and beautifully a voice speaking ... The voices are not speaking to. They are not speaking to each other. They are simply speaking, unaware that anyone is listening ... Who is speaking? We do not know who these voices are. They have sound, but no identity. (Holmberg 1996: 179)

This dissociation of speaker and voice is also heightened in both Bene and Wilson's work by the use of microphones. Indeed, Wilson has said, 'That's one reason I use microphones – to create a distance between the sound and the image' (Holmberg 1996).

Correlatively, the contemporary French director Georges Lavaudant's *La Rose et la hache* might be described as a revival of a homage to Bene's own antinomian adaptation of Shakespeare, *Riccardo III*. Too many steps away from a so-called original for some, one French critic referred to Lavaudant's production as Shakespeare's '*Richard III* cleansed of its historic complexity' (Delord 2006: 78). But as Deleuze remarks of Bene's *Riccardo III*, this is not a theatre concerned with the representation of (an official) History, but with extracting 'becomings against History, lives against culture, thoughts against doctrine, graces or disgraces against dogma' (Deleuze 1997: 243). Lavaudant, like Bene, chose to perform this subtractive operation on a number of plays by 'the great Will'. As we have noted, Lavaudant came to the theatre in and around 1968 while the wider concern of many was to liberate theatre from institutionalized conventions. Like many other French groups at the time, such as the Théâtre du Soleil and Le Folidrome, Lavaudant and the Théâtre Partisan experimented with the process of collective creation. However – much like Carmelo Bene – Lavaudant first came to notoriety on account of his productions of existing works from a more classical repertoire: Musset's *Lorenzaccio* and Shakespeare's *King Lear* (Fayard 2003: 39). Nevertheless, there is no contradiction here. Indeed, David Bradby proposes that 'far from being dethroned in the aftermath of 1968, Shakespeare was produced by both the young turks and the older revolutionaries', including those like Lavaudant 'who, in Leonardini's words "tear the great Will to pieces: unpick him, skin him, slice him, split him, crush him, pulverise him and rip him to shreds"' (Bradby 2008: 110–11).[37]

In this way, it is less that there are fixed major and minor authors; rather, Bene and Lavaudant subject Shakespeare to what Deleuze calls a 'minor

author treatment' (Deleuze 1997: 242). However, this minor treatment is by no means about being against a theatre of language, or simply amputating large parts of Shakespeare's scripts. On the contrary, 'with the exception of two passages taken from *Henry VI, Part III*, virtually all of the lines spoken by the actors [in Bene's *Riccardo III*] are translations of lines from Shakespeare's *Richard III*' (Bogue 2003a: 127). Yet at the same time, more than half of Bene's script is composed of elaborate stage directions that articulate a series of actions and events that bear no connection to Shakespeare's tragic plot, but transplant his words into a new mise-en-scène. Likewise, Lavaudant's *La Rose et la hache* undoes the hierarchy between text and performance, making Shakespeare's words but one part of a totality that includes deformed movements and gestures, the anatural blue light that glows at differing strengths from various surfaces and screens, a table so full of glasses that it has ceased to function as a table, and sculptural costumes 'limiting movement instead of aiding it' (Deleuze 1997: 248). Indeed, in turn, each theatrical element matters less 'in itself' than in its function as the 'material for variation' (Deleuze 1997: 246).

The minor treatment also concerns *how* Shakespeare's words are performed. The major Shakespeare, Deleuze claims, speaks '"the king's English": homogenised and invariant' (Deleuze in Fortier 1996: 5), whereas a minor theatre maker must 'amputate the text because the text is like the domination of language over speech and still attests to invariance or homogeneity' (Deleuze 1997: 245). In contrast, Deleuze suggests that Bene's *Richard III* performs the difference within language, for instance in Lady Anne's differential repetition of the phrase 'You disgust me!' There is no fixed meaning to this enunciation, Deleuze argues:

> It is hardly the same … [enunciation] when uttered by a woman at war, a child facing a toad, or a young girl feeling a pity that is already consenting and loving … Lady Anne will have to move through all these variables. She will have to stand erect like a woman warrior, regress to a childlike state, and return as a young girl – as quickly as possible on a line of … [perpetual] variation. (Deleuze 1997: 246)

In this way, the actress playing Lady Anne transmits an enunciation through 'all the variables that could affect it in the shortest amount of time' (Deleuze 1997: 245), allowing the phrase to actualize its immanent difference. Likewise, at one point in *La Rose* there is a differential repetition of lines, as Ariel Garcia Valdes's Richard whirls into an energetic frenzy:

> When I was last in Holborn, I saw good strawberries: I do beseech you, send for some of them … because … when I was last in Holborn, I saw good strawberries: I do beseech you, send for some of them … because *etc*. (Delord 2006: 80)

Delord argues that this sentence, 'repeated endlessly in every possible way, is eventually emptied of all meaning, in a delirious re-writing of the scene that ends with Hasting's condemnation' (Delord 2006: 80).

As Deleuze says of Bene, the power of language perpetually to differ is also presented by a musical treatment of language, in which changes in tonality and speed take priority over the emphases that might derive from a communicational approach. With both Bene and Valdes's Richard, this takes the form of rapid mumblings that deform words into what Bene called the 'articulations of a troglodyte' (Bene in Deleuze 1997: 250) and, in *La Rose*, are also punctuated by coughs and splutters. Equally, in Lavaudant's *Hamlet* the actors deliver their lines in what Fayard (after Yann Ciret) calls '"chanté-parlé" (speech patterns which are a cross between chanting and speaking)' (Fayard 2006: 222), akin to the kind of *Sprechgesang* that Deleuze admires in Bene's poetic performance of *Manfred*. This musical approach to language is also exemplified by Lavaudant and Bene's rejection of conventional dialogue in favour of the construction of an assemblage of overlapping recorded and live voices in a complex score. In this way, the voice is not a representation of a stable presence that comes before it; no secure signifier of identity. Rather, in *La Rose* we see characters lip-synching to songs, are disorientated by outbursts of disembodied and deranged laughter, and hear the heavy accents of actors being made to perform sections of the play in languages that are evidently not 'their own'.

The differential presence of the destratified voice: Deleuze vs deconstruction

I would argue that the notion of a destratified or disordered voice provides a helpful alternative to the dominant, deconstructive interpretation of Artaud's work in particular, insofar as it makes clear that the call to undo voice and language as communication is based on a pursuit of *differential* rather than self-presence. Pre-empting the logic of his famous deconstruction of Artaud's theatre of cruelty – which we will discuss in detail shortly – Derrida's 'La Parole Soufflée' (1965) argues that Artaud's concept of the body without organs constitutes an appeal to simple or metaphysical presence without difference. For Artaud, Derrida says, it is the division of the body into organs that introduces difference into the body and 'opens the lack through which the body becomes absent from itself' (Derrida in Bell 2006: 157). In turn, given their appropriation of the concept of the body without organs, Jeffrey Bell has recently questioned whether Deleuze and Guattari, together with Artaud,

> long for a lost homeland, a deeply buried purity and freedom which has since been covered over by layers of impurities (in this case, organs) which only serve to hinder the freedom necessary for thought and

creativity. If this is how Artaud is to be read, it is evident, then, that his longing is a metaphysical longing, a striving to regain a lost presence. (Bell 2006: 156)

If this is how Deleuze and Guattari are to be read, then they too would fall foul of deconstructive critique.

However, as Bell goes on to emphasize, for Deleuze and Guattari the enemy of the BwO is not the organs (as what divides and differentiates an otherwise unified body), but the organism as the '*organic* organization of the organs' (Bell 2006: 158, emphasis added). The organism inserts itself into the BwO in order to prescribe to bodies a distinct and restricted function, molar identity or specific, fixed strata. For Deleuze and Guattari,

The BwO is not undifferentiated, but has its own inner differentiation, its composed and positioned 'true organs', and it is in this manner, then, that Deleuze and Guattari can read Artaud's call for a BwO as not being a call for a One in opposition to the multiple. (Bell 2006: 159)

We could add, or for presence as opposed to difference, monism as opposed to dualism. In this sense, the concept of the BwO plays a central role in Deleuze's effort to rethink the process of creation (whether as thought, art or nature) without the need to posit a transcendent, organizing Law, or what Artaud called 'the judgment of god', which controls the creative process from a position outside of it. Conjoining Artaud with Spinoza, the BwO constitutes a refusal of any distinction between worldly products and a transcendent producer, between organizing mind and organized matter, in favour of a univocal notion of being as a processuality 'immanent in whatever manifests it' (Deleuze 1990: 16). To make yourself a body without organs is both to find and to construct that immanent processuality as it is manifested in the processes of writing, performing, thinking, living.

Following on from this questioning of the BwO, in 'The Theatre of Cruelty and the Closure of Representation' (1978), Derrida's deconstruction of Artaud's concept of the theatre of cruelty invites us to conclude that fidelity to Artaud is impossible, because he aspires to create contradictions in the form of *self-identical* and *immediate* theatrical representations (Derrida 1997: 56). We are told that Artaud's theatrical vision sought to transcend the difference that the mind introduces into the body, and to escape the alienation that language injects into the self, in order to arrive at some blissful staging of self-presence and an unequivocal communion with the audience. The theatre of cruelty, Derrida argues, constitutes the

inaccessible limit of a representation which is not repetition, of a *re*-presentation which is full presence, which does not carry its double within itself as its death, of a present which does not repeat itself, that is,

of a present outside time, a nonpresent. The present offers itself as such, appears, presents itself, opens the stage of time or the time of the stage only by harbouring its own intestine difference, and only in the interior fold of its original repetition, in representation. (Derrida 1997: 57)

In this way, Derrida equates the 'intestine difference' of the present with representation. 'Pure presence as pure difference', Derrida argues, is not presence at all. Presence requires representation in order to appear or, as Derrida puts it, 'Presence, in order to be presence and self-presence, has already begun to represent itself, has always already been penetrated' (Derrida 1997: 58). For Derrida, one example of Artaud's pursuit of self-presence emerges in his aim to replace actors enslaved to the reproduction and repetition of an author's text with the presentation of the living actor. As such, while Derrida initially admires Artaud's critique of the binary oppositions undermining representational theatre, he ultimately argues that Artaud wants to escape from differences into the absence of difference.

In his critique of the metaphysical tradition, Derrida argues that Western philosophy is only able to make truth claims on behalf of its representations by positing an originary or grounding self-presence. As Bell has discussed, one example of 'such a presupposed, unquestioned presence' is

the self-presence of our thought within the sounds which express these thoughts. It is the plenitude of this sound, the physicality and self-presence of hearing ourselves speak, which is the unquestioned self-presence one presupposes in understanding truth as the self-identity and coincidence of the world and our thoughts regarding the world. (Bell 2006: 262n)

The notion of truth, that is, depends in part on the assumption that we can say what we think. Or, to rephrase this in the vocabulary of deconstruction, the moment of hearing-oneself-speak is assumed to function as a guarantee for 'the phonocentric identification between self and voice' (Connor 1999: 223).

Echoing this perspective, theatre theorist Jon Erickson (1985) has since defined Artaud's poetic works as concerned to discover a language of self-presence, a voice that speaks the speaker and the world as they are and communicates those self-present meanings directly to an audience. In his essay, Erickson discusses the phenomenon of 'sound poetry', a category of poetic practice that he associates with practitioners from Dadaist Hugo Ball to contemporary poet Steve McCaffrey, and contrasts with what he calls 'sound-text poetry', which he links to figures such as Gertrude Stein. It is clear that Erickson wants to demonstrate the greater value and conceptual sophistication of the latter over the former. 'Sound-text poetry', he says, dramatizes the arbitrariness of signification (Erickson 1985: 281), whereas sound poetry, 'operates through a denial of signification toward an ideal of

the unification of expression and indication' (Erickson 1985: 279). Quoting McCaffrey's call for words to be liberated from a substitutive role, Erickson insists that sound poetry pursues a 'language of presence, as opposed to a language of signification' in which words *are* the thing rather than its mere stand-in (Erickson 1985: 280).[38] He also identifies 'Artaud's cries' in works such as *To have done with the judgment of god* with sound poetry and argues that both want to reduce the potential for difference between language and meaning, or words and things, by re-establishing a natural rather than cultural relation between them. As culturally determined signification, language is understood to keep us apart from the world. In this regard, Erickson implies a direct connection between Artaud's relation to language and the Dadaist reaction against the so-called prison house of language. As Erickson explains, Dada understands language as a wall that separates people from one another, 'words from things, consciousness from presence', and as such language must be torn down and destroyed (Erickson 1985: 284).

Against this divisive language, Erickson argues, Artaud is pressing for an originary, adamic language or *Ursprache* 'that names an object or being in its essence, which means the signifier is one with the signified and their relationship is not arbitrarily fixed' (Erickson 1985: 280). That is, the concept of an adamic language assumes that a thing or being has a self-identical essence that words can name, and in so doing allows us to be at one with the truth of the world. In pursuit of this natural connection between words and things, Erickson argues, this language of presence issues from an undivided body, bypassing the mind, and as such is claimed to be '*more true* for the human condition' than signification (Erickson 1985: 280, emphasis added). Signifying language is understood to falsify the experiences of the body, which are, in turn, taken to be 'more true' than those of a body 'distracted by any cognitive split' (Erickson 1985: 280). Erickson argues that Artaud is against signifying language as that which separates consciousness from presence – understood as 'the simultaneity between consciousness and an object of attention' (Power 2008: 3). For Artaud, Erickson argues that this language of presence originates purely in the body rather than in the mind, since Artaud conceives of the signifying language of the mind as that which breaks the natural presence of the body to itself and its objects.

So there are several qualifications to be made to the idea that Deleuze and Artaud are simply against representational language in ways that leave their writings open to deconstruction. In the first instance, we can say that a theatre without organs would not involve the pursuit of an adamic language through which actors might immediately and truthfully express themselves and the world, so much as the attempt to 'speak difference' with 'a destratified voice'. The destratified voice allows difference to make its presence felt in what Deleuze calls a 'fundamental encounter' that forces on us new, embodied thoughts. In this context, the theatre of immanence now names an encounter with difference or perpetual variation as that which exceeds

the representational consciousness of a subject, forcing thought through rupture rather than communicating meanings through sameness. In this way, the destratified voice of the theatre without organs becomes the correlative language practice to the philosophy of difference, a way of speaking in the theatre that *produces* bodies rather than representing them.

As Simon Bayly has suggested, 'Equating voice with speech and language renders inaudible the yell, the stutter, the stammer, and erring in favour of the dictionary as the sum total of what can be given voice.' And clearly, for Deleuze too, 'These non-verbal phenomena are not the authentic indicators of the self or of presence over and against the artifice of language.' However, in insisting on a redefinition of presence as differential (rather than as opposed to difference), I slightly deviate from Bayly at the point where he concludes that stutters and so forth 'are precisely what *interrupts* the effort to be present, to hold oneself together, to make sense'; a conclusion that seems to leave the equation of presence and self-identity intact (Bayly 2011: 153). I do reveal my capacity to be disorganized when I stutter and stammer before another (who can also be disorganized differently), but we might theorize this encounter as a different form of presence rather than as that which ruptures presence.

On the relation between language and thought

However, Erickson's critique not only frames Artaud's concept of presence as self-identical expression, but as necessarily '*immediate* (re)cognition' (Erickson 1985: 285, emphasis added). Immediacy implies spatio-temporal relations of sameness insofar as it is associated with the instantaneous on the one hand, and with the unmediated or direct on the other. Artaud, Erickson claims, hopes to create a language of instantaneousness through bypassing the mind in favour of establishing contact between bodies. Thought, and by extension the mind, is associated with delay; intellectualization introduces unnecessary pauses in the reception process.

> Sound poetry or Artaud's cries attempt to overcome this temporal gap by denigrating the value of symbolic meaning, the cognition of which takes place in consciousness, and by appealing to the immediacy of a purely physical response (an action of the unconscious). This is an attempt at maintaining presence, which resides in immediacy, and of avoiding slippages of presence that result in individual self-consciousness and alienation from the scene. No one should stop to think. (Erickson 2005: 285)

Erickson is making a number of points here. In the first instance, he seems to equate thinking with consciousness and suggests that, for Artaud, what is valuable in the performance of language is not meaning, but an unthinking, simple presence of the body to the word. But Artaud is not merely concerned

to banish temporal difference, Erickson argues, he also wants to achieve a direct language that speaks to its audience without the mediation of concepts. Bypassing consciousness, it seems, kills two birds with one stone. As such, Erickson suggests that Artaud's concept of presence involves an immediate, unconscious, bodily response to language as sound rather than symbol. This is opposed to 'thinking', understood as that which imposes breaks in presence and distortions of meaning. In contrast, Erickson's own position naturalizes a temporal gap between expression and comprehension as a condition of consciousness. In this way, he points out the contradiction inherent in the notion of 'immediate (re)cognition', arguing that 'meaning' can never be unmediated or instantaneous:

> Consciousness of language is a belated consciousness. Meaning is never comprehended instantaneously, but always a fraction of a moment later ... In a symbolic system 'immediate (re)cognition' is self-contradictory. (Erickson 1985: 285)

Meaning is always delayed and therefore differentiated. And as such, if there is an immediacy or 'presence' between speaker and audience, it cannot be 'meaningful'. Or, vice versa, if the performance of language is 'meaningful' for the audience, it is because there has been a break in presence.

Erickson goes on to propose that, in seeking both self-identical expression and immediate recognition, intonational language takes two key risks. First, the language of presence aspires to a 'universal, emotive language' that can only be unambiguous in the expression of strong emotion and, as such, lacks the capacity to express 'nuance' – understood as a specific, but minor or subtle inflection of meaning. Erickson claims:

> the language of presence can only operate on the level of strong emotion if it is to be discerned or experienced unambiguously. Can there be any hope of finding *nuance* here, below the level of thought (which is essentially linguistic)? (Erickson 1985: 282)

Intonational language wants to be definite and particular, but Erickson argues that it can only achieve the self-identity of expression to which it aspires by limiting the range of meanings of its expressions. In this way, he suggests that subtlety of meaning is specific to the realm of consciousness. Since the language of presence directs itself towards the unthinking body, it has to shout loudly and clearly to be understood. In turn, Erickson contends that the language of presence 'is not devoid of signification, it is just widening and making less definite what is being signified' (Erickson 1985: 288). Intonational language aspires to the elimination of the ambiguity that it associates with the process of signification. In its failure, it signifies only the extremes of the general, rather than the nuance of the particular.

Secondly, the language of presence, as Erickson defines it, risks *hermeticism.* From one perspective, he argues, this is because the language of presence is more concerned with the performer's experience than that of the audience (Erickson 1985). From another, it is because the language of presence seeks to break away from the conventional relations between signifier and signified that form the basis of social communication. In doing so, it risks constructing its own 'prison-house', not of language but of nonsense. Drawing from the example of Artaud's contemporary Hugo Ball, Erickson argues:

> This solitary fortress in which one seeks an inner presence, this incomprehensible sphere can be a prison as well, though its purpose may be to free one from the constraints of language in society. This struggle, this tension, finally led Ball into a state of monastic silence. (Erickson 1985: 285)

Incomprehensibility separates us from one another, Erickson implies, as much as the representational language that sound poetry seeks to escape.

In the main, Erickson's essay seems to associate Artaud with an opposition of thinking and presence; thought is that which interrupts presence. At one point, however, Erickson discusses Artaud's notion of presence not in relation to the performance of language, but in the context of thought itself. For Artaud, Erickson argues, consciousness is that which intervenes to separate him from his own thought; and yet, without consciousness he risks losing his thoughts. This leaves Artaud in a double bind: 'Artaud wishes to be totally conscious, by not being so he suspects that someone is stealing his thoughts, but any attempt to be fully self-conscious while thinking arrests the thought process, so that in a sense he steals it from himself' (Erickson 1985: 286). For Artaud, Erickson suggests, the 'thought process' is both unconscious and in motion. Consciousness, in contrast, involves the arrest of motion – as a process of capture in relation to the thought process, attempting to prevent its escape.

But surely, then, presence cannot be opposed to thought per se if presence is a problem *for* thought. Rather, it becomes clear that we need to distinguish between *conscious* and *unconscious* as two levels at which thought might be understood to take place. In turn, we might suggest that what Artaud wants is to conceive presence not as opposed to thinking, but presence as the *unconscious movement of thought*, and that we can draw from Deleuze to shed further light on this idea. Artaud does not want to make a mindless theatre in which no one stops to think, but he does want to reconsider our notion of the 'mind' and of thinking. Again, it is a question of destratification. As Dale notes, 'Artaud does not reject the mind, he denounces it as an organ of the organized body and as an interpreter of meaning' (Dale 2002: 91). Deleuze provides such an alternative account of thought: not as the recognition of existing meanings, but as an embodied, creative process born

of the encounter. Armed with these Deleuzian ideas, we can not only address Artaud's linguistic aspirations in his radio work, *To have done with the judgment of god*, but his broader ambition to create a theatre – of gestures as well as words – that *makes us think* and in so doing affirms the ontological force of difference in itself, which cannot be 'understood' but can be sensed.

Thus, to construct oneself a theatre without organs is to learn to *think*, as well as to speak, differently. In *To have done with the judgment of god*, Artaud suggests that man thinks as he is made. As Dale argues, Artaud 'throws both mind and body into consternation accusing man of thinking along the organized lines of the organism, that is, of thinking in the same way as he is constructed and vice versa' (Dale 2002: 87). Likewise, in *Difference and Repetition*, Deleuze argues that he and Artaud agree on the idea that to think – genuinely – is to create: to make something new in contact with the world rather than to approach it with preconceived ideas. And it is this creative nature of thought that makes it difficult, for all of us, to really think. However, it also this difficult thought – which Deleuze calls 'thought without image' – that is privileged as the only thought that can approach difference in itself.

Deleuze addresses the nature of thought throughout his oeuvre, but in both *Difference and Repetition* and *A Thousand Plateaus* he proposes an affinity between his and Artaud's understanding of that nature. In both cases, Artaud's key text for Deleuze seems to be the *Correspondence avec Jacques Rivière* (1923–24), in which he and Guattari definitively take 'Artaud's side' against Rivière – the 'man of the State' who attempts to rebind Artaud's errant thought to targets and aims (Deleuze and Guattari 1988: 378). In *Difference and Repetition*, Deleuze argues that Rivière misunderstood Artaud; indeed, he declares, 'Rarely has there been such misunderstanding' (Deleuze 1994: 147). And whereas Rivière takes thinking for granted, Deleuze argues, as an innate function that already exists and must merely be put to work, Artaud

> knows that thinking is not innate, but must be engendered in thought. He knows that the problem is not to direct or methodically apply a thought which pre-exists in principle and in nature, but to bring into being that which does not yet exist (there is no other work, all the rest is arbitrary, mere decoration). (Deleuze 1994: 147)

For Deleuze, 'To think is to create – there is no other creation – but to create is first of all to engender "thinking" in thought' (Deleuze 1994: 147). Artaud, he argues, shares this definition of thought, but also has direct experience of the difficulties of engendering thought as creation. In the *Correspondence*, as Deleuze narrates,

> Artaud said that the problem (for him) was not to orientate his thought, or to perfect the expression of what he thought, or to acquire application

and method or to perfect his poems, but simply to manage to think something. (Deleuze 1994: 147)

This problem is not unique to Artaud, Deleuze suggests; rather, Artaud's particular experience shows up 'difficulties in principle, concerning and affecting the essence of what it means to think' (Deleuze 1994: 147). The nature of thought as creation means that it is difficult, for all of us, to genuinely think.

Deleuze goes on to argue that Artaud's interrogation of his experience of the inability to think provides us with a 'revelation of a thought without image' which he contrasts with what he calls 'the dogmatic image of thought' (Deleuze 1994: 147). With Artaud, Deleuze argues, thought is forced to think its own 'natural "powerlessness"', but he adds that this 'fracture' or 'collapse' essential to thought is indistinguishable from its 'greatest power' (Deleuze 1994: 147). In other words, Artaud's experience of thought's inability to hold itself together as itself, although the cause of suffering for Artaud, actually demonstrates the power of thought as the ceaseless production of itself as difference. After Artaud, Deleuze proposes, the dogmatic image of thought can no longer stand. Deleuze and Guattari return to this idea in *A Thousand Plateaus*, suggesting that Artaud's letters to Rivière reveal thought's essence as its 'own incapacity to take on form' (Deleuze and Guattari 1988: 378). It is not a question, Deleuze says, of 'opposing to the dogmatic image of thought another image borrowed, for example, from schizophrenia, but rather of remembering that schizophrenia is not only a human fact but also a possibility for thought' (Deleuze 1994: 148). We need not approach Artaud's experience (which Deleuze calls 'schizophrenic') as an example of errant or deviant thought; rather, it shows us the creative power of all genuine thought.

In stark contrast to Erickson, for whom, as we have seen, thought is 'essentially linguistic' (Erickson 1985: 282), Deleuze argues that language does not define or condition the process of thought. Thought does not begin with the categories of language, but with 'something in the world' that presents itself to sensation: difference. Thought is not the product of language, but of what Deleuze calls a 'fundamental encounter' (Deleuze 1994: 139). Here, he makes a clear distinction between what he calls 'objects of recognition' and those of *encounter*. Objects of recognition, Deleuze argues, 'do not disturb thought' insofar as they provide thought with 'an image of itself'; they reaffirm for thought, in other words, what it already thinks it knows. For Deleuze, instances of recognition do not involve genuine thought. We only 'truly think' when we have difficulty in recognizing something (Deleuze 1994: 138). Such things produce encounters as the forcing of thought or, as Deleuze puts it:

Something in the world forces us to think. This something is an object not of recognition but of a fundamental *encounter*. What is encountered

may be Socrates, a temple or a demon. It may be grasped in a range of affective tones: wonder, love, hatred, suffering. In whichever tone, its primary characteristic is that *it can only be sensed*. In this sense it is opposed to recognition. (Deleuze 1994: 139, first emphasis in original, second emphasis added)

The object of encounter, then, presents itself to affect or sensation alone, rather than to conscious thought or recognition. Indeed, the encounter 'defies consciousness, recognition and representation' (Bogue 1989: 78). Conceived in terms of its power to be affected, Deleuze also argues that the body can think in ways from which consciousness would do well to learn. Deleuze is not arguing that sensation is able to recognize nuance, as constituted by small degrees of difference between meanings. Rather, he argues that difference in itself is that which 'can only be sensed', since consciousness works with identities.

At times, Artaud's account of theatrical meaning might seem to promote the 'dogmatic image of thought' rather than a 'thought without image'. For instance, in a discussion of what he calls 'undebased mime plays' in ' "Mise en scène" and Metaphysics', Artaud seems to assign the elements of theatre a substitutive role. He explains: 'I mean straightforward mime where gestures, instead of standing for words or sentences as in European mime ... *stand for* ideas, attitudes of mind, aspects of nature in a tangible, potent way' (Artaud in Schumacher 1989: 94, emphasis added). So long as theatre operates as a substitute for something else – be it words or ideas – the break between the absent represented (ideas) and the present representative (gesture) remains. In the same fashion, there is in Artaud's writings a lingering desire to be understood and to dictate audience response, that could be seen to stand in tension with a Deleuzian reading of Artaud's theatre as an encounter that forces (definitively *creative*) thought. For instance, in a 1947 letter to Fernand Pouey, Artaud explicitly rejects an understanding of *To have done with the judgment of god* as 'a work that is chaotic and disconnected ... in which the wandering sensibility of the listener must also take at random what suits him' (Artaud in Sontag 1976: 576). In turn, Artaud describes the broadcast as 'a search for a language which the humblest roadmender or coal seller would have understood, a language which conveyed by means of *bodily transmission* the highest metaphysical truths' (Artaud in Sontag 1976: 583).

Such appeals to understanding and 'truth' might well be taken to imply a desire to banish difference along the lines of Erickson's reading of Artaud. However, Deleuze encourages us to notice Artaud's divergence from such a reading in three different ways. Firstly, he allows us to conceive of Artaud as aspiring to create a theatre as an object of encounter rather than recognition, as forcing thought rather than communicating meanings. With regard to the issue of theatre as substitute, it is important to note Artaud's account

of the *nature* of these ideas for which theatre stands in. These ideas, Artaud suggests, do not *pre-exist* their expression, and as such theatre creates rather than represents them, in much the same way as does the Deleuzian encounter. From these examples we can see that it is not that he wants to divorce theatre from 'meaning' per se, so much as create new meanings beyond those that already exist and can be represented. For instance, in 'Theatre and Poetry' Artaud declares his commitment to freeing objects from their conventional associations or what he refers to as their 'immediate meaning'. He proposes that objects in the theatre

> are cut off from their immediate meaning, and endeavour, indeed, to create a true language based on the sign, rather than based on the word. That is where the notion of symbolism based on the changing of meanings comes in. Things will be stripped of their immediate meaning and will be given a new one. (Artaud in Schumacher 1989: 119)

Rather than thinking of the symbol as that which represents existing meanings, Artaud conceives of symbolism as the creation of new meaning. This is a function that he associates with *poetry*: theatre becomes poetic, Artaud argues, when it seizes its capacity to shake our understandings of the relations between things. Similarly, in the first manifesto of the Theatre of Cruelty, he argues, 'Through poetry, theatre contrasts *pictures of the unformulated* with the crude visualization of what exists' (Artaud in Schumacher 1989: 105, emphasis in original), a process that he associates with cinema. Contemporary society, he complains, 'has made us forget the slightest idea of serious theatre which upsets all our preconceptions' (Artaud in Schumacher 1989: 108). Once distilled to its essence, we must not ask whether theatricality can define thought, Artaud argues, 'but whether it *makes us think*' (Artaud in Schumacher 1989: 122, emphasis in original).

Secondly, Deleuze's concept of the encounter with that which can only be sensed also allows us to return with fresh eyes to Artaud's references to 'bodily transmission' and his concept of 'the Flesh'. Indeed, Deleuze himself creates a concept of 'the flesh' in *The Logic of Sense*, where he talks about the inscription of difference or of 'the depths' in the flesh (Deleuze 1990: 161). Likewise, in 'Theatre and Cruelty' (1933), Artaud argues: 'One cannot separate body and mind, nor the senses from the intellect, particularly in a field where the unending repeated jading of our organs calls for sudden shocks to revive our understanding' (Artaud in Schumacher 1989: 109). Here, the body, or what Artaud also names 'Flesh', is located at the very source of genuine thought, as distinct from the kind of habitual thinking involved in the interpretation of the psychological theatre that Artaud rejects. Specifically, he argues that society has become unaccustomed to a theatre of presence as the forcing of thought, largely on account of 'the damage wrought by psychological theatre, derived from Racine' (Artaud in

Schumacher 1989: 108). Likewise, in 'Situation of the Flesh' (1925), Artaud assigns a particular definition to the notion of flesh beyond a common-sense understanding:

> For me the word Flesh means above all *apprehension*, hair standing on end, flesh laid bare with all the intellectual profundity of this spectacle of pure flesh and all its consequences for the senses, that is for the sentiments. And sentiment means presentiment, that is, direct understanding, communication turned inside out and illumined from within. There is a mind in the flesh, but a mind as quick as lightning. And yet the excitement of the flesh partakes of the high substance of the mind. And yet whosoever says flesh also says sensibility. Sensibility, that is, assimilation, but the ultimate, secret, profound, absolute assimilation of my own pain, and consequently the solitary and unique knowledge of that pain. (Artaud in Sontag 1976: 111)

For Deleuze, too, the presence of difference or perpetual variation has an electric quality: 'It is like lightning coming from somewhere else and announcing something else – a sudden emergence of creative, unexpected and subrepresentative variation' (Deleuze 1997: 252). Using the destratified voice, differential presence is characterized by the 'sudden shock when thought realises itself in the body' (Dale 2002: 91); it is a moment of performance that addresses an acephalic 'mind in the flesh'.

Thirdly, we can also suggest that Deleuze's conception of 'the language of schizophrenia' in *The Logic of Sense* might be productively read alongside Artaud's concepts of language as operating as *incantation* and *vibration* in relation to its audience. Conventionally, 'incantation' is associated with the idea of the spell, chant or mantra: a set of words that, when recited in a ritual context, have some kind of magical effect. In the context of sound poetry, Erickson suggests, incantation refers to an ideal of language as

> summoning forth the power of presence within every fiber and organ, and nerve of the human being, uniting the spiritual with the physical, tapping into the dormant and primal creative energies, and emanating outward toward the listener; it is a sounding of one's human space and the establishing of a resonating field, creating a *harmonious sub- or pre-linguistic communication between poet and auditor*. (Erickson 1985: 280, emphasis added)

However, this notion of incantation is not the only way to understand Artaud's aims with respect to the performance of language. Particularly problematic, perhaps, is the implication that Artaud aspired to a 'harmonious' relation to his audience. On the contrary, we might suggest, incantation for Artaud involves a rupture, which in turn indicates the meeting of difference

(as itself, with itself) rather than identities. For example, we might note the violent terms in which Artaud articulates the impact of incantation in the following quotation from '"Mise en scène" and Metaphysics':

> To make metaphysics out of spoken language is to make language convey what it does not normally convey. That is to use it in a new, exceptional and unusual way, to give it its *full, physical shock potential*, to split it up and distribute it actively in space, to treat inflections in a completely tangible manner and restore their *shattering power* and really to manifest something; to turn against language and its basely utilitarian, one might almost say alimentary, sources, against its origins as a hunted beast, and finally to consider language in the form of *Incantation*. (Artaud in Schumacher 1989: 97, first and second emphasis added, third italics in original)

Here, Artaud emphasizes the way in which a particular usage of language might provide access to the ontological, or what he refers to as the 'meta-physical'. Incantation, Artaud argues, constitutes a break with the tradition of employing language as merely the tool for representing an already exist-ing reality, in favour of exposing the power of language to act on and create the real. This experience is both 'shocking' and 'shattering', rather than 'har-monious' for the audience, because they are forced to encounter physically the novelty of that which has been incanted. For her part, Jannarone argues that Artaud's use of shock is 'more punishing than provocative' insofar as it is primarily characterized as 'physical, nervous, sensual' and focused on the stimulation itself rather than its *effect* (Jannarone 2010: 87). However, a Deleuzian approach allows the alternative interpretation that Artaud's ambi-tion to go 'as far as necessary in the exploration of our nervous sensibility' is an end in itself and, indeed, is a 'hoped-for result' with ethico-political implications. Shock – as a form of affective experiment – is not a means to 'constant questioning' as an end, it *is* an instance of thought in its own way. In turn, the theatre of cruelty as a theatre of affect cannot be described as having 'no intellectual value', since the concept of affect provides us with an alternative account of that value beyond the notion of representational meaning (Jannarone 2010: 87). Incantation acts on the bodies of its audi-ence, we might propose, in a comparable fashion to the way in which words act on the body of the schizophrenic as Deleuze figures it. With Deleuze, making metaphysics out of language means the affirmation of difference in itself through Incantation.

And yet, it would be a mistake to over-emphasize the importance of 'shock' to Artaud as a mode of relation to his audience. Or rather, perhaps we need to distinguish between the 'shattering power' of an encounter with difference as an ontological force and shock as a conscious reaction to a dif-ferent opinion to one's own. As is well known, Artaud's broadcast *To have*

done with the judgment of god was banned precisely for fear that it would *shock* the French public. Indeed, Adrian Morfee notes that it is typical to find in Artaud's late writing 'the infantile delight in naming lower bodily fluids and processes' (Morfee 2005: 126), which, Morfee argues, tends to undermine rather than aid Artaud's thought. However, for all the talk of 'caca', farts and sperm in the radio play, one might argue that Artaud places a greater value on the concept of 'vibration', a more subtle mode of audience response that in fact needs to be protected from being overwhelmed by the shocking or scandalous in order to function. The concept of vibration appears several times in Artaud's oeuvre. In a 1948 letter to Wladimir Porché, the director of the radio station that banned Artaud's radio work, he writes:

> I wanted a fresh work, one that would make contact with certain
> organic points of life,
> a work in which one's whole nervous system
> illuminated as if by a miner's cap-lamp
> with vibrations,
> consonances
> which invite
> > man
> > TO EMERGE
> > WITH
> > his body
> to follow in the sky this new, unusual, and radiant Epiphany.
> But the glory of the body is possible
> > only if
> > nothing
> in the spoken text
> happens to shock
> happens to damage
> this sort of desire for glory. (Artaud in Sontag 1976: 579)

Here Artaud expresses his ambition to create a work that causes the audience's nervous systems to vibrate, leading to a renewed understanding of their bodies. However, he also makes clear that any conscious, 'shocked' response to the text will get in the way of this more intuitive reaction. Equally, although Artaud is often accused of positing a mind/body distinction, the concept of vibration seems more concerned to contrast habitual responses ('shock') with the emergence of the new ('Epiphany').

Twenty years prior to these letters, Artaud had employed the concept of vibration in a short theoretical text concerned with his film project, *The Shell and the Clergyman* (1928). Here, during a short-lived period of preference for the cinema over the theatre, Artaud argues that cinematic images are uniquely endowed with a magical rather than representational quality,

with 'the characteristics of the very vibration, the profound, unconscious source of thought' (Artaud in Schumacher 1989: 53). Cinematic images vibrate, Artaud suggests, and as such they are connected to thought as that which is produced by vibration. In turn, we might read these remarks back into Artaud's letter to Porché: if vibration is the unconscious source of thought, then Artaud wanted *To have done with the judgment of god* to make us think, to vibrate us in order that we might conceive our bodies anew. For Artaud, this impact of vibration lies outside of the powers of explanation and knowing. In *The Theatre and Its Double*, Artaud argues that there is no point 'trying to give exact reasons ... why the nervous system after a certain time is in tune with the vibrations of the subtlest music and is eventually somehow lastingly modified by it' (Artaud in Schumacher 1989: 115). Unknowable, perhaps, and yet combining Artaud's sense of the impact of vibration with Deleuze's theorization of thought as creative encounter does provide some kind of explanation. Like Deleuze, Artaud's concept of vibration traverses the mind/body distinction in order to think the nature of the presence between thinking bodies: not as pure presence, but as the differential presence that forces thought. Differential presence involves an embodied encounter with destratified matter, or matter in itself, which makes us think through an unconscious or intuitive vibration.

Much of the critique of the notion of immersion seems to stem from a residual dichotomy between thinking and feeling, where politics and the capacity for political action are firmly associated with the former rather than the latter. Indeed, Jannarone argues that Artaud's vision for activating the spectator's nervous sensibility is 'the inverse', not only of Brecht's, but 'of *all* politically engaged theatre' (Jannarone 2010: 87, emphasis added); and further, she contends that 'in no way does the Theatre of Cruelty call for intellectual engagement or individual empowerment' (Jannarone 2010: 93). As such, the affective impact that Artaud wanted his works to have on their audiences is construed as necessarily linked to thoughtless conformity and unthinking submission. Of course, Jannarone *does* contest the 'either/or' thinking, also recently critiqued by Jacques Rancière, that would construe the audience as in need of pacification *or* activation, framing Artaud's ambition, instead, as driven by a 'both/and' logic in its desire to envelop the audience in a state of agitated immersion. And yet, binarism ultimately triumphs, insofar as agitated immersion is conceived as a condition in which spectators are 'physically and emotionally agitated and intellectually disabled' (Jannarone 2010: 95).

While it is fair to say that Artaud sees the audience as a group of 'organisms' (Jannarone 2010: 87) in need of disorganization, doing so is not tantamount to construing spectators as submissive matter. After all, the brain *is* one of the organs on which the Theatre of Cruelty aspires to act. Whereas according to Jannarone's implicit ontology 'visceral agitation *forecloses* intellectual reflection' (Jannarone 2010: 95, emphasis added), Deleuze suggests that the

body's affective encounters with other bodies are that which forces thought, understood first as an unconscious movement and only subsequently as conscious recognition. Artaud's aim to immerse the spectator in the event is understood as a means to 'conduct them by means of their organisms to an apprehension of the subtlest notions' (Artaud in Schumacher 1989: 81). In the 1926 Jarry Theatre manifesto, Artaud describes the role of the director as being to 'find the *disturbing element capable of throwing the spectator in the desired state of doubt*' (Artaud in Jannarone 2010: 144, emphasis in original).

The affect–information continuum

However, even these qualifications do not go far enough. Given this affirmation of a destratified voice and a minor usage of language, what are we to make of the fact that *To have done with the judgment of god* is not *solely* composed of howls and cries? In turn, if we propose that Deleuze wants to privilege minor usages of language over major ones, then what can we say about his own written use of language, particularly in the 'drier' form that it takes when he is writing without Guattari? And finally, does the evocation of a destratified voice within a theatre without organs leave itself vulnerable to the same kinds of criticism as those addressed to Deleuze and Guattari's concept of the BwO from a variety of sources? For example, feminist philosopher Luce Irigaray asked: 'In order to make of the "body without organs", a "cause" for jouissance, isn't it necessary to have had, with respect to language and sex – to organs? – a relationship which women have never had?' (Irigaray in Jardine 1984: 51). That is, as Alice Jardine subsequently summarized, Irigaray suggests that the BwO is 'the female body as imagined by men' (Jardine 1984).

Clearly, it is not – for either Deleuze or our practitioners – that the more articulated words are more or less truthful representations of a prior presence. Rather, my proposal is that Deleuze differentiates between information and affect in order to highlight what is normally neglected. But ultimately, and as a thinker of immanence, he wants to reconcile affect and information as differing in degree rather than kind. In turn, and although difference remains Deleuze's ultimate value, it is not that stutterings and stammerings guarantee immanence, nor that such performances can necessarily be valued as 'good' no matter the context in which they are operating. Performances *can* be located along an ontological continuum, differentiated in terms of their position in relation to a maximal and minimal affirmation of the variation of language. However, it seems that this ontological continuum cannot be straightforwardly mapped onto an aesthetic or ethical one; clearly, we cannot simply label any informational use of voice as 'bad' and any affective usage 'good'. What matters, in the end, is how we understand the relationship between affect and information; and this understanding

will become increasingly complex in the practical context of making theatre, where we will have to work hard to account for Bene's Shakespearian operations in positive terms, rather than as the mere negation of a Western canon (that inevitably remains defined by it).

But surely, we might object, this flat ontology *does* continue to invoke duality, whether we think of the division between the body without organs and the organism, or between the major and minor uses of language. Indeed, at times it even appears that one side of such dyads is privileged over the other: the body without organs *over* the organism, the minor *over* the major. However, ultimately, these dualities are Deleuze and Guattari's way of differentiating two tendencies within reality as a whole; each term constitutes one of two poles of a continuum, along which specific instances of thinking through and as performance might be situated. The body without organs, for instance, is not a state at which we can arrive, but a process or movement within every organism. Likewise, the minor is not opposed to the major; rather, actual theatres are always a mixture of both tendencies.

In turn, we need to be careful to avoid using the notion of the strata as a relatively straightfoward way to understand how language works. When Deleuze and Guattari talk about the strata that bind us with their great binary aggregates (subject/object, man/woman and so forth), they are not merely talking about the way in which we use language to separate out the world according to our dualistic categories. As Claire Colebrook makes clear, 'For Deleuze, language is not just a system of signs or conventions that we impose upon the world in order to organize or differentiate our experience' (Colebrook 2002: 20). Or, as Deleuze and Guattari indicate themselves in *A Thousand Plateaus*, it is neither that the strata are simply language, nor that language is simply stratification. At the same time, though, Deleuze and Guattari note the way in which a critique of language can paradoxically end up reinforcing, indeed overstating, its power. For instance, they do not want to say that *all* processes of stratification are linguistic, they do not want to affirm 'the primacy of language over all of the strata', and they want to make clear that 'the system of the strata ... has nothing to do with ... mind and matter' (Deleuze and Guattari 1988: 71). Rather, they say that 'language plays a role' on *some* strata, but not on others; neither all positive nor all negative aspects of the organization of matter can be attributed to the work of language alone (Deleuze and Guattari 1988: 66). And finally, they question whether 'all signs are signifiers, whether all signs are endowed with signifiance', preferring to explore the work of C. S. Peirce rather than Saussure in this regard (Deleuze and Guattari 1988).

Given the importance of semiotics as an analytical method within Theatre and Performance Studies, we need to take a little more time to explore the relationship between these Deleuzo-Guattarian concepts of language and semiology. In the first instance, we might note that Deleuze and Guattari

want to shift the terms of the debate: away from a focus on 'the linguistic relation between the signifier and signified' and towards the language of 'content' and 'expression'; terms that they take from the Danish linguist Louis Hjelmslev. This is not simply a matter of a terminological change, though; rather, the stakes of this shift, for Deleuze and Guattari, concern the need to account for the complex operations of power and organization on the level of bodies. They argue:

> Signifier enthusiasts take an oversimplified situation as their implicit model: word and thing. From the word they extract the signifier, and from the thing a signified in conformity with the word, and therefore subjugated to the signifier. (Deleuze and Guattari 1988: 66)

However, the discursive and nondiscursive do not intersect with one another in this way, they assert. In exchange for 'things' (and signifieds), they suggest that we think in terms of 'forms of content' on a stratum; in exchange for 'words' (and signifiers), they propose the notion of 'forms of expression' or sets of statements that arise from the stratum. Secondly, they argue that it is not only words but also things that express, or again that expression cannot simply be equated with language; and, correlatively, that words as well as things involve substantial action. Take a thing like the theatre: the theatre is a form of content on a stratum and is related to other forms of content (gallery, cinema, church, street). This thing or form does not refer back to the word 'theatre' but to entirely different words and concepts, such as the 'postdramatic', which express a new way of classifying, stating, translating and even enacting theatrical events.[39]

 Finally – and this relates to the notion of indirect discourse in which I touched in the previous chapter – Deleuze and Guattari argue that there is no individual, speaking subject whose words can be separated from what they call a 'collective assemblage of enunciation' (Deleuze and Guattari 1988: 80). 'In the course of a day', for instance, they suggest that an individual 'passes from language to language'; not that she speaks in the 'same' language differently, depending on the context in which she finds herself, but that each contextualized usage evidences the primacy of difference within language itself, such that each usage can be said to be a different language, not a variation of the same (Deleuze and Guattari 1988: 94). Here is a section from *Dialogues* that Lecercle suggests is 'typical of the Deleuzean attitude' to language (Lecercle 2002: 22): 'We must pass through dualisms because they are in language, it's not a question of getting rid of them, but we must fight against language, invent stammering, not in order to get back to a pre-linguistic pseudo-reality, but to trace a vocal or written line which will make language flow between these dualisms' (Deleuze and Parnet 1987: 34). But how might we characterize the ethics of a Deleuzean approach to voice and language?

The voice has long since been understood as a core concern of ethics, largely on the basis of an identity principle where the voice is an 'I': an 'I think' and an 'I feel'. As Bayly has discussed, the voice is understood as ethical insofar as

> To have a voice is to have a say and also to be heard, to exercise a vote and thus to be counted, as well as to be taken into account. To hear a voice as voice is to posit it as the product of an intentionality, the passage of meaning from interior to exterior, the outward and visible sign of an interior consciousness, perhaps of thought itself. In this sense, the voice functions as the sonorous equivalent to the face, as a pre-eminent site of expression. (Bayly 2011: 147)

In turn, Steven Connor suggests that much of the work that has been done on the ethics of voice by literary and cultural theorists 'is governed by a powerfully assumed, and sometimes theoretically uninspected, negative injunction against the privation of the voice, whether through appropriation or silencing' (Connor 1999: 220). To be silent or be silenced, to be spoken for or to have one's voice borrowed or stolen by another, are assumed to be unequivocally 'bad'. But as Connor outlines, such an ethics is based on a particular understanding of the relation between voice and selfhood: 'The wrong done to the voice is a privative wrong, a wrong done to a right of ownership, and self-ownership; to the right and entitlement to speak with one's own voice' (Connor 1999: 221). However, what happens to the ethics of voice when it is no longer construed as the ground and vehicle of self-presence, for instance, in relation to the destratified or disorganized voice that I have attempted to sound out here?

As Connor has suggested, traditional ethical thinking has argued that we do not have an ethical responsibility to those beings that produce sounds rather than speak in a voice – particularly not, for instance, to the animal: 'the traditional association between the voice and ethical questions of responsibility and obligation. The matter is put at its plainest in the discussion of sound and hearing in Book II of Aristotle's *De Anima*. The difference between sound and voice, writes Aristotle, is a difference between unsouled and ensouled entities: 'Voice is a particular sound made by something with a soul; for nothing which does not have a soul, has a voice.' Having distinguished by means of voice between the ensouled and the unsouled, Aristotle goes on to make a further distinction between the different uses of the voice:

> Not every sound made by an animal is voice (for it is possible to make a sound also with the tongue or as in coughing); but that which does the striking must have a soul and there must be a certain imagination (for voice is a particular sound which has meaning, and not one merely of the inbreathed air, as a cough is).

In this way, Connor goes on to explain, ethical evaluations have tended to be based on the notion of a clear distinction between the articulatory and nonarticulatory functions of voices: 'The ethics of the voice – its association with values, obligations and judgements – are concentrated around the articulate voice. That which has no voice, or which utters inarticulately, has no place in or positive bearing upon ethics' (Connor 1999: 232). Within this tradition, Connor suggests, only humans tend to have their sounds heard as voices in ways that award them specific rights. 'A consequence of the breakdown of the old certainties about the distinctions between the human and the inhuman is to release the possibility of hearing voices as other, and the otherness of the voice' (Connor 1999: 234). Connor suggests that the ethical question that we should ask ourselves is whether or not a sound we hear is a voice (Connor 1999: 235).

However, there is another ethical dimension that we might wish to address here. Controversially, as we have seen, Deleuze and Guattari employ Artaud's writing in order to argue that 'schizophrenia is not only a human fact but also a possibility for thought' (Deleuze 1994: 148). Seemingly assuming that the term 'schizophrenia' names some shared, intensive experience, they argue that schizophrenia has philosophical implications that must be brought to bear on how we conceive of thought, language and the encounter with difference. But what is the ethical (rather than exploitative or condescending or romanticizing) way for 'abstract speakers' like Deleuze to relate to those who suffer? Is there something like a 'microethics' of mental health to be extracted from Deleuze's thought with respect to his engagement with Artaud, and in particular from the conceptualizations of disorganized voices that we have presented here? In *The Logic of Sense*, for instance, Deleuze discusses Fitzgerald's alcoholism alongside Artaud's madness and questions the 'ridiculousness' of the academic who positions herself outside of these dangerous experiments:

> Each one risked something and went as far as possible in taking this risk; each one drew from it an irrepressible right. What is left for the abstract speaker once she has given advice of wisdom and distinction? Well then, are we to speak always about ... Fitzgerald and Lowry's alcoholism, Nietzsche and Artaud's madness, while remaining on the shore? Are we to become the professionals who give talks on these topics? (Deleuze 1990: 157)

Likewise, in *A Thousand Plateaus* Deleuze and Guattari ask: 'Is it cowardice or exploitation to wait until others have taken the risks', to wait until others – whether they are drug users, artists or schizophrenics (or all three, like Artaud) – have reached the plane of immanence, before constructing one's own experiment (Deleuze and Guattari 1988: 286)? By this stage of his writing, though, Deleuze (with Guattari) feels more confident to answer

'no' to his own question and, in addition, to affirm the possibility of getting drunk just on water – emphasizing process over content, the line of flight over any one model (Deleuze and Guattari 1988: 286). Thanks to the starting points mapped out by Artaud, we too can join in the undertaking to construct a plane of immanence 'in the middle'.

We know that many of Artaud's ideas emerged in the context of profound suffering: the trauma of his experience of schizophrenia and its inexact treatment by means of electro-shock therapy (among other things).[40] In turn, as we have seen, this distinction is thematized in Artaud's critique of the artificiality of Carroll's *Jabberwocky*, a poem whose style echoed but did not truly emerge from the experience of bodily suffering to which Artaud assigns an authenticating value. Indeed, as we saw, Artaud goes as far as to contend that '"Jabberwocky" is the work of an opportunist who wanted to feed intellectually on someone else's pain' (Artaud in Sontag 1976: 449). Just as Artaud rejects the instrumentalization of theatre for political (rather than metaphysical) ends elsewhere, he also criticizes the outside observers' appropriation of experiences of suffering for intellectual purposes. As such, then, might we not levy a similar critique of opportunism at Deleuze?

This chapter cannot hope to do complete justice to these issues,[41] but for now it remains important to return, finally, to the value that both Deleuze and Artaud place on the theatre, and specifically *how theatre speaks*, in the fight against the oppression of Life by judgement. For his part, Artaud gave much careful consideration to how one might *consciously* effect an *unconscious* vibration, or create an encounter, in one's audience (or in oneself), developing theatrical but also ethical concepts such as 'incantation' and 'vibration' alongside those of cruelty and the BwO on which Deleuze chooses to focus. For example, Artaud argues that incantation involves using language in a way that gives it 'its full, physical shock potential', restoring to language its metaphysical or performative power to manifest something new rather than merely represent the already existing (Artaud in Schumacher 1989: 97). This experience is both 'shocking' and 'shattering', rather than 'harmonious', for the audience because they are forced to encounter the novelty of that which has been incanted, *physically*.

In this respect, we might conclude by arguing that, for both Deleuze and Artaud, language, and specifically Artaud's radio play, can act as less risky but no less potentially successful agents of immanence than madness, alcoholism or drug taking. As Deleuze and Guattari emphasize in *A Thousand Plateaus*, the latter provide no guarantee that we will be able to leap from the plane of organization to that of immanence or consistency. Why not try to encounter difference by *listening* to Artaud or experimenting with your own incantations; generate our own becomings-mad in contact with 'lunatics' rather than becoming 'professional lecturers on Artaud' (Deleuze 1995: 11)?[42]

In 'Letter to a Harsh Critic', Deleuze argues:

What's interesting isn't whether I'm capitalizing on anything, but whether there are people doing something or other in their little corner, and me in mine, and whether there might be any points of contact, chance encounters and coincidences rather than alignments and rallying-points ... The question's nothing to do with the character of this or that exclusive group, it's to do with the transversal relations that ensure that any effects produced in some particular way (through homosexuality, drugs, and so on) can always be produced by other means. (Deleuze 1995)

To pursue these other means is neither a matter of remaining on the shore, nor of wildly destratifying, but of searching for the effects of 'madness' through careful experimentation with the voice and language, alongside the other elements of performance.

Indeed, what I want to suggest is that we can draw from Deleuze to explore the idea that Bene and Wilson's performances are, in some sense, '*for*' those who are diagnosed as disordered or categorized as 'abnormal' in a clinical context. For example, in *What is Philosophy?* Deleuze and Guattari outline Artaud's argument that the aim of art and philosophy should be 'to write for the illiterate – to speak for the aphasic, to think for the acephalous' or headless (Deleuze and Guattari 1994: 109). But, as Deleuze and Guattari make clear, the preposition 'for' here does not mean '"for their benefit," or yet "in their place"' (Deleuze and Guattari 1994: 109). Rather, to think or write or perform for these others 'is a question of becoming', rather than imitating or representing. Becoming-animal, for instance, is 'for' the animal in the sense that it allows the animal to become something else. In turn, the question for us might be: what do disordered voices become in the event of Bene and Wilson's whisperings, stammerings, mutterings and mumblings? In part, this suggestion is inspired by Deleuze's own mighty claims, in 'One Less Manifesto', that Bene's work stands in solidarity with the peasants of his native region of Puglia in southern Italy and against their 'normalization'. Deleuze argues that Bene's minor theatre deviates from what he calls majority rule. Under the majority, groups such as 'women, children, the South, the third world, etc.' (Deleuze 1997: 255) are, despite their numbers, constituted as subordinate minorities in relation to a standard measure: the supposedly universal model of Man, who in fact represents the specifically 'white, Christian, average-male-adult-inhabitant of contemporary American or European cities' (Deleuze 1997: 253). A political theatre, for Deleuze, would not be one that aims to represent these minorities, or to represent conflicts between men and women, the first and third worlds, or the so-called normal and abnormal. Rather, a revolutionary theatre reveals the ceaseless movement and variation underlying these static, representational oppositions. In particular, the minor usage of language on stage, Bene and

Wilson's becoming-aphasic, affirms the creativity of those disorderly voices, rather than evaluating them as deviant or lacking in relation to some transcendent standard.

It is worth noting at this point that Bene himself has resisted traditionally political readings of his work. Furthermore, critics such as Lorenzo Chiesa and Mark Fortier, respectively, argue that 'Deleuze politicises Bene's theatre in an untenable way' (Chiesa in Cull 2009a: 73) and that Bene's work has 'no positive political agenda' (Fortier 1996: 6). In turn, Fortier argues that 'Unlike the avant-garde and those Bene describes as the "crétins de l'extrême-gauche" ("L'énergie" 84), Bene does not believe in or work toward a future or goal. As he sees it, theatre can precipitate a crisis, but only for a moment' (Fortier 1996: 7). Likewise, Wilson has said, 'I'm not interested in politics in the theatre. I always thought that politics divided men' (Wilson in Schechner *et al.* 2003:118). And correlatively, whether they are addressing Wilson, Bene or Lavaudant, there is a tendency for secondary commentaries to characterize these 'theatres of images' as other-worldly, or as that which excludes the 'real world' (whatever that means) in favour of constructing 'a sensual theatre of the mind in which imagination and theory are the ruling agents' (Champagne 1984: 94). As such, a recurring question (and often it is a question that is asked in an accusatory tone) is: 'Is this political theatre?' (Champagne 1984: 94). For many, this aesthetic and unashamedly philosophical theatre appears to have abandoned the 'questions of the spectator or of social conditions' that had been of such pressing concern to the activist theatres of the generation before. But, as Champagne goes on to point out, Lavaudant (at least) is far from apolitical and forces us to rethink what we mean by 'political theatre'. Like Deleuze, Lavaudant rejects the Brechtian, dialectical model in favour of a politics of creativity. 'My first field of intervention,' Lavaudant states, 'is creation. I ask what is the theatrical machine, and how to make it function [as a] zone of illusion, fascination, mystification. If the question: "How is your theatre political?" means only "What does it serve?," I prefer not to respond' (Lavaudant in Champagne 1984: 95).

But surely it is more a question of what we mean by 'political' here, how politics – in the specific case of political theatre – is defined. For instance, although Wilson at times rejects the term 'politics', he nonetheless goes on to identify what might be understood as a political aspect to his work: 'I was more interested in the social aspects of theatre. As I said, theatre can be a forum, a place where ... someone who was going to be locked up in an institution, could be heard' (Wilson in Schechner *et al.* 2003: 118). In this instance, Wilson is referring specifically to his noncorrective, nontherapeutic approach to working with a deaf mute boy, Raymond Andrews, and Chris Knowles, a young man whose severe brain damage made it difficult for him to speak and read. 'What's wonderful about theatre,' Wilson says, 'is that ... we can have many different voices onstage ... You can't do that

in a restaurant or on the street because they will lock you up, but you can get away with it in the theatre. That's one of the things that fascinates me about the stage' (Wilson in Schechner *et al.* 2003: 119). Perhaps what I am suggesting is that, through a Deleuzian idea of a politics of affect or sensation, this hearing of other voices is not symbolic or metaphorical but literal: a voice that sounds different – the whispering voice, the voice that makes language whisper – *is* a way of living differently, *is* an alternate world, albeit one that is conventionally repressed. Might it be that the theatre and the street are closer than Wilson suggests: that to perform the disordered voice is somehow to transform the clinically disordered voice into *one that can be heard*?

In this sense, we cannot think in terms of an ethics of voice without also addressing an ethics of *listening*. After all, works such as *To have done with the judgment of god* can be heard in an infinite number of ways. For Simon Bayly, for instance, 'Artaud's own screams [in *To have done...*] are high-pitched, falsetto even, theatrical to the point of a "camp" femininity. What one heard in Artaud's screams is more like the suppressed rage and frustration of a voice that, true to its own declaration, has indeed forgotten how to scream' (Bayly 2011: 174). Alternatively, Douglas Kahin notes, 'It would be easy to think that no amount of special techniques and rehearsal could inform this demeanour, and what we are hearing is fueled by the abrading remnants of the preceding years of madness' (Kahn 1999: 349).

For Jannarone, Artaud is a paradigmatic case of an autocratic director: an artist who sought to impose his vision on the audience – top-down – rather than inviting multiple responses, in a manner that Jannarone classes as 'fascistic'. The Theatre of Cruelty talks the talk of activating the audience, Jannarone suggests, but in practice it exhibits a desire for authority, for forcibly imposing a seductive vision on a passive crowd. For instance, Jannarone points to 'The Jarry Theatre's choice of artistic sovereignty over audience revolt' as salutary.[43] And certainly, as we've seen, both Artaud and Deleuze are interested in notions of 'shock' – a shock to thought; indeed, Deleuze's very description of an affective encounter as *'forcing* thought' might be understood to imply a certain violence and coercion.

However, we should be clear that, in this particular instance, it is not a question of an individual person – 'Artaud' or 'Deleuze' – forcing thought on us. Rather, it is one characteristic of the inhuman power of difference (change or becoming), at least according to Deleuze, that it can prompt us to think differently. Likewise, there are a range of more subtle and open forms of audience response that interested Artaud, beyond the notion of shock. For instance, it seems important simply to register Artaud's careful consideration of how one might consciously effect an unconscious vibration, or create an encounter, in one's audience or oneself. Contra Erickson's argument that Artaud's use of language, like sound poetry, is more concerned with the experience of the performer than that of the audience, Artaud's response to

Porché's ban evidences his primary concern with what language can do – as intonation, incantation and vibration – to and for those who hear it. For instance, Artaud famously argued in favour of a theatre that allows 'cruelty' to penetrate its every aspect, particularly the nature of its relationship to its audience. Nevertheless, he is clear that cruelty is not about 'wielding a butcher's knife on stage at every possible opportunity' in order to represent violence and destruction (Artaud in Schumacher 1989: 96); rather, it means creating 'a real transformation' in your audience (Artaud in Schumacher 1989: 67) by acting 'deeply and directly' on their sensibilities (Artaud in Schumacher 1989: 103). For Artaud, we might argue, the theatre of cruelty is profoundly ethical – in Deleuze's sense of ethics as distinct from morality – in that it is 'unafraid of exploring the limits of our nervous sensibility' (Artaud in Schumacher 1989: 110), in that it questions *what the body of the audience can do*.

In the next chapter, we will explore these sensible limits in terms of what Deleuze and Guattari call 'becoming-animal' – a process of metamorphosis instigated by an encounter between a human and a nonhuman animal. Interestingly, Deleuze and Guattari locate the voice as central to this process, suggesting that a change in voice constitutes the first indication that a transformation is occurring ('a horde of wolves in somebody's throat' (Deleuze and Guattari 1988: 40). In *Kafka*, for instance, they argue that it is 'through voice and through sound ... that one becomes an animal' (Deleuze and Guattari 1986: 7), an idea later located in Gregor Samsa's struggle to find 'that region where the voice no longer does anything but hum' (Deleuze and Guattari 1986: 13). In turn, in *A Thousand Plateaus*, they appropriate Conan Doyle's character 'Professor Challenger' and stage him giving a lecture to invoke the vocal aspect of becoming: 'Challenger, moreover, had changed since the beginning of his talk. His voice had become hoarser, broken occasionally by an apish cough.' And then later, 'Challenger was finishing up. His voice had become unbearably shrill ... Some of the audience had returned, but only shadows and prowlers. "You hear that? It's an animal's voice"' (Deleuze and Guattari 1988: 80).

And as Max Andrews has argued, Marcus Coates 'knows just as well as Deleuze and Guattari' that the voice presents a range of opportunities for becoming-animal (Andrews 2009: n.p.). For instance, in the video work *Indigenous British Mammals* (2000), the viewer hears 'a repertoire of guttural groaning, bellowing, snorting and choking vocalisations ... apparently emitting from a patch of moss in a rolling landscape'. Alternatively, we might note the connection between another early video piece, *Finfolk* (2003), and the minor usages of language that we will find in Artaud, Bene, Wilson and Lavaudant. As Ron Broglio has described, in this video work Coates 'spouts an inarticulate stream of words', the value of which lies, Broglio argues, 'in the intensity of the performance. The camera focuses on just his mouth frothing with spit, spitting out nonsense syllables, showing

his not-so-vicious teeth and tongue' (Broglio 2011: 111). In what follows, we will focus on voice with respect to an encounter between human voices and bird song in Marcus Coates' celebrated work *Dawn Chorus*. However, we will also look at becoming-animal as a process that might take place through movement and perception, which are less to do with discovering what it is 'like' to be a particular animal, and more about acknowledging the relative nature of what it is like to be a human and experimenting at the limits of what we can do.

3
Immanent Imitations, Animal Affects: From Hijikata Tatsumi to Marcus Coates

As a whole, this third chapter is primarily concerned with the theatre of immanence as a site of bodily experimentation, an event of metamorphosis for performer and audience alike, particularly in the encounter with nonhuman animals. These concerns will be explored primarily through an examination of the performance practice of butoh co-founder Hijikata Tatsumi and the work of the contemporary artist Marcus Coates, alongside Deleuze and Guattari's well known concept of 'becoming-animal'. As Alain Beaulieu has summarized,

> Animals are omnipresent in Deleuze's work, and throughout Deleuze and Guattari's common body of work: the tick's world, the assemblage (*agencement*) of the wasp and orchid, the spider's prehension of the fly, the cat who knows better than the human how to die, the multiplicity of the wolf, the affects of Little Hans' horse, spiny lobsters' nomadism and bird-artists. (Beaulieu 2011: 69)

Within all of these discussions, Deleuze and Guattari insist that humans differ from nonhumans in degree rather than kind; indeed, it is this proximity that allows for the real exchange that they call becoming-animal. In placing this concept alongside specific performance practices, I do not mean to suggest that we should point to Hijikata or Coates's work as mere *examples* of becoming-animal (a particular risk in the case of Coates, given we know that he is familiar with this specific Deleuzo-Guattarian concept). After all, how can we say that Coates's video work *A Guide to the British Non Passerines* (2001) exemplifies becoming-animal when it involves him imitating the calls of 86 different bird species, whereas Deleuze and Guattari explicitly say that 'becoming is never imitating' (Deleuze and Guattari 1988: 305)? How can Hijikata's *Kinjiki* be an example of becoming-animal when it is thought to have involved suffocating a chicken to death – an act that arguably reinforces rather than dismantles a transcendent, hierarchical relation between human and animal?

Likewise, I do not intend to imply that the notion of becoming (-animal, or indeed -minor and -woman) is a universal concept that can be straightforwardly *applied* to vastly differing performing bodies. For instance, while I will only be able to touch on the concept of becoming-woman very briefly here, the chapter still broadly considers the question of how we might speak of and enter into becoming in a manner that registers species, but also cultural and sexual difference. Can we reconcile Deleuze and Guattari's insistence on the universal nature of becoming and their refusal of any transcendent opposition of species, cultures or sexes, with the specificity of distinct corporeal experiences? What is the relationship between becoming-animal as a concept that speaks of human and nonhuman animal bodies in general, and becomings-animal as they manifest themselves in the singularity of particular encounters: not just human-animal but Hijikata-the-human and this particular neighborhood dog in Akita, 'a northern province on the island of Honshu' where Hijikata spent his childhood (Holledge and Tompkins 2000: 144)? In this sense, the conjunction of Deleuze and specific performance practices provides an important reminder of the extent to which what appears as becoming (rather than as reproduction or imitation) is always contextually determined.

The necessary responses to these questions are complex, and will be attempted at various points throughout the chapter. For now, I will simply note that neither practice serves to *illustrate* becoming, specifically becoming-animal, because each constitutes its own different mode of thinking the nature of the relationship between human and nonhuman animals. These thinkings, I propose, have both a proximity and a singularity in relation to one another, such that their juxtaposition is *mutually* illuminating; we learn as much about Deleuze and becoming-animal from looking at Hijikata and Coates as the other way round. Secondly, I would suggest that much hinges on the way in which species (but also cultural and sexual) differences are conceived, *on what basis* human and nonhuman animals (or indeed, Japan and 'the West', men and women) are said to differ. Or again, we need to explore *if, how and why* Deleuze and Guattari's ontology of the becoming of bodies does not constitute a universalization of a specifically white, Western male experience in a manner that homogenizes the difference of other corporealities.

However, before we embark on this investigation, I want to extend my introduction to this chapter's key practitioners, starting with Hijikata Tatsumi. From early examples such as the 1960 film *Heso to genbaku* (Navel and A-Bomb)[44] to his final solo, *Leprosy* within the piece *Summer Storm* (1973), what Hijikata called 'the body that becomes' remained at the centre of his work (Fraleigh 2010: 55). Butoh expert Sondra Fraleigh argues that metamorphosis 'is the metaphysical method of butoh, its alchemical aspect, and its shamanist basis' (Fraleigh 2010: 13). Hijikata specifically uses dance not to *represent* the movement of other bodies, but to locate new and

unfamiliar ways of moving, evoked by an 'imagistic process' that is, at the same time, always struggling to prevent the body from settling into a fixed image that we might recognize. As Fraleigh summarizes, Hijikata 'gave the dance world a profound lexicon of paradoxical imagery ... images in states of becoming and only seldom in states of arrival' (Fraleigh 2010: 43).

References to the animal – from birds and dogs, to slugs and silkworms – populate Hijikata's writing and inspire his development of inhuman modes of movement, or what he also calls 'human remodelling'. Live animals also feature heavily, whether we think of the goat in the film *War Games* that Hijikata made with Donald Richie; the pig in *Revolt of the Flesh*; or the collaborative, photographic book *Kamaitachi* (*Sickle-weasel*), named after a mythical, 'weasel-like beast able to move invisibly and soundlessly through villages and fields', performed for Eikoh Hosoe's camera by Hijikata between 1965 and 1968 (Barber 2010: 82).[45] In turn, Hijikata famously argued that humans should 'learn to see things from the perspective of an animal, an insect, or even an inanimate object', adding that 'the road trodden every-day is alive [so] ... we should value everything' (Hijikata in Holledge and Tompkins 2000: 138). In 1968 (several years before the first mention of 'becoming-animal' in Deleuze and Guattari's 1975 book *Kafka*), Hijikata was already insisting that he did not 'merely imitate' but became the animal in his dances and speaking of his frequent experiences of 'becoming other than myself'. Indeed, Hijikata's entire oeuvre affirms an idea of life as a proc-ess of perpetual rebirth in a manner that resonates strongly with Deleuze's ontology of becoming.

However, at least to my knowledge, there seems to be little existing writ-ing that specifically attends to the role of the animal in relation to Hijikata's work, nor is there much scholarship available in English that has explored his practice alongside Deleuze's philosophy. Exceptions to this include Vida Midgelow's work, which makes reference to Deleuze in order to frame the butoh body as 'in a constant state of "becoming"' (Midgelow 2007: 182).[46] In fairly stark contrast, as Ron Broglio points out, 'it is now rather com-monplace to describe his [Coates's] work in relation to the terms of Deleuze and Guattari' (Broglio 2011: 101). That is, as well as Broglio's own study, Giovanni Aloi and Max Andrews have already done important work to examine aspects of the relationship between Coates's practice and the con-cept of becoming-animal. Likewise, exhibitions such as *Machinic Alliances* (2008) and *Becoming Animal, Becoming Human* (2009) allow us to consider the ramifications of placing Coates's work, among that of other artists, in an explicitly Deleuzian context.[47]

In part, there is nothing surprising about these developments. After all, the vast majority of Marcus Coates's pieces deal with notions of 'the ani-mal' in one form or another – from relatively early video works such as *Stoat* (1999), which shows Coates 'attempting to walk wearing a pair of six inch stilts loosely bound to his feet' (Levy 2007: n.p.), to *Intelligent Design*

Image 2 Eikoh Hosoe, *Kamaitachi #17* (1965). Courtesy of the artist

(2009), a video of two giant tortoises mating that Coates produced during a residency on the Galapagos Islands. However, I would argue that this is not just (or not always) a case of curators or commentators deciding to sprinkle on a little (still relatively fashionable) philosophy of the animal in order to validate or give additional weight to an art practice. Rather, there is much to suggest in what Coates says and does that his is not only a vital project with respect to the consideration of the relationship between human and nonhuman animals, but one that is thoroughly imbued by an immanent perspective. For instance, we might note the Spinozist echoes within Coates's description of the outlook developed in his childhood, 'where everything could be related to or understood on the same level. If God was in everything then I was in everything, why then wouldn't an otter understand me?' Or again, Coates speaks of sensing a 'mysterious and unknowable connection with the world' (Coates in Barnes and Patrizio 2009: 298). At the same time, though, Coates's interest in the animal in the context of shamanism might seem to indicate more transcendentalist sympathies. Consider Romanian philosopher Mircea Eliade's account in his 1951 book on Shamanism:

> All over the world learning the language of animals, especially of birds, is equivalent to knowing the secrets of nature and hence to being able to

prophesy. Learning their language, imitating their voice, is equivalent to ability *to communicate with the beyond and the heavens* (Eliade in Andrews 2009: n.p., emphasis added)

We will continue to explore the question of Coates's immanence through-out the rest of the chapter. For now, while I note that I am juxtaposing two practitioners coming from and operating within very different contexts, I would like to suggest that what they have in common is their emphasis on becoming before being, metamorphosis before metaphor. Furthermore, Fraleigh's emphasis on butoh as a kind of shamanist activity generates an interesting point of resonance with Coates's work, given the latter's engage-ment with a contemporary, Western mode of shamanism in projects such as *Journey to the Lower World* (2004) and *Mouth of God* (2006). Here, Coates is not concerned to reproduce some sort of 'authentic' shamanic ritual (whatever we might understand that to be), although this is not to say that his projects are necessarily ironic or flippant.[48] Indeed, I would argue that what Hijikata and Coates also have in common is their seriousness, not in relation to themselves in a egoistic fashion, but with respect to the *reality* of metamorphosis and becoming; their work is conducted with a diligence and care that seem to resist the conventional dismissal of the desire really to enter into a becoming-animal as sheer naïveté.[49] In contrast, Broglio describes Coates's work in terms of a 'knowing idiocy', which he compares to that of Diogenes' performance of a dog philosophy (Broglio 2011: 101). However, somehow the use of the term 'knowing' sets up too unbalanced a relationship between Coates and his audience – whether we mean the gal-lery audience, his participants or indeed (as we will discuss in due course) a specifically nonhuman animal audience. That is, while an awareness of how absurd his activities might appear is clearly an aspect of the thinking that informs Coates's work, I will suggest that it is equally motivated by a more experimental attitude that starts specifically from *not knowing* – and in particular, from not knowing where the human ends and the nonhuman animal begins.

Furthermore, I will argue that the time-based arts of performance (and video) chosen by Hijikata and Coates are particularly well suited to drawing our attention to the difference between human and nonhuman as a *temporal* one, as something to do with *relative speeds of perception and action*. Or, as Deleuze and Guattari describe:

> Starting from the forms one has, the subject one is, the organs one has, or the functions one fulfills, becoming is to extract particles between which one establishes the relations of movement and rest, speed and slowness that are closest to what one is becoming, and through which one becomes. (Deleuze and Guattari 1988: 272)

Humans and nonhuman animals are not ontologically different in kind, with the former transcending the latter; rather, they differ in terms of what their bodies can do, in terms of their affects, which includes the relationship their bodies have to *duration*. Above all, I will suggest, becoming-animal in performance involves embodying new ways of being in time and, in doing so, exploring how we might expand, extend or otherwise alter our human powers of perception and sensation alongside those of nonhuman animals.

The sheer quantity of relevant existing literature and practice goes beyond any possibility of an adequate summary, given the proliferation of research on both Deleuze and art (including performance) in Animal Studies, on animals and Deleuze in Performance Studies, and on animals and perform-ance in Deleuze Studies (and much else besides that might not fall neatly into these three disciplinary categories). In the first instance, whether in text or in practice, performance has already contributed a great deal to the exploration of the relationship between humans and nonhuman animals in general, and with reference to Deleuze in particular. Alan Read's most recent book, for example, is dedicated to a discussion of theatre as 'the last human venue': a 'place of performance where ... [the] distinctions between human and other animals are played out' (Read 2008: 1). Likewise, there have been multiple competing claims for the status of the live animal on stage: from those who construe the animal as introducing a kind of rupture into repre-sentation, to those who argue that the animal is always already subsumed within a representational matrix. Michael Peterson, for instance, argues that 'the presence of live animals introduces a non or anti-intentional force' (Peterson in Ridout 2006: 101); whereas Nicholas Ridout insists that 'no animal can ever take the stage without producing the illusion of intention' (Ridout 2006: 102). The animal inevitably gets caught up in the human busi-ness of "meaning-production", such that the real difference between human and nonhuman animals is, if not entirely, then 'at least partially effaced' (Ridout 2006: 102). In terms of explicit discussions of becoming-animal in performance, we might look to David Williams (2000), Jennifer Parker-Starbuck (2006), Una Chaudhuri (Chaudhuri and Enelow 2006, Chaudhuri 2007) and Marla Carlson (2011). However, one could argue that in some of these texts, Deleuze and Guattari's thought appears more as a passing refer-ence than as a core resource, and in some cases, as we will see shortly, the notion of becoming-animal in particular is defined in what I construe as misleading ways.

Performance makers have also involved nonhuman animals in their work in a variety of modes, from the egalitarian to the deliberately violent and explicitly exploitative. In the visual art context, seminal performances include Joseph Beuys's *Coyote: I Like America and America Likes Me* (1974), in which 'Beuys spent the duration of the exhibition caged in a gallery in New York with a coyote, that was made to function as a mystical conduit

in a ritual of realignment and reconciliation with native Americans' (Andrews 2009: n.p.). Or, more recently, we might cite Guillermo Vargas's infamous *Exposición No 1* (2007), which featured a 'starving street-dog tied to one corner of the gallery'.[50] In the theatrical context, there is the well-documented work of Italian theatre company Societas Raffaello Sanzio, who have placed a wide range of animals on stage, including chimpanzees, horses and goats. Correlatively, we might think of the highly controversial work of the Argentinian director Rodrigo García, whose theatre works have repeatedly involved other animals suffering at the hands of humans.[51] More specifically, there have been a handful of practice-based performance research projects that have directly engaged with the notion of becoming-animal.[52]

However, given its emphasis on our encounter with the animal as an affective one, the context for this chapter is also constituted by the recent growth of Affect Studies, and in particular by the affective turn within Performance Studies. Erin Hurley and Sara Warner have recently contended that:

Of late, and consonant with what has been called "the affective turn" in the Humanities and social sciences, scholars have renewed theatre and performance's historical attention to questions of sentiment, feeling, and mood with work on racialized affect in/as performance, utopian performatives, and theatre's affective labour. (Hurley and Warner 2011: n.p.)

'Theatre operates as an affect machine,' Alan Read concurs in his most recent book (Read 2008: 13); 'without this affective charge, theatre would be consigned to a potentially entertaining, yet impotent, world of representation, repetition and ... reproduction' (Read 2008: 70) For discussions of performance in the light of Deleuze's specific definition of affect, interested readers might look to Anthony Uhlmann's contribution to *Deleuze and Performance* (2009), James Thompson's *Performance Affects* (2009) and Erin Manning's *Relationscapes* (2009), among others.

Above all, though, Deleuze and Guattari insist, as we know, on the distinction between becoming-animal and *imitating* animals – it is not, they say, a question of one identity or form being copied by another. We do not become-animal by identifying with animals (which risks sentimentality and anthromorphization), but by finding an affective common ground or 'zone of proximity'. In the final section of this chapter, I turn to Deleuze's ethical claim that becoming is 'for' the animal, not in the sense that the performer is the animal's representative, but in the sense that her performative becoming allows the animal to become something else: the bird becomes music in Mozart, Deleuze says, while the whale becomes pure colour in Melville's *Moby-Dick*. Nevertheless, doubts are raised as to the validity of this argument. Are we convinced by Deleuze's notion of the reciprocal yet aparallel nature of becomings? Does the horse, for instance, really enter into a becoming

(as much as the rider) with the invention of the bridle, as Deleuze implies (see Mullarkey 2012)? Does the dying rat genuinely benefit from Hugo von Hofmannsthal's Lord Chandos's 'fascination with a "people" of dying rats' (Deleuze and Guattari 1988: 240)? Given the increasing tendency of artists and theatre makers to involve live animals in their works (in contrast to the more distant role played by animals in the examples of art works that Deleuze employs), the chapter concludes by arguing that theatres of immanence need to reflect carefully on how to ensure that this involvement is ethical rather than exploitative. But let us begin with Hijikata and with the body, in both butoh and Deleuze.

The body that becomes (you are a set of affects): Immanent mimesis in Hijikata's butoh

Along with his lifelong collaborator Ohno Kazuo, Hijikata Tatsumi is the founder of the form of dance-art known as 'butoh', and specifically as Ankoku Butoh. As Vida Midgelow notes, 'Butoh is notoriously difficult to define' (Midgelow 2007: 159); 'Butoh defies description,' Bruce Baird concurs (Baird 2012: 1), not least since it is 'more an aesthetic movement than a specific dance or theatre form' (Fraleigh 1999: 40). At least in its initial conception, butoh was not a 'style' or 'technique' within performance, so much as an experimental investigation of embodied movement as an event of metamorphosis or change. After all, Hijikata himself argued that 'Learning dance is not a matter of where to position an arm or a leg. Since I believe neither in a dance teaching method nor in controlling movement' (Hijikata in Huxley and Witts 1996: 225). Nevertheless, somehow even this notion of butoh as an open-ended experiment does not seem to capture what butoh meant to Hijikata in the light of recollections such as the following from Min Tanaka:

> Hijikata's butoh is a result of a new way of thinking, new kinds of activities. He would often say something is *butoh-teki*, butoh-like. 'Look, isn't he *butoh-teki?*' he would say or, looking at a dog, 'You see, this dog is butoh!' He would find essence of butoh even in non-human creatures including plants. (Tanaka 2006: n.p.)

In this evocation, butoh seems to refer to a tendency that operates beyond the realms of dance and performance; butoh is a way of life or a kind of movement that can manifest itself as much in nonhumans and in the so-called inanimate as in the human body. That is, although many of the features of butoh have perhaps subsequently sedimented into a recognizable 'style' (human bodies powdered white against a black background, out-turned feet, slowed gestures, squatting position and so forth), we might suggest that, in its emergence, butoh presented its audience with

strangeness and uncertainty: flinching and flowing bodies barely visible as they appear out of and retreat back into darkness, limbs like part objects seemingly operating independently of other parts of the body, an absolutely precise yet unrecognizable articulation of movement. As Donald Richie, a collaborator and friend of Hijikata's, puts it, having seen *Kinjiki* in 1959: 'The dancers were behaving in a way I had never seen before. There was a consistency in the movement but its convolutions were extraordinary' (Richie in Barber 2010: 25). And I will suggest that Hijikata's dances, in particular, seek to elude any fixed identification of the performing body in terms of age, health, gender, sexuality, 'animation' or, as I will focus on here, species.[53]

In terms of its literal definition in Japanese, '*Bu* means dance and *to* means step' and so, 'most simply speaking, butoh is a dance step' (Fraleigh and Nakamura 2006: 1), while Ankoku Butoh is usually translated as 'darkness dance' (Fraleigh and Nakamura 2006: 1). In turn, while the intercultural origins of butoh as a practice are deeply complex and as hard to pin down as the concept of butoh, most researchers are willing to locate the formal birth of the movement in 1959, with Hijikata's performance *Kinjiki* (*Forbidden Colours*) – the controversy surrounding which led to Hijikata's resignation from the Japanese Dance Association (Fraleigh and Nakamura 2006: 8). Since then, the term butoh has come to be associated with a global phenomenon: Japanese and non-Japanese butoh companies and dancers can be found 'in nearly every major city in the world', while 'several cities outside Japan have annual butoh festivals' (Baird 2012: 1). Of course, researchers may not agree on the extent to which all these diverse practices can rightfully be called 'butoh', nor are they likely to consider all 'butoh' as belonging to a single 'genre'.

Yet, however we might choose to define the phenomenon of butoh now, we can at least recall that Hijikata's butoh did not emerge in Japan after the Second World War *in a vacuum*, as Baird has emphasized, but alongside a range of practices seeking to create an alternative movement vocabulary for Japanese dance in relation to a context dominated by both Western forms and Noh.[54] As Julie Holledge and Joanne Tompkins suggest, this butoh might be understood as a 'profoundly intercultural' form of performance, since it was both 'inspired by western avant-garde artists' – like Artaud – but also 'born out of a postwar resistance to the enforced 'Americanization' of Japan and its culture (Holledge and Tompkins 2000: 137). In particular, the authors propose, Hijikata developed his metamorphic approach to the performing body as a means to challenge 'the imposition of western individualism' ushered in by the Occupation of Japan:

> Through the process of metamorphosis, Hijikata sought to undermine the basis of individualism and the rational subjectivity he associated with western philosophy and imposed modernity. He attempted to eradicate

a fixed and unified subject position by constantly transforming his per-
forming body. (Holledge and Tompkins 2000: 138)

Correlatively, we might cite this context of rapid industrialization and eco-
nomic growth in 1950s and 1960s Japan as one basis for Hijikata's particular
interest in the idea of a nonproductive body (which also recalls the notion
of the body without organs that we introduced in the last chapter). For
instance, Hijikata argued that 'To a production-oriented society, the aimless
use of the body, which I call dance, is a deadly enemy which must be taboo'
(Hijikata in Barber 2010: 23), going on to insist that 'It is sufficient if we
wipe the eye clouded with practicality' (Hijikata in Baird 2012: 38). A more
extreme and forceful response was needed in order to retrieve the body's
own productive capacities from their appropriation by an increasingly capi-
talist social order.

The specific metamorphoses of Hijikata's butoh were developed through
a variety of practical approaches to the creation of movement. In the first
instance, and this will remind us of aspects of our discussion of cliché in
Chapter 1, Hijikata attempted to 'scrape off the customs of the body' (Baird
2012: 55) and find new ways of moving by 'not bending the joints in the
way they are used to' (Hijikata in Baird 2012: 38). According to Nakajima
Natsu, a student of both Hijikata and Ohno, Hijikata insisted on the need
for dancers to track down 'all the signs of domestication of the body', to
locate their habitual ways of moving and to attempt to shed them like a
dead skin (Nakajima in Fraleigh and Nakamura 2006: 105). In this sense,
then, we might say that Hijikata was interested in finding ways to release
the movement of the body from the transcendent organization of forms,
such as those that may have been imposed and internalized through other
kinds of dance training:

Forms exist so that we can forget them ... We should shed our skins like
snakes, to emerge from what we have learned. Everything should become
our own creation, not just a repetition of what we have learned. (Hijikata
in Holledge and Tompkins 2000: 140)

Despite the apparent individualism of such remarks, we can be clear that
Hijikata's conception of the creation of butoh is not based on the notion
of a sovereign author, nor does it assume the value of bodily control, in
the manner of traditional Western ballet. Rather, butoh manifests Hijikata's
insistence that the body is not simply a pliant matter that can be subject to
the transcendent control of the mind understood as an external force. For
instance, Richie reports Hijikata as having said, 'You can't just use the body
you know. It has a life of its own, you see, a mind of its own' (Hijikata in
Richie 2006: 111). Or again, Hijikata argues, 'Taking into your own body
the idea that your wrist is not your own – there's an important hidden

secret in this concept. The basis of dance is concealed there' (Hijikata in Goulish 2000a: 11). Instead of taking a proprietorial and authorial relation to our own bodies, Ankoku Butoh suggests that '"something moves, something dances"; it is not the individual human being who moves or dances' (Nakajima in Fraleigh and Nakamura 2006: 109). 'There is a small universe in the body,' Hijikata states (Holledge and Tompkins 2000: 137), and trying to unlearn customary ways of moving was one way to access it.

As Baird has discussed, Hijikata's butoh was part of a broader 1960s theatre movement in Japan that was 'not based upon advancement from an amateur to a professional based upon acquiring a skill' (Baird 2012: 5). Butoh artists 'did not try to faithfully replicate traditional forms (although they were not reflexively against them either ...)' (Baird 2012: 5); rather, they were committed to developing a range of body–mind techniques to cultivate a particular kind of embodied thinking in the event of performance. Writing about the second, expanded version of *Kinjiki*, Hijikata writes:

> I am forced to choose the bodies of amateurs who are not spoiled by the aesthetic consciousness of previous dancers. With the background of these young awkward bodies it should be possible to establish a new forbidden material. (Hijikata in Baird 2012: 38)

Among these amateur performers were groups of boys whom Hijikata encountered in 'working-class and industrial neighborhoods' (Baird 2012: 43), boys who worked in garages or factories by day and then came to work with Hijikata at night.

So one means to avoid presenting the audience with bodies moving in recognizable ways was to use amateurs, but another approach that Hijikata developed was a choreographic process based on imitation of the movements of a wide range of what Deleuze and Guattari might call 'minor' or 'minoritarian bodies' (Malins in Guillaume and Hughes 2011: 173):

> the criminals, the diseased and deformed, the *burakumin* underclass responsible for every abject task, the blind shaman musicians, the geishas, and the actors known as *kawara mono* or riverside beggars. (Holledge and Tompkins 2000: 138)

Evidence of Hijikata's encounters with the 'diseased and deformed' might be found in works such as *Hijikata Tatsumi and Japanese People: Rebellion of the Body* (1968; also known as *Revolt of the Flesh*) in which 'A hunchbacked Hijikata contorted himself as if beset with palsy' (Baird 2012: 1). Following an accident in his teens, Hijikata had himself suffered a severe leg injury, with the result that 'one of his legs would always be shorter than the other' (Barber 2010: 13). However, this lived experience would not prevent him from remarking: 'When I begin to wish I were crippled – even though I am

perfectly healthy – or rather that I would have been better off crippled, that is the first step towards butoh' (Hijikata in Mitchell and Snyder 1997: 51).

In this way, Hijikata's choreographical process often involved the imitation of the culturally specific movements of those bodies that surrounded him in Akita, 'the most obvious characteristics' of which where 'the *ganimata* or bow-legged walk, and the *namba* movement, apparently symptomatic of rice-planting cultures, in which the arm and leg of the same side of the body move together' (Holledge and Tompkins 2000: 44). Or, as Hijikata himself describes, 'That's where it all comes from … The paddy fields … You have no idea how tired my parents used to get. They got so tired working in the paddies that they couldn't move. And yet they had to. It hurt to move. And yet they had to because they had to work' (Hijikata cited in Richie 2006: 111). Local children also provided important sources for movement inspiration for Hijikata. He 'tells a story of his fascination with the small children in his village in Akita, who were tied to pillars in the house while their parents went to work in the fields. He observed the strange movement the children made: "One of them was feeding something to his own hand …"' (Sas 1999: 227n) Or again, Hijikata says, 'What I learnt from those toddlers has greatly influenced my body' insofar as 'their bodies were not their own' (Hijikata in Fraleigh and Nakamura 2006: 19). But I would suggest that for Hijikata this is less a matter of a dispossessed body, and more a question of the body as possessed or better, *produced* by multiple forces, not all of which are within the control of the one who is understood to inhabit it.

Finally, and before we move on to Hijikata's specific interest in metamorphosis in relation to nonhuman animals, we might also note his insistent questioning of any fixed distinction between male and female bodies. Indeed, though no doubt this will prove to be too neat a parallel, one might narrate the development of Hijikata's practice as one that starts from becoming-woman and moves to becoming-animal.[55] As Holledge and Tompkins note, 'In the early choreography for his own and other male bodies, the dance is violent and homoerotic; the sadomasochism attempts to break the mould of the male body … to eradicate the unified male subject' (Holledge and Tompkins 2000: 138). Hijikata and Ohno 'often performed in women's costumes' (Midgelow 2007: 178); for instance, in *Revolt of the Flesh*, Hijikata is said to have worn 'a sumptuous full-length shiny ball gown and thick black rubber gloves' for one sequence before bouncing around 'like an excited little girl' wearing a 'thigh length kimono and knee-high athletic socks' in another (Baird 2012: 2). In 1977, Hijikata choreographed the 79-year-old Ohno to dance in high heels, a velvet dress, red lipstick and a 'crumpled pink hat' in *Admiring La Argentina* (Midgelow 2007: 178).

And indeed, just as Hijikata's interest in becoming-animal is offset by his apparent indifference to animal suffering (as we shall see), we should also note that his relationships with female butoh dancers such as Ashikawa and Takai remained patriarchal in many ways. Takai, for example, describes how

'she and Ashikawa were expected not only to dance but also to cook and clean' while they were working at Hijikata's studio (Holledge and Tompkins 2000: 145). Hijikata's particular interest in the female body also betrays some of the romanticization that we will also find in Deleuze and Guattari's rightfully controversial concept of becoming-woman. For example, Hijikata is said to have described men as 'prisoners of the logical world', in contrast to women who are 'born with the ability to experience the illogical part of reality and are consequently capable of incarnating the illogical side of dance' (Hijikata in Holledge and Tompkins 2000: 139). There is much more to say here, of course, but given our chosen focus, I now need to move on to provide some further introduction to the notion of becoming-animal before we explore its relationship to the animal dimensions of Hijikata's work.

What is (not) becoming-animal?

Deleuze and Guattari first introduce the concept of 'becoming-animal' in *Kafka*, developing it further in the later texts *A Thousand Plateaus* and *What is Philosophy?* among others. Often referenced in Performance Studies, but arguably too often ill defined, 'becoming-animal' is based on a, still radical (at least in Western discourse), affirmation of the continuity between human and nonhuman animals. Becomings, in the context of experience, concern the undoing of autonomous subjectivity and affirming the immanence of an 'other' within oneself; in becoming one 'finds oneself before another who ends up being *in* oneself' (Lawlor 2008: n.p., emphasis added). That is, whereas it remains commonplace, in both Western performance and philosophy, to hear that the human transcends all other nonhuman animals (whether on the basis of consciousness or language), Deleuze and Guattari quote René Scherer and Guy Hocquenghem's argument that 'it [is] impossible to say where the boundary between the human and animal lies' (Deleuze and Guattari 1988: 273). There is no ontological basis from which to insist on a qualitative distinction between human and nonhuman, Deleuze and Guattari contend; the human does not occupy a special realm of Being that transcends that of other animals.

Indeed, as Alain Beaulieu has noted, we might even say that 'Deleuze grants nonhuman animals a privilege over humans', insofar as humans are called on to learn from the animal's attention to the affective properties of its environment (Beaulieu 2011: 71). That is, as Nicole Shukin has also discussed, 'animals appear as focal figures of immanent life' in Deleuze; it is only human animals who tend to see themselves and other animals in terms of fixed, molar identities (Shukin 2009: 29). Unlike the human subject, the animal does not attempt to master its natural environment from a transcendent position, but remains open to its alteration by that environment, including by other living organisms. In this sense, the example of the mutually metamorphic relationship between the wasp and the orchid is

only a particularly visible instance of a more general tendency.[56] Indeed, in this sense, as Beaulieu indicates, it is clear that 'the human has no privilege over becomings-animal' (Beaulieu 2011: 78).

In *Kafka*, Deleuze and Guattari say:

> To become animal is to participate in movement ... to cross a threshold ... to find a world of pure intensities where all forms come undone, as do all the significations, signifiers, and signifieds, to the benefit of an unformed matter. (Deleuze and Guattari 1986: 13)

Becoming-animal involves an escape or flight from a restricted mode of existence, but not necessarily in terms of a literal movement in space, which Deleuze and Guattari warn can all too often be 'a movement of false liberty' (Deleuze and Guattari 1986).[57] Becoming is not dependent on this restriction, though, as transgression is said to relate to the law. Becomings are always already going on, we just tend not to attend to them.

In this way, we might note how the articulation of the lived experience of becoming-animal resonates with the experiences that we have already discussed in terms of destratification and in relation to making oneself a body without organs. However, whereas these articulations remained focused on affirming the difference within ourselves, the notion of becoming-animal reminds us that the experience of immanence happens within a world populated by nonhuman bodies, which present the opportunity for all kinds of other creative encounters (we will come to the potential opportunism of this idea in due course). Just as Deleuze and Guattari refuse the notion of a transcendent 'Other' who remains irrevocably distinct from a similarly autonomous self, they also argue against any notion of the human as an ontologically privileged species of animal, of the human defined as a purely rational and representational animal. Indeed, they reject any hierarchy within the nonhuman animal kingdom itself, arguing that 'animals, mice, dogs, apes, cockroaches are distinguished only by this or that threshold, this or that vibration' (Deleuze and Guattari 1986: 13).

Throughout their work, they argue that becoming-animal is irreducible to imitation, mimesis, mimicry (*mimétisme*) or metaphor.[58] It is not simply a fantasy or something that happens in the imagination, nor is it some kind of hallucination or pathological symptom. When it appears in literature – such as Kafka's *Metamorphosis* – becoming-animal is not a metaphor. When it appears in nature, it is not adequately described by the concept of mimicry. Becoming-animal is not about identifying with our little pet cat or dog, but nor is it a magical or supernatural claim that I can literally turn into a rat or a wolf. Finally, and most famously, Deleuze and Guattari insist that becoming-animal is not imitation – it does not involve trying to look like or act like an animal. It is not merely pretending. Becoming-horse, for instance, 'is not a question of imitating a horse, "playing horse", identifying

with one, or even experiencing feelings of sympathy or pity' (Deleuze and Guattari 1988: 258). And in each case, these negative definitions constitute an opportunity for Deleuze and Guattari to provide a critique of an existing discourse; for instance, of the treatment of case studies involving the figure of the animal by psychoanalysis. In this sense, we might suggest that the force of the oppositions on which Deleuze and Guattari insist – such as 'becoming is never imitating' – are more a question of strategic polemic than of ontological accuracy (and hence the caveats by which they are often accompanied).

That Deleuze and Guattari place a particular focus on wolves, rats and horses in their discussion of becoming-animal is not a coincidence. Rather, as Beaulieu notes, Deleuze and Guattari seek to recuperate these animals from their association with three of Freud's famous case studies: his 'analysis of the Wolf Man's neurotic childhood dreams, the Rat Man's obsessive thoughts, and Little Hans' phobic relations to horses' (Beaulieu 2011: 72).[59] In particular, they offer the concept of becoming-animal as an alternative way to understand these kinds of cases, in contrast to the familial interpretations of them by Freudian psychoanalysis and their relegation by Jung to the realm of imagination, dream and fantasy. Beaulieu continues:

> For Freud, wolves, rats, and horses all have a familial and personal symbolic value as he identifies them with family members, the primal scene, and personal sexual drive. Furthermore, Freud is convinced that the recognition of these animal figures as familial characters is the first step towards accomplishing the goal of resolving Oedipal conflicts. (Beaulieu 2011: 72)

In contrast, Deleuze and Guattari argue that Little Hans, for example, was engaged in a 'becoming-horse' that has nothing to do with the familial context (Deleuze and Guattari 1988: 259) but rather with his 'own desubjectivation'. Little Hans is 'becoming horse (not literally ... not analogously, or metaphorically, but concretely), thus creating a new mode of substance, a man-horse, which has left both man and horse behind, and is reducible to neither' (de Beistegui 2010: 149). As such, Miguel de Beistegui argues that it would be 'a grave mistake' to think of becoming-animal 'in terms of a transformation', rather than a deformation, because 'the movement of deformation is not from one form to another, but from the organised, stable body to the disorganised, fragmented body' (de Beistegui 2010: 186). The notion of transformation, he suggests, withholds a sense of idealism in contrast to the emphasis on the reality of sensation that lies at the heart of becoming-animal. Like the productions of desire and delirium discussed in *Anti-Oedipus*, 'however false' becomings-animal might appear from an external perspective, they are also 'utterly real to the person experiencing them'.

Furthermore, this is not to say that these becomings are merely *real to me*, in some kind of imaginative or psychic sense, rather than 'really real'. As Ian Buchanan has described, Deleuze and Guattari 'reject the idea that superstitions, hallucinations and fantasies belong only to the realm of "psychic reality" as Kant would have it' (Buchanan 2011: 15–16).

Secondly, following their critique of psychoanalysis, Deleuze and Guattari suggest that literary criticism has made the mistake of interpreting authors' allusions to human–animal encounters as metaphors. In the case of *Metamorphosis*, for instance, they argue that Kafka 'deliberately kills all metaphor'; or, better, makes clear the way in which metaphor is also metamorphosis too, the way in which language always acts on and differentiates bodies, insofar as words are bodies too. For instance, as Walter Sokel has discussed, the German word *Ungeziefer* (meaning vermin) is applied to 'persons low and contemptible' as well as to unwanted animals and insects. In turn, as Sokel notes,

The travelling salesman Gregor Samsa in Kafka's *Metamorphosis*, is like a cockroach because of his spineless and abject behavior and parasitic wishes. However, Kafka drops the word 'like' and has the metaphor become reality when Gregor Samsa wakes up finding himself turned into a giant vermin. (Sokel 1966: 5)

Likewise, Deleuze and Guattari argue that their concept of becoming-animal is not a metaphor, but a metamorphosis that serves 'to invent new forces' (Deleuze and Parnet 2007: 5). Indeed, they insist:

Metamorphosis is the contrary of metaphor. There is no longer any proper sense or figurative sense, but only a distribution of states that is part of the range of the word. The thing and other things are no longer anything but intensities overrun by deterritorialized sound or words that are following their line of escape. (Deleuze and Guattari 1986: 22)

Thirdly, Deleuze and Guattari also argue that the biological term mimicry 'is a very bad concept', insofar as it allows the reduction of instances of becoming in nature to forms of signifying reproduction. In contrast, they argue that the chameleon, for example, does not *reproduce* 'the colours of its surroundings' in a manner that maintains the sense of chameleon and world as discrete entities.

As we have already seen, Deleuze and Guattari argue that 'Becoming is never imitating' (Deleuze and Guattari 1988: 305); it is a creation of the new rather than a repetition of the same. In this sense, Deleuze's philosophy of difference is 'essentially anti-mimetic' (Bogue 1991: 77); it is defined by its attempt to overturn Platonism, as *the* philosophical tradition associated with subordination of difference to identity, and with the failure to conceive

difference-in-itself as anything but a mere deviation from the same. Here, then, the term 'mimesis' (and indeed the term 'mimicry') tends to be associated with the Platonic demotion of imitation, as the production of an impoverished copy of a fixed and self-present original.

> To become is never to imitate, nor to conform oneself to a model, whether it be of justice or of truth. There is no term from which one departs, nor one to which one arrives or should arrive. Nor are there two terms which are interchangeable ... Because as someone becomes, what he becomes changes as much as he does. (Deleuze and Parnet 2007: 2)

Commentators suggest that Deleuze's rejection of the association of imitation with becoming-animal is a manifestation of his critique of mimesis as an understanding of art, and indeed thought and ethics, per se. For example, Anthony Uhlmann argues that, for Deleuze,

> art does not imitate, it creates; ethics involves living in accordance with one's nature, rather than imitating rules of behavior; philosophy involves engaging with that power of thought which opens up possibilities which are coming into being, rather than describing forms or categories that seek to fix meaning or being. (Uhlmann 2011: 155)

Correlatively, both Hijikata and Marcus Coates have expressed an interest in the strategies that artists might employ to 'overcome mimicry' and enter becoming (Coates in Aloi 2007: 19). For instance, Max Andrews argues that 'Coates' work studiously avoids metaphorical allusions' often assigned to particular animals 'by focussing instead on *behaviour*, most conspicuously its explorations of birdsong' (Andrews 2009: n.p.). Rather than generating images of what Deleuze and Guattari call 'State animals' or, more accurately, treating the animal in a State manner (the eagle as the symbol of imperial strength), Coates focuses on what nonhuman animal bodies *can do*.[60] Likewise, in a 1968 interview, Hijikata had already emphasized the distinction between imitation and becoming in relation to the animal. In the process of performing a butoh dance work, Hijikata states:

HIJIKATA: ... I don't merely imitate the animal. What I want are the movements an animal shows to a child, not the ones it shows to an adult. Take a dog, for instance. How it moves when playing with a child is totally unlike how it moves when playing with grown-ups like us. To get to that point you've got to become a single piece of bone.

SHIBUSAWA: That's a fundamental desire for transformation.

HIJIKATA: That's it. Besides, I've often had the experience of becoming other than myself. (Shibusawa and Hijikata 2000: 53–4)

Rephrased, we might say that Hijikata's creation of movement is explicitly caused by an affective encounter with a dog's way of moving, rather than by treating the dog as an object of recognition (like the stereotypical picture that I might conjure up when I want to pretend to be a dog). *What is a dog?* Hijikata replies: the dog *is* how it can move and, in particular, it *is* how it can move (differently) in connection with a child's body. Hijikata then seems to ask: *what do I need to do to 'get to that point' where my body can do what the dog's body can do; how do I 'enter into composition' with the affects of the dog as it encounters the child?* Deleuze and Guattari's suggestion is that affect might be achieved, and imitation avoided, by the inclusion of an 'aggregate' in the encounter: a third body added to you and the dog, like the shoes that Vladimir Slepian's character puts on his hands or the iron that the performer Lolito chews in their efforts to encounter dog affects (Deleuze and Guattari 1988: 258-9, 274). And perhaps for Hijikata it is the image of the body as 'a single piece of bone' that serves this aggregate function – an image that, in its seeming impossibility, resists reproduction (I cannot really become a bone) and invites affective experiment (can I enter into a becoming-dog if I use the image of my body as a bone as the stimulus for inventing movement?).

When we hear these accounts of what becoming-animal is not, we might be reminded of Michael Taussig's argument that 'mimesis has become that dreaded, absurd, and merely tiresome Other, that necessary strawman against whose feeble pretensions poststructuralists pace and strut' (Taussig in Murray 1997: 6). However, in what follows I will insist that becoming-animal is not simply opposed to mimesis, imitation, metaphor or mimicry. Neither Deleuze and Guattari, nor Hijikata and Coates, straightforwardly reject imitation; rather, each tries to invent an immanent approach to mimesis, to conduct imitation on the assumption that each one is already several and to enter into becomings-animal in ways that affirm the continuity of human and nonhuman animals. Nevertheless, this still leaves the question of why it is that some things *appear* to be imitating rather than becoming others; how the technology that Coates uses, for instance, seems to be able to reproduce the real – to really capture a record of birdsong – rather than affecting and being affected by that which it copies. Correlatively, we might note that although animal mimicry (of humans or other nonhuman animals) may appear to *us* to constitute dumb copying or the mere following of instinct, it may appear otherwise from another (nonhuman) point of view. We will return to these important questions shortly, but first I want to expand on the context for Deleuze's critique of mimesis, before going into greater depth regarding the relationship between imitation and becoming-animal, with specific reference to Hijikata and Coates's practice.

Immanent mimesis

So rather than reinforcing an opposition of becoming and mimesis, or of becoming-animal and imitation, we might do better to think in terms of

'immanent mimesis' or an immanent approach to imitation.[61] As Timothy Murray has discussed, we can trace an aspect of the history of the concept of mimesis back to Ancient Greek texts on aesthetics such as Plato's *Republic* and Aristotle's *Poetics* (Murray 1997: 1). As is well known, Plato 'turned to mimesis to explain the inferior status of the artistic imitation of "essence"' (Murray 1997: 1); the mimetic arts of painting or poetry are 'thrice removed' from the realm of ideal forms, he argues, since they only copy the *appearance* of things in the world, which are themselves copies of a more fundamental reality elsewhere (Plato 1991: 584).[62] The imitator, Plato says, 'is a long way off the truth'; the poet appears to many to know about things as they are, but this knowledge is deceptive (Plato 1991: 583). As such, Plato famously goes as far as to ask, 'Should all imitation be prohibited?' (Plato 1991: 167).

However, Plato does not simply reject mimesis understood as imitation. Even within the *Republic*, imitation is assigned special powers at the same time as it is renounced. For instance, Plato argues that neither actors nor those performing in political roles should 'depict or be skillful at imitating any kind of illiberality or baseness, lest from imitation *they should come to be what they imitate*' (Plato 1991: 96). All too easily, Plato warns, imitations can 'grow into habits, and become a second nature, affecting body, voice and mind' (Plato 1991: 96). Better that the poets use a narrative rather than imitative style to portray 'unworthy' characters in order to keep a safe distance from imitation's powerfully contagious properties (Plato 1991: 97). Likewise, Plato describes how the citizens of the Republic will send away these 'pantonimic gentlemen, who ... can imitate anything', but not before they have fallen down and worshipped them for their extraordinary abilities (Plato 1991: 99). Famously, of course, Plato was critical of imitations produced by artists, but not, Puchner argues, because he was against mimesis per se or, indeed, theatre per se as 'the most mimetic of the arts' (which would not make sense given his own embrace of dramatic form). Rather, what Plato was against, Puchner states, was any form of mimesis that was not 'driven by a genuine ... desire for truth' (Puchner 2010: 32).

In the same way, it seems misleading to suggest that Aristotle understands art to have a merely 'substitutive or vicarious relation to reality' (Murray 1997: 10). As Murray suggests, Aristotle did 'recast mimesis in a positive light to account for the successful poetic representation of "ideal reality"' (Murray 1997: 1). The *Poetics* does argue that imitation offers poets and painters the chance to improve on the faults and flaws of physical reality. But in doing so, Aristotle proposes that artists should not merely reproduce the world, but employ the powers of the imagination to create fictions without model, to plot dramatic actions that go beyond their points of reference insofar as they touch on the universal rather than the particular. Poetry is differentiated from history, likewise, since it is not concerned with the representation of the past, so much as with 'the horizon of the possible' (Gebauer

and Wulf 1995: 54). In dissociating mimesis from referentiality, Aristotle also attempts to ally the arts and nature; in a manner that, as we shall see, can also be found in Deleuze. 'Art imitates nature' (*he techne mimeitai ten physin*), Aristotle famously argued, but not in the sense of copying its forms; rather, art imitates nature because it creates, it produces 'by means of the same force as nature' (Gebauer and Wulf 1995: 55).

At the same time, though, one could argue that any complete disassociation of becoming from imitation is somewhat misleading, both ontologically and from the perspective of performance practice. What is more important is that we note Deleuze and Guattari's refusal of any being/mimesis opposition: 'We fall into a false alternative if we say that you either imitate or you are' (Deleuze and Guattari 1988: 238). In contrast to such dualism, they offer a thoroughly processual ontology in which self-sameness and difference might be construed as tendencies or different speeds of movement, rather than as two discrete and fixed states. As such, all actual activities – including performance – can be understood as varying mixtures of both tendencies, operating along a kind of continuum, with some tending further towards mimesis (at times) and others, like Hijikata's and Coates's here, tending towards becoming (Mullarkey 2006: 23).

In turn, in practice, this becoming-animal may well begin with some kind of imitation, albeit one that leaves neither imitator nor imitated untouched. Both Hijikata Tatsumi and Marcus Coates do imitate animals, after all; but perhaps, as Deleuze and Guattari say of the becomings-animal of Kafka's characters, 'the imitation is only superficial' – a reproduction underwritten by a more fundamental production or creation of an intensive experience (Deleuze and Guattari 1986: 13). Or again, they argue:

> You become animal only molecularly. You do not become a barking molar dog, but by barking, *if it is done with enough feeling, with enough necessity and composition,* you emit a molecular dog. (Deleuze and Guattari 1988: 275)

The critique of imitation, in other words, concerns the imitation of the animal as defined as an organism (as a fixed form viewed from a position of subjective detachment) rather than as a set of relations, a field of forces or a complex of powers to affect and be affected. Indeed, Deleuze and Guattari suggest that the artist will be affected and transformed by the encounter with the animal whether or not this is something they intend; we *cannot* simply imitate or repeat, even if we try. Affect reveals that the real *qua* ceaseless becomings is immanent to what appears as imitation:

> Imitation self-destructs, since the imitator unknowingly enters into a becoming that conjugates with the unknowing becoming of that which he or she imitates. (Deleuze and Guattari 1988: 304–5)

And clearly, both Hijikata and Coates adopt imitation as a practical strategy, as the starting point for becoming-animal. For instance, in recalling his childhood, Hijikata writes:

> Because this was the kind of boyhood I had, and because there was nothing else to play at, like a thief I studied the gestures and manners of the neighborhood aunties, my mom and dad, and of course all my other family members. Then I put them all inside my body. Take the neighbor's dog, for instance. Fragmented within my body, its movements and actions became floating rafts. But sometimes these rafts get together and say something, there inside my body. (Hijikata in Hijikata and Kurihara, 2000: 76)

The human body learns to move differently through an encounter with animal affects, the gestural relation of the dog to its world is stolen but clearly metamorphosed into something new, that is neither 'dog' nor 'boy' (indeed, Hijikata also links his dance practice to the experience of the wolf boy of Avignon, made famous by the 1969 François Truffaut film *The Wild Child*).[63] By focusing on movement – as a key aspect of *what a body can do* – Hijikata's imitation resonates with Deleuze and Guattari's positioning of the animal as a verb rather than a noun: 'The wolf is not fundamentally a characteristic or a certain number of characteristics; it is a wolfing. The louse is a lousing, and so on' (Deleuze and Guattari 1988: 239).

But how can we tell whether this imitation of the dog is a 'good' imitation; what makes an action tend more towards mimesis, at one pole, or becoming, at the other? Or again, how can we differentiate between those theatres that tend more towards the immanence of the human and nonhuman, and those that tend towards their transcendence? In the first instance, we might draw from Deleuze and Guattari to say that it has to do with extent to which the imitation succeeds in positioning itself on the molecular rather than molar level. Imitating the molar dog by copying its bark might start off as a bad imitation, Deleuze and Guattari tell us, but it can tend more towards becoming '*if it is done with enough feeling, with enough necessity and composition*' (Deleuze and Guattari 1988: 275). But what does this mean?

As you might recall, we noted earlier that Deleuze and Guattari conceive of becoming as a process of *entering into composition with* the affects of another body. All encounters between bodies involve a 'composition of relations', but Deleuze makes clear that these meetings are characterized by more or less 'agreement' and 'disagreement', greater degrees of composition or destruction (Deleuze 1978: n.p.). As such, we might suggest that becomings are at their best when they compose a new and 'more powerful body' rather than destroying either of the other bodies involved (Deleuze and Guattari 1988: 275). According to an immanent ethics of composition,

no matter how empowering an encounter might be for a human body, if it involves destroying a nonhuman animal, then it is to be less valued than a becoming that empowers both equally.

From a bad becoming to *butoh-fu*

As we noted at the start of this chapter, the best-known appearance of animals in Hijikata's work (and one that would appear to challenge an account of his practice as informed by a belief in the immanence of human and nonhuman) is in *Kinjiki* – the controversial performance that is said to have marked the start of butoh. As Baird has recently outlined, there are only three solid sources of information on the performance: accounts from the dancer Ôno Yoshito and the dance critic Gôda Nario, and the photographs included in Baird's own book. Loosely based on the novel by Mishima Yukio (1951) and on Hijikata's readings of Jean Genet, Baird describes the basic plotline of Kinjiki as follows: 'man meets boy, gives boy chicken, supervises boy killing chicken, sodomizes boy, someone comes back for the chicken' (Baird 2012: 23). And from Baird's description, it seems that Hijikata was largely unconcerned with the welfare of the chicken in the performance – insofar as the boy (played by Yoshito Ohno) 'scissored the chicken between his legs and sank to the ground suffocating it' (Baird 2012: 20). Likewise, in the first act of *Revolt of the Flesh*, Hijikata is said to have

> emerged wearing a white bridal kimono (worn backwards). He was carried in a wooden container supported by several men who were followed by two noisy terrified animals: a pig in a baby crib and a rabbit on a metal platter held precariously on the end of a pole. This surreal train weaved its way through the audience, thus symbolically throwing the viewer into Hijikata's universe of confusion ... The final act climaxed with Hijikata tearing off a rooster's head with his bare hands. (Moore 2006: 47)

For Hijikata to endorse and repeatedly inflict suffering on animals seems to run counter to the respectful attitude to the animal that he articulates elsewhere. For instance, Hijikata wrote:

> For days I slept holding a chicken and taking care not to eat it ... I slept with the chicken the night before my performance with other new dancers. This chicken which laid an egg in the green room played a vital part in my initiation into love ... Over and over I apologized to the chicken I held while dancing. (Hijikata 2000: 39)

At the very least, here Hijikata seems to demonstrate an awareness of the differences and tensions between his own aims and desires in relation to

the performance and the experience of his nonhuman collaborator. The chicken may play a 'vital part' in Hijikata's desire to be initiated into a more respectful cohabitation of human and nonhuman animals, but what part did Hijikata play for the chicken? How can he experience the proximity of the human and nonhuman if he still has to 'take care' not to see the chicken as meat rather than as a living, affected and affecting body?

But no doubt, some commentators would argue that any response to the performance grounded in a culturally specific notion of 'animal welfare' is merely another attempt to impose Western values onto others as if they were universals. In contrast, Gôda interprets the presence of the chicken in *Kinjiki* in the light of Hijikata's rural childhood 'in which killing a chicken would portend a feast' and goes on to suggest that 'the chicken is a symbol of love' in the performance (Baird 2012: 27–8). Alternatively, Jean Viala and Nourit Masson-Sekine contend that 'the suffocation of the chicken between the legs is a symbolic representation of the actual sexual act' (cited in Baird 2012: 28). Fraleigh and Nakamura argue that Hijikata's 'pre-occupation with chickens and animal imagery per se is emblematic of his search for identity in the midst of the spiritual crisis of Japan after the war' (Fraleigh and Nakamura 2006: 79).

The most convincing of these interpretations, however, is the one provided by Baird, in which he surmises that the chicken 'is payment for a sexual transaction' that represents the Young Man's desperation – he is 'so hungry that he will do anything to eat', including allowing himself to be sodomized. In this sense then, Baird proposes, the chicken is part of a broader narrative that concerns 'unequal relationships', including those between humans and animals, as well as rich and poor, old and young and so forth (Baird 2012: 28). The death of the chicken, Baird suggests, is 'a kind of by-product of unequal social forces', the consequences of which Hijikata mourns. Indeed, Baird claims that the collection of the chicken at the end of the performance was 'accompanied by blues played on the harmonica' in a manner that allowed the performance's ending to include 'a kind of acknowledgement of the real costs of an unequal interaction ... an apology or a manifestation of an unwillingness to let the seemingly dead chicken lie there unmourned' (Baird 2012: 31). In each case, though, these readings of *Kinjiki* (and apparently the performances of *Kinjiki* themselves) reduce the living animal to a symbol.

Beyond imitation and the on-stage use of real animals (living, dying and dead), from 1970 onwards Hijikata also developed the approach to movement creation known as 'butoh-fu'. Sometimes referred to as 'notation', the *fu* in butoh-fu might be literally translated as chronicle, notes or score (Fraleigh and Nakamura 2006: 55). '*Butoh-fu* can be described most basically ... as visual/poetic images used as the basis for butoh movement and gestures' (Fraleigh and Nakamura 2006: 54). Again, though, it is not that images are to be imitated, Fraleigh and Nakamura suggest; rather, butoh-fu can

be understood as an experiment in 'becoming an image' (Fraleigh and Nakamura 2006: 55). And a great many of these images invite performers to become animal images, such as in the improvisational processes that Hijikata called 'bug ambulation' (Fraleigh and Nakamura 2006: 19). As a specific instance of butoh-fu, bug ambulation

> sets in process an existential experience of eating and being eaten – one bug morphs into millions moving in the tree outside the body (the dance) – and inside the body (the dance) – itching the flesh – eating the flesh – eating consciousness – until only consciousness remains. (Fraleigh and Nakamura 2005: 55)

Another butoh-fu was based on the image of a chicken – perhaps the animal to feature most frequently in Hijikata's work. As Ojima Ichiro explains:

> The idea was to push out all of the human inside and let the bird take its place. You may start by imitating, but imitation is not your final goal; when you believe you are thinking completely like a chicken, you have succeeded. (in Holledge and Tompkins 2000: 199n)

Affect as duration: Coates and the relativity of human perception

Like Nicole Shukin, I would argue that becoming-animal cannot 'be understood without understanding the role that affect plays in the work of Deleuze and Guattari' (Shukin 2009: 30). For Deleuze, becomings, including becomings-animal (but also becoming-woman, becoming-minor, becoming-imperceptible), involve affects. Indeed, he says that affects are 'becomings that spill over beyond whoever lives through them (thereby becoming someone else)' (Deleuze 1995: 137). In this sense, affect is a contagious and excessive (though not transcendent) kind of force; another name for that which disorganizes subjects and destratifies voices in the manner articulated in Chapters 1 and 2. Affect is not synonymous with human emotion, for Deleuze and Guattari; rather, it 'crosses species boundaries that are normally ontologically policed' (Deleuze 1995: 31), passing between bodies of differing species and drawing them into 'unnatural participations' and 'unholy alliances' (Deleuze and Guattari 1988: 241).

As we noted in the Introduction to this book, Deleuze and Guattari draw from Spinoza in defining affect as *what a body can do*, what is in its power or what it is capable of in relation to other bodies (Deleuze and Guattari 1988: 256–7). However, the affects or powers of a body are not fixed for Deleuze; rather, they are constantly increasing and decreasing depending on to what extent the other bodies we encounter 'agree' or 'disagree' with us, to what extent they bring us 'joy' or 'sadness'. *What I can do* is extended or expanded

when I encounter a body that brings me joy; joy is not an emotion, it is an increase of my power to act and an extension of *what I can do*. As Deleuze puts it, 'the affects of joy are like a springboard, they make us pass through something that we would never have been able to pass if there had only been sadnesses' (Deleuze 1978: n.p.).

In turn, just as the affects of any given body are always varying, it is also the case that those affects or encounters that produce relatively joyful or sad affects will be different for every body. There cannot be one evaluation of a body as good or bad that stands for all. The heat of the sun, for example, affects my body in a more enabling, joyful fashion than it does a photosensitive body; likewise, Deleuze notes, 'a fly will perceive the sun in another fashion'. Affect is not just a category of human experience, in Deleuze. And what is good for me, or for humans, is not 'inevitably good' for others, including non-human animals (Deleuze 1978). Given this objection to the imposition of any transcendent or universal value of 'the good', Deleuze and Guattari also embrace Spinoza's unconventional definition of ethics as an affect-oriented study of bodies. Breaking away from the conventional definition of ethics as 'systematizing, defending, and recommending concepts of right and wrong behaviour' (Fieser 2006: n.p.), they join Spinoza in insisting that a body should be defined by and studied according to its affects *qua* what it can do, rather than 'by its organs and functions' or 'Species or Genus characteristics' (Deleuze and Guattari 1988: 257).

Affect, *qua* becoming, is accorded ontological primacy in Deleuze. Becoming (or relationality) comes first and is not dependent on a fixed identity or 'thing' that becomes; likewise, then, affect has its own reality that comes prior to and produces affected bodies. Secondly, the equation of affect and becoming helps us to secure affect as an *immanent* rather than transcendent phenomenon. That is, the idea of affect as an excess that goes beyond the subject and as an external projectile coming from the 'outside' that we invoked above (not to mention Massumi's emphasis on 'the autonomy of affect') might mislead us into thinking that affect is somehow an other-worldly event. But understanding affect as becoming makes clear that this is not the case. Becoming is not product or goal oriented, constantly aiming to arrive at some imagined end-point; rather, Deleuze and Guattari insist that 'becoming produces nothing other than itself' (Deleuze and Guattari 1988: 238) or, again, that 'there is nothing outside of becoming to become' (Mullarkey 2012: n.p.). Likewise, through the exposition of specific affects such as becoming-animal, it is evident that affect *is* accessible to thought and experience, albeit not to conscious thought or recognition.

And it is this ontological status of affect or becoming that allows Deleuze and Guattari to maintain that becoming-animal 'does not occur in the imagination', arguing instead that we would do better to question the reality of the 'supposedly fixed terms through which that which becomes

passes' (Deleuze and Guattari 1988: 238): terms such as 'human' and 'animal' and the discrete categories of being that such terms are understood to describe according to transcendent ways of thinking. They clarify that 'If becoming animal does not consist in playing animal or imitating an animal, it is [also] clear that the human being does not "really" become an animal any more than the animal "really" becomes something else'. But this is not to say that becoming-animal is metaphorical (as Marla Carlson suggests); rather, 'what is real is the becoming itself', the process. Marcus Coates does not become 'a bird' in any fixed or 'molar' image of that animal, but there is, nevertheless, 'a reality of becoming-animal' (Deleuze and Guattari 1988: 273), in terms of the affective experiences of the bodies that express it. Understood as affect, becoming-animal is a real experience of relationality that occurs within a 'zone of exchange between man and animal in which something of one passes into the other' (Deleuze and Guattari 1994: 109). In these ways, the concepts of both affect and becoming are central to Deleuze and Guattari's responses to the mind–body problem; neither affect nor becoming involves dematerialized thought (as Peter Hallward might have us believe) or thoughtless materiality. As such, it is misleading to construe becoming-animal as 'a politically strategic *mental* operation, a way to *imagine*' alternative ways of being (Carlson 2011: 206, emphasis added). Becoming-animal is not about thinking ourselves out of our humanness; or, at least, this is not the case if by 'thinking' we mean something distinct and separate from affect or embodied change, or as akin to some kind of representational 'seeing as'.

Rather, I would now like to suggest that we move furthest away from the pole of 'bad' imitation and towards 'good' affective becoming, when we approach becoming-animal as a specifically *durational* process, bearing in mind Henri Bergson's argument that there is not only one time (a simple 'Now' or singular present) but several; indeed, that there are as many presents as there are ways of living. From this perspective, the reality of affects such as becoming-animal is the reality of an encounter with the 'co-existence of very different "durations"', including nonhuman durations (Deleuze and Guattari 1988: 238). Different animals have different ways of being in time that produce what lies above and below their threshold of perception. Or, as Deleuze and Guattari put it, 'Doubtless, thresholds of perception are relative; there is always a threshold capable of grasping what eludes another: the eagle's eye' (Deleuze and Guattari 1988: 280). Likewise, perhaps it is this same awareness of the relativity of human perception that motivated Hijikata to argue that humans should 'learn to see things from the perspective of an animal, an insect, or even inanimate objects' in a manner that affirms a distinction between looking like an animal (to an outside observer) and trying to see the world from an animal point of view.

Coates's work goes a long way to foreground the relativity of human perception, experimenting with a variety of high- and low-tech prostheses that might serve to multiply our powers to sense other bodies. For instance, Coates often exhibits the 'functional tools' that he employs in his shamanist-inspired performances, such as his *Compound Lenses* (2010), a set of four ordinary pairs of prescription glasses taped together that remind us how simple it might be literally to see differently. Or again, for a 1999 photographic piece called *Goshawk (Self Portrait)*, Coates 'persuaded foresters to tie him to the top of a pine tree so that he could get close to the point of view of a hawk scanning the countryside for preys [sic]' (Aloi 2007: 19). In interviews, Coates recalls that at the time he made this work he was reading Thomas Nagel's famous 1974 essay 'What Is It Like to Be a Bat', which ultimately emphasizes the ineffability of an other animal's point of view. In response, Coates states:

A bat does not see like us or feel like us, it uses echolocation to find its prey and so on. I suppose my intuitive response to ... this is that although you may not enter an animal's consciousness there may be a degree of closeness that can allow us to leave behind our own consciousness in order to at least enter that of another animal. This mainly is the area that my work is concerned with. (Coates in Aloi 2007: 19)

In particular, though, Coates's descriptions of the process of making his 2007 video installation *Dawn Chorus* expose the key role that technology can play in both exposing the relative nature of human perception and extending or expanding that perception. For instance, having set up an elaborate microphone network to record a dawn chorus in a Northumberland wood, Coates describes how he and his collaborator – the sound recorder Geoff Sample – 'took the recording of bird songs back to the studio and slowed them down about 20 times' (Coates in Aloi 2007a: 20). Whereas, Coates notes, 'a bird song at normal speed could contain 4 or 5 notes' (or, we might say better, could appear to contain 4 or 5 notes to a human listener), 'slowed down it could reveal up to 40 notes offering a different level of complexity to the listener' (Aloi 2007a: 20). Thanks to a technological prosthesis, a moment of melody appears to contain 10 times more internal differentiation; what a human ear can hear (the affects of the ear as a body) is extended or intensified.

However, for Coates the key factor was that this deceleration also allowed the birdsong to 'come into the pitch range of the human voice' and, in turn, enabled human performers – mostly amateur singers in local choirs - to mimic this slowed-down song.[64] Critically, though, this process of productive repetition or becoming began with a casting process based on seeking out what we might call (after Deleuze and Guattari) 'zones of imperceptibility' between the human and bird performers; areas of affective overlap, that

Image 3 Eikoh Hosoe, *Kamaitachi #8* (1965). Courtesy of the artist

is, between what these human and nonhuman performing bodies *can do*. As Coates describes:

> We ... had to choose our singers according to the original range presented by the birds. So for a Robin we had to choose a young person that was able to go very high and very low. The robin really takes big breaths and does not breath for a long while so the person singing its song has to do the same. (Coates in Aloi 2007a: 20)

Having recorded the human performer singing, Coates then speeds up the film to what he calls 'the original bird speed', with the result that 'you get a very accurate human rendition of birdsong and coincidentally bird like

Image 4 Marcus Coates, *Goshawk (Self Portrait)* (1999). Courtesy of the artist and Workplace Gallery

movements' (Coates in Aloi 2007b: 33). As much as this film produces a contagious picture of 'becoming-animal', what is also of interest is the 'education of attention' that Coates's project offered its participants as well as subsequent gallery viewers. For example, as Coates has discussed in interview, each of the individual singers had to perform their song for 'up to 2 hours (resulting in 8 minutes when sped up)'. As Coates notes, 'the concentration and endurance required for mimicking the bird sounds over this period meant the singers could not mentally sustain a conscious interpretation, it became very instinctive' (Coates in Aloi 2007b: 34). This altered encounter with time is a key element in an experience of a genuinely alternative, embodied point of view; albeit one that is an expanded

human perspective rather than a bare repetition of what it is like to be a bird.

Theatre for animals or animal theatres?

So, a theatre of immanence might be one that is made *for* the animal (where the word 'for' will be given multiple senses, inspired by Deleuze). On the one hand, this might be a theatrical version of what Matthew Fuller has called 'art for animals', which is defined as 'art with animals intended as its key users or audience', or again, 'work that makes a direct address to the perceptual world of one or more non-human animal species' (Fuller 2007: n.p.). In this regard, Fuller is thinking of works such as Paul Perry's 1995 installation *Predator Mark*, a scent-based work addressed to the olfactory perception of the animal population of a forest in the Netherlands, but also of Coates's work – in particular the early video works, *Sparrowhawk Bait* (1999) and *Out of Season* (2000), as well as *Dawn Chorus*. In *Sparrowhawk Bait*, as Fuller describes:

> Coates makes himself the target for a predator. The corpses of: a Blackbird; a Blue Tit; a Mistle Thrush; a Grey Wagtail and a Green Finch are tied to his hair. He runs through the forest, with the anticipation that a local Sparrowhawk will be attracted by and pounce on the momentarily re-animated bodies. (Fuller 2007: n.p.)[65]

No Sparrowhawk comes and, as such, the work might remain on the now rather too familiar level of inviting the human audience to take pleasure in the failure of a (supposedly) deliberately absurd task. But by altering the speed of the video – by slowing it down – and accompanying the video with the amplified sound of slowed breathing, Coates alters the impression of the action for his human viewers. That is, even if the task of attracting the hawk fails, it might be understood to succeed at another level, insofar as Coates himself enters into a becoming with prey. Having occupied the perspective of the predator in *Goshawk (Self Portrait)*, Coates now attempts to see the forest from the point of view of those preyed on, desperately running from one hiding place to another in the hope of escaping capture.

Equally uncertain with regard to its degrees of success or failure is *Out of Season*, a video work for humans but also a live performance work for birds in which we see a 'lone male Chelsea football supporter chanting his repetitive songs, threatening curses and bragging in an idyllic woodland brimming with summer birdsong' (Andrews 2009: n.p.).[66] In an interview, Coates states that this work

> looked at one aspect of the scientific definition of the birdsong dawn chorus as a functional instinct to define territory. Male birds use song to defend and define territory – employing loud and aggressive melodic

Image 5 Marcus Coates, *Out of Season* (2000). Courtesy of the artist and Workplace Gallery

phrasing, repetition, improvisation and showing their colours to warn and signal their strength to other males and their virility to females – I saw an analogy in the use of song by football supporters. (Coates in Aloi 2007: 33)

Or again, as Fuller suggests, 'Taking the football chants to the forest, sets out ... an idea of how human communications may often be so similar in their territoriality to those of birds' (Fuller 2007: n.p.). But how might the work have been received by the birds themselves; how did they hear Coates's songs? Perhaps the football supporter did not sing for long enough – or, as we will see, with enough attention to the context – to move this action further towards the pole of becoming in a manner that would draw attention to the *nonfunctional* behavior of its nonhuman audience as much as 'setting out an idea' for its human one. After all, it is well known that birds incorporate the persistent sounds of their environment into their songs:

Birds in rural areas have added the sound of horses whinnying, lawn mowers and even chainsaws to their repertoires. In cities, birds have

added car alarms, the warning beep of a truck backing up and police sirens to their calls. (Charny 2001: n.p.)

Indeed, one could argue that we need to take greater care given the power of our actions wittingly or unwittingly to draw nonhuman animals into becomings, which can be more or less creative, more or less destructive. For instance, the birdsong applications recently developed by mobile phone companies to help wildlife photographers and bird-spotters to attract birds are said to have been heard by mating male birds as 'the sound of rival male birds invading their territory' causing the birds to leave their chicks 'unattended in their nests, vulnerable to attack from predators and without food, to see off the apparent threat' (Dolan 2011: n.p.).

Theatre for animals, in contrast, would share Fuller's emphasis on examining the multiplicity and complexity of perception and sensory experience. In this way, such work might be understood as 'for' the animal, and indeed for nature, not only in the direct sense that it seeks to address an animal audience. That is, as Fuller goes on to argue, these art works for animals

make art step outside of itself, and make us imagine a nature in which nature itself must be imagined, sensed and thought through. At a time when human practices are rendering the earth definitively *unheimlich* for an increasing number of species, abandoning the human as the sole user or producer of art is one perverse step towards doing so. (Fuller 2007: n.p.)

In other words, theatre for animals might also involve animal theatres – insofar as we are willing to extend the category of artists and theatre makers to include nonhuman animals, and to perceive inter-animal behavior as already its own kind of theatre rather than reducing it to the mere display of genetically determined behaviour. After all, why do we need artists like Coates and Hijikata to mediate between us and nonhuman animals? Could we argue that, despite their intentions, this very mediation serves to reintroduce a sense of separation between the human and animal realms? Does Coates's *Dawn Chorus*, for instance, do any more to induce a becoming-animal in us – its audience – than were we simply to go to the forest and listen to the dawn chorus ourselves? If, in other words, nonhuman and human animals are already and necessarily immanent, why commend Coates and Hijikata's work, or indeed any art in particular, in relation to other activities?

After all, much of Coates's own attitude has emerged as the result of his interest in and practical engagement with ornithology. It was through his study of birds that Coates learned of the blackcap bird who can sing '"in the style of" a robin ... A bit like a classical singer, singing an aria in the style of Frank Sinatra' (Coates in Aloi 2007: 33). Likewise, this study enabled him

to explore the instances when birds' vocalizations occupy a 'realm beyond obvious function':

> Some birds, for instance the American Blue Jay, sing in their sleep, some birds as we witnessed during the fieldwork embellished their songs with such complexity that we would struggle not to call it musical. (Coates in Aloi 2007: 33)

And yet, it seems clear that ornithology is no guarantee of immanence in itself; that is, it could equally lead to the damaging actions of the mobile phone users noted above, or indeed, according to the power/knowledge paradigm, it might lead us to assume that birds are identical to our knowledge of them, in a manner that reinforces the transcendence of the omniscient human.

There is a long legacy of philosophical thought that grounds this notion of human transcendence. Influentially, in the *Poetics*, Aristotle

> emphasizes the mimetic aptitude as an anthropological constant distinguishing human beings from other animals. It is innate and therefore manifest from early childhood on. The child begins learning through mimesis before becoming able to develop other forms of appropriating the world. (Gebauer and Wulf 1995: 53)

Centuries later, and despite its ethological origins, Lacan would argue for the uniqueness of the human developmental experience that he called 'the mirror stage': an event of identification, or 'the transformation that takes place in the subject when he assumes an image' and begins to structure himself as an 'I' (Lacan 2001: 1).[67] In turn, Lacan argues that it is this alienating gap between our embodied experience and our image that makes the human animal special insofar as it is 'capable of imagining himself as mortal' (Lacan 2001: 150). Furthermore, as Giovanni Aloi has recently noted, we find the residues of this transcendent thinking in more recent uses of art as the means to differentiate human and nonhuman. For instance, Aloi quotes from a 1996 text by art theorist Laurie Schneider Adams, who argues:

> Animals build only in nature, and their buildings are determined by nature. These include birds' nests, beehives, anthills, and beaver dams ... Such constructions are genetically programmed by the species that make them, and do not express individual and cultural ideas. (Adams in Aloi 2012: xviii)

Of course, as Aloi points out, much depends on our definition of art – which Adams tautologically defines in human terms (for instance in terms of 'conscious choice' and 'narrative ideas') in the first place. But such definitions

seem to exclude as much of the alternative nature of the process of human art (such as its unconscious dimensions) as they do nonhuman practices.

Conventionally, then, animal behaviour is interpreted as necessarily functional, habitual and biologically determined. Animal creativity is differentiated from aesthetic activity – for example, birdsong from music – with recourse to an opposition 'of the functional and the aesthetic, of activities that are purposive means and those that are self-sufficient ends' (Bogue 2003c: 70). In particular, as Matthew Potolsky notes, a recurring idea in the history of the theory of mimesis has been 'that humans can best be distinguished from animals by their facility with imitation' (Potolsky 2006: 160). Of course, this has not gone unnoticed by animal-oriented theatre and performance scholars, who have sought to nuance this opposition. Alan Read, for instance, at times appears to understand the difference between humans and animals as quantitative rather than qualitative, regarding the degree to which human and nonhuman animals can and do pretend.[68] Read says:

> *Homo sapiens* is *homo performans* because it can pretend. It is certainly not unique in this among other animals, bower-birds and stotting-gazelle, for instance, display gloriously and intelligently ... but the human is able to receive a remarkable variety of forms and faces upon its evacuated identity. The human is, as Elvis said ... the one who 'pretends too much'. (Read 2008: 93)

So Read acknowledges pretending itself as that which might produce a 'zone of proximity' between human and nonhuman animals. But this passage also invites us to think in terms of two different aspects of imitation as a tendency. On the one hand, we have the (more nonhuman) tendency in which some thing is 'like' another thing (an insect that looks like a leaf) less because it involves active pretending, and more because of a continuation of qualities. On the other, we have the (more human) tendency towards imitation as that which involves the intention to reproduce a model in the form of pretending to be something else. Here representation tends to intercede. But whereas the predominant discourse would value the latter over the former (conceiving the latter as more sophisticated, artistic and so forth), an immanent perspective finds greater value in the instances when imitation tends towards one body's continuation of another's movement, without tracing that movement according to a pre-existent image.

Indeed, Deleuze and Guattari imply that the more an activity tends towards this nonhuman mode of imitation, the closer it comes to genuine art. In *A Thousand Plateaus*, for instance, Deleuze and Guattari describe animals' marking of territory as 'art in its pure state'. Art 'begins with the animal', they suggest; 'at least with the animal that carves out a territory and constructs a house', since this marking of territory 'implies the emergence of

pure sensory qualities, of sensibilia that cease to be merely functional and become expressive features' (Deleuze and Guattari 1994: 183). In this way, Deleuze and Guattari avoid the separation of the realms of actuality and creativity, or art and Life, by 'turning art into a natural "living" process' (Zepke in Cull 2009a: 114), as likely to be performed by nonhuman animals – like the Australian rainforest bird, the *Scenopoetes dentirostris* or Stagemaker bird – as by human artists. Here, they call the Stagemaker 'a complete artist' (Deleuze and Guattari 1988: 184), approaching human art as but one part of the much wider phenomenon of 'organic creativity' in which all living beings might be said to 'have art' (Bogue 2003c: 65–9). Deleuze and Guattari's perspective realigns this relation between the functional and the aesthetic, suggesting that a work of art, such as birdsong, can both serve a purpose and have a life of its own:

Are there not ... musician birds and nonmusician birds? Is the bird's refrain necessarily territorial, or is it not already used for very subtle deterritorializations, for selective lines of flight? (Deleuze and Guattari 1988: 302)

Here, Deleuze and Guattari are echoing the words of the composer Olivier Messiaen, who also famously described birds as probably 'the greatest musicians existing on our planet' (Messiaen in Bogue 2003b: 28). Animals are artists too, insofar as they engage in their own processes of transformation, becoming and creating fictions.

Conclusion: The ethics of animal affects

Since at least 2003, Una Chaudhuri has been developing an articulation of *zooësis*, a term she coined, firstly, to designate a broad range of activities undertaken in a variety of modes at the intersection of performance and animal studies (Chaudhuri 2005: 103). Chaudhuri states that, for her, zooësis 'includes the myriad performative and semiotic elements involved in the vast range of *cultural animal practices*' (Chaudhuri 2005: 103, emphasis in original), including both literary and dramatic representations of animals, performances by animals and social practices involving animals. As such, plays like Edward Albee's *Zoo Story* constitute zooësis, but so does 'pet-keeping' and 'meat-eating' (Chaudhuri 2005: 104). However, it soon becomes clear that Chaudhuri has a particular understanding of *how* such activities operate when she concludes:

Comprising both our actual and imaginative interactions with non-human animals, zooësis is the *discourse of animality* in human life, and its effects permeate our social, psychological and material existence. (Chaudhuri 2005: 104, emphasis in original)

Activity has become discursive; zooësis may be anthropocentric or pro-animal, but it is always an 'ideological discourse'. In this sense, a distinction between Chaudhuri's and Deleuze's approaches, between zooësis and becoming-animal, becomes apparent; that is, where Chaudhuri seems primarily concerned with 'social construction and cultural meaning' and the role of animal practices in the production of discursive categories, Deleuze and Guattari affirm the nonhuman animal as that which permeates the human not only discursively, but affectively. Nevertheless, this should not be understood as some kind of naïve appeal to simple presence; the encounter between human and animal bodies is an instance of what I have described elsewhere as 'differential presence' (Cull 2009b). That is, Deleuze's position suggests that bodies (and what Chaudhuri calls 'activities' or 'practices') participate in other forms of differentiation that are irreducible to discourse. Bodies are not simply differentiated or changed by (and at the speed of) human discourses, but have their own processes of difference – *affect*.

Whether located in Deleuze, Hijikata or Coates, the political dimensions of becoming-animal lie in its resistance to an ontological distinction, and therefore any hierarchy between human and nonhuman animals. Furthermore, aspects of the work of both Hijikata and Coates acknowledge and respond to 'the need to open ourselves affectively to the actuality of others'; and, especially, to animal affects (Mullarkey 2004). Two ways of performing this opening, as I have tried to show, are to affirm the immanence of becoming to imitation; and to explore affect as a durational or temporal relation. And yet, as we noted at the start, Deleuze's thought does not have a straightforward relationship to animal affects. On the one hand, as John Protevi has argued, we could suggest that 'Deleuze's most basic philosophical instinct is against anthropomorphism' (Protevi 2005) and against the subordination of the world to consciousness and common sense. In turn, with respect to animal suffering, Deleuze's emphasis on affect invites us to break with the condescension of pity, in favour of 'unnatural participations' (Deleuze and Guattari 1988: 240): a 'strictly affective' relation concerning, not pity, but 'forces, or degrees of motion and rest' (Mullarkey 2012: n.p.).

Yet, on the other hand, we might remain suspicious as to how reciprocal becomings-animal really are, whether the affects of Hijikata's becoming-animal would always take priority, for Deleuze and Guattari, over the chicken's own affective experience (would it matter, for them, for instance, whether the chicken was killed or not?). And indeed, this is the critique that John Mullarkey has recently proposed, arguing that in a Deleuzian becoming-animal:

> what should be (at least) a two-sided process involving healthy, active becomings for all participants, invariably only profits the human ... There seems little place for the animal's own genuine 'becomings' in the

alter (animal)-side of a human becoming-animal. What of its or their 'becoming-human'? (Mullarkey 2012: n.p.)

Or is it that the human is deemed so 'molar', so much a tendency towards mastery, that 'there can be no "becoming-human"', just as Deleuze and Guattari argue that becomings are always minoritarian, always in the direction of the minority rather than the majority (Hallward 2010: 38)? As such, though, we might still attend to the nature of animals' own becomings, to the inter-animal becomings to which Deleuze and Guattari still pay relatively little attention.

Correlatively, we need to consider how we can prevent the experimental ethics of affect from becoming one that is indifferent to suffering, without going back to the reactive morality of *ressentiment*. Perhaps it is that becomings-animal through performance, particularly when they involve live animals, must be evaluated (rather than judged) according to the extent to which they increase or decrease the nonhuman animal's power of acting as much as the human's. That is, an ethico-political performance of becoming-animal must be one that empowers both nonhuman and human bodies to act at the limit of what they can do. We do need to open ourselves to the affects and durations of animals, but with the care and caution implied by the fact that we do not know what nonhuman bodies can do, nor how they can be affected by our experimental acts.

However, as Beaulieu has argued, 'becoming-animal is not a response to a moral indignation in the face of animal suffering, and in particular the suffering caused to non-human animals by human animals' (Beaulieu 2011: 83). An ethics based on suffering would come too close to the reactive force of pity for Deleuze and Guattari:

> The question is not to defend the rights of animals or plants, pity the beasts, or experience deep feelings for plants. Rather, it is to be worthy when confronted with the joy or suffering that all beings face, and to forge alliances with non-human beings. If there is a Deleuzo-Guattarian ethics of the environment, it is not an ethics of compassion in the face of suffering but rather an ethics through which one becomes worthy of the zone of proximity that happens, an ethics of solidarity with affects that seem to be the furthest from those simply produced by humans. (Beaulieu 2011)

Indeed, Deleuze and Guattari specifically want to move away from the language of pity. For example, in *What is Philosophy?* they state:

> We think and write for animals themselves. We become animal so that the animal becomes something else. The agony of a rat or the slaughter of a calf remains present in thought *not through pity* but as the zone of

exchange between man and animal in which something of one passes into the other. (Deleuze and Guattari 1994: 109, emphasis added)

However, direct physical violence is only one aspect of the problematic treatment of the animal by performance and philosophy. Less initially shocking but no less damaging in a longer-term sense, we might also cite the complicity of both spheres with the ongoing anthropomorphization of nonhuman animals. But one could argue that Deleuze and Guattari still encourage something of an exploitative relation to animals, and indeed to all so-called nonphilosophy. 'One does not think without becoming something else,' they argue in *What is Philosophy?*. However, they also argue that this something is '*something that does not think* – an animal, a molecule, a particle' (Deleuze and Guattari 1994: 42, emphasis added).

In relation both to Hijikata and to Coates, the question also arises as to what extent becoming-animal is something that can be made available in performance, to what degree a performer's becoming-animal might be contagious and extend to include an audience, including a nonhuman audience, in creative (rather than destructive) ways. What purpose can there be in staging such metamorphoses for others? How do becomings-animal affect those who observe them as audiences rather than participating in them themselves; indeed, are becomings observable at all? As Fraleigh and Nakamura discuss, 'Hijikata and Ohno identified their work as *dance experience* first of all', suggesting that dance experience approaches butoh as 'a personal experience not accessible through mere observation or interpretation. In this sense, butoh is a somatic study, since somatics is concerned primarily with first-person experience – how you perceive your body-self in changing states of being – not what others see' (Fraleigh and Nakamura 2006: 101). Now, while we will go further to question the basis for any qualitative distinction between observation and participation in the next chapter, it is worthwhile to introduce here the potential tension between becoming as process and becoming as performance. Does my entering into a becoming-animal necessarily invoke a becoming-animal in others? In *What is Philosophy?* Deleuze and Guattari argue that the role of artists is to stage affects as encounters that exceed 'those who undergo them'; they must invent affective works that 'make us become with them' (Deleuze and Guattari 1994: 175). In turn, we can say that the work of the performer is not to represent emotion or to represent other bodies in the world, but to devise a procedure to extract the affects of bodies, to somehow reconstruct in performance the power of another body to pierce us like an arrow, force us to think and enable us to act in new ways.

For his part, Beaulieu argues that becoming-animal

implies no integral change of identity that would make it impossible to recognize the one experiencing the metamorphosis. Indeed, all

becomings are molecular that is to say, imperceptible – though they escape molecular perception. (Beaulieu 2011: 75)

Becoming does not occur on the level of molar form, but on the level of embodied intensities and temporal variations, and hence it is not a question of us recognizing becoming-animal from the outside. However, I do not think that this is tantamount to saying that there can be no role for an audience with respect to becoming-animal. In the next chapter, we will move on to address the relationship between participation and observation in detail, arguing against any easy association of the former with guaranteed activity or of the latter with necessary passivity. In turn, it is important to note that, as Beaulieu suggests, 'becoming is not the effect of an intentional choice, of free will or of a voluntary act' (Beaulieu 2011: 75); all kinds of becomings have the uncontrollable and unpredictable quality of the encounter, forceful precisely to the extent that it takes us unawares. As Deleuze and Guattari say, 'We can be thrown into a becoming by anything at all, by the most unexpected, most insignificant of things' (Deleuze and Guattari 1988: 292).

As we noted at the outset of this chapter, Hijikata argued that humans should not only 'learn to see things from the perspective of an animal, [or] an insect', but that they should also acknowledge the perspective of 'an inanimate object', going on to argue that even the stones beneath our feet, 'the road trodden everyday is alive [so] … we should *value everything*' (Hijikata in Holledge and Tompkins 2000: 138, emphasis added). Performance should attend to the life of all things, Hijikata suggests, not only the life of human and nonhuman animals.

Even within Kafka, where the concept of becoming-animal first appears, Deleuze and Guattari cast doubt over its powers, drawing from texts like *The Metamorphosis* to note the capacity of becomings-animal to fail, to be defeated or, less dramatically simply, not to go far enough in terms of dismantling that which blocks the path to immanence. And again, in *A Thousand Plateaus*, Deleuze and Guattari seem to suggest a kind of developmental underpinning for becomings, such that becoming-animal is (problematically) presented as somehow more difficult or more advanced than becoming-woman or becoming-minor, and becoming-molecular or imperceptible as going further than becoming-animal. Indeed, this idea does seem to be primarily spatial: the thinking being that animals are closer to us in terms of their affects than molecules, while people classed as 'minorities' in relation to a majority are in greater proximity still and, hence, 'easier' to encounter. Clearly, we will not want to allow such a model to confer differing value on performance such that work involving encounters with non-animal materials like ice (such as Kaprow's) are implicitly framed as 'better' or 'harder' than those involving animals or 'minorities'. Rather, as we move

to the fourth chapter of this book dealing with Allan Kaprow's and Lygia Clark's work, the idea is simply to extend our sense of the repertoire of practices that might be available to us in pursuit of the production of theatres of immanence. This is not a repertoire to repeat with the expectation of guaranteed results; rather, if we repeat Kaprow and Clark we do so with the purpose of experimenting with what his scores can do in conjunction with the multiple singularities of contemporary contexts.

4
Paying Attention, Participating in the Whole: Allan Kaprow alongside Lygia Clark

This chapter concerns theatres of immanence alongside the concept of participation, in the senses given to that term by philosophy and art, with a particular emphasis on Deleuze's Spinozist account of participation and the participatory works – or 'Activities' – made by the American artist Allan Kaprow from the late 1960s onwards, and with reference to the 'propositions' and experiential events made by the Brazilian artist Lygia Clark around the same time. From the outset, it appears that Kaprow and Clark mapped similar trajectories in their contemporaneous practices: moving from making art works for spectators to creating events for participants, and shifting from producing things that look like 'art' as we (think we) know it to facilitating experiences that resist any clear distinction between 'art' and 'life'. However, with Jacques Ranciere's 'emancipated spectator' in mind, we will need to be wary of developmental accounts that implicitly or explicitly denigrate watching or observing in favour of participating or doing, especially when the latter is assumed to be a necessarily more active, engaged or immanent mode of relation. Indeed, such an account would prevent us from appreciating the extent to which both Kaprow and Clark were concerned with perception itself as a kind of action on perceiver and perceived alike; or again, in *observation as a kind of participation*. Likewise, perhaps, we need to take care to emphasize that neither Kaprow nor Clark is purely 'anti-art', nor were they able entirely to escape Art as one force among others that might serve to stabilize the otherwise disorienting powers of their works (the very fact that both have fairly recently had major retrospectives dedicated to their work that toured across international art institutions proves as much, perhaps).[69]

Participation is clearly a core concern of contemporary practice and scholarship in the overlapping contexts of art, performance and theatre. That is, while participation is acknowledged to have had a long and rich history in the arts (as well as in philosophy and politics, as we shall see), it has also emerged as an absolutely central concept over the last decade. Indeed, the contemporary interest in participation is so extensive that we will be able

to do little more than sketch a very summary outline here, before going back to Kaprow and Clark as key forerunners for many of the projects being undertaken today. To cite but a few well-known examples with respect to theatre and performance practice, we might think of the 'outsourced' performances of Rimini Protokoll, experiments with technologically mediated participation by Blast Theory and Gob Squad, and the participatory dance works of Felix Ruckert. We might also wish to reflect on the growing interest in the 'immersive theatre' of contemporary companies such as the Shunt Collective and Punchdrunk in the United Kingdom and SIGNA in Denmark, and on the forms of participation manifest in the recent resurgence of verbatim and documentary theatre (such as the ongoing series of 'tribunal plays' at the Tricycle Theatre in London).

In terms of art, recent years have seen major exhibitions such as *The Art of Participation: 1950 to Now* (2008) in San Francisco, which featured the work of both Kaprow and Clark.[70] Likewise in scholarship, although 10 years have now passed since Nicholas Bourriaud's influential text *Relational Aesthetics* (2002) was translated into English, we are still seeing a proliferation of further Anglophone publications on those practices that are also often termed 'socially engaged art', following on from other key texts by Claire Bishop (2004, 2006), Miwon Kwon (2004), Grant Kester (2004) and Dave Beech (2008). And while these essential publications on participation might initially have emerged from within the specific context of (so-called) visual art theory (despite the de-emphasis on the visual in many of the practices discussed), we are now seeing more prominent responses from within Theatre and Performance Studies too, including Shannon Jackson's *Social Works: Performing Art, Supporting Publics* (2011) and the two joint special issues 'On Participation' published by the UK-based journal *Performance Research* in the same year.

As Carl Lavery writes, in 'performance theory today, the word "participation" ... can sometimes appear to say so much that it means virtually nothing' (Lavery 2011: 7). However, while the infinite extension of what can be understood to belong to the category of 'participation' necessarily risks rendering the term meaningless, we will also find it very difficult to locate a basis for its limitation. After all, an immanent view insists on a fundamental connectedness between the apparently unconnected, and a shared nature among the seemingly opposed or discrete, which must include participatory performance and 'observed theatre' (or works of art designed for contemplation rather than participation). That is to say, an immanent perspective is inherently participatory in outlook – not only thinking in terms of a continuum of tendencies between the two poles of immanent participation and transcendent separation, but also construing participation (or immanence) as the more fundamental of the two tendencies. Or again, according to thinkers of immanence, it is not that we begin with separate things (such as 'an actor' and 'an audience member'), which then take part in each other in a manner

that presents participation as derivative of the participants. Rather, immanence suggests that participants are *produced by* processes of participation. As such, our question should not be 'What is participatory performance?' (to which the answer would be 'everything'), but 'Why (and under what circumstances) do some performances appear nonparticipatory?' and 'What types of participants do different performances produce?' – bearing in mind that 'participants' (or the products of participation as a process) might not only be human, but any other type of what Deleuze and Guattari call 'assemblage'.

As Deleuze says in *Expressionism and Philosophy* – one of two books he devoted to Spinoza – 'participation consists in being a part', and so in turn, philosophies of participation invite us to consider 'mereological' relations: the relationship of parts to a whole (Deleuze 1990: 169). But this chapter will ask: What is involved in participation in Kaprow's Activities? What is it to be a 'part' of a Kaprow Activity when the event as a 'whole' aspires to affirm the participation of art in life, to draw our attention to our participation in the whole of the world? What kind of 'part' are we (and other nonhuman bodies) to the 'whole' of the world? What type of 'part' is *art* in relation to the 'whole' of *life*? These questions will bring us to the heart of Deleuze's immanence, but also to recent debates around the nature of his ontology – his mereology – following on from the influential critiques of his work by fellow philosophers Alain Badiou (1997), Slavoj Žižek (2004) and Peter Hallward (2006), each of whom has argued that Deleuze is ultimately a thinker of the One rather than the Many, one whose philosophy ultimately dematerializes and homogenizes the difference of the parts in order to insist on their participation in a whole, understood as a pure thinking or other-worldly form of thought. In contrast, this chapter will emphasize the immanent nature of Deleuze's account of participation. Likewise, in contrast to Stephen Zepke (2009) – who ultimately uses Deleuze to take what might be construed as a 'Hallwardian' stance against Kaprow for a correlative transcendence – this chapter will insist that the aim of the Activities and Clark's 'Collective Body' works was not to go beyond the material world in a form of Zen meditation (with Kaprow) or therapeutic escape (*pace* Clark), so much as to train our attention to perceive the self-differentiating powers of *this* world, in all its multiplicity. Neither Deleuze, Kaprow nor Clark is concerned with getting away *from* difference in favour of unity, nor about getting away from matter to get *to* difference *qua* some kind of 'absolutely creative being or force' (Hallward 2006: 2). Rather, each is primarily concerned with the complexities of participation – of what it is to be part of a material whole, when that whole is also perpetually in process.

So there is this existing work that links Kaprow and Deleuze that we will address and diverge from here. However, we might also wish to note in passing that it is Clark, of the two artists, who has the more direct relation to Deleuze, partly on account of her friendship with the psychoanalytic thinker Suely Rolnik, who took courses with Deleuze at Vincennes.

According to Rolnik, Clark was 'very interested in the *Anti-Oedipus* when it came out in 1972' and 'took a great interest in the clinical practice that was going on around Guattari and the whole experience of La Borde', in which Rolnik was involved (Larsen and Rolnik 2009: n.p.). Correlatively, though, given Deleuze and Guattari's invocation of the notion of 'assemblage' as a name for the nonhierarchical connection of the different (another imaging of part–whole relations), Kaprow is one of those artists whom we might have hoped and expected to turn up in *A Thousand Plateaus*. Indeed, Kristine Stiles berates Deleuze and Guattari for failing to cite 'the living artists who invented and developed assemblage', including Kaprow, arguing that the philosophers 'culled' the model of the assemblage from visual art without honoring their sources (Stiles 1999: 3). After all, given their friendship with the French Happenings artist Jean-Jacques Lebel, who met Kaprow in 1961 and remained friends with him throughout his life, it seems highly likely that Deleuze and Guattari were aware of Kaprow (and vice versa).

Nevertheless, I have not chosen to focus on Kaprow, and to discuss Clark, on this basis. Rather, my interest in Kaprow and Clark stems from the extent to which they developed participation as a means to explore the art/life relationship in terms of immanence, and the lengths to which both were willing to go in order to contest the 'transcendental values' that keep 'everything in its proper place (art in the gallery, the market, in the studio, on the wall, but not in our life, not as a question of life)' (Zepke 2005: 52). With Clark and Kaprow, the *event* of art (or art *as* event) 'does not appear in a judgment assuming our exteriority to the work' (whether that work is a painting on a wall or a seemingly participatory performance); rather, 'Art emerges – it is created – in our experimental relations' in a manner that constitutes it as a decidedly ethical practice (Zepke 2005: 52). That is, the extent to which participants are not only given permission to experiment, but also the structural basis (or 'creative constraints') from which to do so, will be critical here.

In turn, my specific interest in participation is as *one strategy among others* that performance makers might continue to develop in order to affirm the fundamentally processual nature of the whole. I am not interested in participation as a 'form'; indeed, I would agree with Carl Lavery that participation is not a specific type of art or performance (Lavery 2011: 8). Rather, I would argue that not only all art but all 'things' are participatory; immanence means that *everything* takes part in everything else, it is just that some things *appear* not to take part in others. Not all things – including participatory performances – take part in everything else in the same way and to the same degree; rather, there some things – including some performances – that are more, less and differently participatory than others. Indeed, for our part, we will attempt to suggest that there are specific instances of participation that have been more 'successful' than others in terms of constructing a theatre of immanence rather than transcendence, as well as trying to articulate the techniques and approaches through which this success has been achieved.

Degrees of immanence, or what I will also discuss in terms of degrees of 'openness', are by no means something that we can mathematically calculate, but they are no less real on account of being something felt or lived.

With these issues in mind, I also want to avoid any assumption that participatory performance somehow guarantees immanence; or, to put it another way, to question the assumption that the direct, physical participation of audience members in performance necessarily places them 'inside' the life of the work in a qualitatively distinct way from spectatorship. That is, we want to try to avoid any ontological or philosophical privileging of participatory forms of performance akin to the aesthetic and political privileging that Claire Bishop identifies with reference to the contemporary visual art context. Participation has perhaps come to be too straightforwardly seen as 'good', both aesthetically and politically, Bishop suggests:

> the gesture of ceding some or all authorial control [through the participation of the audience/viewer] is conventionally regarded as more egalitarian and democratic than the creation of a work by a single artist, while shared production is also seen to entail the aesthetic benefits of greater risk and unpredictability. (Bishop 2006: 12)

Likewise, writing from the perspective of Performance Studies, Lavery has argued:

> Whereas the 'contemplative spectator' is conveniently positioned by the champions of participatory and relational aesthetics as a willingly servile subject overawed by the immensity of the work in front of them, 'the participative spectator', on the other hand, is portrayed as being involved in the production of the artwork. (Lavery 2011: 7)

As such, Lavery notes, 'it is not difficult to see how the participative spectator has been fashioned ... as a figure of democracy' (Lavery 2011: 7). Too easily, both Bishop and Lavery suggest, participatory works are taken to be on the side of egalitarian politics in a manner that asks too few questions of the distinctions between specific instances of participation and, indeed, of spectatorship within so-called traditional theatre.[71] Ultimately, Bishop suggests, 'participation is arguably no more intrinsically political or oppositional than any other' approach to art (Bishop 2006: 12). In the same way, we must be careful not to assume that Kaprow or Clark's work (rather than what Kaprow calls the 'Art art' of gallery-based practices) necessarily offers an imitable model for future theatres of immanence; rather, we need to ask after the nature of the difference, with respect to immanence, between practices that invite embodied participation and those that keep the audience physically separate from a performance enacted by others – where that questioning is explicitly based on the contention that body and mind belong to one kind of existence.

In some ways, then, the opening premise of this chapter is akin to Rancière's core claim in *The Emancipated Spectator*; namely, that the spectator was never passive in the first place and, hence, does not need to be emancipated in the ways that some theatre practitioners appear to have proposed. Or, as Rancière puts it: 'Spectatorship is not a passivity that must be turned into activity.' He argues: 'We don't need to turn spectators into actors. We do need to acknowledge that every spectator is already an actor in his own story and that every actor is in turn the spectator of the same kind of story' (Rancière 2007: 279). However, whereas Rancière emphasizes the role of narrative and active storytelling in his characterization of spectatorship, I will be developing an account of the activities of participants (who are also often participating observers) based on a concept of 'attention' taken from Bergson as well as Deleuze, in order to articulate a new facet of immanent experience. As Kaprow notes, 'What happens when you pay close attention to anything, especially routine behaviour, is that it changes. Attention alters what is attended' (Kaprow 2003: 236). But it also alters the attender in a reciprocal determination. That is, I will suggest that Kaprow and Clark's works allow us to conceive of the theatre of immanence as a form of 'attention training' (in contrast to the 'entertainment' of attention of which Rolnik accuses much relational aesthetics[72]), in which the work participates in the participant as much as the participant in the work.

Before we move on to such ideas, I want to begin by going into more detail regarding the practices themselves, with a particular focus on the relationship that they construct between participation and observation. We will then outline what I will call the 'immanent mereology' that connects Deleuze, Kaprow and Clark's philosophical perspectives, in order to get to what is really at stake in their production of participatory events – stakes that I am suggesting are best understood, positively and indeed politically, through and as philosophies of immanence (which are themselves ordered in terms of the degrees of attention they offer), rather than purely with respect to institutional critique or as forms of meditation that aspire to take us out of this world.

Kaprow's 'Activities', Clark's 'propositions'

Less well known than his Happenings, Kaprow's Activities are written scores that act as instructions for volunteer participants to engage in a series of seemingly banal actions and interactions made strange through a variety of compositional devices:

> wetting a finger with saliva
> holding it up till dry
> calling out: now!
> walking on. (cited in Leddy and Meyer-Hermann 2008: 225)[73]

driving to airport
with suitcases of packaged sand
(tagged with owner's name). (cited in Leddy and Meyer-Hermann 2008:
225)[74]

A, telephoning B, saying:
 you must be thinking of me
B, replying, unh-hunh
hanging up. (Kaprow 1976b: 261)[75]

Between the late 1960s and 2001, Kaprow scored and enacted more than 100 Activities.[76] In order to provide a general picture of what the Activities were like, we might follow Jeff Kelley in distinguishing between those events that took place in an educational context (which were mostly the US Activities enacted by small groups of students) and those that were commissioned by galleries or art festivals (which were mostly the European Activities, enacted by invited and volunteer participants from the host cities; Kelley 2004: 161). Alternatively, though, the Activities might also be characterized as operating between two poles: at one of them, inhuman materials take centre stage while people function as attentive workmen (such as *Level* from 1970 and *Durations* from 1976); while at the other, the specific conventions of human behaviour are of primary concern (such as *Take Off* from 1974, or *Maneuvers* and *Satisfaction* from 1976). At the former pole, the actions that Kaprow proposes often involve processes of building, physically demanding labour and the materials of construction (in this sense they are reminiscent of some of the Happenings), for example in *Tracts*, *Sweet Wall* (both 1970) and *Scales* (1971). At the latter pole, participants are frequently grouped into mixed-sex couples who enact various forms of exchange and contact with one another – sometimes just using their bodies, and at other times supplementing the relationship with technologies such as telephones, microphones, cameras and tape recorders (Kelley 2004: 190). In between these two limits, there are the bodily experiment works like *Meters* (1972), *Highs, Basic Thermal Units* (both 1973), *Affect* (1974) and *Air Condition* (1975). These involve inhuman materials like light, ice and water, but no construction or manual labour. Likewise, although they invite participants to enact forms of contact and exchange, there is less apparent concern with behavioural conventions or body language as much as with the sensory affects of an encounter with such materials.

Like Kaprow, Clark began her artistic career with painting and sculpture, on which she focused for 16 years from 1947. However, Rolnik reminds us:

as early as 1963 ... her investigation took a radically innovative turn that proved irreversible, moving towards the creation of proposals that depended on the process that they mobilized in the body of the participants as the basis of their realization. (Rolnik 2007: n.p.)

Image 6 Photograph illustrating how to perform *Basic Thermal Units* from the Activity booklet
Sponsored by Galerie Inge Baecker, Museum Folkwang and Stiftung Wilhelm Lehmbruck Museum.
Apartments in Essen, Duisberg, Bochhum and Remscheid, West Germany.
Courtesy Allan Kaprow Estate and Hauser & Wirth. Photograph: © Estate Lothar Wolleh, Berlin.

In 1963, this proposal or 'proposition', as Clark called it, took the form of the participatory work *Caminhando* (translating as *Trailings* or *Walking*) in which participants were invited to create and then cut along the planes of a paper Mobius strip. This work and other propositions such as *Pedra e ar* (*Stone and air*) (1966) were grouped under the title *Nostalgia do corpo* (Longing for the Body). And according to Rolnik, Clark's subsequent trajectory can be understood as moving through a series of four further main phases: starting with *A casa é o corpo* (The House Is the Body, 1967–69) and *O corpo é a casa* (The Body Is the House, 1968–70); followed by *Corpo Colectivo* (Collective Body, 1972–75) – a phase that Clark 'subsequently named *Fantasmática do corpo* (Phantasm of the body)' – and finally, the late psychotherapeutic phase that Clark called *Estruturação do Self* (Structuring the Self, 1976–88; Rolnik 2011: 74).[77]

In 1972, for instance, Clark was teaching at the Sorbonne and was 'creating multi-sensory experiences (Collective Bodies) for and with her students (deliberately not the usual art public)' (Almenberg 2010: n.p.). The best

known of these experiences is perhaps *Baba Antropofágica* (1973) '(translated in English as "Dribble"), meaning literally "Anthropophagic Drool" or "Cannibal Spit" (Osthoff 1997: 28). As Simone Osthoff recounts,

> For this work, participants placed in their mouths a small spool of coloured thread that they unwound directly from their mouths onto another of the participants, who lay stretched out on the ground. The body of the latter was gradually buried under a mottled web of regurgitations. (Osthoff 1997: 28)

But while the photographic images of this and of the closely related work *Canibalismo* (1973) seem to invite a range of visually oriented readings of the event, Clark insisted, 'There is no spectator here' (cited in Borja-Villel and Mayo 1998: 28). As Guy Brett describes, the participant on the ground lies with their eyes closed, such that the spit-covered cotton 'is felt rather than seen', in what for Rolnik at least was an experience of beginning 'to be that slobber tangle' (Borka-Villel and Mayo 1998: 28).

In this way, with regard to Kaprow first, it might seem as though the Activities mark a concluding phase of an ongoing struggle by the artist to get away from the specular eye of a distanced, observing audience: a struggle that leads Kaprow from making paintings to immersing viewers in 'Environments', from choreographing Happenings for a mobile audience (such as *18 Happenings in 6 Parts* in 1959) to orchestrating 'performer only' Happenings (such as *Calling* in 1965 and *Self-Service* in 1967)[78] and then finally to making Activities, participatory events that often took place in private homes. That is, we could tell the story of his artistic development in terms of a move from making things that were clearly 'art' and were for observers, to making things that he called 'nonart' and that could only be experienced through participation. Correlatively, Clark too could be seen as moving from painting to the orchestration of participatory experiences; from the paintings and sculptures that she produced as a member of the Brazilian Neo-Concrete Movement, through to works like *Caminhando* – of which she said, 'The special meaning is in the act of doing it' (Clark in Best 2006: 90) – and then to the events for participants alone, such as the 'rites without myths' that she made with her students, or the one-to-one therapies that she offered towards the end of her career.

These parallel developments were also coloured, for Kaprow and Clark, by a profound concern to explore the relationship between art and life and, correlatively, what might at the very least be described as a deeply ambivalent attitude to the notion of a separate 'art world', a distinct category of persons called 'artists' and a discrete kind of object or event called 'art', discontinuous with everything else (as 'life'). That is, both artists share an affinity to the tradition known as 'institutional critique' in art, ceaselessly returning to questions of recuperation and cooption in relation to the powers of the

museum and the capitalist art market to capture and petrify experimental art practice. 'Artists of the world drop out! You have nothing to lose but your professions!' (Kaprow 2003: 109). As far back as his Environments and early Happenings, Kaprow had sought to make works of art with 'a maximum ambiguity of identity (what is it?)' (Kaprow 1992: 24). For instance, what he initially liked about the Happenings was their nonrecognizability according to the existing formal categories conventionally applied to art:

> Coming into the Happenings of the late fifties, I was certain the goal was to "do" an art that was distinct from any known genre (or any combi-nation of genres). It seemed important to develop something that was not another type of painting, literature, music, dance, theatre, opera. (Kaprow 2003: 195)

Kaprow conceives of artistic conventions as a set of traits that allow us to recognize an event (as theatre, as dance) and trigger a conventional mode of relation to that event. In contrast, he sought to create unknown forms of event to which we must invent new ways of relating.

In turn, starting in the early 1970s, Kaprow wrote extensively on the con-cept of nonart – or what he variously referred to as 'lifelike art' or un-art and un-arting. What is art and what is not art cannot easily be established, he suggests, particularly in the three-part essay 'The Education of the Un-Artist' (1971–74); rather, there is a whole gamut of objects and practices that are not what they appear to be. There is not only 'art' and 'nonart', but also 'Art art' (or 'artlike art') and 'Art art in the guise of nonart' or 'quasi nonart' (Kaprow 2003: 101). That is, it seems that for Kaprow, nonart is not so much a 'thing' to which we can point as a particular mode of experience that 'exists only fleetingly' and can at any moment become 'a type of art' (Kaprow 2003: 98).

In 1971, Clark wrote: 'At the very time that the artist is more and more digested by this society ... what remains for him ... is to try to inoculate a new manner of living' (Clark in Borja-Villel and Mayo 1998: 248). If they allow themselves to be completely swallowed by capitalism, artists become 'the engineer of the leisures of the future ... an activity which will in no way affect the balance of the social structures'. In contrast, Clark argued that 'the only way to escape recuperation is to seek out a launching of the general creativity, without any psychological or social limit. His creativ-ity will be expressed in that which is lived' (Borja-Villel and Mayo 1998: 248). Here Clark seems to articulate what Deleuze will come to describe as a jointly ethical and aesthetic project concerned with 'inventing new pos-sibilities of life' – a project less concerned with making 'Art' and more with living life as a work of art (Deleuze 1995: 95). However, neither Kaprow nor Clark appears to think that the boundary between art and life can be undone simply by rejecting the institutions of art. In a 1970 letter to Helio Oiticica, for instance, Clark suggests that they should accept that art

institutions – such as museums and galleries – can change, as much as they themselves have. She writes:

> It is very pretentious to think that we change for the better but that on the other side they only want to "recuperate" us ... I also think that if we don't open our eyes we won't have the conditions to communicate anything ... I make my propositions wherever I am invited to. (Clark in Borja-Villel and Mayo 1998: 256)

Beyond the participation/observation binary

Likewise, although appropriate on one level only, I would be inclined to temper an understanding of either Kaprow or Clark as simply moving from spectatorship to participation in a manner that would leave the participation/observation binary intact. Rather, to begin with Kaprow's case, I propose that we might favour an alternative account of his development as departing from a participation/observation binary and moving towards a position that conceives of attention *as a particular mode of observation* in which ontological participation – or being part of the whole – might occur. To support such a view we might note that, although Kaprow began to use the term 'Activity' around 1968–69, he continued to make new 'Happenings' until around 1970, and indeed to reinvent past 'Environments' and Happenings *alongside* creating new Activities for the rest of his career.[79] As such, it is not the case that there is a discrete 'Activities phase' that necessarily constitutes a formal progression or development from the Happenings (or a rejection of the form of the Environments as merely a step along the way to a more extensive mode of participation). Indeed, the first essay in which Kaprow uses the term 'Activity' – 'Pinpointing Happenings' from 1967 – confirms not only a practical but a conceptual overlap between Activities and Happenings. Here, Kaprow attempts to describe and define what he calls an 'Activity Happening' or 'Activity type Happening' as a subcategory of Happenings. An 'Activity Happening', he says, is

> directly involved in the everyday world, ignores theatres and audiences, is more active than meditative, and is close in spirit to physical sports ... fairs ... and political demonstrations. It also partakes of the unconscious daily rituals of the supermarket. (Kaprow 2003: 87)

However, Kaprow then goes on to say, 'The Activity Happening selects and combines situations *to be participated in, rather than watched* or just thought about' (Kaprow 2003: 87, emphasis added) in a manner that reiterates the very participation/observation binary that he would later undo (and, correlatively, the mind/body or thinking/doing binary). That is, I want to suggest that it is not observation per se that Kaprow ultimately wants to

avoid, so much as a particular kind of disembodied watching (and, indeed, of distracted or mindless doing) that allows us to forget the participation of matter and thought in one another.

In Clark's case, correlatively, one can find instances where she seems to oppose the participant to the spectator, doing to observation. For instance, around the time of *Caminhando* Clark argued that the role of the artist is:

> To give the participant the object which in itself is of no importance, and which will only become so as the participant acts ... When the work was a ready fact, the spectator could only try to decipher it – and for this to happen many generations were necessary. It was a question of the elite. (Clark in Borja-Villel and Mayo 1998: 66)

Here, Clark seems to suggest that art works for spectators are necessarily 'closed' or, rather, only open to *interpretation* rather than creation, in contrast to those that are made with participants in mind. Likewise, art historian Yve-Alain Bois (who was also a friend of Clark's) suggests that Clark's 1970s work 'had nothing to do with any performance whatsoever ... It was impossible to "attend" one of these "courses", to retreat from it as a spectator' (Clark and Bois 1994: 88). Attending, spectatorship and indeed 'performance' per se are necessarily associated here with retreating, and with distance.

However, we might also wish to note that, as early as 1956, Clark stated: 'I firmly believe in the search for the fusion between art and life' (Clark in Best 2006: 86). That is, even while she was making paintings, Clark was not thinking of the artwork as a transcendent entity, occupying a discrete realm from that of the observer. During her participation in Neo-Concretism, for example, Clark spoke frequently of the need to conceive of the work of art as a 'living thing' (Clark in Best 2006: 87). In this sense, whereas Simone Osthoff argues that Clark's work develops 'from form to experience', one might argue that Clark was always interested in the experiential aspects of form and the evental nature of (what appear to us as) objects (Osthoff 1997: 28). Rolnik's research supports such a view, noting that

> Even in her early practice of painting and sculpture, Lygia Clark tried to shift from the reduction of the eye's exercise to its retinal potency (that which apprehends the forms), in search of its resonance potency (that which apprehends the forces) and the paradoxical dynamics between both. (Rolnik 2011: 75)

For Kaprow and Clark, in the end, it is not the rejection of observation so much as the openness of the participants' experience that matters in terms of securing what Clark calls 'true participation'; albeit that the attempt to invite and maintain this openness will prove a very difficult exercise for both. For instance, Kaprow struggled to create scores that allowed his

processual concerns to register an impact alongside more metaphorical interpretations of his work. Think of *Sweet Wall* – an Activity that involved participants building a wall out of cinder blocks with bread and jam as the mortar and that was deliberately enacted 'within sight of the Berlin wall'. As such, Jeff Kelley states, 'The political symbolism of constructing and knocking over a mock wall so close to the Cold War's most concrete expression of the Iron Curtain was, of course, evident to all.' However, he also acknowledges that although Kaprow 'was fully aware of the political implications' of *Sweet Wall*, he was in fact '*more interested* in the actual process of laying out, layering up, mortaring together, sighting, pushing over, and then cleaning up the concrete blocks, which, by then, were smeared with sticky jam and wadded with dirty, wet bread' (Kelley 2004: 163, emphasis added).

Representational implications are not denied then (how could they be with such a forcefully and, as such, problematically symbolic backdrop?), but it is important to note that Kaprow himself explicitly argues against any simple distinction between form and content in order to avoid producing works of art that will 'remain only an illustration of a thought' rather than providing participants with what he calls an 'experienced insight' (Kaprow 1992: 25). Such works do not represent a preconceived set of concepts, an approach to art making that Kaprow dismisses as 'not a worthwhile activity' (Kaprow 1968: 156). That is, although, as Kaprow notes, the form of his works is always 'simple and clear', the actual experience of the event 'is uncertain and unforeseeable, which is why I do it, and its point is never clear to me, even after I've done it' (Kaprow 1991: n.p.). What matters most to Kaprow are the experiential products of the interference of the processual in the symbolic, the immanent in the transcendent, in the event of participation itself, not what the Activity looks like from a position outside of it. As such, it does not make sense to 'read' the Activities purely as objects, and particularly not as representations of predetermined artistic intentions.

To take another example, here is Kaprow's score for *Level* (1970), an Activity suggestively dedicated to his wife, Vaughan Rachel:

> placing a block of ice and bale of straw
> near each other somewhere
> ice melting slowly
> reducing bale, straw by straw
> (keeping pace with the ice)
> until nothing remains. (Kaprow in Leddy and Meyer-Hermann 2008: 46)

In turn, art writer Annette Leddy has interpreted *Level* biographically, transforming the Activity into a symbol of Kaprow and Rachel's relationship:

> Because of the dedication and the pairing of the objects, it is tempting to see Level as a portrait of Kaprow's marriage, then in its fourteenth year. If

so, it is a grim one, worthy of Robert Frost, in which marriage is a levelling process that reduces both people 'until nothing remains'. (Leddy and Meyer-Hermann 2008: 46)

Ice is not just ice here, Leddy proposes, nor straw simply straw. Rather, the block and the bale are metaphorical stand-ins for Kaprow and his wife. Equally, Leddy suggests that in works like *Warm-Ups* and *Basic Thermal Units*, 'melting ice is a metaphor for overcoming emotional distance' (Leddy and Meyer-Hermann 2008: 45) and that *Affect* was created 'as a piece about a disharmonious relationship' (Leddy and Meyer-Hermann 2008: 49). However, while such readings are clearly not without some basis, I would argue that they have the unfortunate effect of reducing, rather than enriching or deepening, the complexity of the Activities. That is, the alternative does not necessarily constitute a return to some kind of literalism, in which ice, for instance, would be conceived of as a self-same object that 'is what it is' for a subject, neither more nor less. Rather, Kaprow's interest in participation lies in its power to connect us to material bodies like ice and straw precisely as things that differ from themselves and from the ideas that we have of them.

Image 7 Allan Kaprow, *Level*, 1970. Photograph illustrating how to perform *Level* from the Activity booklet. Sponsored by the Arts Council of the Aspen Institute for Humanistic Studies
A field in Aspen, Colorado. Courtesy Allan Kaprow Estate and Hauser & Wirth. Photographer unknown.

In this sense, we might consider both of these artists' activities in the light of the concept of affective encounter and becoming that we explored in the last chapter, albeit that these encounters involve other human bodies and various material bodies – from ice to thread – rather than the bodies of non-human animals. As we learnt, Deleuze draws from Spinoza to argue 'that the body surpasses the knowledge that we have of it, and that thought likewise surpasses the consciousness that we have of it' (Deleuze 1988: 18). And as such, we might suggest that both Kaprow and Clark's works seek to provide a context in which to explore both 'the unknown of the body' and the 'unconscious of thought' (Deleuze 1988: 19) in ways that expose us to new ways relating to both, to new ways of living. And indeed, Clark explicitly announced, 'I want to open the body. My fundamental interest is the body. And what I now know is that *the body is more than the body itself.*'

This resistance to an understanding of the Activities as the mere enactment (by participants) of a pre-existing idea (belonging to the artist) is important for an understanding of *why* participation matters and *what kind of* participation matters to Kaprow. That is, Kaprow was clearly concerned with how the term 'participation' was used, and wanted to differentiate between *pseudo*-participation and the real thing. Whether it is achieved through attentive observation or attentive action, Kaprow's pursuit of participation is motivated by the desire to allow an audience to inhabit a creative and co-authorial relationship to the work. While some of Kaprow's writing from the late 1960s is critical of the conventional audience in observed theatre, he is equally critical of events, including his own, that attempt to invite participation by giving the audience small tasks to do within a performance or environment – the nature of which is already determined. For instance, he argues that to 'assemble people unprepared for an event and say that they are "participating" if apples are thrown at them or they are herded about is to ask very little of the whole notion of participation', Kaprow argued (Kaprow in Beech 2008: n.p.). Likewise, speaking of his own earlier Happenings, Kaprow argues:

> Tasks on the order of sweeping or reading words remain relatively mindless as long as their context is a loose theatrical event prepared in advance for an uninformed audience. (Kaprow in Beech 2008: 185)

Or, in other words, audience participation does not secure the creative or attentive relation to the work that emerges as Kaprow's priority. The task then was how to enable a seemingly 'mindless' action such as sweeping to become an occasion for embodied thought on the part of the participant. In this way, we might suggest that the defining characteristic of participation for Kaprow is less to do with physical action versus the passivity of observation, and more to do with a process of co-authorship through which an audience is actively 'collaborating in the art making and meaning making

process' (Kaprow 1991: n.p.) – bearing in mind that 'meaning' for Kaprow is understood as 'lived change' or 'experienced insight' rather than inter-pretation. Here, for instance, Kaprow differentiates between the modes of communication that defined what he calls 'Art art' and nonart (or lifelike art) respectively:

> For each kind of art, the conveyance itself is the message ... Artlike art sends its message on a one-way street: from the artist to us. Lifelike art's message is sent on a feedback loop: from the artist to us (including machines, animals, nature) and around again to the artist. You can't 'talk back' to, and thus change, an artlike artwork; but 'conversation' is the very means of lifelike art, which is always changing. (Kaprow 2003: 204)

The experiential 'message' of the Activity, 'conveyed by a process of events that has no definite outline', is repeated back to the artist but with a differ-ence, like Chinese whispers (Kaprow 2003: 204).

According to such a definition, in turn, there is no reason to oppose observation and participation. As Jonathan Crary has discussed, Western culture – including art and theatre – has historically developed in a manner that has tended to 'sunder the act of seeing from the physical body of the observer, to decorporealize vision' (Crary 1990: 39). However, what we see in the Activities – many of which involve acts of observation (of one partici-pant by another or by participants of themselves) – is arguably an attempt to reconnect observation and action, to re-embody the viewer as what we might call a 'participant observer', to borrow a term from ethnography.[80] Indeed we might say that the Activities constitute attempts to re-view vision itself as having the power to operate as a kind of participation in and of the whole. For instance, the score for a 1975 Activity called *Useful Fictions* includes the following instructions:

A and B (close behind)
walking up long hill (or flights of stairs)

A, holding large mirror before face
keeping eyes on B's reflection throughout
B, copying A's movement

Or again, if we look at the score for the Activity, *Meditation 1* (1981), we see that it involves both a 'sweeper' and a 'watcher' among its participants (sub-sequently instructing the participant 'who began as a watcher' to become a 'listener' of leaves being swept; Leddy and Meyer-Hermann 2008: 278). In this way, it becomes clear that it is neither watching, nor 'tasks on the order of sweeping' in themselves, to which Kaprow objects. Rather, for him, it is the way in which participation in a theatrical context fails to encourage us to

attend to these tasks in other than habitual (and transcendent) ways: as symbolic of predetermined artistic intentions, for instance, or as 'mindless' tasks that involve no creative power in and of themselves. That is, this type of participation allows us to continue to believe that we know what sweeping is. We tend to impose our idea of the action of sweeping onto the bodies involved (arms, broom, floor, dust) rather than seeing those bodies as differing from our transcendent conceptions, or, indeed, as sources of ideas in themselves.[81]

Clark's work integrates participation and observation too. In the 1968 work *Goggles*, for instance, a former pair of diving goggles were adapted by Clark, using four mirrors that 'fragmented the wearers' perception of their surroundings'. Or again, her 1967 work *Máscaras sensoriais* (*Sensorial Hoods*) 'equalized eyesight, hearing and smell in a pluri-sensorial cluster' (Brett in Borja-Villel and Mayo 1998: 21). Here, Brett argues that Clark's work involves 'a progressive de-emphasis on the visual sense' and 'a pioneering attempt to re-integrate visual perception with the body as a whole'. Likewise, Rolnik's account of Clark's work with students in post-1968 Paris emphasizes perception – including observation – as 'the focus of her investigation', exploring the dual capacity of the senses – including vision – to project

Image 8 Allan Kaprow. *Useful Fictions*, 1975. Photograph illustrating how to perform *Useful Fictions* from the Activity booklet. Sponsored by Galleria Schema, Florence
Courtesy Allan Kaprow Estate and Hauser & Wirth. Photograph © Bee Ottinger.

subjective representations onto the world as if it were an object, but also to encounter the life of the world as 'a diagram of forces that affect all the senses in their capacity for resonance' (Rolnik 2007: n.p.).

More 'in the midst of things': Techniques for increasing participation

However, if there is no binary between participation and observation, no grounds for the equation of spectatorship with passivity, then why are we continuing to emphasize Kaprow and Clark's participatory performance as theatres of immanence, rather than examining 'observed theatre'? One response is to make clear that the rejection of a difference in kind between participating and observing does not discount the preservation of differences in degree. For instance, while both Kaprow and Deleuze suggest that all modes of perception are creative rather than merely reflective, it seems that Kaprow wants to assign both specificity and additional value to attention in the context of action:

> Watching and listening in the midst of doing is very distinct from the specialized observations of a physically passive audience (only the mind is awake for a traditional audience, at best; and it has no responsibility for the actual work. It can only judge). (Kaprow 1986: n.p.)

So Kaprow does argue that there is a difference between the way we watch a work that *appears* to be independent of us, and what happens to observation when audiences are invited to be part of a whole that they *appear* to have the power to change. The illusion of transcendence (of mind over body, existing idea over present event) becomes stronger, Kaprow implies, when we feel a diminished responsibility for how events unfold. Or is it that transcendence and a loss of a sense of responsibility are mutually reinforcing? Ontologically, we are always 'in the midst of things' (Deleuze and Guattari 1988: 280) – changing and being changed by them, moving between tendencies between the poles of immanence and transcendence – but the extent to which we act according to this immanence varies, the degree to which we acknowledge our 'partness' or partiality can and does differ (bearing in mind that 'acknowledgement' here need not be understood in a representational sense). Indeed, as Deleuze puts it, via Spinoza, an individual being has 'no power of its own except insofar as it is part of a whole' (Deleuze 1990: 91). This is not to take away from the power of individual beings themselves or to make worldly things into 'mere appearances', Deleuze insists; rather, it is to emphasize that our powers to act and be acted on, to change and be changed, are themselves the result of our immanent participation (Deleuze 1990: 92).

Ultimately, what is at stake in participation, for Kaprow, is some kind of 'genuine' thought – beyond judgement and the opposition of mind and

body. As we have seen, this encounter is theorized by Kaprow as 'experienced insight': an event of embodied thinking by the participant in the act of doing, which is not the same as the recognition of some underlying metaphorical meaning of the Activity determined in advance by the artist. Experience, Kaprow believes, 'is physical, not intellectual. An experience is thought which has been "incorporated", on a muscular, neural, even cellular level, into the body' (Kaprow 1992: 26). Having long since dispensed with the accommodation of a traditional audience, what matters for Kaprow in the Activities is the 'direct, physical involvement' of those who choose to do it: 'Meaning is experienced in the body, and the mind is set into play by the body's sensations' (Kaprow 1986: n.p.).

For Clark, too, there is a difference between pseudo-participation and what she calls 'true participation', as that which rests on the provision of openness. She says:

> True participation is open and we can never know what we are giving to the spectator-author ... I don't even put on my masks or clothes and

Image 9 Lygia Clark, *Baba Antropofágica* (1973). Courtesy Cultural Association, 'The World of Lygia Clark'

I always hope that someone will come along to provide a meaning to this formulation. And the more different the experiences are, *the more open is the proposition* and then it is more important. (Clark in Borja-Villel and Mayo 1998: 236, emphasis in original)

Indeed, Clark referred to 'the *vécu*' or participant experiences of works like *Baba Antropofágica* as 'the most important thing' about the work; she says that the participant's response is

the most interesting part, as the same work gives rise to completely different things and there are also changes, depending on whether it is the first or second time that the person is experiencing them. (Clark in Borja-Villel and Mayo 1998: 288)

And in this regard, it is worth noting that individual participants' responses were not always in line with Clark's own interpretations of her work, but that she nevertheless presents the same openness to them as Kaprow (unlike the Living Theatre[82]). For instance, having taken part in *Baba Antropofágica*, one participant is reported by Clark as having experienced the event as 'showing him how women ensnare men in their spiders' webs' (Best 2006: 98). Writing in her diary, Clark initially says that this response 'depressed her', but she later comes to the view that it is 'absolutely right ... she felt she already knew that she was the cannibalistic spider catching people up in her propositions, but the clear formulation of it came as a shock' (Best 2006: 98). That is not to say that the participant in question was *exclusively* right; rather, it demonstrates Clark's own willingness to acknowledge that the artist's view of an event is only one part of what constitutes that event as an always unfinished, incomplete whole.

As well as trying to get beyond the preconception that participants ought to interpret the events as representative of predetermined artistic intentions, Kaprow also faced the problem that the Activities might be experienced as simply routine. That is, just as he wanted to block the participants from identifying the actions as 'art' (and behaving accordingly), he also needed to prevent them from recognizing them as 'life' (and falling into the habit of inattentive participation that we often occupy in relation to the everyday). To some extent, the actions that the participant is invited to perform for the Activity are familiar: blowing one's nose, opening a door or taking a pulse. And this familiarity was important for Kaprow in respect to his concern that the work be accessible to as many people as possible. However, Kaprow then develops a range of practical strategies in order to prevent the participants, including Kaprow himself, from slipping into routine behaviour and experiencing the Activity as life, rather than what we might call 'art-life' or 'life-art'. For example, Kaprow uses what he calls 'feedback devices' to alter how participants attend to the actions they are performing. In a 'sketch for

a possible breathing piece' (1979), for instance, Kaprow refers to a loud-speaker, a mirror and a tape recorder used in the sketch as 'feedback devices' that produce 'displacements of ordinary emphasis' (Kaprow 2003: 198). The Activity repeats everyday actions, like looking at ourselves in a mirror, but employs feedback devices as a means to draw attention to the ordinarily unattended ('fleeting mist on glass') and away from the obvious (the recognition of our selves in terms of the reflected image).

Alterations of speed are another method that Kaprow used for preventing the Activities from slipping into conventional behaviour. For instance, in *Rates of Exchange* (1975), Kaprow approached the handshake as an example of a routine that could be forced to break down. As Kelley suggests, 'If you slow down the motion of a handshake enough it becomes impossible to shake hands; some other exchange takes place' (Kelley 2004: 195). What this experiment exposes is that the identity of the action 'to shake hands' only functions at a particular relation between speed and slowness; at another relation, the action becomes imperceptible as shaking hands and becomes something else that, in turn, can be experienced by the participants as some other kind of contact. Kaprow had been interested in speed as a factor relating to thresholds of perception as far back as *18 Happenings* – in which, at one point, '(light fades imperceptibly over a long period of time...)' and, at another, there are sounds 'barely remaining long enough to be heard clearly' (Kaprow in Kirby 1965: 58). The Activities take this interest further by involving the entire body in attempts to slow down 'walking' – to give another example from *Rates* – until it reaches a point of transformation.

In his introductory textbook on Performance Studies, Richard Schechner argues that Kaprow's Activities invite us to notice 'how ritual-like daily life is, how much daily life consists of repetitions', concluding that 'there is no such thing as "once-behaved behavior"', only reproductions of familiar habits and routines – including the ritual of shaking hands (Schechner 2002: 23). In contrast, I would argue that, for Kaprow as for Deleuze, there is always novelty within what Schechner calls 'restored behaviors', the unknown within the apparently ordinary, difference within repetition (Schechner 2002: 22). This is the case within an 'ordinary' handshake too, which is as much a part of the processual whole as Kaprow's version. However, what matters is that the decelerated handshake *appears* to us as a part, whereas the 'ordinary' handshake often does not. This is not to say that the 'ordinary' handshake is a mere reproduction of a self-same behaviour, but that it tends to occur in contexts in which our attention is contracted to include a limited range of perceptions and to exclude others. Indeed, Kaprow also used repetition itself as a feedback device, instructing participants to repeat behaviours like opening and closing a car boot or opening and closing a door to the point that repetition enables an expanded perception of the action.[83] Whereas the repetition of these acts over an extended period allows them to *appear* as twice behaved (think of how many doors you have opened

and closed over your life thus far and how few of those you remember), their repetition in as short a time as possible reconnects us to them via the differential with them as always once-behaved behaviours. We attend to the difference of the action as its repetition endures; the first (door opening) is not the same as the fifth, but not because it is 'more new'. The first is a repetition of past behaviours, as Schechner suggests – otherwise we would not know what Kaprow's score is asking us to do – but it is a *differential* repetition, the repetition of which eventually leads us to question (whether we really know) what it is to open a door or shake a hand at all. What counts as 'hand-shaking' and 'door-opening' expands to include a whole spectrum of embodied actions of which its recognizable version is but a part.

Clark was also concerned with how to enable participants to undo habit. Writing in 1973, Clark wrote that the work of her 'Collective Bodies' phase

> was done with the idea of liberating man, lifting repression, since the participant found a sensorial energy which had been deliberately put to sleep by our social habits. (Clark in Borja-Villel and Mayo 1998: 14)

She also noted that participants struggled to affirm 'the capacity of letting oneself be affected by the forces of the environment of one's daily life' (Rolnik 2007: n.p.). But whereas we might suggest that the Living Theatre sometimes mistakenly sought to liberate themselves and the audience by removing literal blockages and physical restrictions, Clark tended 'to approach the notion of liberation by means of its opposite: Binding, blocking, restricting' (Brett in Borja-Villel and Mayo 1998: 24). That is, in a manner more akin to Cage and Goat Island, Clark located creativity and the break from habit in constraint, for instance in the blocking of vision in the case of the head-pieces that Clark called *Máscaras abismo* (1968). In this participatory experience,

> A blindfold covers the eyes. Hanging from the head-harness are large inflated plastic bags surrounded by netting and weighed down by stones ... The wearers fondle or clasp their arms around the light-heavy airbags, alone or in groups. (Brett in Borja-Villel and Mayo 1998: 21)

Despite this physical restriction, Clark explicitly saw her work in emancipatory terms, construing the restriction of vision, for instance, as a means to free participants 'from the hypnotic hold of imagery and single meanings' (Brett in Borja-Villel and Mayo 1998: 25). Given the focus on embodied experience, it should be clear that the way to tackle habit is not through some specular self-monitoring or conscious control of the body, for Clark or Kaprow; the role of the Activities or the Collective Bodies work was not to encourage us to use our minds to think our way out of or beyond the socially habituated body, so much as to engage a thinking body in new

forms of sociality, including the production of new habits concerning the lived relationship between mind and body.

Now, however, and in an attempt to go further to articulate the specificity of the notion of participation in which I am interested here, I want to go into a little more detail regarding the particular philosophy of participation that we find not only in Deleuze, but also in Kaprow and Clark, who both took notably philosophical approaches to their work. From here, we will also explore participation in the light of Bergson's account of attention, which I will employ in order to provide an alternative perspective on the onto-logical and, indeed, political implications of Kaprow's Activities that contrast with Stephen Zepke's recent critique of them as encouraging mystical tran-scendence. At this point, we will also note a parallel between Zepke's critique and the objections that Peter Hallward has levelled at Deleuze, both of which will be disputed through an emphasis on immanence and embodiment.

Immanent mereology and attention training

As we have already noted, the concept of participation has also been mul-tiply defined by philosophers, including Deleuze, particularly as a means to address the mereological relationships between Being (or existence per se) and beings (specific existences), the One and the Many, reality at its most fundamental and the so-called real world or (in the theological tradition), between God and worldly creatures. Specifically for Deleuze, moreover, Christian Kerslake argues that there is a need to address 'the original prob-lem of participation'; namely, 'how to conceive the principle of the self-differentiation of the One, the expression of the One in the material world', how to emphasize the immanence and equality of the part in relation to the whole (Kerslake 2009: 35). For this he turns to Spinoza, who, as we saw in Chapter 2, insisted on the univocal nature of Being, as that which speaks itself in and as all beings, in the same way. At the same time, though, we noted that for Spinoza and Deleuze, Being is differential; Being (or the whole) may be voiced in the same way by all 'things' (or parts), but what those 'things' have in common is their power to differ from themselves, their being processes rather than 'things', movements rather than objects (albeit that they may appear otherwise to certain points of view).

In this sense, the concept of participation relates to our discussion of the history of the philosophy of mimesis in the previous chapter, inso-far as Plato, for instance, can be said to have understood participation 'imitatively'. 'To participate is to imitate' for Plato: things take part in reality as imitations of ideal forms and art takes part in reality as the imitation of these imitations (Deleuze 1990: 169). And in this way, Deleuze argues, Plato always seems to see participation as a troublesome thing, because he sees it from the point of view of 'the whole'; participation involves 'a violence suffered by what is participated' (namely, the ideal forms), it involves the

suffering of 'division' and 'separation' – some kind of loss or unwanted contamination in the event of participation. In turn, Deleuze also contrasts Spinoza with Neo-Platonist thinkers like Plotinus, who went on to characterize participation as a kind of self-fulfilment, rather than diminishment, of Being, but nevertheless retained a hierarchy between participants and the participable. Through Plotinus, Deleuze argues, we get the image of Life as a force of generosity – 'a donative Cause' – that is most itself when it gives of itself through producing individual beings that *emanate* from it, rather than imitating it. And yet, Deleuze also contends that, in Plotinus, 'The giver is above its gifts' and those gifts are valued differently depending on their proximity to the 'donative Cause' (Deleuze 1990: 170).

As such, it is not until Spinoza, Deleuze suggests, that we receive a thoroughly immanent philosophy of participation in which part and whole are accorded the same ontological status and value. And this univocity emerges, Deleuze argues, because Spinoza exchanges the concepts of imitation and emanation for the concept of expression. As Deleuze explains:

> Expression is on the one hand an explication, an unfolding of what expresses itself, the One manifesting itself in the Many ... Its multiple expression, on the other hand involves Unity. The One remains involved in what expresses it, imprinted in what unfolds it, immanent in whatever manifests it. (Deleuze 1990: 16)

The whole expresses itself in the parts or, to put it in Spinoza's own language, 'substance' expresses itself in what he calls individual 'modes' or bodies (remembering Deleuze's expansion of that term to include inorganic bodies).[84] There is only one kind of 'substance' or Nature, Spinoza insists, and it expresses itself in and as all worldly bodies. These bodies are not the representations of expression, or the signs of participation, though; rather, expression itself *is* this ontological participation. Likewise, as Marjorie Gracieuse makes clear, 'the point of Deleuze's book, ... *Spinoza and Expressionism*, is not to affirm that everything is equal' or the same, 'but to explore the various levels or degrees of expression of life', to examine the *differing* ways in which individual bodies express their participation in difference (Gracieuse 2012: n.p.).

So we can express our participation in the whole to varying degrees, and indeed both Deleuze and Bergson suggest that we can invent ways of living, including modes of perception, that increase the amount of our expression. For example, in the collection of texts that make up his last published work, *The Creative Mind* (1934/1992), Bergson characterizes ordinary perception as both utilitarian and relative. Our faculties of perception and action are attached to one another, he argues, the result of which is that perception tends 'to turn away from what it has a material interest in *not* seeing' (Bergson 1992: 137, emphasis added). Already in *Matter and Memory*

(1896/2004), Bergson had argued that perceptual action tends to be reductive and immobilizing, insofar as it tends to be determined by interest; we insist on a clear-cut distinction between things and their environment, on the division of matter into objects, in order to be able to act on it (Bergson 2004: 278–9). 'Life demands that we put on blinders,' Bergson also contends; and yet, philosophy can 'lead us to a completer perception of reality by means of a certain displacement of our attention', away from the merely useful (Bergson 1992: 137). Philosophy needs to provide an 'education of the attention' that removes these perceptual blinders and frees perception 'from the contraction that it is accustomed to by the demands of life' (Bergson 1992: 139). Attention here is not associated with consciousness; indeed, for Bergson, as Howard Caygill has recently discussed, the point is that 'we see much more than our consciousness allows us to see' and we need to find ways to access that extra-conscious perception (Caygill 2013: n.p.).

And so – whether we choose to adopt a Platonist, Neo-Platonist, Spinozist-Deleuzian or Bergsonian perspective – the philosophy of participation clearly has implications for how we think about performance, and specifically participation in performance. Performance theorist Karoline Gritzner's account, for instance, seems to be initially informed by Plato who, as we have seen, insists on a degree of separation or non-identity between the Ideal Forms (the participated) and those things in the world that participate in the Forms. In turn, Gritzner draws on contemporary philosopher Alexander Garcia Duttmann's work to suggest that, paradoxically (or at least counter-intuitively, perhaps), participation hinges on the *separation* of art and nonart, work and spectator (Duttmann 2011: 138). There can be no relation, only coincidence, within an immanent paradigm, Gritzner and Duttmann argue: 'For if that to which we relate did not remain unrelated, we would no longer relate to it but, in a sense, coincide with it' (Duttmann in Cull and Gritzner 2011: 3). However, as I have already tried to emphasize, for Deleuze at least immanence is not tantamount to sameness or unity; it remains possible to think immanence *and* difference, monism and pluralism together. The other participants in an Activity, for instance, are related to us precisely insofar as they differ from themselves too; art and life are parts of the whole in the same sense because they both involve the production of difference rather than the reproduction of the same (whether we construe the latter in terms of the repetition of social habits or the perpetuation of artistic clichés).

But what is this 'whole'? I would argue that one of the primary things that Kaprow and Clark have in common, both with each other and with Deleuze, is a processual and immanent mereology in which 'the whole' is not conceived as a unity or totality, but as *change* and *movement*. That is, there is evidence to suggest that both Kaprow and Clark held comparable philosophical perspectives to Deleuze (and Bergson): ontologies of immanence and change that both informed, but were also arguably *formed by*,

their artistic practices. For instance, when speaking of his use of ephemeral materials relatively early on his career, Kaprow argues:

> Change, governing both reality and art, has extended ... from the expression of an idea arrested in a painting, to a work in which the usually slow mutations wrought by nature are quickened and literally made part of the experience of it; they manifest the very processes of creation-decay-creation almost as one watches. (Kaprow 1966: 169)

As ephemera, art then offers us the chance to see reality at a different speed: the imperceptible changes of nature's 'slow mutations' are rendered perceptible. Kaprow also speaks of reality as 'constant metamorphosis', arguing that it is this conception that lies 'at the root' of his work (Kaprow 1966: 169). Furthermore, Kaprow argues that change and the fleeting need not be *represented* as the Impressionists did (while still making lasting works of art); rather, he says, 'If change is to be lived and felt deeply, then the art work must be free to articulate this on levels beyond the conceptual' (Kaprow 1966: 169). But, as I will discuss in more detail in due course, what is particularly of interest with regard to an immanent mereology are Kaprow's brief allusions to 'becoming "the whole"' as the goal of the Activities. Kaprow suggests that the Activities might be one way 'to rediscover the whole' or a 'sense of the whole' by training ourselves to let go of the notion of the transcendent self (Kaprow 2003: 217–18).

For her part, Clark declares: 'Permanent movement is the essence of my work' (Clark in Borja-Villel and Mayo 1998: 168), because 'everything in reality is a process' (Clark in Borja-Villel and Mayo 1998: 345). She also insists that 'There are no static things. Everything is dynamics. Even an apparently static object is not stopped' (Clark in Borja-Villel and Mayo 1998: 112). And some of Clark's writings also indicate the difficulty she experienced in trying 'to live on the basis of what is precarious' (Clark in Borja-Villel and Mayo 1998: 187). For instance, she seems to be berating herself when in 1963 she wrote: 'I am crying over the fixed which has no meaning anymore, instead of accepting the precarious in the greatest joy, as a concept of existence' (Clark in Borja-Villel and Mayo 1998: 168). And again in 1967: 'At times I feel tired ... I want to benefit from gain as something stable, but the precarious knocks over all the possibilities and implacably proposes the miracle of life. It hurts a lot to feel that one is miraculously tossed around like a spinning top' (Clark in Borja-Villel and Mayo 1998: 217). Indeed, Clark specifically speaks of her practice in terms of immanence (albeit we will have to explore further to what extent her concept of immanence relates to our own, Deleuzian one). For instance, in a 1968 interview, Clark stated: 'Before expression was transcendental. The plane, the form, pointed towards a reality which was external to them. Today, in art, things are worth what they are. The expression is immanent' (Clark in Borja-Villel and Mayo

1998: 228). Or again, writing in 1983, she states: 'In the immanent act we do not perceive a temporal limit. Past, present and future become mixed' (Clark in Borja-Villel and Mayo 1998: 165).

So now we can return to the question of participation in the context of these shared emphases on movement and change as what characterizes the whole. For instance, Kaprow's Activities can be understood as inviting participants to attend to their (thinking) bodies as a site of lived change and as immanent or embedded in, rather than transcendent to, the world as change. Or again, Kaprow could be seen as enacting one possible version of the relation to the world that Bergson calls for in his philosophy: a relation to the world that he calls on philosophers to attempt and indeed to offer to everyone. However, before we go on to develop this immanent account, I want to position it in relation to a contrasting interpretation; namely, Deleuzian scholar Stephen Zepke's critique of Kaprow's (late) Activities as encouraging a transcendent flight from the world, rather than a greater attention to it. In his essay, Zepke begins by celebrating what he perceives to be the Deleuzian nature of Kaprow's Happenings and early Activities as 'self-determining' compositions, works that he claims

> not only sought to introduce something new into life, but were aimed against the normalized subjectivity of human being itself ... The event transforms the *conditions* of experience and in so doing constructs a new form of subjectivity, and a new kind of art. (Zepke in Cull 2009a: 110, emphasis in original)

However, then Zepke goes on to demote Kaprow's later Activities, for three interrelated reasons: firstly, on account of a perceived 'conceptualism' or focus on meditation rather than (political) action; secondly, because of what Zepke calls Kaprow's wish to place the experience of the Activities '*against* art of any sort' (Zepke in Cull 2009a: 118, emphasis in original); and finally, because he sees the first two developments as constitutive of Kaprow's divergence from Deleuze and Guattari (which can only be a bad thing from Zepke's point of view). On this basis, Zepke criticizes Activities such as *Scales* (1971) and *Time Pieces* (1973) because they 'take on the character of "work"' in ways that he argues 'can no longer be called "art" or "aesthetics"' (Zepke in Cull 2009a: 119). 'In both cases,' Zepke claims, 'the "work" is a means of attaining a meditational awareness that emerges from, but at the same time transforms, the most banal forms of life' (Zepke in Cull 2009a: 119). What Zepke seems to want to object to in this is what he sees as Kaprow's increasing emphasis (indicated by these two earlier Activities, but particularly problematic in Kaprow's work from around 1978) on a conceptual, rather than actual, transformation of life. In his conception of the later Activities as 'Performing Life', Zepke argues, 'Kaprow offers a process of self-reflective meditation on everyday actions and experiences' that does not construct

new ways of living, 'but simply promises a mystical transcendence of life'. In other words, no real escape occurs for these Activities participants; banal life or 'the subjective form of experience' may be conceptually evacuated or superficially coloured through a transcendent experience, but ultimately it is left untouched (Zepke in Cull 2009a).

In part, Zepke's reading here is based on the knowledge that Kaprow had begun to practise Zen Buddhism in 1978, and in support he quotes Kelley's suggestion that, after this time, Kaprow's work offers 'secular, operational analogues to the koan' (Kelley 2004: 204). According to Zepke, the koan

> was a study form developed mainly within the Rinzai school of Zen ... and aimed at intuitive flashes of insight or 'satori': 'cosmic triggers' in which the perspective of the individual ego was overcome and the interconnectedness of the world appeared in its living vitality. (Zepke in Cull 2009a: 120)

Zepke then goes on to argue that this constitutes a break with Deleuze:

> This mystical style of knowledge as self-overcoming, achieved through performance is, Kaprow claims, 'an introduction to right living' (2003, 225). But it is increasingly uncertain that this still bears any resemblance to what Deleuze and Guattari call ... art. (Zepke in Cull 2009a: 120)

Some readers of Deleuze (like Peter Hallward and Alain Badiou) would beg to differ. Deleuze, for them, *is* a mystic. Yet for now we can note that Zepke's reading is also partly based on his understanding of Kaprow's relation to Duchamp and the gesture of the readymade. It is Kaprow's 'absolute fear of recuperation' by the art market or its institutions, Zepke claims, that leads him to position the experiences of the Activities against or outside of art (Zepke in Cull 2009a: 119). The critique of everyday life is overwhelmed by Kaprow's obsession with fully collapsing art into that mode of life. He argues that from the early 1970s, Kaprow reconceives his work, not as art, but as 'Performing Life', which 'is not an aesthetic process, and nor does it produce art; instead, it is an entirely conceptual decision that turns an everyday action such as shaking hands or speaking on the telephone into a performance' (Zepke in Cull 2009a: 119). In this way, Kaprow is taking advantage of the impact of Duchamp's readymade in a move that relies on the participant's ability to apply 'the art-bracket' to any aspect of life whatever. Here, Zepke argues, Kaprow gives 'an interesting Zen twist to Conceptual Art's emphasis on intellectual processes as the essence of art [but] nevertheless dematerialises the art-life dialectic by dissolving the first in the second through turning it into a state of mind' (Zepke in Cull 2009a: 120). Art is merely a state of mind conditioned by a conceptual framing device, divorced altogether from the creation of affects. For Zepke,

the late Activities constitute a withdrawal of art from the social, and from the task of changing it, in favour of a 'search for a private and meditative awareness transcending the conditions of ordinary perception' (Zepke in Cull 2009a: 122).

Regarding Kaprow's relationship to Zen, I would suggest that we need to follow Kelley here, in terms of his differentiation between the worldliness of what he calls the 'American Zen', disseminated to Kaprow by John Cage, from the transcendentalism of other forms of Zen.[85] 'Cage wanted to be *in* the world ...' Kelley argues, 'he was not an enthusiast for transcendence' (Kelley 2004: 200, emphasis added). Likewise, Kelley proposes that Kaprow was more interested in the notion of 'heightened awareness' associated with the Soto school of Zen, rather than the 'sudden enlightenment of the Rinzai' (Kelley 2004: 200). And while Zepke notes Kaprow's interest in the koan developed by the Rinzai school, Kelley nuances this position by arguing that

> To Kaprow, their key feature was that any answers were *worked out in experience, not just in the head*, and were thus different for each devotee. In this sense, koans were very like his works' (Kelley 204: 200, emphasis added).[86]

As such, the Activities are only akin to the koan insofar as they were both concerned not with escaping the world, but with participating in it and attending to it more fully as bodies with unique or individual powers to affect and be affected.

Contra Zepke's argument, Kaprow is very clear that the goal of the Activities (as nonart or lifelike art) is immanent rather than transcendent:

> The purpose of lifelike art was therapeutic: to reintegrate the piece-meal reality we take for granted. Not just intellectually, but directly, as experience – in *this* moment, in *this* house, at *this* kitchen sink. (Kaprow 2003: 206, emphasis added)

Lifelike art does not hold out a 'promise of perfection in some other realm', he insists, but demonstrates 'a way of living meaningfully in this one' (Kaprow 2003: 218). Living meaningfully, for Kaprow, means rediscovering a 'sense of the whole'; indeed, it ultimately involves becoming the whole by letting go of the self as discrete subject. For Kaprow, the aim of the Activities is a form of 'self-knowledge', not as a strengthening of self-present identity, but as 'the passage of the separate self to the egoless self. Lifelike art in which nothing is separate is a training in letting go of the separate self' (Kaprow 2003: 217). But at the same time, while Kaprow states that this embodied self-knowledge 'is where you start on the way to becoming "the whole"', he is careful to add that this process might equally take 'the form of social

action or personal transformation' (Kaprow 2003: 217). Immanent participation in the whole does not necessarily involve an escape from the public into the private, or the social into the personal, as Zepke suggests.

For her part, and despite appearances at times, Clark too is concerned with attention rather than escape. Writing about people wearing her sensorial masks in 1967, Clark at first seems to want to take her participants out of this world: 'At the moment when the spectator puts on the infra-sensorial helmet he isolates himself from the world ... and in this introversion he loses contact with reality' (Clark in Borja-Villel and Mayo 1998: 219). However, she then goes on to clarify that for her, the participant's state might be thought of in terms of 'the immanence of the absolute'; 'this loss of apparent reality' is in fact an encounter with 'another type of reality' that seems, for Clark, to be a form of auto-affection, or what she calls the 'infrasensorial' (Clark in Borja-Villel and Mayo 1998: 220). In a comparable fashion, Bergson is very clear in *The Creative Mind* that the perception of the metaphysical reality of which he is thinking does *not* involve a Platonic move of 'breaking away from life' or 'transporting oneself immediately into a world different from the one we inhabit' (Bergson 1992: 139). Above all, Bergson argues that one should not try to 'lift oneself above Time' in order to encounter ontological reality in itself, since he wants to seek the real *in* change not beyond it. To challenge the relativity of our perception, Bergson insists:

> we should not have to get outside of time (we are already outside of it! [namely, when we hypostatize change by intellectualizing it]), we should not have to free ourselves of change (we are already only too free of it!); on the contrary, what we should have to do is to grasp change and duration in their original mobility. (Bergson 1992: 142)

It is not change that must be transcended to achieve metaphysics, for Bergson; rather, it is our tendency to spatialize time and divide up movement that takes us away from reality, from 'the uninterrupted humming of life's depths' (Bergson 1992: 150).

I would also argue that Kaprow is less interested in the conceptual decision to see life as art, or the idea that anything can be made into art, than he is in what we might call the becoming-Life of art as nonart. Or rather, he appreciates the need to move on in the thinking of the relation between art and life, beyond the linguistic gesture of a subject through which 'nonart can be art after the appropriate ceremonial announcement' (Kaprow 2003: 128). There is nothing radical for Kaprow in the idea that art is whatever an artist, or art-conscious person, says it is, or whatever is placed into a gallery.[87] Rather than being a conceptual decision, 'Performing Life' is an aspect of the process of what Kaprow calls 'un-arting': a new mode of research and development in the preparation of works, distinct from the conventional idea of

the artist at work in her studio – especially if the studio is a place detached from daily routines of eating and sleeping and so forth. Kaprow's concept of 'performing everyday life' names a research process in which the un-artist engages before creating an Activity. Such performance involves a particular kind of *attention* or framing that transforms that which is attended to – the routine or the everyday. Attention exposes the artificiality of what appears natural, Kaprow argues, or increases the perceptibility of those aspects of life that have become 'almost too familiar to grasp' (Kaprow 2003: 188, 190). Imperceptibility, Kaprow suggests, can be the product of perceptual habits. For example, Kaprow discusses brushing his teeth as an act that 'had become routinized, nonconscious behaviour' in comparison to his 'first efforts to do it as a child'. Kaprow reports:

> I began to suspect that 99 percent of my daily life was just as routinized and unnoticed: that my mind was always *somewhere else*; and that the thousand signals my body was sending me each minute were ignored. (Kaprow 2003: 221, emphasis added)

Here, Kaprow alludes to the human capacity to experience thought as disembodied and to fail to perceive the thinking presence of the body. As Kaprow indicates when he refers to 'the thousand signals' sent by the body, the artist's affective presence to the 'here and now' rather than 'somewhere else' does not involve an overcoming of difference per se, although it does reject the artificial distinction between mind and body. Rather, through attention, we gain a heightened awareness of the complexity or self-difference of our body's perpetual variation in relation to its surroundings. The becoming-perceptible of the imperceptible (the 'unnoticed' and 'ignored') need not involve drugs or other extreme forms of experimentation, as Deleuze and Guattari sometimes imply. The transformation of perception, which Deleuze and Guattari theorize in terms of jumping from the 'plane of organization' to one of immanence, might equally happen through attending to rather than evacuating the body as affect, as 'the variation that occurs when bodies collide or come into contact' (Colman in Parr 2005: 11): tongue–teeth–water–paste–brush–arm.

However, this is not a question of the recategorization of toothbrushing, for instance, as art: Kaprow is more interested in the act of brushing one's teeth in itself, than in how we define it. Nor does Kaprow simply stop here: 'performing everyday life' is a research process, which is not the same as an Activity. In this sense, Zepke's reading seems to confuse two distinct aspects of Kaprow's practice in this period: his pre-Activity research process (which he describes as 'performing life') and the Activities themselves. As the essay 'Participation Performance' (1977) makes clear, Kaprow does not conceive of performing everyday life through attention as an end in itself. Or rather, although performing everyday life will have its own pleasures and insights,

Kaprow goes on to suggest that a 'prescribed set of moves' (or what Kaprow also calls *lifelike performance* or an *Activity*) might be 'drawn from' such everyday routines as 'the ways people use the telephone' (Kaprow 2003: 188). The normal, familiar routine is experienced as unknown and strange through observation as part of a preceding period of research or study, but then this action must be treated in a particular way in order to become an Activity that is neither too much like 'Art art' (rather than nonart or lifelike art) nor too much like routine life (rather than Life, or lived change).

On the basis of these arguments, I would suggest that Kaprow's Activities are best understood as attention-training exercises that affirm our onto-logical participation in immanence, change and movement. In this sense, the Activities enact the 'education of attention' for which Bergson calls and constitute a method for leaping onto what Deleuze calls 'the plane of immanence'. Such ontological participation does *not* involve a dissolution of the material self in order to become the adequate vessel for the passage of a dematerialized thought. On the contrary, it involves paying attention to our capacity to change and be changed by other material bodies, and an experience of 'growing in the midst of things' rather than being irrevocably separated from them (Deleuze and Guattari 1988: 280). That is, whereas Hallward and Zepke emphasize the (a)political implications of the transcen-dence that they attribute to Deleuze and Kaprow respectively, Kaprow him-self tellingly described participation as 'the most ... democratic contribution of the late avant-garde' (Kaprow 1994: 52).

Conclusion: Becoming the whole as change

In this chapter we have looked at Kaprow and Clark alongside one another, noting their shared concerns and the resonance of their experiments for our own concern to explore the extent to which a theatre of immanence might involve participation. The implication has been that, while Kaprow and Clark were largely operating in conversation with the context of art – in often fraught and complex considerations of artistic traditions and institutions – their work, nevertheless, has much to offer considerations of participation in the overlapping context of performance. Emphasizing the ontology of change and the immanent mereology that Kaprow, Clark, Bergson and Deleuze have in common, I have argued that although our immanent view insists that all things take part in being as change, this does not preclude the idea that individual bodies express this participation to greater and lesser *degrees*, for instance in terms of greater degrees of openness to the whole as change and movement. Likewise, while we have forcefully rejected any simple opposition of participation and observation in performance, we have acknowledged that there are particular forms of performance that *go further* to provide the context for immanent expression. Or again, while we have seen that neither Kaprow nor Clark is simply against Art or its institutions (since these too are parts of

the changing whole, and therefore also capable of perceptible change), we have also noted that there are forms of art and life that *do more* to restrict a sense of immanence and to reinforce the idea that present experience is limited to the ideas we already have of it.

Correlatively, then, I have argued that Kaprow and Clark produced various, specific practices to increase the likelihood that a participant might experience a 'sense of the whole' – practices involving the undoing of habit, the defamiliarization of routine and the training of attention. And, as we noted along the way, these practices also included alterations of speed, as one method among others that Kaprow explored to enhance imma-nent experience. In turn, this question of the relationship between time and immanence will be the focus of our next and final chapter. We have already touched on the notion of temporality at a number of points in the book so far, for instance in our discussion of Marcus Coates's work as that which places human and nonhuman rhythms and ways of being in time alongside one another. In what follows, I will go into more detail regarding Deleuze's specific philosophy of time, as one that is strongly influenced by the Bergsonian concept of 'duration', but I will also examine the relation between time and immanence by returning to the work of Goat Island and Robert Wilson. Whereas Clark and Kaprow sometimes called on us to step outside the gallery in order to access immanent experience, Goat Island pro-pose that we can stay in the theatre and still increase the degree to which we take part in the multiple nature of the present. Indeed, the company will go as far as to say that – as a 'live', durational art – performance is especially well equipped to increase our exposure to the plurality of durations, and indeed to the ethical implications of this encounter.

5
Ethical Durations, Opening to Other Times: Returning to Goat Island with Wilson

The last chapter raised many questions that deserve fuller responses than those we have provided thus far: for instance, we need to go further to explain the nature of 'the whole' of which we have said that all things, including theatres of immanence and this book as an account of theatres of immanence, are a part. That is, we must continue to pursue this question of the relationship between the whole and the parts, or the One and the Many, within our account of immanence, as well as addressing the aesthetic and ethical question of how different performances or different experiences of participation might be *valued* with respect to immanence. After all, given that ethics has been a concern from the start, surely the issue of *value* must be paramount to our investigation as it comes to its conclusion. How can we measure the value or 'success' of the various theatres of immanence that we have articulated here (or are they all on a par, laid out on a plane of immanence with equal value)? Moreover, how do we measure (if we can) the value of a theatre of immanence over other theatres in general, theatres outside of immanence, whatever they might be? Or is there no outside to immanence – as has often seemed to be the case – such that all theatrical forms lie on the one continuum between the ideal poles of pure immanence and pure transcendence, only *tending to* either one end or the other without ever being *at* one or the other. In which case, how do we measure value on such a continuum that is now differentiated only in degrees; that is, horizontally rather than vertically (qualitatively)? And is the language of 'degrees' the most appropriate one we can find to speak of how these theatres might be ordered? Can we go further to articulate the *difference* of 'things' in terms of immanence – to say how, why and to what end specific performances differ with respect to their participation in what the last chapter described as an 'open whole'? Is it all a question of perception, ultimately down to the nature of the attention that audiences pay to what they participate in; or can performance makers do more and less to attract, or even force, that attention?

These are the kinds of questions that this final chapter must attempt to answer as we turn our attention to the *temporality* of theatres of immanence.

In this sense, our questions might now be rephrased as follows: How do these theatres take part in the whole understood as duration? What is the nature of the difference between theatres that operate at different speeds or at different rhythms? And in turn, what is the relationship between these differences and the (qualitative) difference in kind that Deleuze says constitutes the nature of time or duration per se? Is the value of the 'slow theatre' of Robert Wilson and Goat Island different in kind from those hyperactive theatres that offer immediate entertainment in confirmation with the dominant evaluation of the accelerated? Or do they only differ in degree, in ways that are always relative to one another and to their wider context?

As this chapter will try to make clear, this is not a question of performance *representing* time differently; it is not a matter of the audience becoming *conscious of the idea* that life operates at multiple speeds, in a variety of time signatures. Rather, as Wilson and Goat Island will help us to emphasize, performance allows our life to really beat to a new rhythm, whether as audiences or performers; it allows the multiplicity of duration to be something *lived*, rather than merely contemplated or reflected on from a safe distance. In this way, as Bogue has emphasized, we will see how what Deleuze calls the 'plane of immanence' is not only a realm of affect and ontological participation, as we have already described, but also specifically a *temporal* 'dimension of rhythms, movements, pauses, accelerations and decelerations, in which each body's form and function emerge as secondary products of *kinetic* relations among particles' (Bogue 2007: 11, emphasis added).

Furthermore, while we must acknowledge that all performances and indeed all aspects of life offer this real chance to alter our felt time, I will argue that Wilson and Goat Island are among those who have gone the furthest or been the most insistent in terms of putting their audiences in the midst of a plurality of durations. For sure, all performance is constituted by its participation in duration; no matter how seemingly organized in terms of rigid distinctions between past, present and future, all performance is actually immersed in time as change. However, Hans-Thies Lehmann has argued that it was Robert Wilson who 'created a "theatre of slowness". Only since Wilson's "invention" can we speak of a proper aesthetics of duration' (Lehmann 2006: 156). And yet it is not even the question of 'firstness' that interests us here, but the question of what these practitioners *do*, less to make us *consciously notice* duration, as Lehmann suggests, and more to make us *feel time* in new ways.

However, we will have to go further still in order to say something concrete with regard to the *ethics* of immanence, and with respect to theatres of immanence. In the first instance, as we have already hinted at with respect to Marcus Coates's relationship to the speeds of animals, opening up to other ways of being in time – as Goat Island and Wilson do – is one way to respond to an ethical demand 'to open ourselves affectively to the actuality of others' (Mullarkey 2004: 488). The multiplication of the present,

or the relativization of the human form of lived time, implies an ethics in which other durations are somehow taken into account, are not forced to speed up or slow down according to some supposedly universal standard. Secondly, we know from our discussions of 'affect' in Spinoza and Deleuze that there are sadnesses as well as joys to be had in our encounters, and that performance too can constitute empowering or disempowering affects for those caught up within it. In order to pursue the implications of this, the present chapter will also attempt to conjoin Deleuze's experimental ethics of affect with a more Bergson-inflected ethics of duration, emphasizing the temporal dimension of affect before going on to consider the ethical basis on which we might attribute value to different ways of being in time. As André Lepecki has suggested, 'ethics emerges as the immanent force of philosophy, as a radical mode of composing the infinite velocities and slownesses of being' (Lepecki 2007: 122). But on what basis might we order such compositions, at what speed might compositions be at their most joyful (and why is joy connected to one speed rather than another)? Thirdly, we might also wish to consider the temporality of ethics itself, given Deleuze's rejection of a universal and eternal ethical system based on transcendent values. That is, although we might agree on the impossibility of an ethics that could be applied to all things at all times, can we make any sense at all of a concept of a temporary or mobile ethics? Finally, then, we will have to bring performance back into the discussion by attempting to invoke the ethics of theatres of immanence per se – a problem that will lead us to the conclusion of the book as a whole.

By way of introduction, I want to start by giving a necessarily summary outline of existing accounts of performance and time, alongside a brief exposition of some of the key ideas within Deleuze's highly complex philosophy of time, which is strongly influenced by Bergson. As we shall see, the relationship between performance and time has been differently configured with respect to the notions of 'drama', 'postdramatic theatre', 'performance' and 'live art', but, in each case, much of the questioning revolves around the nature of 'liveness' and to what extent performance has a special relationship to 'the present' and to 'presence' in relation to other arts. In turn, it is clear that time is a central concern for Deleuze's thought and receives in-depth treatments in many of his works, including *Nietzsche and Philosophy, Bergsonism, Difference and Repetition, The Logic of Sense* and the *Cinema* books.[88] In each case, as we shall see, Deleuze turns towards time in order to articulate pure difference or difference in itself. In this way, bringing Deleuze and Bergson into these performance-based conversations will allow us to provide some alternative accounts of what constitutes 'the present' in the first place; indeed, to propose that there is no such thing as '*the* present' or a single 'Now' but a 'multiplicity of presents, each with a correlatively different past and future' (Mullarkey 1999: 54).

Indeed, Matthew Goulish of Goat Island has explicitly discussed performance in these terms. He writes: 'I simply, but hopefully not simplistically, propose that performance figures in our dialogue as a set of practices that enact, or reenact, or articulate duration's multiplicity as live or as lived' (Goulish in Cull 2009a: 132). In this way, as we noted in Chapter 1, there can be no doubt that Goat Island as a company have been influenced by Deleuze, but more recently (and of much interest, as we will see, for this chapter) they have also been influenced by Bergson, who, perhaps above all, shaped Deleuze's philosophy of time. Specifically, this chapter will show the evidence not only for a long-standing engagement by Goat Island with Deleuze's thought in general, but also for a particular engagement with the Deleuzo-Bergsonian notion of time as duration, becoming and a multiplicity of presents that would throw a final light (that is both philosophical and ethical) on theatre's immanence. Again, this is particularly evident in Goulish's writing. For instance, the Deleuzo-Bergsonian concept of duration takes centre stage in Goulish's paper 'The Time of the Ordinary' (2008), just as the idea of time as ceaseless change or becoming (rather than a container of such change) is foregrounded in Goulish's contribution to the collaborative essay 'A Dialogue on Becoming' (2007). In the latter, Goulish writes:

> Memory exists in each perception, because each moment, however small, has duration. A change transpires in each moment. Memory in a sense coheres a moment as a moment, as we might remember its start a certain way at its end, in order to make it one thing, a moment. We perceive duration through change; we perceive change through movement. A moment, then, is moving. Because it is moving, it is always becoming. It will never become what it is becoming. (Goulish in Watt and Meyer-Dinkgräfe 2007: 61)

Finally, we might also note that one of the most recent texts published by company director Lin Hixson not only foregrounds Bergson's time philosophy, but also points to the implications of these ideas for rethinking presence in performance. Of *The Lastmaker*, Hixson writes:

> You sit on one side of the performance. I sit on the other. When I look across the room and see you watching the performers sing songs around the dining room table, I know your heart beats at a different rate than mine. This tells me we will die at different times. Knowing this I wave good-bye to you ... My duration encompasses and discloses yours. Your duration encompasses and discloses mine. (Hixson 2008: 52)

Hixson's text perhaps constitutes the most direct acknowledgement of the company's interest in the Deleuzo-Bergsonian idea of the present as constituted by the coexistence of multiple durations; that is, in the idea that there

is no single 'here and now', but several different and self-differing actualities. However, the purpose of this chapter is not simply to point out that Goat Island are interested in Deleuze and in Bergson. Rather, in this chapter we will be focusing on Goat Island's work alongside that of Robert Wilson in order to examine the specifically temporal aspect of immanence. But before we move on to Goat Island and Wilson in particular, I want to contextualize these remarks by giving a brief overview of some of the existing ways in which the relationship between theatre and time has been conceived.

One, two or many durations? Time in performance and philosophy

> A director must sense time without having to look at his watch. A performance alternates dynamic and static moments ... This is why the gift of rhythm seems to me to be one of the most important prerequisites for a director. (Stanislavski, cited in Pavis 2003: 146)

Just as Stanislavski emphasized the value of a sense of rhythm for directing, Meyerhold argued that 'One must teach actors to feel time on stage as musicians feel it' (Pavis 2003: 145). And yet, despite the obvious importance of temporal considerations to the notion of performance, there remains surprisingly little extended scholarship focused on the relationship between performance and time. The reasons for this are no doubt manifold. Patrice Pavis, for his part, notes that time 'is not easy to describe, as description implies being outside time' (Pavis 2003: 409). Any philosophy *of* time – which includes Deleuze's – must answer the question of its own relationship to the time it describes, or rethink description itself temporally. Secondly, Pavis suggest that 'The analysis of ... rhythm and temporality poses major problems' for the theatre scholar, 'and yet these elements often leave indelible traces in the spectator, traces that resist being measured and mapped' (Pavis 2003: 147). We know that we are affected by the time of performance, but perhaps our language of degrees will come under question here too, as one equally inadequate way to articulate what it is that different durations do to the audience. Thirdly, Pavis proposes that 'Like Saint Augustine, we could say, "I know what time is, as long as no one asks me"' (Pavis 2003: 147). This quotation will be of particular interest to us here, given its implication of the difference between embodied knowledge and conscious knowledge or representation with respect to time, between lived duration and its explication. That is, might it be that such an idea will bring us to a greater understanding of what is really at stake in conceiving *performance as a kind of thinking in its own right*, or of *performance as philosophy*? Is it that performance offers us the chance to know more of what time is, but specifically in a lived rather than representational sense? We may not be able to say, when asked, what we have lived in and as performance,

but this does not make that experience any less valuable – particularly in an ethical sense.

However, we are getting ahead of ourselves. It is time to slow down and begin again. According to Pavis's account, there are two kinds of time in theatre from the spectator's point of view: the 'dramatic time' of the fictional world of a play and the 'stage time' of the theatre event. And, for him, while the former must be 'reconstructed using a symbolic system', the latter is simply a time 'that refers to itself' – the 'here and now' or 'the unfolding of the performance' (Pavis 1998: 409). Regarding stage time, Pavis continues:

> This time unfolds in a continuous present, for the performance takes place in the present: what happens in front of us happens in our spectator's time scheme, from the beginning to the end of the performance. (Pavis 1998: 409)

In this way, Pavis suggests, stage time marks the coincidence of

> the time of the performance under way and of the time of the spectator watching it. It consists of a continual present that is constantly vanishing and being renewed. It is measurable chronometrically – from 8.31 to 11.15, for instance – and is psychologically tied to the spectator's subjective sense of duration. (Pavis 1998: 409)

In contrast, Pavis's concept of 'dramatic time' concerns the construction of enunciations that produce the illusion of past, present and future events taking place 'in a possible world', distinct from the here and now of the theatre event (Pavis 1998: 409). Thirdly, though, Pavis also proposes that we might use the term 'theatrical time' to refer to the relationship between stage and dramatic time, where theatrical time is then characterized by 'the co-existence of two times of different natures' (Manceva, cited in Pavis 1998: 409). Different natures or kinds, Pavis suggests – that is, for him, the time of the stage and the time of the auditorium belong to two different orders that coexist alongside one another within the spectator's experience.

This notion of a duality of time in relation to theatre might be traced back to Aristotle, who insisted on a clear separation between 'drama and the external world', albeit that his arguments would later be interpreted to insist on the 'identity of represented time and [the] time of representation' (Lehmann 2006: 161). That is, as Lehmann relates, Aristotle's concept of 'the unity of dramatic time' sought to 'demarcate a sealed off sphere of the aesthetic with its own artistic time' and internal coherence, in a move that valued the power of drama to bring 'logic and structure into the confusing plethora and chaos of being' (Lehmann 2006: 160). Aristotelian drama improves on the unsettling, worldly experience of time by rendering its discontinuity seamless and unknowability predictable. Or, as Lehmann puts

it, Aristotle conceived of an aesthetic that aimed *'to prevent the appearance of time as time'* in a tradition that continues to inform Hollywood cinema (Lehmann 2006: 160, emphasis in original). Real time must go unnoticed in order for the drama to be the focus.

But of course, we cannot think in terms of the time of theatre and performance 'in general'. That is, while I am arguing that all performance is immanent (to immanence itself), the myriad historical forms of performance occupy infinitely varying levels of immanence. Hans-Thies Lehmann provides a helpful summary of the conversation between Western philosophy and performance in this regard, indicating how experiments with the treatment of time in theatrical form might be understood as practical parallels to the theorizations of man's relationship to time from Aristotle to Kant, Nietzsche and Freud (Lehmann 2006: 155). In particular, Lehmann contextualizes some of Wilson's work within a broader tendency towards 'the loss of time frame' across the arts from the 1950s onwards. In these new dramaturgies of time, Lehmann argues that artists

> suspend the unity of time with beginning and end as the enclosing frame of the theatre fiction in order to gain the dimension of the time 'shared' by the performers and the audience as a processuality that is on principle open and has structurally neither beginning, nor middle, nor end. (Lehmann 2006: 155)

For his part, Pavis discusses how time is treated in the 'closed form' of dramaturgies like the 'well-made play' (in ways that might be contrasted with our discussion of the 'open whole' in the previous chapter).[89] In the closed form, Pavis explains, both space and time are structured to remain as homogeneous as possible; an apparent, internal consistency of time is valued over change as that which secures the illusion of the fictional world.

> Time has a value as duration, as compact and indivisible substance, as a brief crisis concentrating all the dramatic phases of a unified action. It retains the same quality throughout the performance; as soon as it threatens to alter or distort the time of the main hero's inner action, it is mediated by a narrative and reconstructed by discourse. (Pavis 2003: 57)

However, clearly performance does not always value time in this way. Josette Féral, Peggy Phelan and Adrian Heathfield, among others, have explored the ways in which performance art and its close relative 'live art' have valued time as ephemerality, not least as that which allows performance to differentiate itself from 'drama', 'theatre' and 'art'. Féral, for instance, argues that performance does not imitate another time; it is that which simply 'takes place' and occupies 'a continuous present – that of the immediacy of things, of an action taking place' (Féral 1997: 292).[90] In this sense, Féral

conceives of performance as doing away with what Pavis called 'dramatic time' in favour of an exploration of the aesthetico-political implications of 'stage time' explicitly understood as a time *shared* by performer and spectator alike (Féral 1997: 296). In this way, there is a paradoxical sense in which such articulations of performance as distinct from theatre in fact suggest a connection to drama in their emphasis on unity. Indeed, Lehmann notes as much when he suggests that 'The basis of dramatic theatre was the demand that the spectators leave their everyday time to enter a segregated area of "dream time", abandoning their own sphere of time to enter into another' (Lehmann 2006: 155). For instance, Lehmann argues that what he calls 'the new dramaturgies of time' (namely, postdramatic theatre) think in terms of a 'new concept of shared time' in which the time 'aesthetically shaped' by the performance maker and the 'real experienced time' of the audience are like 'a single cake, so to speak, shared by visitors and performers alike' (Lehmann 2006: 155).

Likewise, Heathfield argues:

> From its beginnings ... performance has consistently replaced or qualified the material object with a temporal act. Performance's birth within and against theatrical form is equally rooted in an engagement with the time of enactment and its disruptive potential in relation to fictive or narrative time. (Heathfield 2004: 8)

According to our own continuum thinking, we might wish to revise such theatre/performance distinctions in the language of more and less, noting the extent to which drama and theatre had already embraced 'disruptions' to the representation of fictional time and, likewise, painting and sculpture had explored their durational aspects long before the birth of 'performance' as a specific category. Or again, interventions of artists notwithstanding, our very ontology insists that there is always already a temporality in 'material objects' like painting and sculpture, always already a multiplicity of times (including the differing times of truths and fictions) in even the most 'conventional' manifestations of theatrical form.

But whereas much of the contemporary discourse surrounding live and performance art continues to value such practices on the basis of a presumed hereness and nowness, Deleuze's philosophy of time refuses any such concept of a self-same present. When we think about time, we tend to start by thinking in terms of 'things' or 'selves' that *then* go through time, to put being before becoming. But for Deleuze, becoming (time) comes before any being ('thing' or 'self'). For example, in *Nietzsche and Philosophy*, Deleuze follows the early Greek thinker Heraclitus in arguing that present reality does not have 'being', that 'there is no being beyond becoming, nothing beyond multiplicity; neither multiplicity nor becoming are appearances or illusions' (Deleuze 1983: 23–4). Whereas for Heraclitus' rival Parmenides it is

only what is *unchanging* that is truly real, only that which does not become different from itself that can be genuinely said to exist (Turetsky 1998: 11), for Heraclitus and Deleuze what there is *is* becoming: ceaseless change, perpetual variation or difference. For Parmenides, change is appearance, not reality, and time itself is unreal; for Deleuze, as we shall see, time is no mere 'receptacle of being' (Boundas in Patton 1996: 93) – it is the real itself, the power that constitutes life as becoming. In this way, for Deleuze, existence is best understood in terms of 'the event': the only philosophical concept, he says, capable of ousting the verb "to be"' (Deleuze 1995: 141). It is not that there are static beings to whom things happen; rather, life is a complex of mutually constitutive happenings, events going on at multiple levels and at different speeds – becoming is everywhere.

However, as we have already noted, Deleuze's philosophy of time is particularly shaped by his encounter with the thought of Bergson. Going against the hostility to Bergson and vitalism that characterized the intellectual climate of his times, Deleuze framed Bergson's philosophy as making 'the greatest contribution to a philosophy of difference' (Deleuze 1999: 42), the modernity of which lies in its emphasis on 'the durational character of life' (Ansell-Pearson 1999: 21). We must, Bergson insisted, think in terms of duration. Crucially, though, Deleuze also takes from Bergson the idea that time 'is invention or it is nothing at all' (Bergson 1911: 361); the idea that time is always qualitatively differing from itself rather than merely differing in degree; and, finally, the idea that time can be equated with change and creativity in opposition to the 'essentially inert and uncreative' nature of space.[91] For Bergson, Deleuze argues,

> Duration is always the location and the environment of differences in kind; it is even their totality and multiplicity. There are no differences in kind except in duration – while space is nothing other than the location, the environment, the totality of differences in degree. (Deleuze 1988: 32)

In this scenario, 'every moment brings with it something "radically new"' (Mullarkey 1999: 9–10).

In his early work, *Time and Free Will* (1889), Bergson posits a clear distinction between duration and spatial extension. However, as his thought developed through *Matter and Memory* (1896) and *Creative Evolution* (1907), and as Deleuze's *Bergsonism* makes clear, whereas actuality is made up of mixtures of duration and matter, this is not to suggest that duration and matter are the two ingredients of a rigid dualism. Rather, matter is a tendency of duration itself; it is what happens to duration at a particular speed. Or, as Deleuze puts it, 'duration is differentiated in two directions, one of which is matter. Space is divided into matter and duration, but duration is differentiated as contraction and dilation, dilation being the principle of matter.' So just as duration is 'the variable essence of things' (Deleuze 1988: 34), things are a

case of duration differing from itself too. But as we have found in the other expressions of immanence in Deleuze's thought so far, this temporal articulation of immanence as duration still leaves immanence with the upper hand over transcendence. No matter how different duration becomes, no matter to what degree it becomes matter, it is still duration or difference in kind; difference in degree is the most dilated and most decelerated state of difference, but it is never a pure space, it has never slowed difference to a halt altogether. As Boundas explains: 'Difference of nature is one of the tendencies (duration) and matter is the indifferent, that which repeats itself, being incapable of changing its own nature and, therefore, varying only in terms of degrees' (Boundas in Patton 1996: 95).

Here, then, the notion of quantitative difference is devalued in relation to the qualitiative; duration as difference in kind is where all the real change happens, relative to differences in degree, which now no longer to seem to be classed as real difference at all. Perhaps with regard to our own continuum, in turn, we now need to specify that the degrees in question (that differentiate one immanent theatre from another) are amounts of qualitative difference. The continuum that we are attempting to conceive is not a homogeneous one in which every theatre would simply be another version of the Same, but a heterogeneous continuity that allows us to distinguish between varying quantities of immanence (participation, openness) as a quality.

Nevertheless, Deleuze's notion of duration remains a highly complex idea. He insists that duration or becoming is not limited to consciousness or to human psychology; rather, duration is a process of alteration, 'belonging to things as much as to consciousness' (Deleuze 1988: 8). In its simplest form, Deleuze says, duration is 'a lived passage or transition', but to say that it is lived, he argues, 'obviously doesn't mean conscious' (Deleuze 1978: n.p.). In turn, duration is presented as synonymous with Bergson's particular concept of 'memory', which, as Deleuze explains, he defines as 'the conservation *and* preservation of the past in the present' (Bergson in Deleuze 1988: 52). As Deleuze argues:

We have great difficulty in understanding a survival of the past in itself because we believe that the past is no longer, that it has ceased to be. We have thus confused Being with being-present. Nevertheless, the present is not; rather it is pure becoming, always outside itself. (Deleuze 1988: 55)

But what does it really mean to think of time in terms of pure becoming, 'difference' and especially 'multiplicity'? Throughout his work, and particularly in *Bergsonism*, Deleuze uses the term 'multiplicity' in a particular way that differs from the standard philosophical distinction between the One and the Multiple – to say that something is a 'multiplicity' is not just to say that it is made up of more than one thing, something that multiplies itself

in a reproductive manner (a collection of Ones, if you like). In *Bergsonism*, for example, Deleuze distinguishes between two types of multiplicity – 'quantitative' (or discrete) and 'qualitative' (or continuous) – of which the former is spatial and homogeneous (e.g. a flock of sheep or a clock's ticking of the self-same seconds) and the latter is temporal and heterogeneous (e.g. a 'complex feeling' or dissolving sugar). What matters for us here is that for Bergson, Deleuze argues, 'duration was not simply the indivisible, nor was it the nonmeasurable. Rather, it was that which divided only by changing in kind' (Deleuze 1988: 40). In other words, duration can be divided into individual moments, but this is a form of abstraction that alters the nature of the qualitative multiplicity as a continuous unfolding of difference.

As we shall see in due course, this idea will have a bearing on how we conceive of repetition in performance. But for now, we might simply note that it is this distinction (between space and time, matter and memory, the inorganic and the living) that leads Deleuze to his deconstruction of presence/the present according to the conceptual pairing of the 'virtual' and 'actual'. For Deleuze, it is especially important that we do not confuse the virtual with the possible. The virtual constitutes a real and immanent realm of difference that conditions the production of the new in the actual world, as distinct from 'the possible', which for him lacks any existence of its own, insofar as it is merely *derived* from the real as a facsimile projected into the past as if it were the anterior condition of this reality. Borrowed primarily from Bergson's *Matter and Memory* (1896), Deleuze's notion of the virtual/actual distinction is used both as an alternative to the possible/real distinction and, Smith suggests, 'as a way of reformulating the relationship between the empirical and the *transcendental*' – as distinct from *transcendence* – 'the latter being the "ground" or "condition" of the former' (Smith in Protevi 2005: 7, emphasis added). The possible, Deleuze argues, prevents us from understanding life's creation of differences because it is retrospectively constructed from the real 'like a sterile double' (Deleuze 1988: 98), despite the fact that we tend to think of things being possible before they become real over time. With the concept of the possible, the real is understood to be limited to reproducing the image of the possible that it realizes and, at the same time, the possible 'is simply traced off the empirical' in a manner that does nothing with respect to the project to think the conditions or ground of reality (Deleuze 1988: 98).

The concept of the virtual is designed to remedy this problem. Unlike the possible and the real, the virtual and the actual do not resemble one another; the former is not a blueprint for the latter. And secondly, unlike the possible, the virtual does not lack existence prior to its passage into the actual in the temporal process that Deleuze calls 'actualization' or 'differenciation': a slowing-down of the chaos of the virtual, or a deceleration that allows consistent forms to emerge. So already, the very emergence of individual bodies is understood to involve some kind of change of speed, a passage across a temporal threshold after which a body can emerge as such.

In short, Deleuze says, 'The characteristic of virtuality is to exist in such a way that it is actualized by being differentiated' (Deleuze 1988: 74). The virtual is dependent on the actual to exert its creative force and the actual (or empirical) on the virtual as its transcendental condition. Despite this association with the transcendental, Deleuze insists on the immanence of the virtual within the actual; the virtual is not outside or distinct from the actual, he argues, but inheres within identifiable forms as the motor of their becoming.

Finally, and most challengingly perhaps, Deleuze defines the virtual as pure (rather than personal) memory or as the persistence of the past. The virtual is that which conditions the production of the present and makes it pass, Deleuze argues, in a manner that has a number of implications for common-sense notions of time. For instance, Deleuze's notion of the virtual seeks to dismantle the binary between the presence of the present and the absence of the past, inviting us to think instead of the becoming of the present and the virtual presence of the past. Likewise, as Constantin Boundas suggests, the Deleuzo-Bergsonian theory of time insists that

> the present can no longer be thought of as becoming past after a new present has come to replace it, nor can the past be thought of as being constituted after it has ceased to be present ... We are indeed asked to think that the entire past preserves itself and, therefore co-exists with every present. (Boundas in Patton 1996: 93–4)

That is, Deleuze and Bergson propose that it is not that the past has been present and then passes, but rather that 'the present is constituted as past at the same time that it is constituted as present', in a kind of simultaneous doubling of reality as both virtual and actual (Boundas in Patton 1996: 93–4). The presence of the present, then, is differential rather than self-identical.

So, this is very much a counter-intuitive theory that invites us to abandon almost all of our current associations with the term 'past' as a tense, but also one that seems to many to risk a reintroduction of the transcendent (through the notion of the virtual as 'condition') in ways that we will attempt to avoid here. Instead, we will take this opportunity to go further in our exploration of some of the recent critiques of Deleuze that we began to address in the last chapter. Does Deleuze place a greater value on the virtual over the actual, or on 'creation' rather than 'creatures' (to translate the question into Hallward's terms)? Or is it more that there are Virtualist *Deleuzians* who have tended to denigrate the actual in favour of the virtual, creating a hierarchy between the two concepts on the basis of the idea that actual forms are 'ontologically dependent upon a ground that is not their own', as Mullarkey suggests (Mullarkey 2004: 470)?[92] Whereas Deleuze and Bergson's original struggle was to convince skeptical empiricists of the

reality of a virtual realm of difference and duration, Mullarkey seems to suggest that the balance has now swung too far the other way – such that *only* the virtual is considered real and fundamental, while actual forms are treated as mere by-products that must be forgotten or relinquished in order to access the durational processes understood to bring them about. In turn, Mullarkey argues, there has been a tendency in recent Deleuze Studies to set up a Manichean distinction between the 'good' virtual (molecular, rhizome etc.) versus the 'bad' actual (molar, tree etc.). However, if the actual really is 'bad' or (at best) less worthy of attention than the virtual, then this clearly has implications for how we act in actuality, for our ethics and politics.[93]

In contrast, Mullarkey argues that it is the notion of a realm of virtuality that is the psychological by-product derived from the reality of actuality (not the other way round).[94] And in turn, he proposes what he calls 'Actualism', based on other aspects of Bergson's work, in which the virtual is understood not as *grounding*, but as itself *grounded by* 'a play of actualities' (Mullarkey 2004: 471). He argues that 'the actual is always already actualised somewhere, to some point of view'; whereas the virtual is but 'a perspectival image seen from ... an interacting set of actual positions' (Mullarkey 2004: 469). What may appear 'virtual' or 'past' from one perspective is 'actual' and 'present' from another; what is 'beyond experience' clearly depends on the notion of actual experience with which we begin. In what we might call 'the virtualist Deleuze', the virtual is conceived as some kind of hidden potential or secret force that explains the phenomenon of actualization: that what there is, differs. Mullarkey, however, wants to relativize the perspective from which this perception of an 'ontological hinterworld' derives (Mullarkey 2004: 471). It is not, he argues,

> that there is one type of actual perception with the virtual existing beyond and around it (as a reservoir of difference) but rather that there are numerous different forms of actualities that *virtualize* their mutual differences such that a lowest common denominator is abstracted or spatialized – termed disparagingly 'the actual' or 'the perception of *the* present' or simply 'presence' – whilst those differences are consigned to a halo surrounding that single actuality and called 'the virtual' or the 'memory of the past' (Mullarkey 2004: 474–5, emphasis in original)

Here is where the concept of Actualism becomes central not only to the concerns of this chapter but to an objective of this book as a whole: to construct a notion of immanence that is neither a simple presence nor a single present, nor an appeal to a transcendent 'beyond'. This task is also, correlatively, to conceive a theatre of immanence that is not simply 'here and now' nor only 'differed' and 'deferred' according to an anthropocentric emphasis on language and representation. Rather, Actualism takes account

of the myriad actual perspectives that constitute the heterogeneity of the whole, in order to suggest that there is not merely 'one type of presence everywhere' in relation to which everything else is either past or future – that is, 'virtual' – but multiple presents and actualities that can be perceived through an enlargement of human perception (Mullarkey 2004: 487).

In this way, the Actualist project is underpinned by an ethical demand to acknowledge the reality of multiple actualities (not only a single 'actual'), rather than 'virtualizing' these actualities as the differential ground to a single, dominant actuality or presence. It may be that Virtualism seemingly celebrates this virtual as the creative engine behind the actual, but nevertheless, Mullarkey suggests, this celebration masks a form of oppression or a denial of the reality of difference.[95] As such, beyond merely deconstructing presence according to the virtual/actual distinction, we need to acknowledge the presence of multiple actualities, even when those actualities are invisible or imperceptible to 'us'. That is, regardless of the limits of our specific perspective, these multiple actualities 'are always actual in and for themselves' (Mullarkey 2004: 481). Presence is a *plurality* of presents, or a multiplicity of inhuman as well as human ways of being in time. Therefore, the approach to the temporality of presence that Actualism promotes is one that is less anthropocentric than either the metaphysics of presence (as deconstructed by Bergson, Derrida and Deleuze) or Virtualism, but also less 'past-ist' than the latter, given its support for the development of an enlarged perception to encounter the thickness of the present (as presents, plural).[96] And it is my contention that there are few better contemporary examples of this approach at work in performance, or of a response to this call to enlarge perception (and with that, our understanding of what is involved in 'spectatorship' or what goes on in theatrical space), than Goat Island and some aspects of the work of Robert Wilson. In what follows, I will attempt to explain why.

Speeds and slownesses, plural

Slowness and slow motion in performance are something that a number of the practitioners discussed in this book have explored. As Jannarone reports,

> Artaud returns repeatedly to slow motion in his staging ideas … In his 1925 *Le Jet du Sang* (*Jet of Blood*) … stage directions call for objects – including human flesh, heads of hair, scorpions, and a scarab – to fall with 'a dispiriting, a vomit-inducing slowness'. (Jannarone 2010: 156)

Likewise, she describes how in his 'production plan for *Le Songe*, a "slow-motion effect" allows characters and their doubles to "arrive on stage without anyone having noticed it"' (Jannarone 2010: 156). In turn, Georges Lavaudant defines theatre in terms of its speeds and against any

informational relation to its audiences, exploring unexpected tempos via the slow-motion movements of figures in works such as *Palazzo Mentale* or the slow-motion battle scene in *Richard III*. Lavaudant argues:

> Theatre can take everything in. It must absorb everything. Theatre with its fragility and slower rhythm holds its own against the omnipresence of rapidly moving images. And I stand with it against all the 'great communicators' who try to mystify us. (Lavaudant in Fayard 2003: 37)

Or again, we might note the way in which 'eternally slow continuously morphing movement' has come to be recognized as a characteristic feature of butoh, where the decelerated movement of bodies is often received as having a dream-like quality (Fraleigh and Nakamura 2006: 80). Of course, as we will explore further in what follows, one could argue that in becoming recognizable, the very affect of slowness is lost, or at least diminshed: if we expect butoh to be slow, slowness comes as no surprise. Whereas in the previous chapter we saw how Kaprow used alterations of speed as one way to invite participants to detach gestures from our ideas of them, and to embody alternative ways of being in time. One example was the instruction to shake hands as slowly as possible – an action included in a number of the 'attention-training' workshops that I have recently run. Participant responses vary, exposing the complexity within an apparently simple event: some report a phase of questioning at the start of the action (how slow is 'as slow as possible'? Does the action end when I reach the other person's hand or only when we have also shaken hands a number of times? How many times? and so forth); others describe their conscious or unconscious decision to attempt to 'keep pace' with their partner, to slow down to the same degree as the other with whom they are to shake hands; while others still speak of a sense of disassociation from their 'own' arm – a feeling that their arm has somehow begun to resist instruction and is exploring its own durational thresholds.

This instruction 'as slow as possible' may well be an implicit homage to John Cage. In 1985, Cage composed the suite for piano or organ entitled *Organ2/ASLSP* (As SLow aS Possible). The performance of the score began at Halberstadt Cathedral in Germany in 2001 and 'is scheduled to end in 2639', with the length of the performance having been determined by 'the instrument's age (639 years) when the concert began' (Paull 2007: 279). As Carl Honore reports:

> To do justice to Cage's piece, the organizers built an organ that will last for centuries. Weights attached to the keyboard hold down notes long after the organist has left. The ASLSP recital began in September 2001 with a pause that lasted seventeen months. During that time, the only sound was that of the organ bellows inflating. (Honore 2010: n.p.)

Here we might recall Berkeley's famous question of whether or not a falling tree makes a sound if no one is there to hear it, the Deleuzian answer to which must be that there is always someone, some hearer there, albeit that the listener may not be human. And likewise, it is not that no one can hear Cage's ASLSP, so much that the recital requires an expanded perception, an alternative way of being in time than a human audience can offer.

In another homage to Cage, 'As Slow As Possible' was also the title of the most recent AV Festival in the North-East of England, the promotional description of which explicitly framed deceleration as a form of resistance to the increasing cultural emphasis on the value of fastness, in ways that appear to resonate with Goat Island's own attitude to slowness.[97] As company member Karen Christopher explains:

Slowness is part of our process and is a reaction against speed. Collaboration is a slow process and devising is a slow process for us. On top of this, we are manipulating the viewers' sense of time by going at other than usual paces and using improbable time signatures. A quick understanding of circumstances or ideas often misses depth and complication, so slowness is also a way of allowing complexity into the work. (Stanier and Christopher 2004: n.p.)

In this sense, and as many other commentators have noted, slowness operates on multiple levels in Goat Island, at the level of process and rehearsal as well as in performance. As Sara Jane Bailes has described, 'Goat Island builds each show in an emphatically slow and methodical way over extended periods of time' – a decelerated approach to performance making that has since become more commonplace despite the financial difficulties it raises, but was certainly not the norm when the company began in the late 1980s (Bailes 2010: 119).[98] But they also aimed to resist convention in terms of the expected speeds of performance itself. In part, this embrace of slowness in performance can be attributed to Hixson's earlier experiences of the work of Pina Bausch and Tadeusz Kantor, 'which she read as actively resisting (albeit in very different ways) the contemporary cultural pressure to communicate or entertain quickly' (Bottoms 1998: 442). They acknowledge that this means that their work placed 'attention demands in the audience' as well as 'physical demands on the performers' (Goat Island 2009: n.p.).

For Heathfield, Goat Island's approach to time is part of a broader contemporary tendency in performance to want to 'slow things down, to examine gesture, relation, [and] meaning production not only *as* a process, but *at* a significantly slower speed' in relation to 'the demands so prevalent in contemporary culture for instantaneous relationships between art and meaning, intention and realisation, desire and fulfilment' (Heathfield 2004: 10, emphasis in original). And to some extent, we might consider such remarks in the light of Paul Virilio's 'dromology': his studies of the logic of

speed in works such as *Speed and Politics* and *The Aesthetics of Disappearance*. Virlio emphasizes the prevalence of a 'political economy of speed' in contemporary culture, arguing that 'if time is money ... then speed is power' (Virilio, cited in Armitage 2001: 35). In particular, Virilio wants to think in terms of the temporal thresholds of both politics and thought, simply stating: 'Politics depends upon having time for reflection. Today we no longer have time to reflect, the things that we see have already happened. And it is necessary to react immediately' (Virilio 2005: 43).

However, there is more to Goat Island's use of slowness than this and, indeed, their emphasis on duration as *the* material of performance affects every facet of their work – including not only the overall pace of the work, but also their approach to aspects such as 'character', as we shall see. In the first instance, I would argue against any straightforward celebration of slowness per se (particularly as a political value) and a correlative denigration of speed as if it were an absolute. Rather, perhaps our ethics of time must begin with the *relativization* of our concepts of speeds and slownesses. Indeed, we might note that, more recently, slowness too has been absorbed by capitalism, becoming the foundational value of a whole new set of lifestyle choices, thanks to the growing prominence of the 'slow movement'. That is, just as slowness and stillness have become popular in performance – think of Lepecki's discussions of these forms in contemporary dance – we are also being invited to buy into slowness in the form of slow food, slow schools, slow travel and even slow money with the notion of 'nurture capital'.[99] That is not to say that slowness cannot compete with the still dominant political economy of speed that Virilio has outlined, but it is to suggest that we need to temper any unquestioned and decontextualized attribution of anti-capitalist value to 'the slow', just as we might wish to complicate any immediate appeal to the catastrophes of acceleration.

Indeed, Goulish directly engages with Virilio's lament for the disappearance of space or latitude, emphasizing the relativity of speed with respect to the assumed 'threat posed by accelerated communication'. That is, Goulish proposes that we think in terms of the impact of new technologies, for instance in terms of the *multiplication* of latitude, rather than its disappearance. He writes:

> The introduction of the 'instant' message into the technologies of communication appears as an acceleration if one compares it to, for example, the speed of the same message handwritten onto a postcard and carried in the mail. We then say that the shared latitude has virtually disappeared. Could we not instead say that instant messaging has introduced a different latitude onto the globe; that now we have the postcard latitude and the text message latitude, and we understand speed as a comparative relation between the two? (Goulish in Cull 2009a: 127)

Likewise, I would argue against the idea, evoked by Virilio among others, that *thinking* is something that occurs at a particular and universal speed – and, as such, that one could operate at a speed that we might characterize as 'too fast to think'. In particular, I think that we need to question the characterization of thinking as some kind of distanced reflection that can only occur outside the accelerating velocities understood to constitute contemporary capitalism. Rather, again, I suggest that it is a question of multiplying our definition of thinking, beginning with the acknowledgement that the specific speed of consciousness is not the only time to consider with respect to thought.

No doubt there is a value in experimenting with the pace of thought. As Goulish writes:

> Most of us live in fear of slowing down our thinking, because of the possibility that if we succeed we might find that in fact nothing is happening. I guarantee this is not the case. Something is always happening. In fact, some things happen which one can only perceive with slow thinking. (Goulish 2000a: 82)

Nevertheless, there are also occasions when quick thinking is what is required. Remember in Chapter 1, for instance, we noted that Goat Island's creative process 'values the considered response no more and no less than the seemingly unrelated distraction' (Goulish in Bailes 2011: 112). And so here too, it is not a question of producing a new hierarchy in which slowness is fixed as the dominant value, but of placing a value on the *multiplicity* of duration(s), not only those speeds that meet the needs of capitalist forms of organization at any given time.

Immanent theatre in the context of the postdramatic

Hans-Thies Lehmann has argued that one defining aspect of 'postdramatic theatre' (a category of contemporary theatre in which he includes both Wilson and Goat Island) is a 'real-time' aesthetic characterized by 'the intention of utilizing the specificity of theatre as a mode of presentation to turn *time as such* into an object of the aesthetic experience' (Lehmann 2006: 156, emphasis in original). Postdramatic theatres seek to dismantle the conventional ways in which time has been organized, whether we think in terms of structuring devices like curtains, intervals, scenes, acts, plot and narrative, or in terms of audience expectations with respect to standard lengths of performance, speeds of speech and movement, and dominant desires for particular rhythms of action and entertainment. By way of example, Lehmann notes that 'Wilson caused a stir by stipulating "intermissions at your discretion"' (Lehmann 2006: 155).

But there are important differences between Lehmann's concept of this real-time aesthetic and our own argument. Firstly, Lehmann says that the

'distortion' of time becomes important in postdramatic technique because 'Only an experience of time that deviates from habit provokes its explicit perception'. While this might sound a lot like what we have said regarding Kaprow in the last chapter, we should be clear that it is not habit per se that a theatre of immanence must target. Rather, there are better and worse habits with respect to immanence and, specifically, with respect to time. Particularly in *Difference and Repetition* as well as his early book on Hume, Deleuze asks after 'the ontological status of habit', looking to explore habit as something operating on the level of the metabolic or organic, as well as at the level of the perceptual and imaginative (Protevi 2011: 34). Time does not only concern consciousness, for Deleuze, but influences and constitutes the nature or 'style' of organic and inorganic life, all the way down to our smallest 'parts'. We are made up of habits, we are our habits, Deleuze suggests, and indeed some habits are absolutely necessary to our survival as organisms. The lungs have to repeat their habitual synthesis of oxygen, for instance, in order for the human body to continue to live; as a kind of metabolic habit (or what Deleuze also calls the 'first passive synthesis of time'), breathing involves time insofar as the lungs can be said to have expectations of the elements that they encounter.[100] As Protevi explains, our metabolic habits operate on the basis of a '"faith" that things will repeat in the ways we are used to' (Protevi 2011: 33), the expectation that the earth's atmosphere – for instance – will behave in the same way in the future as it has in the past. In this way, rather than reject habit outright, we will go on question whether there might be habits and expectations that we can do without.

Secondly, Lehmann's language suggests that he is thinking about the postdramatic experience of time representationally, as when, for instance, he frames slowness as one technique for distorting time that permits it 'to move from something taken for granted as a mere accompaniment to the rank of *theme*' (Lehmann 2006: 156, emphasis added). What interests Lehmann is time as a theme and as 'consciously noticeable duration', which he describes as 'the first important factor of time distortion in the experience of contemporary theatre' (Lehmann 2006: 156). Contemporary theatre prolongs time, he suggests, extending the length of a 'work' and putting performers in slow motion in ways that allow the subjects of theatre to notice what they habitually ignore. Similarly, Colin Counsell has argued: 'when actions are substantially slowed, spectators are encouraged to scrutinize them intensely, to seek in them a greater than usual concentration of meaning' (Counsell 1996: 187).

What interests us, by contrast, is a less representational encounter with multiple temporalities, one in which slowness need not be construed, derivatively, as a *distortion* of a single, 'natural' time nor simply as a consciousness-raising technique. For instance, contra Lehmann's account, Wilson himself has argued that the appearance of slowness in his work is not a distortion of 'natural' time. He insists that the work 'is not in slow

motion, it's in natural time. Most theatre deals with speeded-up time, but I use the kind of natural time in which it takes the sun to set, a day to dawn' (cited in Shevtsova 2007: 56). Here, then, Wilson notes the multiplicity of the time of the whole, such that the differentiation of the bodies in the world (the sun, a day) can be understood as a temporal phenomenon, first and foremost. Things *are* their way of being in time – their cycles (which differ at each repetition) and their speeds of change. As John Protevi has proposed, all organisms are 'polyrhythmic'; for instance:

> There are thousands of rhythmic periods that compose the organic being of humans: from the long periods of childhood, puberty, adulthood and menopause to monthly hormonal cycles to daily cycles (circadian rhythms) to heart beats and breathing cycles, all the way down to neural firing patterns. Everything has a period of repetition, everything is a habit, and each one of these repetitions forms a living present that synthesizes the retention of the past and the anticipation of the future as need. (Protevi 2011: 35)

And, correlatively, Goat Island seem to approach the notion of 'character' in terms of rhythm, rather than as that which is determined by 'notions of roundness, depth and interiority' (Wallis and Shepard 2004: 179). Christopher, for instance, describes her process as follows:

> When I play a character I play a series of gestures and sounds. I repeat certain positions and cadences and rhythms. I am not trying to repeat the person, only their motion and their sound. (Christopher in Bottoms and Goulish 2007: 84)

When she plays the figure of the pilot Amelia Earhart in *Daylight Dies*, for example, Christopher does not conceive of her 'self' as a tool for representing the truth or essence of an 'other' in a manner that assumes and imposes stasis on both performer and person performed. Rather, she approaches Earhart as a set of rhythmic tendencies that produce differing ways of speaking and moving differently from her own; by altering her own rhythms she can unlearn her own habits and learn Earhart's in a manner that affirms the persistence and presence of differing pasts. Or again, when Christopher plays the late comedian Lenny Bruce in *The Lastmaker* and in *A Last, A Quartet* (the film that followed the performance), the temporal is both the what and the how of her performance. Christopher as Bruce says:

> There's a moment coming – it's not here yet, it's on the way. Still the future ... Here it is – oh! ... It's gone. .. There's no present; everything's in the near future or recent past. No wonder we can't get anything together, man. We got no time.

But in describing her performance, Christopher also emphasizes time:

> She describes her new action as one of referral, not imitation; she borrows Bruce's rhythm, and some of his flinches, but she can only wonder what it would be like to have his fingers. His face. (Schmidt in Goat Island 2009: 23)

In this sense, our approach to character depends on who or what (or when) we think 'Amelia Earhart' or 'Lenny Bruce' is, on who or what we think any 'one' is. In the conventional account, Earhart is a self-present individual who was born and died, who had a life that began and ended at clearly demarcated points in time.[101] But this is to construe Earhart as what Deleuze would call a 'molar' entity; whereas Christopher's durational approach to character suggests that Earhart was also a set of molecular traits that can be extracted from her form and then used in a 'different milieu', or 'deterritorialized' as Deleuze and Guattari would say, in order to produce new, alternative outcomes (Schmidt in Goat Island 2009: 23). In this way, whereas molar forms can die or end, a durational style can live on by inhabiting different molarities (such as a Goat Island performer). A tone of voice, a turn of phrase, the rhythm of a gesture: all of them present, differently.

And, in turn, Wilson's early plays in particular were concerned with *what theatre is* as a way of being in time. Discussing this early work, Wilson says:

> I created plays that were twenty-four hours long or even one that lasted seven continuous days. I even thought there could be a theatre with a play that ran continuously, so that you could go for your lunch break for fifteen minutes or for the afternoon the way you go to the park to sit and watch clouds changing or people walking. There would be no beginning, middle or end like in Shakespeare, but simply one continuous line. (Wilson and Eco 1993: 95)

Goat Island can be seen to take their concern with repetition, imitation and copying to a 'meta-level' in *September Roses*, exploring the idea of performance as its own double. Here the 'finished' performance appears as that which might have been (and could still be) otherwise. As Bailes describes, *September roses* was 'performed in two parts/versions over two nights, using the same blocks of material, presented in a different sequence each night, with the addition of a section that is unique to each version' (Bailes 2007: 38). The second night is not the 'bad copy' of the first; both nights are and are not the 'final' show, insofar as the very decision to structure the performance material in two different forms opens up the idea that the material could equally be structured in more than two, perhaps an infinite number of, ways.

Why wait? Bergson and the value of impatience

One way to develop the specificity of this account is with reference to the philosophical value that Bergson and then Deleuze assign to the *feeling* of impatience that may occur in the act of waiting. Goat Island are particularly interested in the notion of waiting, in the performers' waiting and making the audience wait in a manner that, for Sara Jane Bailes, 'enfolds the performer and spectator into the same condition of (unfulfilled) expectancy' (Bailes 2007: 39). However, I want to address the process of waiting in Goat Island through Bergson's well-known example of waiting for sugar to dissolve in water, which Deleuze takes up both in the essay 'Bergson' (1956) and the book, *Bergsonism*. In *Creative Evolution*, Bergson writes,

> If I want to mix a glass of sugar and water, I must, willy-nilly, wait until the sugar melts. This little fact is big with meaning. For here the time I have to wait is not that mathematical time which would apply equally well to the entire history of the material world, even if that history were spread out instantaneously in space. It coincides with my impatience, that is to say, with a certain portion of my own duration, which I cannot protract or contract as I like. It is no longer something *thought*, it is something *lived*. It is no longer a relation, it is an absolute. (Bergson 1911: 10)

The one who waits does not merely contemplate, but lives the difference between his/her own rhythm and that of the sugar – which is taking too long (in the waiter's actuality) to dissolve into the water. From this experience, Deleuze emphasizes, we can see that the sugar need not only be approached in terms of its spatial organization, or its difference in location from other things: the glass, another lump of sugar and so forth. Considered in terms of space, the sugar differs from other things in degree, but, as Deleuze stresses,

> it also has a duration, a rhythm of duration, a way of being in time that is at least partially revealed in the process of its dissolving and that shows how this sugar differs in kind not only from other things, but first and foremost from itself. (Deleuze 1988: 32)

As we have mentioned, Goulish also takes up this example of the dissolving sugar and Bergson's contrasting example of the ticking clock in 'The Time of the Ordinary'. As Goulish describes, for Bergson, the clock leads us to misunderstand time by describing it in spatial terms, since

> the clock attempts to measure changes in duration according to differences of degree (two minutes is sixty seconds more than one minute)

rather than kind (what was a recognizable cube-shaped lump of sugar after one minute has become after two minutes a globular form one-quarter the original size, as three-quarters of it is now in liquid suspension in the hot tea, transforming the contents from 'tea' to 'tea with sugar,' this difference in kind being of course the point). (Goulish 2008: n.p.)[102]

But the example of the melting sugar is not merely about the sugar, but about the one who waits, and it is in this sense that it relates to performance and particularly to the question of audience reception. As Deleuze argues:

> Bergson's famous formulation, 'I must wait until the sugar dissolves' has a still broader meaning than is given to it by its context. It signifies that my own duration, such as I live it in the impatience of waiting, for example, serves to reveal other durations that beat to other rhythms, that differ in kind from mine. (Deleuze 1988: 32)

The affect of becoming-impatient is what alerts us not only to our own duration, but to its difference in kind from the many other durations pulsing within the real. There is an inherently performative dimension to all this, insofar as Bergson and Deleuze focus on the act of witnessing as that which triggers the exposure of both my own and other durations. However, as Ansell-Pearson notes, the relationship between the philosopher and the sugar dissolving is not that of spectator to spectacle, but rather 'a special kind of complicity' – a coexistence of multiple durations in the event of attending to life's way of being in time (Ansell-Pearson 1999: 29). In this way, while we have moved on from the literally participatory performance of Kaprow, Goat Island are still concerned with ontological participation reconceived as taking part in the plurality of rhythms making up the actual.

The very first of Goat Island's works, *Soldier, Child, Tortured Man* (1987), asks after the difference of the performer in a comparable fashion. We do not have to wait for the performer to melt, of course, but we do have to wait for her/him to become exhausted, to reach the point when s/he is physically unable to perform a further repetition of a choreographic sequence. In early interviews Hixson explains this use of physical exertion in performance as derived from the company's fascination with 'that which was not illusionary, like the body getting tired or the involuntary breathing of a performer after running' (Hixson 1990: 18). However, this use of exhaustion can be alternatively read, through Deleuze, as allowing the performer's way of being in time to define the temporal structure of the performance. It is not about the self-presence of a real body versus the representational illusion of acting, but about the difference of the body from itself as revealed in the process of becoming-exhausted. For instance, in an interview with Irene

Tsatsos, Goulish recalls how the structure of *Soldier* was altered in response to the performers' levels of physical fitness:

> The physical training for *Soldier* was constructed around five permutations of movement that were stated and then repeated with variations ... Lin [Hixson] tried to construct it so that by the end we were so tired that we couldn't do a sixth repetition. As we got in better shape, we didn't tire so easily. Lin made the piece more difficult. She put the hardest stuff at the end. So we really are exhausted by the end. (Goulish in Tsatsos 1991: 67)

This interest in the difference of the performer as exhaustion is also evident in the later work, *It's Shifting Hank* (1993), although, in this piece, the emphasis is not merely on the specificity of human duration in general, but on the performers' individual ways of being in time. It is important that they are allowed to tire 'one by one' rather than all at the same time.

Or again, we might consider a particular part of the company's fifth performance, *How Dear to Me the Hour When Daylight Dies* (1996). Here, as associated member C. J. Mitchell describes,

> Matthew Goulish spends upwards of 10 minutes standing and rubbing the back of one hand with the fingers of his other hand ... leaving the audience with time to watch *seemingly very little* for – in theatrical/performance terms – a long time. (Mitchell in Goat Island 1999a: n.p., emphasis added)

So, in the first instance, perhaps we might recall Bergson's sugar example to re-evaluate the likely experiences of impatience or boredom that the performance's extension of such a gesture might provoke. When we feel impatience, can we (re)train ourselves to feel it as a revelation of 'other durations that beat to other rhythms' (Deleuze 1988: 32)? Indeed, might we say that Goat Island's performances constitute a kind of (re)training in themselves? I am deliberately using the word 'training' here in order to suggest a process other than one characterized by conscious decision, or by a choice to try to *see* something that we have previously interpreted one way *as* something else. That is, although changes in perception and observation would absolutely be included in the training that I am evoking, this is not simply a question of '*seeing as*' in a representational sense; albeit that such a shift in consciousness might well be a by-product of the changes at the level of the body that I am emphasizing. Rather, I am interested in the question of to what extent Goat Island's production of performance as an event in which the audience has to wait might really have the revelatory power that Bergson and Deleuze assign to the dissolving sugar (after all, who other than Bergson himself might have experienced waiting for sugar to melt in this way?).

Just as Kaprow and Clark encountered 'blockages' within their participants (particular behavioral habits or conventional interpretations prompted by the recognition of some thing as 'art' or 'life'), Goat Island too have met with resistance to their strategies. For instance, and specifically discussing this 'handrub' gesture, Hixson has said:

> the handrub has to take a certain amount of time, you have to let things take the time that they need to fulfil themselves ... and I don't see that happening much in the larger culture, I just see things speeding up ... and *some people interpret our work as being pretentious*, because of the way time is used. I don't really understand that whole idea of pretentiousness, but to kind of take people through this time thing ... it needs to pay off in a certain way. (Hixson in Bottoms 2006: n.p., emphasis added)

The interpretation of such slowness as pretention is perhaps a result of the sense that time confers value on something in some contexts; if a single gesture is allowed to take up a long time, audiences might wonder what is so important about it (that particular gesture, rather than another one) that it is *worth* prolonging, *worth* repeating. 'Anything worth doing is worth doing slowly', as Mae West said (Honore 2010). And no doubt, a choice has been made here – there has been a singling out of the handrub gesture rather than any gesture whatever.[103] On the one hand (literally perhaps!), the gesture has been selected for its *apparent* simplicity; as Mitchell emphasizes, the audience are left to watch '*seemingly* very little' for what may feel like a long time. But clearly what is perceived as 'a little' or 'a lot' going on must always be relative and dependent on the perceiver, as well as conventional-ized through expectation. And likewise, what counts as 'a long time' clearly varies depending on the context – the 7 minutes and 22 seconds for which Litó Walkey stands on one leg in *September roses* (Bailes 2010: 123) may *feel like* a long time, both for Walkey and for the audience here, but the 'same' length of time may seem to fly by in another context. As such, then, I now want to extend and enrich the proposition that we raised in relation to Marcus Coates's work; namely, that performance might have the capacity to alter this relative perception, to enact 'a deep reconfiguration of our viewing thresholds' (Mullarkey 2009: 153).

Reference to the theorization of the speeds and slownesses of cinema will help us to take this idea further. For instance, in his book on film phi-losophy, *Refractions of Reality* (2009), John Mullarkey discusses the reception of the *Bourne* (2002–07) series of films (*The Bourne Identity* and so forth), which are 'widely recognized as having popularized a hyperkinetic form of film-making (involving much hand-held camera work, elliptical editing and extremely rapid narration)' (Mullarkey 2009: 152).[104] At the same time, though, Mullarkey notes how 'some in the audience do not follow them, literally'; there is too much going on too fast for some in ways that interfere

with their ability to grasp the narrative. However, Mullarkey then goes on to propose that such responses might be malleable rather than fixed; 'given enough time', he argues, the Bourne films can really change their viewers with respect to their way of being in time, and hence their relationship to the speed of the film. Here it is worth quoting him at length. Mullarkey continues:

> When I first saw Lars Von Trier's *Breaking The Waves* (1996), I found its agitated, hand-held camera work distracting from the story. It was too fussy. Now, after more than ten intervening years of pop videos, TV commercials and a host of other films using this technique and others like it (the latest extreme being *Cloverfield* in 2008), I don't notice it at all. Indeed, the technique not only doesn't stop me following a story any more, for me it has actually become a part of it. It almost seems as if something in me has become part of its time, an accelerated viewer, no less than my watching *Sátántangó* drew forth an effort in the reverse direction of slowing down. We may be 'slow beings' as Deleuze said, but our temporality can be altered in many ways. (Mullarkey 2009: 152)

For my own part, when I first saw Goat Island perform live, I did find the work almost unbearably slow; whereas when watching *The Lastmaker*, some years later and having viewed my way through the company's back cata-logue, I no longer felt the slowness as such, nor did I feel that I was being asked to wait for things to happen.

According to Cage, 'Standing in line, Max Jacob said, gives one the oppor-tunity to practice patience' (Cage in Nicholls 2002: 11). But what is left to value if the feeling of impatience is in fact erased by the very 'success' of work like Goat Island's, at least for those who put the time in to engaging with it over an extended period? Is it that we have to continue to practise because there will always be 'things' for which we have to wait beyond the threshold of our current tolerance, 'things' that operate at a speed that still feels 'too slow' from our point of view?

Finally, given that we have already brought cinema into our discussion, are there limits to performance's powers here, with respect to time, given the capacity of film to employ the camera's inhuman way of being in time to show us movements at the real extremes of perceptible speed and slowness? Of course, given the incorporation of cinematic media by many contem-porary performance companies in ways that allow performance to include particular perceptual forms hitherto seen as the exclusive province of film (such as the close-up), aspects of this line of questioning may be redundant. But nevertheless, we might still note the extremity of some of Wilson's experiments with regard to the duration of performance events, which have few if any parallels in film. His piece *KA MOUNTAIN AND GUARDenia Terrace* (1972), for instance, was performed in 268 hours over 7 days, on a

mountain in Iran, as part of the Shiraz Festival (Innes 1993: 188). As Innes has described, the performance included actions performed in 'extreme slow motion'; for instance, he says that 'at one point the only movement was that of a live turtle crossing the empty stage, which took almost an hour' (Innes 1993: 202). In this way, Ossia Trilling suggests that the piece was both 'inspired by' and a 'logical sequel' to Wilson's highly influential work *Deafman Glance*. According to Colin Counsell's description:

> *Deafman Glance* opened on a tableau of a mother and her two children, and for the first half-hour nothing moved. The mother then rose from her chair and, after pouring glasses of milk for her offspring, stabbed them to death, the whole process taking a further thirty minutes. (Counsell 1996: 187)

Likewise, in the 'Overture' section of *KA MOUNTAIN*, 'members of the company could be seen, often moving at such a slow pace that *one was scarcely aware that they were in motion at all*' (Trilling 1973: 36, emphasis added). Nothing much *seemed* to be happening, then, but as we have seen with respect to film, these perceptions of 'too much' or 'not enough' are open to alteration.

Again, aspects of how Goat Island, at least, discuss their work suggests that they assign a political and ethical value to stillness as well as slowness in relation to the context of contemporary capitalism. Hixson says:

> you have to be moving in order that your worth as a person is appreciated. You have to be in motion, you have to prove your productivity as a person, and that's very scary for those that are not in motion. For someone who is ill, or doesn't have money, or is not in motion in this capitalistic way: those people are cut off the chart now, in terms of being even considered a part of our culture ... Repair has to do with stillness ... People have to stop for a moment ... and wait. (Hixson in Goat Island 2006a: n.p.)

However, what Hixson is critiquing here is not movement itself, but attempts of dominant capitalist forces to establish one, homogeneous rhythm and speed as universal, to segregate the (valuable) moving and the (useless) still from their own perspective. Movement at a speed determined by the needs of capitalism is not the only movement. That is, not least on account of their commitment to a processual ontology, it is clear that this is not a question of a Manichean distinction between radical stasis and enforced mobility (although such a conception might serve as a welcome palliative for tendencies towards the pure celebration of movement and change for its own sake in some quarters of Deleuze Studies). As the sugar example suggests, seeming immobility is not the absence of movement, but rather movement at a different speed.

Likewise, the company acknowledge that the appearance of stillness depends on who is doing the perceiving. From the performer's point of view, for example, a great deal is going on in instances of stillness and waiting. In his early work, Wilson says that he was not only 'interested in stillness' but in 'the movement in stillness'; something that has remained a lasting concern in his more recent opera work. And Wilson suggests that 'sometimes when we're very still we're more aware of movement than when we move a lot' (Wilson in Schechner and Friedman 2003: 115). Likewise, here is Karen Christopher, describing her performance of waiting in *September roses*:

> The tiny hairs on my face are ecstatic. They straighten out from my face and waver in the air around my head. I'm listening. I'm trying not to project a sense of something. My gaze is not direct and my body not in a loud posture that states: I am waiting, I am wanting, I am showing. (Christopher in Goat Island 2006b: n.p.)

Or again, discussing a memorable moment of the same piece – when Litó Walkey stands on one leg for a duration 'determined by the digital logic of the mathematical Fibonacci sequence' (Bailes 2010: 123) – the duration of the act gives us time to appreciate the extent to which apparent stillness often involves an acceleration of movement going on elsewhere: 'the shaking of the leg, the breathing of the lungs, the pumping of the heart, the work of the mind, the passing of time all mean that nothing stops or stands still' (Christopher in Bailes 2010: 116). What appears is not the body as a solid and static thing, but the body as part of a world in perpetual motion. In attempting to be still, what becomes perceptible are the rhythmic shudders and vibrations of muscle tension; something *is* happening after all. The performance's duration has made something happen to us that allows us to perceive happenings where we saw nothing (but stillness) before; seeming immobility is not the absence of movement, but rather movement at a different speed. As time unfolds, change occurs, even when, seemingly, 'nothing' is happening. Indeed, it is perhaps precisely *when* nothing or very little seems to be happening – as in the uses of slowness and waiting in this performance – that time's production of difference or novelty, which is always already going on in and alongside us, becomes most apparent.

Nevertheless, we have said that what we are interested in here is the capacity of performance to alter the nature of the relationship between time as it is *felt* and time as it is interpreted or, again, in the power of performance to intervene at the level of our unconscious encounters with time, prior to our conscious representation of that experience. To what extent is our perception of time or our mode of living in time malleable? Can we adapt or be adapted, by performance in particular but also by other means, in order to perceive faster and slower rates of change than those that conventionally lie within our threshold of perception? For his part, Bergson is clear that we do

Image 10 Photograph from Goat Island, *When will the September roses bloom? Last night was only a comedy* (2004). Pictured left to right: Bryan Saner, Litó Walkey. Photo by Boris Hauf

not have complete freedom to change our perception at will. In the example of the sugar water/waiter, you will recall, Bergson says that the extent of our enforced impatience is due to the fact that we 'cannot protract or contract' our duration as we like. Likewise, Mullarkey argues that 'Bergson believes that our power of perception is elastic to a certain degree, but, at the level of the species, our thresholds of perception represent our degree of closure to other species and the enduring world' (Mullarkey 1999: 146).

Attempting to measure or quantify the precise limit point of such protractions and contractions would be more within the purview of science, rather than the performance-philosophy project on which we have embarked here. But, nevertheless, performance seems well placed to let us know what it feels like to brush up against those limits. And indeed, we might suggest that Goat Island's use of repetition as much as of slowness – in the recurring development of intricate and precise 'dances' based on repeated gestures, jumps, phrases, lifts and so forth – is in order to test our powers to perceive change. And again, it is partly this '*aesthetic of repetition*' that enables their work to be included within Lehmann's category of the 'postdramatic' (Lehmann 2006: 156, emphasis in original). However, in *39 Microlectures*,

Goulish's report of an anecdote reveals his Deleuzian understanding of the notion of repetition:

A few years ago, a producer whose name was Rollo made a special trip to see a performance of Goat Island's piece *It's Shifting, Hank*. Afterwards he wanted to give us his reaction, and I was elected to talk to him. I can summarize the conversation now as follows: Rollo said: What is the reason for all this repetition? And I said: What repetition? (Goulish 2000a: 33)

For Goulish, what Deleuze would call 'bare, material or unproductive repetition' is all a matter of perception; for instance, of the difference in perception between what he calls the 'informed' or 'ecstatic' viewer. 'As John Cage said in his "Lecture on Nothing",' Goulish notes '"Repetition is only repetition if we feel that we own it"' (Goulish 2000a: 33). This is the relation to dance of the 'informed viewer' who feels able to recognize when a dancer repeats a step, on the basis of a sense of ownership of choreographic language. Goulish's 'ecstatic viewer', in contrast, 'is ignorant of dance and claims no ownership of its language' and, as such, observes only the differences of steps that the informed viewer subsumes within the recognition of the same.

Goulish goes on to suggest that this distinction extends to performer as well as audience, where the ecstatic performer is one for whom 'no difference between two moments is insignificant' (Goulish 2000a: 34) or, better (perhaps), every moment is different – since Deleuze wants to take us beyond the perception of difference as not-sameness; beyond, for instance, the not-sameness of two dance steps. Likewise, Lehmann explicitly acknowledges Deleuze's influence when he argues that 'even in the theatre, there is no such thing as true repetition. The very position in time of the repeated is different from that of the original. We always see something different in what we have seen before' (Lehmann 2006: 157).[105] The production of difference, rather than the reproduction of the same, has always been at work in the theatre, for Lehmann and Goat Island, even in traditional productions of Shakespeare – despite Wilson's claims.

Again, Lehmann is drawing from Deleuze here who wrote of the power of repetition to foreground difference in relation to the work of Andy Warhol, specifically his screen-print paintings and the 'Death and Disaster' series (Zepke 2005: 32). As Goat Island dance, this attention to the difference of repetition does not simply occur as an entire sequence is repeated, but in the repetition of a gesture by different company members, in which the 'same' movement is transformed in the context of a different body. And yet, we will still want to differentiate our perspective from Lehmann here, in much the same way as we did with respect to the analysis of slowness. That is, just as Lehmann seems more concerned with time as a conscious idea and less with slowness as a lived experience, he also emphasizes 'the *significance* of

repeated perception' and the aesthetic of repetition as that which 'turns the stage into the arena of *reflection* on the spectators' act of seeing' (Lehmann 2006: 157, emphasis added). In contrast, we might suggest that repetition, like slowness, can really change our perception over time, such that what we see is less and less a repetition of the same and more and more a repetition of difference.

Conclusion: Including the times of others

We started this chapter with some difficult questions regarding the relationship between faster and slower theatres, a question that we placed in the context of Deleuze's fundamental argument, following Bergson, that duration simply is the power to differ in kind. What is the relationship between the way in which things like theatres differ from each and the way in which they differ from themselves insofar as they are parts of duration? Indeed, as we also noted at the start, these questions are another way of asking how it is that immanence can be both one *and* multiple, how we can think in terms of univocity *and* difference, monism *and* pluralism. And the same 'problem' arises with respect to time: are we saying that there are one or many durations? And if we are saying 'both', then how?

In *Matter and Memory*, Bergson argues that 'our' duration is not *the* duration; and that the mixture of perception and memory, the balance of attention to the present and to the past, varies among individual people, but also across species and inhuman forms of life. 'The duration lived by our consciousness,' he argues, 'is a duration with its own determined rhythm ... In our duration ... a given interval can only contain a limited number of phenomena of which we are aware' (Bergson 2004: 272–3). Events that appear simultaneous to 'us' may appear multiply differentiated from another point of view. Bergson refers here to the speeds of different kinds of light to emphasize the relativity, or 'crudeness' even, of our perception. But he also invites us to imagine 'a consciousness at a higher degree of tension than our own', which could perceive the whole of human history in a condensed and intensive form (Bergson 2004: 275) – like the kind of perceiver who could hear the whole of Cage's organ recital. Bergson argues:

> The distinction we make between our present and past is ..., if not arbitrary, at least relative to the extent of the field which our attention to life can embrace ... My present, at this moment, is the sentence I am pronouncing. But it is so because I want to limit the field of my attention to my sentence. This attention is something that can be made longer or shorter, like the interval between the two points of a compass. (Bergson 2004: 151–2)

What I call 'my present' might include what I said before this last quote from Bergson if I exert a greater attentive effort: this so-called past is not

separate or divided from the so-called present; they both belong to the indivisible melody that is my experience.

From this perspective, it seems that we are not all contained in the same present. There is a multiplicity of presents and therefore of pasts and futures – not one all-encompassing present, nor indeed a haunting realm of 'the past in general', another Bergsonian concept popularized and reinvented in Deleuze's account of 'the virtual'. As Mullarkey argues, if we posit 'a multiplicity of presents, each with a correlatively different past and future, the need to enlist the services of a conserved past, virtual memory or any other ethereal entity has been removed' (Mullarkey 1999: 54). This emphasis on plurality must also be seen as an ethical demand: to acknowledge the reality of multiple actualities (not merely a single 'actual') – including inhuman ways of being in time – rather than 'virtualizing' these actualities as the differential ground to a single, dominant actuality or presence. In contrast, Mullarkey suggests, those perspectives that seemingly celebrate the virtual or the pure past as the creative engine behind the actual nevertheless mask a form of oppression or a denial of the reality of otherness, simply because those actualities are often invisible or imperceptible to 'us'. That is, regardless of the limits of our species-specific point of view, these multiple actualities 'are always actual in and for themselves' (Mullarkey 2004: 481).

Through slowness, waiting, repetition and imitation, Goat Island's performance work acknowledges and responds to 'the need to open ourselves affectively to the actuality of others' (Mullarkey 2004: 488). But why is it important to feel time in this way; why does this temporal aspect of immanence matter? In the first instance, the response to these questions can be *metaphysical*: that it matters that we perceive time in itself – as qualitative change, as a multiplicity of presents – rather than distorting it through the dominant philosophy of the same, and misleading concepts of repetition, imitation and a simple 'here and now'. However, there is another response that locates an *ethical* content within this metaphysics of time: an ethics of others, and specifically of other ways of being in time.[106] As Colebrook notes:

> Because we perceive the world from our own interested viewpoint we usually locate all other durations within our own ... We perceive other persons as bodies, like ours and within our world; we don't perceive the different 'world' of the other, their own duration. (Colebrook 2002: 47)

This act of reducing the different, the novel or other to the same can be construed as an act of repression. Likewise, in *Creative Evolution*, Bergson suggests that an 'attention to life' – or an 'openness' to other durations – is what creates a hierarchy of species in nature: the more open, the 'higher' or more expressive the specimen (inasmuch as the purpose of evolution is not to have an end-point, but to remain open, to stay evolving or moving).

For Bergson, the lower form of life acts as if 'the general movement of life stopped at it instead of passing through it. It thinks only of itself, it lives only for itself' (Bergson 1911: 268) – remaining open to movement is one and the same as remaining open to others, because participation with others (and, reciprocally, others with/in you) is the key to becoming, in all its forms.

But again, the question of the relationship between the One and the Many might return to trouble us here. After all, what are the nature of these 'other durations'? Do they belong to the time of *a* world (as its parts) or do they constitute temporal worlds of their own? Boundas argues that it is fundamental to note Deleuze and Bergson's ultimate 'commitment to the idea that there is only one duration. Duration is universal, univocal and unique. It is a concrete universal' (Boundas in Patton 1996: 97). However, if this is the case, then what happens to the 'coexistence of very different "durations" ... all of them in communication' to which Deleuze and Guattari refer in *A Thousand Plateaus* (Deleuze and Guattari 1988: 238)? One answer is that they are parts of duration as what Bergson calls the 'open whole' – a whole that never stays the same as itself.

Goat Island's last work is *A Last, A Quartet* (2009), a film based on the material of their last performance, *The Lastmaker*. One of four films released by the company alongside their live performance works, *A Last, A Quartet* takes advantage of the specific powers of film to 'juxtapose different rhythms and temporalities' by dividing the screen – at times into two, at others into four – such that the viewer might have the impression of watching the

Image 11 Video still from *A Last, A Quartet* (2009) by Lucy Cash and Goat Island

world from multiple points of view, or of being witness to multiple worlds (Williams in Goat Island 2012: 8).[107] It could be that we experience this multiscreen view in terms of simultaneity: that we have the sense that a dance or a rehearsal for a dance is taking place in 'the main hall at Pulaski Park Field House in Chicago' *at the same time as* a horse is being walked through an area of woodland and *at the same time as* a man with a green baseball cap pulled down over his eyes is timing himself singing the last minute of Bach's *The Art of Fugue*. I hear the recorded birds singing on the soundtrack *at the same time as* I hear the live ones singing outside my window as I write.

Nevertheless, these things only appear simultaneous from a point of view outside of them. For Bryan Saner, the placing of these worlds alongside one another 'acknowledges that there's another world ... And that it is always there. And that it may have a relationship to us, even though we haven't thought about it.' He talks about the split screen not in terms of simultaneity but as 'a gesture of inclusiveness', one of 'respect' (Schmidt in Goat Island 2012: 25). I wonder whether this might be a good last word for us too, a provocation to act ethically in a world that we conceive as both the univocity of duration and a multiplicity of presents. Over-emphasize the former, and we find ourselves guilty of transcendence again, of undertaking the impossible task of reaching beyond matter as if the best we can be is to be the conduit for pure duration. But in so doing we seem to risk reimposing our own experience of duration, our own difference in degree from duration as difference in kind, as *the* present, *the* Now, *the* way of being in time. Instead, our project might be to consider how to respect the lives of events that may already or still be happening but are not yet or no longer happening for us. A difficult task for sure, but one that cannot be impossible, since we do not yet know what performance or philosophy can do.

Conclusion: What 'Good' Is Immanent Theatre? Immanence as an Ethico-Aesthetic Value

The conclusion of this book needs to operate on a number of levels. At one level, I want to elaborate on the matter of how we might differentiate between theatres of immanence, going further to articulate how and why some theatres tend more towards immanence than others, given our previous argument that *all* theatre is immanent theatre, to a degree, no matter how transcendent it might seem. I need to say more about how we might position specific theatres along the continuum between immanence and transcendence or, again, how we might discern the degree to which a particular theatre tends towards immanence. And, furthermore, if we are not thinking in terms of mathematical degrees or measurable units here, then what do we mean by the term 'degree' in this context? Is there a difference between thinking in terms of degrees of immanence and degrees of participation in immanence? Of what exactly is there 'more' in some theatres than others; or again, what can we conclude having more immanence looks or feels like when it comes to theatre and performance? Having done this, though, we also need to move to another level in order to explore to what extent this continuum is not only quantitative, but also a measure of aesthetic and ethical value. We need to ask whether tending towards immanence is necessarily 'a good thing' (aesthetically, ethically) in all cases and contexts and, correlatively, whether any traces of transcendence are necessarily 'bad'. What is 'the good' in terms of immanence? Is immanence 'good' in itself and, if so, in what sense? In other words, we have to address the meta-level question of why we might value immanence in the first place before we finally commit to exploring the kind of ethics that immanence itself requires or produces.

We have already touched on the ethical dimensions of immanent theatre at a number of points in this book and from a variety of different points of view – noting the openness to others involved in collaboration and participation, for instance, but also touching on the question of (nonhuman) animal rights/ethics. As such, it has become clear that there are multiple ways to understand what we mean by the ethics of performance. Now,

however, we will be pursuing an immanent ethics of performance inspired by Deleuze's specific definition of the ethical (as distinct from the moral). It will also be helpful for us here to consider how Deleuze's ethics, most notably influenced by Nietzsche and Spinoza, might be in conversation with Bergson, Levinas and Kant too. Already we have the sense that ascertaining the ethical dimensions of Deleuze's work will be a complex task, given his critique of the notion of 'judgement' and his affirmation of the value of chance and experiment. However, we will not be alone in taking it on, since the question of Deleuze's, and Guattari's, relation to ethics has emerged as a core problem for Deleuze Studies in recent years. On the one hand, scholars have acknowledged that 'Deleuze is not ordinarily the first to come to mind when one considers continental philosophers who have made significant contributions to ethical thought' (Bryant in Jun and Smith 2011: 29). Indeed, Deleuze is still more likely to be associated with the relativist, 'anything goes' attitude that was attributed to him and Guattari by critics of *Anti-Oedipus* (Bourg 2007: 122). In turn, Levi Bryant is not alone in finding Deleuze's remarks about ethics 'cryptic and fleeting' (Bryant in Jun and Smith 2011: 30); while Ian Buchanan has argued that 'it is difficult if not impossible to answer the question "what is the right thing to do?" from a Deleuzian perspective' (Buchanan 2011: 7).

On the other hand, others have argued that there is 'a deeply ethico-normative dimension to Deleuzian-Guattarian philosophy' that has not only been overlooked by much of the literature sympathetic to Deleuze, but has also been refused or denied by critics, such as Žižek and Boltanski and Chiapello (Jun in Jun and Smith 2011: 2). For instance, Ronald Bogue has argued that 'there is a sense in which all of Deleuze's work is concerned with ethics, in that ethical principles inform his basic conception of thought and what it means to think' (Bogue 2007: 7). Foucault, of course, famously described *Anti-Oedipus* as 'the first book of ethics to be written in France in quite a long time' (Foucault in Deleuze and Guattari 1984: xiii). And finally, we might note that Deleuze clearly does address the issue of ethics in many of his texts, most explicitly perhaps in *Nietzsche and Philosophy*, *Spinoza: Practical Philosophy* and *The Logic of Sense*. Specifically for us, now, exploring the details of Deleuze's immanent ethics will provide us with the means to evaluate theatres of immanence: to clarify whether and why theatres that tend the furthest towards immanence might be of value, and to whom or what.

Ethics in the direction of command and chance: Theatre as the relation of force

One way to begin to address Deleuze's ethics of immanence is with recourse to his work on Nietzsche, and particularly his interest in texts like *On the Genealogy of Morals*, in which Nietzsche suggests that differing systems of value are the products of distinct modes of life, particularly the difference

between the way of being that he assigns to 'the noble' (or 'master') and 'the slave'. As Deleuze recounts, Nietzsche defines a slave morality as a system of values derived from reaction and negation, rather than affirmation, as built on the principle of *ressentiment* or 'imaginary revenge' (Deleuze 2006: 81). For instance, a slave attitude to life is characterized by the attribution of blame; when something goes wrong, the slave either says 'it's your fault' (in an act of *ressentiment*) or 'it's my fault' – an instance of what Nietzsche and Deleuze call 'bad conscience', which is when a reactive force of *ressentiment* is turned inward *towards* the self, via imaginary others (my alleged persecutors), rather than an active force moving outwards *from* the self (Deleuze 2006: 20). Here, the chance occurrence (to recall the terms of Chapter 1) is not affirmed or accepted for what it is ('the relation of force with force' and 'the essence of force'), but is reacted to as an unwanted deviation from expectations or predetermined ideas (Deleuze 2006: 37). And it is reaction rather than action that dominates the production of values in slave morality. The slave can only produce a notion of 'the good' as a kind of double negation, as 'the not not-good'. In contrast, the noble or master way of life produces notions of goodness through affirmation alone.

For Nietzsche, Deleuze argues, the world is composed of two different *qualities* of force, the active and the reactive, which are understood as dominant and dominated respectively. 'Obeying,' Deleuze says, 'is a *quality* of force', as is commanding. Pure obedience and pure command, we might add, are thereby two new ways to conceive of the ideal poles between which theatres of immanence operate. Like all actual 'bodies' or 'things', theatres of immanence are the result of unequal amounts or *quantities* of these *qualities* of force entering into relation with one another. Or, as Deleuze puts it,

> There are nothing but quantities of force in mutual 'relations of tension'. Every force is related to others and it either obeys or commands. What defines a body is this relation between dominant and dominated forces. Every relationship of forces constitutes a body – whether it is chemical, biological, social or political. Any two forces, being unequal, constitute a body as soon as they enter into a relationship. This is why the body is always the fruit of chance. (Deleuze 2006: 37)

So each theatre would be a quantitatively different mixture of reactive obedience and active command as two qualities of force, and the emergence of different bodies of performance is said to be relatively arbitrary, the product of chance. Hence, to be a body at all is to be in a relation of obedience and command, reactive and active qualitatives, *to some degree*. And theatre is a kind of body.

Let us deal with these proposals one by one. Firstly, this notion of theatre as a mixture of tendencies towards command and obedience will remind us of the conclusions that we came to in Chapter 1, in which we argued against

the dichotomization of directing and collective creation, as transcendent and immanent modes of authorship respectively. That is, we suggested that specific collaborative practices – such as the work of the Living Theatre and Goat Island – are not instances of pure immanence any more than the work of seemingly controlling auteurs such as Carmelo Bene constitutes purely transcendent theatre. However, we still struggled with the question of value here; namely, with the difficulty of whether or not to construe instances of transcendence within immanent theatres (such as the return of the director within the Living Theatre's processes of collective creation) as 'failures' of some kind. Correlatively, we struggled to assimilate Deleuze's celebration of cinematic auteurs and authoritarian theatre directors like Bene into our emphasis on immanence as an aesthetic and ethical value.

However, returning now to these claims within the language of a Nietzschean ethics of force may provide us with some answers. After all, Bene's approach to directing sounds as if it contains a great deal of active or dominant force, a greater amount of commanding (actors, in particular) rather than obeying. Indeed, does it not now start to appear that a Deleuzian ethics of authorship would be more on the side of the dominant director than on the dominated cast, a system of values more likely to affirm the '*master*-work' of the visionary author than to find creativity in those who merely do as they are commanded? Fortunately, though, this is not the case. Deleuze is not saying that behaviours that we might call 'obedience' cannot be active, or that what we might see as 'command' cannot be reactive. For example, as Deleuze makes clear, Nietzsche is not necessarily referring to actual slaves or actual masters and nobles when he differentiates between the two systems of value. Deleuze explains:

> The Nietzschean notion of the slave does not necessarily stand for someone dominated, by fate or social condition, but also characterizes the dominators as much as the dominated once the regime of domination comes under the sway of forces which are reactive and not active. Totalitarian regimes are in this sense regimes of slaves, not merely because of the people that they subjugate, but above all because of the type of 'masters' they set up. (Deleuze 2006: ix)

Again, it comes down to how we evaluate what counts as command and obedience in the first place, and how we measure the amount of active and reactive force in any given body. We will not necessarily find large quantities of obedience and *ressentiment* where we expect them to be in theatre, or anywhere else; hence the need to go as far as possible to address the singularity of specific performance practices, rather than trying to generate some kind of blueprint for all immanent theatres to come.

And again, Deleuze insists that active command is not a matter of seeking power *over* others, whether these others are human or nonhuman. Deleuze

says: '"to want or seek power" is only the *lowest degree* of the will to power, its negative form, the guise it assumes when reactive forces prevail in the state of things' (Deleuze 2006: x, emphasis added). A director who approaches directing as a way to control others, to restrict the creativity of others, is more a product of reactive than active force. But again, we might note that it is not a question of excluding altogether the products of these more reactive forces from our category of immanent theatre. The most top-down forms of directed theatre are collective creation in disguise, Deleuze suggests: Lin Hixson disguised as Carmelo Bene, The Living Theatre disguised as Grotowski.

We can easily see how Deleuze's discussion of Nietzsche becomes an ethics based on the value of chance, and on an understanding of the differing degrees of affirmation and negation that might make up our response to chance (contingency, unpredictability) as one further way to characterize the nature of the whole. That is, as we saw in Chapter 1, we can respond to this ontological context and its 'fruits' in various ways – of which Deleuze values those that say 'yes' to the unpredictability of chance more highly than those that attempt to control its outcomes. And this is a system of value that Deleuze reinforces in *The Logic of Sense*, in which he argues:

Either ethics makes no sense at all, or this is what it means and has nothing else to say: not to be unworthy of what happens to us. To grasp whatever happens as unjust and unwarranted (it is always someone else's fault) is, on the contrary, what renders our sores repugnant – veritable *ressentiment*, resentment of the event. There is no other ill will. What is really immoral is the use of moral notions like just or unjust, merit or fault. (Deleuze 1990: 149)

Here, though, Deleuze does not mean to encourage 'a passive acceptance of what happens' (Bryant in Jun and Smith 2011: 32). An ethics of chance is not about lying back and waiting to see what happens, resigning ourselves to whatever events may befall us and our theatres, because this would merely be *ressentiment* and obedience in a new guise. Deleuze adds:

What does it mean then to will the event? Is it to accept war, wounds, and death when they occur? It is highly probable that resignation is only one more figure of *ressentiment*, since *ressentiment* has many figures. If willing the event is, primarily, to release its eternal truth, like the fire on which it is fed, this will would reach the point at which war is waged against war, the wound would be the living trace and the scar of all wounds, and death turned on itself would be willed against all deaths. (Deleuze 1990: 149)

So, a response is required that somehow matches the chance event. In theatrical terms, this need not mean the use of chance procedures; it need

not mean repeating the gestures of Cage, the Living Theatre or Goat Island. Indeed, to try purely to repeat these precedents would be a kind of *ressentiment* in itself, a failure to will the event of our own plurality of presents and to produce the new responses required by today's wars and wounds. But at the same time, and given that we know that bare repetition is impossible anyway, we could do worse than to begin to relate to past, chance-based practices through what Goat Island call 'creative response': make a new work, but one 'that would not have existed without the work you are responding to', a new performance that enters into a becoming by attempting to echo a 'miraculous moment' from a previous one (Goat Island 2009: n.p.).

The 'ideal' participant?

However, this question of obedience pertains as much to our consideration of the evaluation of participatory theatre as it does to chance procedures, and to the processes of directing and collective creation. For instance, we might suggest that the amount of obedience operative when carrying out a Kaprow instruction is precisely that which secures its success or failure. On the one hand, if we allow the force of obedience to dominate – by worrying about whether we are doing it 'right', questioning whether we are 'getting it' or understanding the artist's intentions – then Kaprow's Activities can turn into a less immanent, more transcendent theatre.[108] But what happens, on the other hand, if we abandon Kaprow's score altogether, if we to refuse to do as we are told, as some of the 'original' participants did? To what extent would this be an instance of active force that ought to be celebrated, and how much is it a kind of reactive disobedience, a behaviour dominated by an advance judgement of how an activity will turn out? In *Take Off* (1974), for instance, an Activity undertaken by nine people in Genoa, Italy, only one group of three (which included Kaprow) actually carried out the written plan to its completion, with the other two groups rebelling against Kaprow's instructions in one way or another (Piltzer *et al.* 1975: 90).[109] James T. Hindman (1979) suggests that this is something that Kaprow attempts to prevent through the careful supervision of each stage of the process of realizing an Activity. Kaprow is omnipresent in his work, Hindman argues,

> to make sure that the events are actually performed with some degree of honesty and involvement, rather than destructively or indifferently. Although each scenario can be developed with full freedom and flexibility, Kaprow foresees an 'optimum' performance as one that occurs with thoroughness and commitment, in a genuine spirit of inquiry, within the structure he has proposed. (Hindman 1979: 102)

Kaprow also explored various strategies with respect to the preparation of participants. For instance, in his account of a 1979 Activity, *7 Kinds of*

Sympathy, Kaprow justifies the need for explanatory notes, which were given to the participants along with the score for the Activity:

The notes accompanying the program intentionally pointed out guidelines to interpretation. It is worthwhile mentioning this aspect of the preparation for participating. An unfamiliar genre like this one *does not speak for itself.* Explaining, reading, thinking, doing, feeling, reviewing, and thinking again are commingled. (Kaprow 2003: 167, emphasis added)

What does this say about participants' capacity (or Kaprow's faith in the participants' capacity) to relate to the unknown? On the one hand, we might argue that the need for a textual supplement undermines any belief in the affective power of the Activities themselves, as Hindman notes: Kaprow's decision to provide participants with an 'interpretive introduction' carries 'the danger of establishing expectations for participants', but nevertheless 'Kaprow feels that something concrete on the possible nature of the experience is necessary, since normal social "contracts" for interaction are suspended' (Hindman 1979: 98). All the same, Hindman concludes that 'The work must speak for itself, anyway, despite Kaprow's intrusion, because of the unique experience facing each participant' (Hindman 1979: 98). For Kaprow, an Activity's accompanying notes served the purpose of sensitizing participants to the experiences involved in the Activity, but not to prescribe in advance the kinds of experiences that they were to have (Kaprow 2003: 168). Indeed, in his essay 'Participation Performance' (1977) Kaprow describes his 'ideal' participants as having 'a shared *openness to novelty*, to being sensitized, to flexibility of stance rather than to possessing a body of hard information and well-rehearsed moves' (Kaprow 2003: 183, emphasis added).

So, for Kaprow, participants are valued on the basis of their willingness to experiment within the context of carrying out or 'obeying' a set of instructions. And in this sense, a mixture of tendencies are valued in this particular instance of participation in a way that relates to the tension between the notion of experimentation and the traditional concept of ethics as a question of the application of transcendent principles. In *Anti-Oedipus*, Deleuze and Guattari cite John Cage's definition of the experimental: 'not as descriptive of an act to be later judged in terms of success or failure, but simply as an act the outcome of which is unknown' (Cage in Deleuze and Guattari 1984: 371n). If, by definition, experimental performance has no predetermined outcome, Cage suggests, there is no standard in relation to which the actual resulting event or process can be judged to have succeeded or failed. What does this mean for the evaluation of immanent theatres, both in an ethical and aesthetic sense? In order to go further with a response to this question, I want to expand on our existing exposition of Deleuze's ethics,

paying attention, now, to how he brings Nietzsche's ethics of force into contact with Spinoza's ethics of affect, in a manner that will ultimately allow us to address the relationship between experiment and application.

Less *power over*, more *power to*: Force meets affect in the ethics of experiment

Deleuze's ethics might be broadly characterized as a meeting between Nietzsche and Spinoza, a combination of the ethics of active and reactive force with the ethics of joy and affective power. For instance, Deleuze argues:

> A force of desire or active force is one which 'goes to the limit of its power,' i.e., which expresses itself creatively to the fullest extent of its ability, which produces rather than represses its object. (Deleuze 1983: 59)

Joyful affects 'are like a springboard,' Deleuze argues, 'they make us pass through something that we would never have been able to pass if there had only been sadnesses' (Deleuze 1978: n.p.). In contrast, reactive forces 'decompose; they separate active force from what it can do; they take away a part or almost all of its power ... they dam up, channel, and regulate' the flow of desire (Deleuze 1983: 33, 66).

So, the more active the force, the more joyful, creative and enabling an encounter; the more reactive the force, the more destructive and sad. However, as we know, it is not a question of theatres manifesting one kind of force or another, since active and reactive, joys and sadnesses, are two tendencies of one differential force, which produce theatres as the product of their relation. But the two tendencies are mixed together in varying amounts in different theatres, just as they are in all other bodies. That is, Deleuze's evocation of the 'fullness' of forces above provides us with a further way to consider and order the differences between theatres of immanence; it suggests that we might value the extent to which a specific performance expresses what it can do. This expression of power might occur at many different levels within a particular performance too: in the sense that we might value the degree to which an individual performer pushes herself to the limits of what she can do, or when a performance maker finds new powers within a particular technology, the limits of which we thought we already knew.

In turn, we know that this impression of a degree of active force or joyful affect is dependent on the audience or participants whom, as we have seen, can have greater or lesser responsibility for the authorship of the performance. As we have also seen, there is no reason to assume that greater amounts of physical audience participation are necessarily to be linked to active force or to the increase of the audience's power to act. Our most

enabling encounters may equally be instances of observation, whether in the form of spectatorship or as the sort of observation in action that interested Kaprow. In this way, though, this account of performance as more or less joyful, more or less enabling, will also have an impact on our understandings of audience beyond the question of participation. In particular, perhaps, an affective account of audience reintroduces the issue of singularity and collective response in new and provocative ways. For instance, the positioning of an affect as sad or joyful is always relative rather than absolute in a manner that could be seen to imply the radical singularization of audience. After all, what is good for me with respect to performance is not 'inevitably good' for others (Deleuze 1978: n.p). And yet, this is not to say that performance involves an entirely individuated experience, where each audience member affects and is affected by the performance in discrete ways. Affect is always a question of relation – to my own impatience in the event of waiting for something to happen, or my relation to another audience member. Remember Hixson:

> You sit on one side of the performance. I sit on the other. When I look across the room and see you watching the performers sing songs around the dining room table, I know your heart beats at a different rate than mine. This tells me we will die at different times. Knowing this I wave good-bye to you ... My duration encompasses and discloses yours. Your duration encompasses and discloses mine. (Hixson 2008: 52)

So we are saying that the greater the amount of active joy or desire in a performance event, the more immanent the theatre, while acknowledging that the relativity of affect means that we must also always ask: 'Joyful for *whom*?' But can we really then move straight away to the claim that the more the theatre tends towards immanence, the better? (Why) is immanence better for us, ethically and aesthetically? Is immanent theatre really 'good' theatre or is this to conflate philosophical, ethical and aesthetic value in a problematic fashion? And furthermore, given that what counts as joy for one body may be encountered differently by another, how can we possibly construct an affective ethics, except in some highly singular sense? For Deleuze, following Spinoza, ethics just is affective experiment, a definition that goes against the conventional understanding of ethics as 'systematizing, defending, and recommending concepts of right and wrong behaviour' (Fieser 2006: n.p.). Whereas morality is based on determined principles and transcendent laws that are conceived as intervening prior to action, and indeed as helping us to decide how best to act in the first place, Deleuze's ethics of the affective encounter might seem to be worryingly based on evaluation after the fact, in a way that makes no claims to prevent 'the bad' from happening. Deleuze says: 'You do not know *beforehand* what good or bad you are capable of; you do not know beforehand what a body ... can

do, in a given encounter' (Deleuze 2005: 60, emphasis added). For Deleuze, to live a good life is to live at the limit of what your body can do, and this limit can only be tested through and as affect, as encounter. The more we experiment, the more we come to know what our body can do in composition with others and, hopefully, the fewer mistakes we make, the fewer bad encounters we enter into.

> That individual will be called *good* ... who strives, insofar as he is capable, to organize his encounters, to join with whatever agrees with his nature, to combine his relation with relations that are compatible with his, and thereby increase his power. For goodness is a matter of dynamism, power, and the composition of powers. That individual will be called *bad*, or servile, or weak or foolish, who lives haphazardly, who is content to undergo the effects of his encounters, but wails and accuses every time the effect undergone does not agree with him and reveals his own impotence. (Deleuze 1988: 23)

Such an ethics seems to require a hyper-attentiveness to embodied learning, which produces a growing, felt knowledge of our powers to act. But it will never rule out the chance of failure altogether, since experiment by definition must remain unpredictable to some degree in order to be experiment at all. And while the implications of an immanent ethics in this sense might be a cause for concern, so too are those of a transcendent morality based on an assumed capacity to predict the future and on the application of principles and laws to perpetually changing contexts. Ethics is a matter of an attitude to time, then, as much as anything else. As Levi Bryant has discussed, traditional approaches to ethical theory tend to involve 'applying a rule or a scheme to a particular *case*' in a manner that ignores the uncertainty and specificity that characterize actual ethical situations (Bryant in Jun and Smith 2011: 26). Within such an approach, the work of ethics is to find universal laws that can be applied to *all* situations, to postulate abstract principles that can be understood to operate in *every* realm and instance. Or as Nathan Jun puts it, what defines a normative principle is 'the fact that in all relevantly similar circumstances it applies equally to all moral agents at all times' (Jun in Jun and Smith 2011: 100). In this context, Bryant suggests that it is less a matter of asking what ethics is, and more a 'question of *when* ethical problematics arise' (Bryant in Jun and Smith 2011: 26, emphasis added). For instance, he proposes that ethics is *when* 'an organized and stable situation has become unsettled and it is no longer clear as to how that stability is to be maintained or whether a new organization entirely should emerge' (Bryant in Jun and Smith 2011). An ethical decision is less a matter of choosing between a closed set of 'clearly delineated possibilities and alternatives', but of experimenting in the context of the contingency of the open whole.

In actuality, all actions must be (and are already) a mixture of ethics and morality, of experiment and application, as two tendencies of the same creative process. At times, as we saw in our discussion of 'habit' in Chapter 5, we have to assume that things will behave as we expect them to and we try to avoid bad, sad or destructive encounters on this basis. But we cannot solely operate on such predictions; things are always also behaving otherwise than we expect, in ways that call for a frequent re-evaluation of what counts as good or bad for any particular body. No doubt this becomes incredibly complex when we remind ourselves of Deleuze's expanded definition of the body, which includes bodies as constituted by the relation of socio-political or aesthetic forces as well as biological ones.[110] In this way, it is complicated by the question of how to value the affects of bodies that differ in scale, number and duration as well as the more familiar categories of species, gender, sexuality and ethnicity. How big does a body need to be in order for its value of the good to be respected by others? How many bodies of a particular type do there need to be in order for their joys and sadnesses to matter? How fast or slow does a body need to be to be attended to?

Clearly, the affects of some bodies are always going to be valued by some more highly than others; indeed, it is hard to envisage how what counts as good for every, different body (all the way down to the smallest and briefest) could ever be taken equally into account, even within a collective body of the size of a theatre company, let alone a city, a country, a universe. But nor does this mean that we are all free to pursue joy in our own way, regardless of the consequences for others. As we discussed in Chapter 3, becomings are to be valued according to the degree to which they are *reciprocal*, the extent to which they function as *mutually* enabling encounters, rather than one-sided instances of exploitation, parasitism and so forth – whether the exploited bodies are human or nonhuman. Experimenting with one's changing power to act is less a matter of having power *over* others, which presumes too much fixed separation between bodies, and more a question of living (as far as possible) according to the implications of relation. As Ronald Bogue emphasizes:

> What is important to note is that the ethical imperative in bodily experimentation is not that of an increase in power *over* a world, but an increase in powers of affecting *and being affected*, a responsiveness to a selected world and an openness to *interaction*. (Bogue 2007: 12)

As Deleuze asks, the question is: 'How can a being take another being into its world, but while preserving or respecting the other's own relations and its world?' Or again, how can individual bodies be involved in the composition of 'an increasingly wide and intense world' while still respecting the diverse affective worlds of other bodies (Deleuze, cited in Bogue 2007: 12)? That I have a power to affect and be affected implies the need for new concepts

of 'rights' and 'responsibilities' – to use the traditional terms of ethical discourse – a right to produce joyful encounters paired with a responsibility to attend to the relativity of affective experience.

In turn, as *Anti-Oedipus* and *A Thousand Plateaus* make clear, this ethics of immanence is also an intervention into a context in which bodies contribute to their own exploitation, and take part in the very processes that cut them off from their powers of acting. We 'cling to' the strata as a source of security and stability; 'we flee from flight' and 'give ourselves over to binary logic' (Deleuze and Guattari 1988: 227). Power tends towards immanence too. It is not a matter of the strata – 'The State', 'The Subject', 'The Signifier' – bearing down on us from above, from outside. Rather, our work is precisely to experiment with the strata as immanent phenomena, to develop events and actions that increase powers of acting and dissolve those internal sedimentations that block joyful experiment.

Is immanent theatre 'good' theatre?

What about the 'goodness' of immanent theatre in an aesthetic sense? In her writing around socially engaged art practices, Claire Bishop has argued that the contemporary milieu is one in which ethical value has become the dominant criterion for art criticism (in the United Kingdom at least), at the expense of aesthetic value. For Bishop, this tendency is particularly evident in the critical reaction to the work of the Mexico-based artist Santiago Sierra, best known for self-explanatory works such as *250cm Line Tattooed on Six Paid People* (1999).[111] While critics expressed 'indignant outrage' at the ethics of Sierra's practice, Bishop claims that they failed to acknowledge the value of the work according to aesthetic criteria: the artist's production of powerful images that affect the viewer in profound, unsettling and ultimately political ways. And for Bishop, this over-emphasis on the ethical is indicative of a broader tendency that art criticism inherited from the previous UK government. New Labour, Bishop argued while they were still in power,

> uses a rhetoric almost identical to that of socially engaged art to steer culture toward policies of social inclusion. Reducing art to statistical information about target audiences and 'performance indicators,' the government prioritizes social effect over considerations of artistic quality. (Bishop 2006)

In turn, Bishop states that

> Artists are increasingly judged by their working process – the degree to which they supply good or bad models of collaboration – and criticized for any hint of potential exploitation that fails to 'fully' represent their subjects, as if such a thing were possible. (Bishop 2006)

Ultimately, Bishop argues, recent art discourse has been dominated by 'the idea that art should extract itself from the "useless" domain of the aesthetic and be fused with social praxis' (Bishop 2006: 183). For her, works such Sierra's and Francis Alys's *When Faith Moves Mountains* (2002) 'attempt to think the aesthetic and the social/political together, rather than subsuming both within the ethical' (Bishop 2006: n.p.).[112]

In terms of theatre, we might suggest connections between this argument and the influential polemic of James Thompson's book *Performance Affects: Applied Theatre and the End of Effect* (2009). Thompson draws from Deleuze's account of affect to argue that the discourses around applied theatre practice have tended to become too concerned with the measurable *effects* of their work and have failed to find a vocabulary to account for the value of its *affective* dimension.

Further, though, Deleuze's account of affect suggests that ethical and aesthetic value cannot be as easily separated as Bishop perhaps suggests; or, more accurately perhaps, it cannot be a question of aesthetics being subsumed within ethics, for Deleuze, because for him, the values of ethics and aesthetics very much coincide. The affectivity of an artwork or an applied theatre project *is* the source of both its ethical and aesthetic value. Neither ethics nor aesthetics is a matter of 'judgement' in this Deleuzian account, because this would imply transcendence: an external judge evaluating an artwork from a position outside of it. Rather, ethics and aesthetics are allied for Deleuze insofar as both are concerned with 'inventing new possibilities of life' (Deleuze 1995: 95). Affect, as we have seen, is primarily for Deleuze a name for a type of change or creation. '*Affects are precisely these non-human becomings of man* ... We become with the world; we become by contemplating it. Everything is vision, becoming' (Deleuze and Guattari 1994: 169, emphasis in original). And one way in which we enter into these becomings is through art, in our capacity both as artists and as audiences. For Deleuze and Guattari, artists are the 'presenters of affects' who not only create them in their work, but also 'give them to us and make us become with them, they draw us into the compound' (Deleuze and Guattari 1994: 175). At its best – that is, at its most active and joyful – the work of art makes perceptible 'the imperceptible forces that populate the world, affect us, and make us become' in ways that, for Deleuze, have intrinsic ethical import (Deleuze and Guattari 1994: 182).

In this sense, Deleuze and Guattari introduce an 'ethico-aesthetic paradigm' (Guattari 1995) that is 'based on the apprehension of a force that expresses a change in the manner of feeling, in the affects, in existence, before this becomes expressed in knowledge and language' (Lazzarato in O'Sullivan and Zepke 2008: 180). But, since they define life as creative force, we can also say that they introduce an 'onto-aesthetics' (Zepke 2005: 4), such that all three, ontology, ethics and aesthetics, become inseparable.[113] However, this triple project of ontology, ethics and aesthetics is not only

concerned with producing becoming, it is also a matter of 'freeing life wherever it is imprisoned' (Deleuze and Guattari 1994: 171). It was Spinoza who discovered 'that freedom exists only within immanence', Deleuze and Guattari argue (Deleuze and Guattari 1994: 48). But in what sense does immanence relate to freedom and, therefore, in what sense might a theatre of immanence be understood as having an emancipatory dimension? As we have seen, immanence has 'two powers' or tendencies: a chaotic tendency towards the greatest degrees of movement and change, and an organizing tendency towards the production of relatively stable forms and identities. The immanent continuum's own tendency towards the pole of pure immanence is also a tendency towards life's power to differentiate itself, to liberate itself perpetually from fixed formations. And correlatively, then, immanence's tendency towards the pole of transcendence is indicative of life's power to imprison itself, or, in less value-laden terms, to restrict itself to greater degrees of repetition or reproduction. If we value life as change and movement, the thinking goes, then we must value those activities that do the most to support (unleash, free or affirm) life's power as differentiation.

No doubt, life's tendency towards immanence brings its own risks, in practical and aesthetic terms, insofar as it leads to chaos; we are not saying that the tendency towards immanence is simply 'good' and that towards transcendence 'bad'. Indeed, taken to an extreme, an immanent theatre might well tip into a chaos that would be 'too great, too unbearable' for many of us (Deleuze and Guattari 1994: 171). There is a threatening dimension to excessive degrees of movement that should not be forgotten even as we acknowledge immanence's power to liberate. 'As a rule immanent to experimentation: injections of caution' (Deleuze and Guattari 1988: 150). Our theatres of immanence must find the right mixture of stratification and destratification, order and chaos, to produce a new possibility of life that is livable, tolerable, bearable for all those involved in it. As Deleuze and Guattari warn us in *A Thousand Plateaus*, if you free life 'with too violent an action, if you blow apart the strata without taking precautions, then ... you will be killed, plunged into a black hole, or even dragged towards catastrophe' (Deleuze and Guattari 1988: 161). The processes through which we decrease the amount of stratification in performance must be more of the order of a *gentle* tipping of the balance towards movement. We need to '*patiently* and *momentarily* dismantle the organization of the organs we call the organism', for instance, rather than botching our experiments by 'wildly destratifying' (Deleuze and Guattari 1988: 160–61, emphasis added).

Tending from 'the Other' to actual others: Levinas meets Deleuze

The ethical dimensions of immanence and thus theatres of immanence need not only be understood in terms of the liberation of life as creative

force; indeed, the emphasis on terms like 'freedom' and 'power' here may sound more like politics than ethics to some. Rather, alternatively, the ethics of immanent theatre also concerns a rethinking of the traditional association of ethics with the question of 'the Other', a concept of radical alterity particularly associated with the ethical philosophy of Emmanuel Levinas. Much of the existing work on ethics in performance is based on Levinas, not least on account of his emphasis on the face-to-face encounter with the absolute singularity of the Other, which – whether it be taken literally or not – immediately suggests some kind of relationship to theatre as the encounter between audience and performer.[114] For Levinas, ethics comes before ontology, insofar as he defines the qualitative difference of the Other as that which transcends Being: a responsibility to relate to that which is irretrievably separate from us is where the problem of existence begins. It is not that our freedom comes with responsibility, for Levinas; rather, our 'responsibility for the freedom of others' precedes our own (Levinas in Mullarkey 1999: 108). And, in this sense, the Other constitutes an absolutely fundamental ethical demand.

As performance theorist Jon Erickson suggests:

> Levinas continually states the importance of the maintenance of separation between self and Other as essential for maintaining the ethical relation; in particular he marks the separation that prevents one from seeking reciprocity with the Other, which could at some point could easily dissolve into an illusion of the complete identification between the two parties. (Erickson 1999: 10)

As such, we might recall here too Karoline Gritzner and Alexander Garcia Duttmann's arguments (which we recapitulated in Chapter 4), given their emphasis on separation, rather than subsumption, as the paradoxical condition for the possibility of participation and relation. This paradox leads to the sense of both ethics and participation (or ethics as participation) as an impossible project that can never be achieved, but must be ceaselessly undertaken nevertheless. As Dan Smith describes, Levinasian ethics is characterized by 'an absolute responsibility for the other that I can never assume, or an infinite call to justice that I can never satisfy' (Smith 2007: 68).

On one level, then, Levinas's ethics of radical alterity seems to be a quintessential instance of a philosophy of transcendence and, as such, deeply incompatible with Deleuze. In calling on us to do the impossible, Levinas is separating us from our power in a manner that, for Deleuze, means that his philosophy is more of an expression of the reactive, rather than the active tendency of force. For Deleuze, as we have just seen, ethics is precisely a matter of experimenting with what we *can do*; it is a matter of going as far as possible to produce joyful *affects* rather than sad ones, of creating relational bodies constituted by greater amounts of active rather than reactive force.

But there can be no simple summary of Deleuze's relation to Levinas. That is, despite Deleuze's consistent allergy to appeals to transcendence (which figure large in Levinas's ethics of the radical Other), the two philosophers clearly still have inclinations in common, as Bayly has recently emphasized in his comparison of the concept of 'the face' in Levinas with that of 'faciality' in Deleuze and Guattari. As Bayly reminds us, both Levinas and Deleuze criticize a regime of faciality that limits the encounter with difference, including the difference of other people, to an instance of recognition (Bayly 2011: 91).[115]

More important for us, though, is the extent to which Levinas and Deleuze share an influence from Bergson.[116] Indeed, on this basis we might now note the resonance between Levinas's insistence on the primacy of ethics with respect to being or ontology and the Deleuzo-Bergsonian emphasis on relation as that which comes before any relationships between 'things' (Mullarkey 1999: 108). Becoming does not begin with some 'thing' that becomes; the Other does not depend on a pre-existing self to encounter it. For all three thinkers, the priority of ethics and philosophy must be to avoid the reduction of alterity to sameness, to retrieve novelty, change and difference from the derivative status they have been conventionally assigned by Western thought. In particular, as Mullarkey suggests, we might understand Levinas as having 'ethicized' Bergson's philosophy of duration, or as rethinking Bergsonian novelty as the Other (Mullarkey 1999: 109). And indeed, recourse to both Bergson and Levinas here provides us with some valuable reminders for the Deleuzian practice of becoming. That is, in both cases this ethics of duration makes clear that

> it is impossible to gain a total knowledge of the other. The specificity of the time of the other, every detail of his or her *durée*, requires one actually to become that other person as part of what it is to know him or her totally. In other words, so long as there is any temporal distance or separation between self and other, that will ensure that the other as other remains unknowable in absolute terms. (Mullarkey 1999: 109)

Likewise, we must be clear that Deleuzian becoming does not suggest that we can actually become another person in a way that would allow us to know them and their way of being in time in totality. But nor is it, in our immanentist account at least, that the alterity of the other, including his or her (or its) duration, belongs to a realm that is beyond any aspect of our experience (bearing in mind that relation is not dependent on representation for Deleuze and Bergson).

Furthermore, an important distinction between our project and a Levinasian one concerns the humanism of his ethical account. 'The Other', in Levinas, is always a human other; it is the radical alterity of another person and never that of a nonhuman other. As Mullarkey reminds us, 'The candidates

for paradigmatic alterity (or the first revelation of alterity) have varied along Levinas' philosophical evolution: the feminine, existence, time, language' (Mullarkey 1999: 108). But – and this is crucial for our understanding of the difference between Levinas and Deleuze (and Bergson) – Mullarkey goes on to note that 'Underlying this development, though, has always been a humanist concern: the alterity is that of another human being – the gender, being, time or speech of a human person' (Mullarkey 1999: 108). Ultimately, Levinas's ethics 'disregards the value of non-human forms of life' in favour of an emphasis on human subjects (Mullarkey 1999: 110). And convention-ally, as Erickson has discussed, the ethics that informs theatre studies tends to be defined as a human concern, 'a questioning reflection of interpersonal accountability within human society, between both individuals and groups' (Erickson 1999: 5). Likewise, Simon Bayly argues (in Levinasian terms) that theatre philosophy constitutes itself as an ethics

> because the theatre concerns itself with how the human species appears to itself; how it recognizes what counts as 'human' and what cannot be recognized as such; how we show or present ourselves to each other; how we appear (and disappear) vis-à-vis, face-to-face with our so-called fellow humans, with our so-called communities. (Bayly 2011: 16)

If the nonhuman is taken into account at all, it is only done so negatively; if animals have a place in an ethical theatre, it seems, it is only because they have something to tell us about what it means to be human.

Of course, this is not the case with all considerations of the relationship between theatre and ethics; much of the extensive work on performance alongside Animal Studies, aspects of which we referenced in Chapter 3, has already done important work to foreground ethical considerations in relation to the use of animals in performance. Likewise, in philosophy, Levi Bryant argues that 'Ethical theory has suffered tremendously as a result of treating ethics exclusively as the domain of the human divorced from all relations to the nonhuman' (Bryant in Jun and Smith 2011: 28). In turn, then, one way to challenge this exclusion would be to address traditional ethical questions to animals as well as humans; to consider what rights should be accorded to nonhumans, for instance, and, correlatively, to what extent nonhumans are also accorded ethical responsibility for their actions. Indeed, in Chapter 3 our discussion entered into the ethical territory of nonhuman animal rights, as we raised objections to the suffering imposed on animals in Hijikata's work, as well as in the contemporary theatre of Rodrigo García.

However, the concept of 'rights' is not the only way to understand the specifically nonhuman dimensions of the ethics of immanent theatre. Rather, Chapter 3 suggested that one reason to value immanent theatre is because it affirms the continuity of human and nonhuman; it construes the human and nonhuman as differing in degree rather than kind and enters

into the real experiences of becoming that this continuity allows. However, we now need to go into more detail regarding the distinction between these claims and conventional concepts of 'responsibility'; or, rather, we need to do more to indicate what new concepts of rights and responsibilities might emerge from the Deleuzian emphasis on experimental becoming, instead of, say, the Kantian emphasis on duty and moral law. Likewise, we must remain vigilant to the difference (in degree) between 'active' and 'reactive' becomings, between those mutually enabling actions that genuinely affirm the immanence of human and nonhuman, and those more self-centred forms of experimentation that justify the suffering of animals as a means to an end. But how can we tell the difference? How do we ascertain the degree to which a given performance affirms immanence with respect to the nonhuman?

In turn, it seems important to acknowledge here that the ethics of immanence pertains to all forms of life, not merely human and nonhuman animals. That is, although it has been outside the bounds of the present study to address 'the life of things', future work will certainly follow Deleuze and Bergson's extension of the philosophy of immanence to include all bodies, organic and inorganic. Indeed, Bergson's thought in particular will help us as we move towards the final sections of this conclusion, and hence of this book as a whole, in which I will attempt to tackle the lingering problem of Deleuze's sometime dualism, or what I will refer to as the problem of 'the pure'. Pure difference, pure duration, absolute movement, the virtual: all these allusions to purity that we can find in *aspects* of Deleuze do not sit comfortably within our immanent account. In contrast, we might find ourselves more allied with Bergson in this respect, given his argument that: 'Radical instability and absolute immutability are ... mere abstract views taken from outside of the continuity of change' (Bergson in Mullarkey 1999: 141). Likewise, in these closing sections I want to reiterate that the concept of immanent theatre is ultimately an attempt to produce an instance of continuum thinking, in which radical instability and absolute immutability are the ideal poles of a univocal yet differential process. In turn, we will have to accept that this means that our continuum itself, this book itself, is definitively *within* the continuum of process it has attempted to describe, just as 'Bergson's philosophy of change cannot allow itself to stand outside of the flux to gaze in detachment at the immutable verities' (Mullarkey 1999: 142). *Theatres of immanence* cannot be a true description of theatre's immanence as if it were written from the perspective of an 'outside eye'. *Theatres of immanence* is, in itself, a mixture of tendencies, some 'thing' that might be positioned along its own continuum but where that act of positioning must itself be understood immanently.

Continuum thinking and the problem of 'the pure'

So I have argued that immanence and transcendence are not opposed substances so much as divergent tendencies, such that actual 'things' and processes

are always mixtures of the two. There are no pure theatres of immanence, in turn, only theatres that tend towards immanence to a greater degree than others and, correlatively, theatres that tend more towards transcendence than others. But this still leaves us with the problem of how to account for, or how to conceive of, the two poles that we positioned at either end of our continuum. And indeed, we must also return to the question of Deleuze's own apparent appeals to notions of 'purity' as well as notions of mixture, for instance in his discussions of 'pure immanence' and the virtual as 'pure duration' and 'pure difference'; Aion as the pure and empty form of time; his distinction between de jure/de facto and so forth.

For some Deleuzians, such allusions to purity are relatively unproblematic: they are conceptions of a transcendental phenomenon, which is nevertheless immanent to the real, rather than an appeal to transcendence. James Williams, for instance, has recently argued that 'Deleuze's philosophy allows for metaphysical terms such as "pure" without having to concede a separate and self-sufficient pure realm' (Williams 2010: 94). And for Williams, this is because immanence or difference 'may be defined as absolute or pure or unity *yet nonetheless be incomplete in relation to other processes*' (Williams 2010: 101). The virtual, for instance, cannot be considered as complete apart from the actual; like immanence and transcendence, the two are 'inseparable processes' caught up in circular movements of 'reciprocal determination', such that the actual is understood to create the virtual as much as the other way round (Williams 2010: 101). Ultimately, Williams argues that

> Deleuze's work is open to an interpretation where immanence and transcendence are never treated as fully separable, but rather must be considered as essentially and indivisibly related as processes. Neither term should be treated independently of the other. More importantly ... a great risk lies in treating one as a mere subset or as an eventually dispensable illusion within the other. (Williams 2010: 102)

Alternatively, we might compare the idea of 'pure immanence' to Deleuze's articulation of the method that he calls 'transcendental empiricism', which might be understood as Deleuze's answer to Kant. According to Kant, we can have no experience of the metaphysical real (as shown by the antinomies generated by thinking about the real as if it were knowable or 'phenomenal'), but we can *infer* its existence (*qua* 'noumenal') through transcendental logic.

However, for other Deleuzian and post-Deleuzian thinkers, this notion of the transcendental still leads to transcendence – an impression that can either lead to the critique and rejection of Deleuze (in the case of Hallward and Žižek, following Badiou) or to the Actualist interpretation of Deleuze that we outlined in Chapter 4 (in the case of Mullarkey). According to the former, the idea of 'pure immanence' signals an 'insidious return of the transcendent in a philosophy of creation' in a manner that we have already

discussed (Williams 2010: 100). But according to the latter, such allusions to the pure need not be read as appeals to sameness; rather, we must remind ourselves that *it is difference that is univocal* for Deleuze. When we speak of a continuum, it is always a continuum of heterogeneity, so that when Deleuze speaks of 'pure immanence' we might argue that it refers to a purity of movement, rather than to any kind of self-presence. Indeed, for my part, Williams's account of transcendence and immanence as 'inseparable processes' remains misleading insofar as it suggests that they are *two processes*, rather than *two tendencies of the same (differential) process*; it might do away with the notion of the virtual as a 'privileged realm', but it still seems to maintain the transcendent geography of a two-worlds view, albeit Williams insists that these realms are co-constitutive.

For me, in contrast, it is not that there is some pure immanence, participation, duration, virtual or difference in kind in which theatres take part to varying degrees, although perhaps I have given that impression at times. This is not the case because immanence is not a thing: immanence is not substantial, but processual. As such, we have to try to move beyond the language that forces us to think in terms of immanence as a state of being 'immanent *to*' something, or of participation as a question of taking part *in* something. Perhaps the most basic call of Deleuze's philosophy is the call to us to think difference, to conceive difference in itself rather than as a 'difference between', 'difference from', or as the simple negation of some prior identity. In trying to respond to this call it becomes difficult not to conceive difference as a substance, or to construe difference as some kind of realm of potential, futurity or creativity, operating at the fringes of our own world. But to do so seems to repeat the Platonic principle of participation, not to overturn it; it is to locate the explanation for creativity in this world in some transcendent real beyond it. In contrast, I would take the Actualist view that the concept of 'the virtual' – as one name for this purity – is an abstraction of the actual becomings in the world, becomings that do not need to be explained with recourse to 'a condition of possibility' outside of themselves. The notion of a virtual condition, no matter how much its immanence is protested, still seems to diminish the power of the actual, which, from my point of view, is always already movement in itself. The actual is change and process, even when that change is going on at speeds that are too fast or slow for *us* to see them; and as such, it does not need to be understood as the product of a realm of pure change and process elsewhere. At times, the images that Deleuze gives us do not help us to steer away from this kind of thinking. For instance, when Deleuze alludes to the abstract thinker who 'remains on the shore' of madness, it might make us think that degrees of immanence have something to do with the difference between dipping our toe in the water and plunging straight into it. But really, we are always already in the sea and hence the more helpful image, perhaps, is the question of how we approach learning to swim.

The Logic of Sense is valuable in other ways here, though, not least insofar as it reminds us to question whether immanence is necessarily 'good' for us. Artaud's proximity to the beating heart of reality was good for him in some ways, but clearly not good for him in others. Likewise, in a 1980 interview on *A Thousand Plateaus*, Deleuze holds back from assigning any absolute ethical value to the tendency towards stratification (which we discussed in relation to the voice in Chapter 2) and the tendency towards smoothness or destratification. He says: 'We can't assume that lines of flight are necessarily creative, that smooth spaces are always better than segmented or striated ones: as Virilio demonstrates, nuclear submarines establish a smooth space devoted to war and terror' (Deleuze 1995: 33). That is, if we want to evaluate some thing we have to take into account not only how it works, but also what it is being used *for*; and, perhaps, we need to acknowledge that an immanent tendency like destratification can be taken up in ways that go against other immanent tendencies. But is it that the destratification can be used in 'good' and less good ways, or does there come a point when the less good usages are no longer destratification at all? Again, we must answer that in favour of the former, because, though immanence can vary from itself to an enormous degree, it will never become so unlike itself that it stops varying or reaches the end of its power to vary.

Consider the well-known take-up of the concept of 'smooth space' by the Israeli Defence Force.[117] Does this make 'smooth space' a bad concept (recalling from Chapter 3 that Deleuze and Guattari referred to 'mimicry' as a bad concept)? Surely not, or, at least, not entirely. Or again, think of Boltanski and Chiapello's accusation that Deleuze's affirmation of immanence (unwittingly) generated a new spirit of capitalism; namely, a 'set of beliefs associated with the capitalist order that helps to justify this order and, by legitimating them to sustain the forms of action and predispositions compatible with it' (Boltanski and Chiapello 2007: 10).[118] Perhaps *A Thousand Plateaus* does not go far enough to pin down, fix and clarify its concepts, but should this lead us to reject Deleuze's call to us to create mobile concepts? That concepts, like all other bodies, have the power to differ from themselves is clearly a cause for celebration as well as caution; and that an immanent tendency can be co-opted for purposes that tend in the opposite direction is not necessarily a fault of the tendency itself. And while we are now suggesting that we can value these usages of tendencies differently depending on their results, depending on the values produced by the way of life to which they belong, it seems that we cannot exclude any process from immanence altogether; phrased more hopefully, perhaps, there is no process that can escape from immanence altogether, no matter the intentions of its participants.

This may sound terrifyingly relativist to some. Indeed, Martin Puchner describes our contemporary moment as one in which thought is 'dominated by relativisms of an epistemological, moral, and linguistic kind',

thanks, in particular, to the legacy of poststructuralism (Puchner 2010: 195). As a result, he argues, 'the very invocation of truth has come to be seen not only as hopelessly naïve but also as outright suspect' (Puchner 2010: 198). In contrast, Puchner would have us return to Plato and particularly to the Dialogues as a form of dramatic philosophy that not only exposes 'false certainties' but also, and more importantly for Puchner, undoes the 'false uncertainties' of relativism (Puchner 2010: 30). Puchner argues that 'Heraclitus' claim that everything is in motion and always changing' laid the groundwork for relativism insofar as an ontology of flux 'also means that nothing can be said with certainty about the world' (Puchner 2010: 30). For Puchner, as for Plato, this is a bad thing, which allows clever argument rather than the pursuit of truth to become the goal of philosophy. As Puchner describes, Plato developed philosophy 'as the assertion that there must be an absolute point of reference for knowledge, otherwise arguments would be won by the stronger and knowledge would become subject to power. There must be a single idea of the good, otherwise value is at the mercy of willful manipulation' (Puchner 2010: 195).

In turn, Puchner also criticizes what he sees as the culturally and ethically relativistic implications of an ontology of difference, implying that they necessarily lead to a kind of blind tolerance, in which all manner of cultural practices – no matter how seemingly violent or oppressive they might appear from a Western perspective – are protected from critique insofar as they are valued as simply 'different'. In contrast, Puchner argues that 'the ontology of difference has to be called into question by a hypothetical universalism ... we have to act as if universalism is possible' (Puchner 2010: 197). Though otherwise very differently philosophically inclined from Puchner, Alan Read has also criticized what he sees as the political or pragmatic implications of relativism. 'There is no urgency in relativism,' he argues, 'nor means to ascertain those imperatives that require attention before others' (Read 2008: 50).

However, in *The Fold*, Deleuze explicitly discusses the kind of relativism that interests him, which is more a question of *perspectivism* than of a conventional understanding of relativism as an ethical vacuum in which 'anything goes'. For Deleuze, perspectivism concerns 'a truth of relativity (and not a relativity of what is true)' (Deleuze 2006: 23). For Nietzsche, perspectivism means that 'there are no facts, only interpretations' (Nietzsche 1954: 458). But as Smith clarifies, for Nietzsche one's interpretation is not a product of one's ego or conscious self; rather, it is one's unconscious drives that produce multiple (and perhaps contradictory) interpretations of the world. In turn, Deleuze wants to clarify that perspectivism is not based on a point of view or truth that 'varies with the subject', but rather with the subject's perception of the truth of variation or metamorphosis (Deleuze 2006: 21).

Indeed, it may be by going further into the relationship between truth and immanence, and with reference to the reality of plural perspectives, that

we are able to reach a satisfactory conclusion not only about immanence as our subject, but about the immanent nature of the claims of this book.

Perceiving *Theatres of Immanence*

Of course, I am not alone in trying to perform continuum thinking with respect to theatre. In his seminal 1972 essay 'On Acting and Not-acting', Michael Kirby introduced his acting-not-acting scale, designed to differentiate the amounts of acting operative within a variety of performance events, according to five main categories situated between the two poles of not-acting and acting: non-matrixed performing, non-matrixed representation, 'received' acting, simple acting and complex acting (Kirby 1972: 8). Kirby insists that the continuum is not concerned with measuring 'the degree of "reality"' in any given performance and, as such, that the continuum can include all acting styles and approaches, from the melodramatic to the naturalistic. Rather, the position of a specific performance along the scale indicates how much acting is involved in it, based on Kirby's particular definition of acting as 'to feign, to simulate, to represent, to impersonate' (Kirby 1972: 3).[119] Acting, Kirby suggests, is a measurable phenomenon that 'can be said to exist in the smallest and simplest action that involves pretense', hence the continuum can be used to 'measure the amount or degree of representation, simulation, impersonation and so forth in performance behaviour'. As the essay unfolds, Kirby differentiates this definition of acting in terms of degrees of what he construes as active pretending and those of a more passive occupation of a representational context or 'matrix', distinguishing between pretending as something *done by* the performer and representation as something that might be *done to* him or her (Kirby 1972: 4). A performer may be 'read' as acting simply because they are imbedded in a context designed to stand for a fictional place and time, but s/he can add to this reading with varying degrees of active pretence.

No doubt, there is much that we, or others, might wish to dispute here – particularly, perhaps, the idea of extreme/pure not-acting. For many Performance Studies scholars, there can be no position outside of a representational matrix, no 'not-acting' or 'non-matrixed performing' at all. But this is not why we would question the reality of this ideal pole on Kirby's scale. Rather, it is because, whereas Kirby's degrees of not-acting are based on the abstract concept of a pure self-same presence – in which the performer is 'merely himself' (Kirby 1972: 4) – our continuum maps the divergent tendencies of what we might call 'differential presence', within which representation is only one dimension of the ways in which bodies differ from themselves. Likewise, when we say that we cannot position ourselves outside immanence, we do not mean that there can be no escape from representation. Rather, immanence is already constituted by multiple, immanent outsides, within which the process that we call 'representation' is

only one speed of relation among others. And finally, we might suggest that Kirby's continuum itself concerns the identification of degrees of acting, apparently based on the notion of performance as a noncontinuous event of interpretation of an object by a subject. The difference between acting and not-acting is a matter of degree, and yet the process by which these degrees are measured seems to separate the measurer and the measured as different in kind. At one point, Kirby does mention that 'the exact point on the con-tinuum' at which different observers might position a given performance 'undoubtedly varies quite a bit from person to person', but the model itself is apparently still based on the principle of a transcendent subject, in con-trast to the immanent model we have developed here (no matter the *form* of theatre in question).

But what is to stop the same accusation being laid against my own con-tinuum? Is it not liable to a similar charge, inasmuch as I have evoked the notion of a scale that might be used to measure degrees of immanence and transcendence in performance in a manner that continues to treat perform-ance as an object for a transcendent subject, rather than treating both as an immanent process? Or again, how do we differentiate the continuum from a measuring tool to be used for the purposes of ethical judgement? One way to do this is to emphasize the relativity of any one perceiver of a performance; another might be to consider the perspectival nature of the continuum itself. As we saw in Chapters 3 and 5, perception is always rela-tive, whether we think in terms of species difference or differences between individual human perceivers. And likewise, given that we know that affects can be more or less empowering depending on the bodies involved, there can be no imaginary universal observer here, nor any true measurement of a particular event.

But we should not see the practices discussed in this book as providing formulae for future action. None of the specific performances or processes tackled here are meant to be taken up as exemplary models to be copied, or as guaranteed ways to create immanent theatre. The strategies created and explored by the practitioners I have discussed were the products of experiments taking place in specific contexts. When Artaud arrived in Paris in 1921, 'a theatre audience ... assumed the general form of an obedient group of spectators sitting silently in a darkened auditorium' (Jannarone 2010: 75). In their 1959 production *Many Loves*, the Living Theatre ges-tured towards including the audience by placing actors among them in the stalls in a manner that was innovative then, but has since become insti-tutionalized. That is, what counts as what Bryan Saner called a 'gesture of inclusiveness' does not remain static over time; we have to find new ways to include the audience, nonhumans, chance and change itself. Indeed, we will even have to admit that we do not yet know what 'inclusion' itself might become in theatre and performance. So, while daunting in one sense, this acknowledgement of unknowing is also a positive indication of

the open rather than prescriptive nature of our project. We can only come to know more by experimenting in our context(s) now. And this book has been an attempt to perform one such experimental gesture, to which other gestures, including practice-based gestures, must be added. These gestures might occur in any formal context: we might explore immanence in musical theatre as well as performance art, and there is no reason to suppose that our experiments must happen outside proscenium arch theatres. To think theatre immanently means precisely that there is no outside, no approach that can position itself or be positioned outside immanence. No matter how well made the play, it is also a chance to live the multiplicity of duration.

Nevertheless, this should not be an occasion for claustrophobia. Just as immanence is everywhere, it is also the inclusion of elsewheres, a naturalization of a multitude of outsides as definitively *in this world*. In this regard, it is important to remember that we have also conceived immanence as an 'open whole'; namely, as 'a whole which changes' (Deleuze 2005: 9 228).[120] The open whole is the whole of duration; but, crucially, it is a poly-rhythmicity rather than a temporal container that would unite and homogenize all the differing rhythms of life according to its own privileged rhythm (Colebrook 2002: 45). As the latter, immanence would have become transcendent again: somehow outside of time rather than time as whole. As poly-rhythmicity, in contrast, or as the ceaselessly varying collection of the totality of different ways of being in time, the whole might serve as a reminder of the kind of openness that constitutes the basis for the evaluation of different, immanent theatres. As ceaseless variation, the open whole cannot be a transcendent model for theatre to imitate. Nor is this because theatre is 'a microcosm as closed as the whole is assumed to be' (Deleuze 2005: 10). It is more a question of sensing our inclusion within the whole and of adding new rhythms to it. Theatres of immanence are not only included within the open whole – they are the whole, collectively, along with every other form of life – but they also have the power to change it. As Alexander Lefebvre has discussed, this account of the whole is what ultimately differentiates Deleuze and Bergson from Spinoza and Kant. For Spinoza, the whole is given and closed, 'the total set that contains all subsets', while for Kant it is 'nongivable and meaningless'. But for Deleuze, the open whole is, by definition, not a given 'because it is the Open and because its nature is to change constantly, or to give rise to something new' (Deleuze 1986: 9). And, in turn, 'the whole is not a set, a collection of sets, or a totality. Instead, the movement that defines the whole ... *is* duration, it *is* becoming' (Lefebvre 2008: 247).

In this way, perhaps it is that theatres of immanence can be valued differently on the basis of their openness, on the basis of the extent to which they constitute their own open whole (included within *the* open whole), rather than a closed totality that attempts to organize the different according to

a single, dominant rhythm or point of view. It is in this sense that our horizontal continuum becomes a vertical one: theatres of immanence can not only be positioned at particular points between the ideal poles of pure immanence and transcendence. they can also be ordered vertically insofar as a greater degree of immanence, of openness, is understood to have an ethical value. 'The good', here, is that which construes itself as an open whole 'comparable to the whole of the universe', as 'open upon a world' that is itself open (Deleuze 2005: 10).

But why is this good? Or why might we choose to affirm openness as our principle ethico-theatrical value rather than Levinas's radical alterity or Kant's moral law? In German, one word for attention is *Achtung*, but in *The Critique of Practical Reason* Kant also uses this in another sense, to mean 'respect' (Caygill 1995: 356). Here, as Howard Caygill explains, '*Achtung* may be translated as respect for persons' to the extent to which they uphold the moral law (Caygill 1995: 357); *Achtung* is a kind of 'moral feeling' that serves 'as an incentive to make the moral law our maxim of action' (Caygill 1995: 356). But we can take advantage of this double meaning of *Achtung* to invent our own ethical principle or, rather, a concept of ethical *feeling* as something like 'respectful attention' or 'attentive respect'. As we have seen, there is no place for transcendent laws in Deleuze's immanent ethics, no way even to begin to posit laws in the context of the ungivable nature of the open whole. However, this is not to say that we abandon evaluation altogether, that 'anything goes' – to recall the usual characterization of relativism. There *will be* more or less 'good' theatres at any given time, and the values of openness and 'attentive respect' might be one way for us to produce and order these differentiations (whether as audiences or performance makers).

And this 'more or less', or these 'mores or lesses' (plural), will be definitive, relative to their frames of reference, even though there is no permanently given (transcendent) definition of what those frames of reference are. Where Kirby has a (non-)acting matrix of five variables that are given, the whole is never 'given' (Bergson 1911: 39–41) – there is no final matrix that can fully capture immanence, no fixed continuum that can map it and its various tendencies once and for all. Rather, the variable elements of immanent theatre that we have explored here – authorship, vocality, animality, participation and temporality – are always immanent too, always within their own changing contexts. Indeed, it is this changing and therefore nongiven nature of immanence that is, ultimately, a value. Hence, when we say that the 'degree of immanence, of openness, is understood to have an ethical value', it is more accurate to say that the *degree* of immanence, of openness, *is* ethical as such: it is an open continuum, a continuum of heterogeneity, a heterogenesis of qualities (authorships, vocalities, animalities, participations, temporalities), a vertiginous world containing more and more worlds within it. If this sounds like a relativism of perspectives, we might add that

what counts as immanent in terms of the variables (and values) of author-ship, vocality, animality, participation, temporality will be definite and given, in their particular context, assuming that we give that context the attentive respect that is its due. Throughout the chapters of this book I have offered a glimpse into what we might now understand as various accounts of what this attentive respect feels like and under what historical contexts and circumstances other performance practitioners and audiences have found it. What remains for us now is to go and experiment with what else might provoke this ethical feeling today, in our own particular contexts.

Coda

In this book I have argued that performance performs immanence to greater and lesser degrees, in a context in which what counts as a greater or lesser degree of immanence to immanence (as 'univocal difference') is indeterminate, by definition. It changes; it is open. As such, and as I noted from the start, this book could never hope to be a fail-safe how-to guide, either for practitioners seeking to make themselves a theatre of immanence nor for scholars aiming to create immanent theatre as audience members who become with the work they encounter, and to pass on that becoming by articulating the concepts that those encounters produce. But nevertheless, I have attempted to map some guidelines, to indicate some points of departure for both theoretically and practically inclined research in performance:

1. *Pay attention (abandon the blueprint, not the proscenium arch)*: The greatest theatres of immanence (the theatres of the greatest degrees of immanence) may not be found where we expect them to be. We will not necessarily find large quantities of obedience and *ressentiment* where we thought we would; rather, when we look again, we find the 'bottom-up' in the 'top-down', participation in observation, and the body without organs disguised as State theatre.

2. *Multiply yourself*: We need to find ways to adapt our research to acknowledge, affirm and enact the relativity of our perception. 'To see with as many eyes as possible', as Nietzsche said, since 'there is always a perception finer than yours, a perception of your imperceptible'. Locate a means to say 'yes' to the time of the goshawk and of the ice, because their actuality is not a virtuality on the fringes of some really real, but a different way of being in time that is already actual in itself and for itself.

3. *Carefully measure out your quantities*: Remember, 'staying stratified is not the worst that can happen' (Deleuze and Guattari 1988: 161). Try turning the dial slowly, a teaspoon at a time: a little less authority, articulation, imitation, observation, instant gratification. Or if that doesn't work, try

again: a little *more* imitation perhaps; imitation for as long as it takes to compose something new. As long as it takes, or as slow as possible, but not at the expense of others' experiments, which we are always in the midst of, whether we attend to them or not.

4. *Respect unknowing and the unknown*: Much – thankfully and frustratingly – eludes our control, our understanding, our knowledge (though not knowledge, per se, since it never stops producing itself). The task, then, is to test out how to relate to this contingency and this unknown, how to unlearn our habitual desire for capture. Our new habit is not to practise resignation or 'tolerance' as another form of separation, so much as to extend our values to include the unintended, the accident, the error. Start with a creative response to a chance procedure. Take me into your world, but know that your world is not '*the* world', your now is not 'the Now'; don't make me run to keep up if I get too tired and I won't make you wait too long.

5. *Think alongside performance's own thinking*: We do ourselves and the work a disservice if we treat performance as the mere illustration of extant philosophical ideas, or as the pliant material that must await our intervention in order to become 'meaningful'. Human and nonhuman bodies have their own powers of differentiation, their own powers to differ from themselves within a whole range of encounters – not just with theorizing subjects, interpreting audiences, conscious intentions. Performance thinks in its own, multiple ways: as the emergent, decentralized thinking of collaboration and collective creation, which challenges our habitual, proprietorial thought; as the stammerings, stutterings and whisperings that assure an identity of self and voice as much as they speak difference and vibrate those who hear them; as mutually empowering encounters between the human and the nonhuman, where immanent imitations tend towards one body's continuation of another's movement; as events of experienced insight and attentive respect that increase our participation in an always unfinished, incomplete whole; as an extended 'openness' to other durations, to the impatience of waiting sometimes, to the exhaustion of accelerations at other times. Open the window a little wider, since it is 'something *in the world*' that 'forces us to think' (Deleuze 1994: 139). Open to others, since 'one does not think without becoming something else (Deleuze and Guattari 1994: 42). For goodness is itself a matter of movement and composition; always a part, relative, open.

Notes

1. Like Alan Read (2008), I am deliberately using the terms 'theatre' and 'perform-ance' together here 'in order to re-establish their affinity at a disciplinary moment that would appear to witness their withdrawal from each other'. While in the past I have no doubt been guilty of what Read calls the 'sleight of hand' of simply replacing the term 'theatre' with 'performance', with the latter understood as a more general category incorporating a 'plurality of practices', but also as that which necessarily involves radicality in contrast to some presumed conservatism within 'theatre' (Read 2008: 28). Here, however, I hope no such presumptions are made. I have precisely used the term '*theatres* of immanence' in order to ward off any potential impression that a Deleuzian practice must necessarily take the form of performance art, or performance at its avowedly least representational, rather than drama. Likewise, I am specifically interested in the transdisciplinary gesture of discussing Artaud and Marcus Coates, the Living Theatre and Lygia Clark in the same context. No doubt, there is much to say about how the terms 'theatre', 'drama', 'performance', 'performance art', 'live art' and so forth are used in our contemporary context, and specifically about the values assigned to such terms in different contexts within our current milieu. But this is not the project of this book. So I hope that readers will forgive the sleights of hand that no doubt remain in my interchangeable use of 'theatre' and 'performance' (and sometimes 'art') as merely indicative of work yet to be done, of work beyond the parameters of the present study.

2. Professor Ian Buchanan of Cardiff University is one of the main architects of the sub-discipline of Deleuze Studies, which has its own triennial journal published by Edinburgh University Press and edited by Buchanan (of which the first volume was published in June 2007) and an annual conference, the fourth of which was held in Copenhagen in June 2011.

3. There are performance and philosophy working groups in the UK-based organiza-tion TaPRA (Theatre and Performance Research Association), in ATHE (Association for Theatre in Higher Education) and in PSi (Performance Studies international). The latter, which I have chaired since its inception in 2008, now has over 200 members from more than 15 different countries. For more information, see the working group website: http://psi-ppwg.wikidot.com/.

4. The notion of a 'theory explosion' refers to the translation, dissemination and subsequent influence of key structuralist and then poststructuralist texts (includ-ing those by Jacques Derrida, Jacques Lacan and Michel Foucault) on the study of the arts and humanities in anglophone universities, starting in the 1970s. In their Introduction to the seminal collection *Critical Theory and Performance* (1992), editors Janelle Reinelt and Joseph Roach narrate the impact of this academic event, arguing that the new theory invited researchers to question the 'underlying assumptions' of the methods of Theatre and Performance Studies, including an interrogation of the nature of the relationship between presence and representa-tion and of 'the self' (Reinelt and Roach 1992: 4). They also credit new theory with the effect that 'performance can be articulated in terms of politics: representation, ideology, hegemony, resistance' (Reinelt and Roach 1992: 5), enabling myriad

articulations of the ways in which performance has both perpetuated and challenged dominant stereotypes of racial, ethnic, gender, sexual and class difference.

5. Here, as well as Goat Island, we might think of the choreographers Jan Ritsema and Jonathan Burrows; Koosil-ja; Body Weather; Julia Lee Barclay's Apocryphal Theatre; Paul Hurley; and the Italian theatre company Masque Teatro, among many others.

6. Other book-length examples might include Erin Manning's book *Relationscapes* (2009) and Matthew Goulish's *39 Microlectures* (2000).

7. In *Pure Immanence*, Deleuze insists that it is Charles Dickens who has best described this impersonal life in *Our Mutual Friend*. In this text, Dickens describes an event in which 'A disreputable man, a rogue, held in contempt by everyone, is found as he lies dying'. At the point when he seems to be dying, those around him are able to forgive or even forget his misdemeanours. But as soon as he 'comes back to life', their contempt for his personality returns. What interests Deleuze is the way in which Dickens's account suggests a moment when an impersonal life dissociated from his subjective reputation emerges. 'Between his life and his death, there is a moment that is only that of *a* life playing with death' (Dickens in Deleuze 2001: 28). Here, for Deleuze, a disreputable man is transformed into a *homo tantum* (into 'only life') in the moment of dying. While the notion of *homo tantum* is referenced positively by Deleuze here, it is a negative term in Hardt and Negri's *Empire*, used to mean '*mere man and nothing more*', in contrast to *homo-homo*, defined as 'humanity squared, enriched by the collective intelligence and love of the community' (Hardt and Negri 2000: 203–4). In this sense, it differs from Agamben's notion of 'bare life' too. At the disreputable man's moment of dying, life is a haecceity rather than an individuality. But it is not only 'when individual life confronts universal death' that *a* life presents itself, Deleuze says; it also appears in small children, whom he describes as singular but not individual (Deleuze 2001: 30).

8. In his 1960 production *Kordian*, Grotowski experimented with the idea of treating the spectators as actors – or, as he put it, with the idea that 'the theatre has eaten the audience'. In this piece, the performance space was transformed into an insane asylum full of beds that were occupied by actors and audience alike. In contrast, in *The Constant Prince* (1968) Grotowski used a set made up of large wooden barriers that emphasized the separation between audience and event. As Grotowski describes: 'We put the spectators in a voyeuristic relationship to the production. They were watching something prohibited. The room was constructed so that the audience was almost hidden behind a wall. They watched something much lower down – as medical students observe an operation, a psychic surgery – and there was no relation whatsoever between actors and spectators. None. One could see over the wall the heads of the audience, and one could observe the rhythm of these heads and, at certain points, the rhythm of breathing. Some of my foreign disciples were deceived. They said, "You are a traitor to the idea of osmosis between the spectator and the actor." I am always ready to be a traitor to an absolute rule. It is not essential that actors and spectators be mixed. The important thing is that the relation between the actors and the spectators in space be a significant one. If the contact between the spectator and the actor is very close and direct, a strong psychic curtain falls between them. It's the opposite of what one might expect. But if the spectators play the role of spectators and that role has a function within the production, the psychic curtain vanishes' (Grotowski in Schechner and Wolford 1997: 50–51).

9. Although Protevi cites the two volumes of Capitalism and Schizophrenia as the defining texts of this third period, we should also note the two other main texts that Deleuze and Guattari wrote together: *Kafka: Towards a Minor Literature* (1975) and *What Is Philosophy?* (1991).

10. This suggestion is then reiterated by Slavoj Žižek in his book *Organs without Bodies: Deleuze and Consequences* (2004).

11. This Deleuzian sympathy is particularly pronounced in the cases of Artaud, Cage, Bene, Clark, Lavaudant, Goat Island and Coates. Artaud, Cage and Bene have been written about by Deleuze himself, while there is evidence that Clark, Lavaudant and Coates are familiar with Deleuze's work and Goat Island explicitly theorize their work in Deleuzian terms.

12. However, Jannarone also critically frames the Living Theatre as having utilized Artaud for their own ends, rather than reading him in his own right. The Living Theatre, she argues, 'provide some exemplary instances of how Artaud's ideas for a Theatre of Cruelty have been used in the service of a liberal "revolution" ... Artaud's "cruelty" served as a necessary precursor to their end goal, which was realization of a free community here on earth, or "Paradise Now"' (Jannarone 2010: 13).

13. Deleuze and Guattari first introduce the conceptual dyad of 'major' and 'minor' in *Kafka: Toward a Minor Literature* (1975). However, the concept of the minor is also significantly elaborated with reference to theatre in Deleuze's essay 'One Less Manifesto'.

14. What Lenora Champagne has called 'the explosion of May 1968' might be summarized as an eruption of student protests, riots, workers' strikes and occupations that sought to effect change in what the protesters saw as the repressive social relations that had come to dominate France under capitalism. However, while starting in France, the spirit of revolt soon spread around the world with comparable protests and occupations taking place in the United States, Germany, Italy and Japan, among others. As David Calder (2012) discusses, companies such as the Théâtre du Soleil worked directly with committees of factory workers 'on experiments in relations of production, attempting to construct viable alternatives' to existing capitalist models built on fixed hierarchies and the division of creative and manual labour (Calder in Syssoyeva 2012: n.p.).

15. The Living Theatre is an American experimental theatre company founded in 1947 by Judith Malina and Julian Beck, which still continues to work today. The Living Theatre originally conceived of itself as a challenging alternative to the mainstream Broadway theatres, at first on the basis of its choice of material by modern poets and playwrights whose work was 'decidedly *not* part of the familiar repertoire of that era' (Rabkin 1984: 9). This unfamiliar repertoire included plays by Paul Goodman, Gertrude Stein and Federico Garcia Lorca; however, this chapter will be largely focused on the works that the company generated through 'collective creation'.

16. We can be sure that the Living Theatre were known to both Deleuze and Guattari; for instance, in 'One Less Manifesto' Deleuze cites the company among an alliance of practitioners whom he perceives to be working with theatre as 'non-representative force' (Deleuze 1997: 241). And six years later, in an interview with Charles Stivale, Felix Guattari would refer to the Living Theatre in order to argue that the notion of a 'deterritorialized' America is not just a utopian dream. Guattari says, it is not 'that there isn't a potential America, an America of nomadism. Some people still exist ... I was thinking of Julian Beck, of Judith Molina [sic],

the former members of the Living Theater. Just because they've been completely marginalized is no reason to ignore their existence. They still exist nonetheless. (Guattari in Stivale 1993: n.p.).

17. There are countless other examples of Deleuzianism in Goulish on which we could have drawn here. For instance, we could suggest that it is no coincidence that the company draw on Matheson's *The Incredible Shrinking Man* for their performance *The Sea & Poison*, a resource central to Deleuze's exposition of the concept of becoming-imperceptible.

18. However, each of these figures – Massumi, Protevi and DeLanda – has tended to place an emphasis on the concept of 'the virtual' in Deleuze's thought, which I will not be reproducing here. It is on account of their participation in the virtual, it is suggested, that form can be construed as immanently produced rather than transcendentally imposed. In turn, they suggest that if Deleuze's actual is what emerges and the virtual is what conditions emergence, then it is arguably the twin processes of *actualization* and *counter-actualization*, and the related concept of becoming, that constitute Deleuze's inventive response to emergence. As the names suggest, the former indicates a movement proceeding from the virtual to the actual dimension of the real, while the latter suggests a movement in the opposite direction: a utilization of the virtual, creative dimension of the real from a position in actuality, with the capacity to change the actual. As Massumi says, 'The limits of the field of emergence are in its actual expression'; but clearly this actual can and does change (Massumi 2002b: 35). My resistance to reiterating such an account is that it seems to me to risk reintroducing a binarism in which the virtual becomes the source and explanation of the actual's creativity.

19. One of the company members, Gene Gordon, expresses doubts about the power of theatre in the face of the contemporary socio-political climate, saying 'I see the rise of fascism again. I find it difficult to work on a play about Paradise Now without working on the real problems of fascism – money war wages ... To change the world we have to get rid of money and governments' (Living Theatre 1969: 94–5), while another, Henry Howard, argues that *Mysteries* and *Antigone* have already dealt with these problems and that the ambition now should be to 'create a play that will change ... the outlook' (Living Theatre 1969: 94–5).

20. With respect to this process, it is interesting to note that Deleuze is said to have 'hated endless group discussions and could or would only work with two or three people at most', whereas Guattari 'had always worked in groups' and found it quite difficult to adjust to the relatively solitary work that he undertook alongside Deleuze (Dosse 2011: 7).

21. To be fair to Holland, he does acknowledge that his clean separation of transcendent and immanent modes of organization is a 'heuristic distinction', specifically designed to aid our understanding of how these modes operate, not as a precise analysis of how classical music and jazz might actually operate in practice. But I cite it here, because I wonder whether it is not also misleading heuristically, as well as an instance of application.

22. In interviews with Biner, Beck also acknowledges that he and Malina control the casting for every production (Biner 1972: 165).

23. Cage has remarked: 'What I do, I do not wish blamed on Zen, though without my engagement with Zen (attendance at lectures by Alan Watts and D.T. Suzuki, reading of the literature) I doubt whether I would have done what I have done' (Cage 1978: xi).

24. The question of chance and the figure of the dice throw was central to the controversy between Deleuze and Alain Badiou that took place during the early 1990s. In his letters to Deleuze, and in their subsequent summary in *The Clamor of Being*, Badiou claims that, for Deleuze, the game of dice is not really about the affirmation of chance as the production of difference, but the 'eternal return of the Same' (Badiou 1997: 75). In this sense, the notion of chance plays a key part in Badiou's ongoing characterization of Deleuze as a thinker of the One rather than multiplicity.

25. As Claude Schumacher (1989) reports, the radio programme was recorded between 22 and 29 November 1947 by Artaud and his collaborators. Originally commissioned by Fernand Pouey, the programme was censored by Wladimir Porché, the director-general of the radio station, on the day before it was scheduled for broadcast: 2 February 1948 (Schumacher 1989: 189). As Marc Dachy (1995) tells us in a short, introductory essay in the cover notes of the recording, the broadcast had two private hearings for Artaud's friends and colleagues. The first was held on 5 February 1948, in the hope of changing Porché's mind about the ban. Those who attended – including Jean-Louis Barrault and Roger Vitrac – passed a favourable verdict on the recording, but the ban was maintained, resulting in Pouey's resignation. The second private hearing was held on 23 February 1948 'in a disused cinema' (Dachy 1995).

26. I would like to express my gratitude to Juliette Caron from the archives at the Théâtre national de l'Odéon in Paris for providing me with the video documentation of the 2004 performance of *La Rose et la hache*.

27. There are a number of Deleuze Studies scholars who have already explored the relationship between Deleuze and Artaud, including Catherine Dale (2001a, 2001b, 2002); Ronald Bogue (2003a) and Jeffrey A. Bell (2006). Within Artaud Studies, Deleuze is discussed by Scheer in Cull (2009a), Butler in Scheer (2000) and by Artioli, Scheer and briefly by Goodall in Scheer (2004). However, the Deleuze–Artaud conjunction has not been addressed at length in Performance Studies; that is, with a particular emphasis on its implications for theatre and performance. Milton Loayza (2000) does invoke Deleuze and Guattari's distinction between Chronos and Aion in his essay on Artaud's theatre, however I hope that this chapter adds something new to this existing body of work by providing an in-depth discussion of Deleuze's work specifically on Artaud, and what it means for our understanding of Artaud's theatrical work, particularly with regard to the debates around language and voice.

28. Martin Puchner, for instance, argues that 'Artaud himself was more of a visionary, articulating his conception of a theatre of repetition in manifestos and letters and only occasionally on the actual stage' (Puchner 2010: 170). Indeed, Puchner goes on to suggest that Artaud 'was less interested in founding theatres than in creating the theatre's philosopical equivalent' (Puchner 2010: 170). Other writing on Artaud has challenged this persistent tendency; for instance, Kimberly Jannarone's work emphasizes Artaud's directing practice within the Alfred Jarry Theatre (Jannarone 2005, 2010).

29. Artaud's 'Jabberwocky' has little in common with conventional translation, sharing more with Bene's interpretations of Shakespeare, as we shall see. That is, although Artaud's text could not have existed without Carroll's poem, Artaud's writing was in no way bound by any sense of obligation of fidelity to an original.

30. It is beyond the parameters of this book to address the relationship between Deleuze's use of the terms 'schizophrenia', 'schizophrenic' and 'schizo' in relation

to their conventional clinical definitions, both in 1970s and contemporary psychiatry. As readers will know, 2011 marked the centenary of the first usage of the term 'schizophrenia', which remains a highly controversial diagnostic label for service users and health practitioners alike. Deleuze's concepts of 'schizophrenia' and 'schizophrenic language' are not intended to operate in a clinical context, although, no doubt, they were strongly influenced by Guattari's experimental psychiatric practice at the La Borde clinic. In what follows we will touch on Paule Thévenin's critique of Deleuze's use of the language of 'schizophrenia', but I also plan to address this topic much more fully in future research. For now, though, readers might also be interested to look at a further article I have written on the ethics of Deleuze's use of Artaud: see Cull (2011).

31. Aside from the reference to the body without organs at the end of the radio play as it was performed, Artaud had hoped to include an additional poem, 'The Theatre of Cruelty', which expands on the idea as follows:

> The body is the body,
> it is alone
> and needs no organs,
> the body is never an organism,
> organisms are the enemies of the body ...
> Reality has not yet been constructed because the real organs of the
> human body have not yet been formed and deployed.
> The theatre of cruelty has been created to complete this deployment,
> and to undertake, by a new dancing of man's body, a diversion
> from
> this world of microbes which is merely coagulated nothingness ...
> (Artaud in Schumacher 1989: 173)

However, according to Schumacher, the poem 'had to be left out because of lack of air time' (Schumacher 1989: 172).

32. Thévenin republished her essay in 1993 as part of a collection of writings on Artaud entitled *Antonin Artaud, ce désespéré qui vous parle* (Paris: Editions du Seuil). As Jeffrey Attebury (2000) reports, the collection's introduction includes an apology of sorts to Deleuze from Thévenin, which Attebury reads as an acknowledgement of the inherent difficulty of reading Artaud. Here, Thévenin refers to her early critique of Deleuze as 'a little bit exaggerated' (Thévenin in Scheer 2004: 27).

33. This is my own rough translation of a quotation that Attebury gives in the original French: 'D'emblée, Gilles Deleuze, tombant dans le piège majeur, identifie Antonin Artaud à la schizophrénie' (Thévenin 1993: 200).

34. At one point, the stage directions of *The Spurt of Blood* call for: '*Silence. Noise like a huge wheel spinning, blowing out wind. A hurricane comes between them. At that moment two stars collide, and a succession of limbs of flesh fall. Then feet, hands, scalps, masks, colonnades, porticoes, temples and alembics, falling slower and slower as if through space, then three scorpions one after the other and finally a frog, and a scarab which lands with heart-breaking nauseating slowness*' (Artaud in Schumacher 1989: 18). They later demand that '*At a given moment a huge hand seizes the* WHORE's *hair which catches fire*' (Artaud in Schumacher 1989: 19). From such examples it is not difficult to imagine why the play remained unperformed in Artaud's lifetime (see Cohn 1979).

35. Ghérasim Luca (1913–94) was a Romanian poet, however he wrote the majority of his poetry in French. Deleuze refers to his work on a number of occasions, not only in 'One Less Manifesto', but also in *A Thousand Plateaus* and in the essay 'He Stuttered' in *Essays Critical and Clinical*.

36. In clinical research, in vocology and, indeed, in psychoanalysis, whispering voices emerge among myriad other 'voice disorders'. Although it is beyond the parameters of this book to address these ideas in detail, I hope that my future research may enable me to explore what links there might be between the use of the voice by performance practitioners like Artaud, Bene, Lavaudant and Wilson and those disorders that were in Freud's time referred to as 'hysterical', rebranded in our time as 'conversion' phenomena. One example of this is 'conversion aphonia', which refers to 'involuntary whispering despite a basically normal larynx' (Aronson and Bless 2009: 179), a condition that challenges the tendency to think of whispering as a voluntary action. As is well known, Freud diagnosed his patient Ida Bauer – or 'Dora' – with hysterical aphonia, arguing that her loss of voice was the result of a conversion of her anxious desire for her parents' acquaintance, 'Herr K.', into physical symptoms.

37. My translation.

38. Erickson quotes the following remark from McCaffrey: 'Sound the event not the servant of semantics becomes a possible antidote to the paradox of sign. That a thing need not be a this standing for that but immediately a that and so free of the implications of the metaphysics of linguistic absence' (McCaffrey in Erickson 1985: 280).

39. I am borrowing Deleuze and Guattari's mode of expression here, appropriating their discussion of the prison-form in *A Thousand Plateaus*, and adapting it for my own purposes (Deleuze and Guattari 1988: 66).

40. As is well known, Artaud was forcibly institutionalized in a number of French 'asylums' for nine years from 1937 (Atteberry 2000: 715), and it is this issue of involuntary commitment that continues to focus much of the ethical debate around schizophrenia and mental health service provision more broadly. Unfortunately, it is beyond the scope of this book to address these debates, the ethics of Guattari's call for the 'depsychiatrization of madness' (Guattari in Genosko 1996: 478) or his argument that 'the true scandal is the existence of incarcerative structures which literally exterminate the mentally ill and the personnel who work there, in the place of creating living systems' (Genosko 1996 485). However, I hope what follows provides some indirect stimulus for reflecting on these matters, and on how academia might relate to the 'mad' through a direct consideration of Deleuze and Guattari's complex and changing treatment of Artaud.

41. Likewise, this chapter has constituted only a very early attempt to construct some kind of connection between my own research into Deleuze's philosophy and a place outside this book (and indeed Deleuze's books), which we might designate the realm of mental health: as a diverse range of embodied experiences, therapeutic practices, medical professional/patient dynamics and as a site for fraught disputes over rights and ethics, particularly with respect to the issue of involuntary containment. Clearly, there is a great deal more work to be done here, perhaps particularly regarding what we might call the minor literature of mental health, which includes the work of Artaud. In terms of filmic practice, there is an extensive history of experimental documentary that might also be construed as invoking a 'mad' people-to-come, including Raymond Depardon's *Urgences*

(1987), which Guattari described as 'working upon our own lines of fragility'; Allie Light's *Dialogues with Madwomen* (1994); and Nicholas Philibert's *La Moindre des choses* (1997). See Peter Stastny (1998) for a more extensive list of films that might be considered to belong to this minor literature on mental health.

42. Clearly, I am asking these questions as much of myself as a scholar-artist as I am of any interested readers. Just as this is an early theoretical response to Artaud, I have also performed some initial practical responses. One example of this can be found in the performance 'Manifesto' (2008) that responds to Artaud, alongside Deleuze, Allan Kaprow, John Cage and Goat Island. 'Manifesto' was presented at the ICA in London as part of the exhibition *Nought to Sixty*, and can be watched on YouTube at http://www.youtube.com/user/lauramullarkey#p/a/u/2/WN9TG5fg5Gc.

43. As Jannarone notes, 'The Surrealists, led by Breton, threatened to disrupt the second performance of Strindberg's *A Dream Play*, and the Jarry Theatre kept them out by hiring police' (Jannarone 2010: 217n).

44. *Navel and A-Bomb* was a collaboration between Hijikata and photographer Eikoh Hosoe. According to Chris MaGee, 'The film took its inspiration from a poem by Abstract Expressionist painter Taro Yamamoto and was shot on a beach at Cape Taitozaki near the town of Ohara in Chiba Prefecture. Hijikata choreographed Yoshito Ohno, four local fishermen, and six village boys in a modern spin on the Adam and Eve story. After the dancers are expelled from Eden by a nuclear explosion a chaotic spirit from the sea, played by Hijikata, threatens another apocalypse by stealing the forbidden fruit of a boy's navel, the symbolic "pushing of the button" that would herald World War 3' (MaGee 2010: n.p.).

45. According to Baird, a sickle-weasel is 'the name for a phenomenon in which one's skin is cut without having come into contact with anything. A folk explanation ascribes such wounds to a whirlwind (or a supernatural being such as an invisible weasel) lacerating the skin with a sickle' (Baird 2012: 109). Hijikata says, 'It was not that I played the part of the sickle-weasel, but rather that the person who snapped the shutter was the sickle-weasel' (cited in Baird 2012: 109). That is, it is not the performer who introduces a cut into the bodies of the world, but the camera.

46. There are some exceptions to this, of course, which we will discuss in more detail in what follows. For instance, interested readers might look to Julie Holledge and Joanne Tompkins Deleuzian discussion of butoh and specifically the female body in butoh in the book *Women's Intercultural Performance* (2000), as well as Michael Hornblow's 2006 essay 'Bursting Bodies of Thought: Artaud and Hijikata'.

47. Coates's work has featured in a number of exhibitions that place it in a Deleuzian context. In 2008, he was featured in the show *Machinic Alliances*, which took Deleuze and Guattari's notion of the machine as 'the basis from which to propose unholy affiliations between categories of human/animal/technological' (see http://www.daniellearnaud.com/exhibitions/exhibition-machinic-alliances.html). Then, in 2009, his work appeared in a exhibition at the Neue Gesellschaft für Bildende Kunst (NGBK) in Berlin entitled *Becoming Animal, Becoming Human*, whose curators explicitly took 'the idea of becoming-animal formulated by Deleuze and Guattari in *A Thousand Plateaus* as a starting point' (see http://becoming-animal-becoming-human.animal-studies.org/html/babh_intro.html). As much as anything, this kind of exhibition seems to evidence the extent to which Deleuze and Guattari's work has influenced the visual art world – insofar as we acknowledge this to be a distinct if overlapping realm of activity in relation

to that of theatre and performance. And here, it is not merely a case of Deleuzian vocabularies being lightly woven into gallery press releases, although one can find instances of this. Rather, and unlike theatre and performance until much more recently, we can see how Deleuze and Guattari's work has been thoroughly absorbed and reflected on by artists, curators and visual culture scholars.

48. In her review of a 2010 show of the materials used in Coates's shamanic performances at the Kate McGarry gallery, Hannah Forbes Black begins by arguing, 'The big question about Marcus Coates is: Are you kidding, or what?' She goes on: 'His performances ... always have the appearance of sincerity. But it's unclear if the straight face is for real, or part of the game.'

49. In contrast, Jonathan Griffin (2007) argues that the humour of works such as Coates's *Goshawk* (1999) is the result of 'the naivety of the desires they embody'.

50. Vargas's piece has been the source of much speculation, debate and protest, not least on account of the absence of clear information regarding the treatment of the dog during the exhibit. According to some of the websites apparently created in protest to the piece, the dog was starved to death by the artist, whereas the gallery claims that the dog was only tied up for a short period and was given food and water. The artist, in turn, responded to protests by emphasizing that no visitors to the gallery intervened to release the dog. The artist said: 'The purpose of the work was not to cause any type of infliction on the poor, innocent creature, but rather to illustrate a point. In my home city of San Jose, Costa Rica, tens of thousands of stray dogs starve and die of illness each year in the streets and no one pays them a second thought. Now, if you publicly display one of these starving creatures ... it creates a backlash that brings out a bit of hypocrisy in all of us ... [The dog] was a very sick creature and would have died in the streets anyway' (Vargas in Aloi 2012: 127).

51. According to Lourdes Orozco, 'Strongly hierarchisized animal-human encounters have populated García's theatre for over twenty years. Frequently placed in a subordinate position in relation to the performer, animals have been manipulated, tortured, sexually molested, and slaughtered. In *After Sun* (2000), actor Juan Loriente violently played with two rabbits, whisking them around the room while dancing to Tom Jones' hit 'Sex Bomb' – a scene closely reproduced in García's last production *Versus* (2008); in *Haberos quedado en casa, capullos* (You Should Have Stayed at Home, Dickheads, 2000), child actor Rubén Escamilla repeatedly attempted to drawn two gerbils in a fish tank while a mouse themed children song was played in the background; in *A veces me siento tan cansado que hago estas cosas* (Sometimes I Feel so Tired that I Do Things Like This, 2001) geese, rabbits, pigeons, and a goat shared the stage with children and adults; and, finally, in *Une Façon d'Aprocher l'Ideé de Mefiançe* (One Way of Approaching Mistrust, 2006) performers play around with hens while a turtle is left to wander around a stage flooded by milk, honey, water, compost, and talcum powder.' Finally, Orozco cites García's *Accidens: Matar para Comer* (Accidents: Killing to Eat, 2006), 'an encounter between a human and a lobster, in which the lobster is tortured and finally killed, cooked and eaten by the human' (Orozco in Cull and Daddario 2012: n.p.). In 2009, a production of *Accidens* for the Europe Theatre Prize was interrupted by both 'an upset spectator and the police' (Fricker 2009: n.p.).

52. In terms of practice-based research explicitly engaging with the concept of becoming-animal, one might cite *The Salon of Becoming-Animal* (2005) by Edwina Ashton and Steve Baker; *The Animal Project* (2004), initiated by Una Chaudhuri,

Fritz Ertl and Steven Druckman; and the work of the UK-based practitioner Paul Hurley, among others.

53. I use the term 'animation' here to evoke Hijikata and indeed Ohno's interest in the transformation of the body in relation to so-called inanimate matter like stones or wind. We could also note both practitioners' insistence on the lack of a fixed distinction between the living and the dead (Fraleigh 2010: 13).

54. Bruce Baird's recent book makes an excellent argument against the tendency to see Hijikata as alone in exploring modes of moving beyond existing conventions and recognizable movement vocabularies. As Baird has discussed, Hijikata was 'one among many who were trying to find new kinds of dance' in Japan in the late 1950s (Baird 2012: 17). These lesser known others include Wakamatsu Miki, Tsuda Nobutoshi (with whom Hijikata studied) and Nagata Kiko, among others.

55. Incidentally, Coates too has touched on the exploration of gender, though in much less extensive ways than Hijikata; namely, in the photographic work *Galapagos Style* (2009), which features Coates posing as a female tourist (in a bright pink dress and pink sunglasses) against the backdrop of two giant tortoises mating in a mock cover of *Esquire* magazine.

56. Famously, Deleuze and Guattari seek to rethink the nature of the relationship between a wasp and an orchid that appears to imitate it in order to attract it to pollination. Deleuze and Guattari accept that 'It could be said that the orchid imitates the wasp, reproducing its image in a signifying fashion' (Deleuze and Guattari 1988: 10). However, they then argue that 'at the same time, something else entirely is going on' which they call becoming, or the formation of a 'rhizome' between wasp and orchid. Despite their species difference, despite their heterogeneity, the insect and the plant have the power to change and be changed by one another in a more material fashion that the notion of imitation conventionally implies.

57. Likewise, we might describe Hijikata as a 'nomad' in Deleuze's sense, a sense that Deleuze claims has nothing to do with travelling around. After all Hijikata 'never left Japan, and rarely even left Tokyo' (Barber 2010: 8) and yet, in another sense, he spent his entire life moving, becoming, differing.

58. Indeed, Deleuze and Guattari sometimes seem to equate mimesis, mimicry (*mimétisme*), reproduction and imitation in ways that are likely to jar for Theatre and Performance Studies scholars familiar with the important work that has subsequently been done by scholars such as Elin Diamond and Homi Bhabha, who particularly emphasize a distinction between mimesis and mimicry.

59. 'Little Hans' (whose real name was Herbert Graf) is the subject of Freud's 1909 case study 'The Analysis of a Phobia in a Five-Year-Old Boy'. Freud interpreted 'Little Hans'' sexual curiosity and 'phobia' of horses according to an Oedipal model of desire in which the horse is understood to represent the father. The Rat Man 'was a twenty-nine-year-old lawyer and soldier, Ernst Lanzer, who came to see Freud in 1907 because of his inability to rid himself of his obsessional and upsetting thoughts ... The immediate cause of the Rat Man's seeking analysis, and the source of Freud's strange nickname for him, was a story the Rat Man had heard from a fellow officer. This man had told him about a Chinese torture technique in which a pot was filled with rats and tied to a victim's buttocks: the rats eventually gnawed their way into the victim's anus' (Thurschwell 2009: 61–2). The Wolf Man was 'a wealthy young Russian named Sergei Pankeiev' whose name 'issued from a nightmare he had as a child that resulted in a phobic fear of wolves'. In his analysis, Freud argued that 'the dream was a distortion of a scene

that the Wolf Man had witnessed when he was only a tiny child, perhaps one-and-a-half years old: ... his father have sexual intercourse with his mother from behind' (Thurschwell 2009: 65).

60. In the last chapter, we saw how Deleuze and Guattari differentiated between major and minor usages of language, rather than between major and minor languages per se. In the same way, we might suggest that although at times they appear to differentiate between three types of animals in *A Thousand Plateaus* – 'Oedipal', 'State' and 'demonic' – it is more that these terms designate three ways of *treating* or relating to any animal. For instance – contra Donna Haraway's critique of becoming-animal in *When Species Meet* – they do take care to acknowledge that '*any* animal is or can be a pack' and that even the seemingly domesticated cat or dog can be 'treated in the mode of the pack', just as 'there is always the possibility that a given animal, a louse, a cheetah or an elephant, will be treated as a pet, my little beast' (Deleuze and Guattari 1988). So, whereas to treat an animal in an Oedipal fashion is to sentimentalize them and to treat them in the 'State' manner is to render them symbolic in some way, Deleuze and Guattari favour the third form of treatment of animals as 'demonic'. However, as Beaulieu explains, 'Here, "demon" should not be understood as "mischievous spirit", but rather in the Greek sense of *daïmon*: situated in between the world of the living (states-of-beings) and some kind of suprasensible world (immanent to the first world) that, according to Deleuze and Guattari, is made up of inorganic life, affects, and impersonal forces' (Beaulieu 2011: 77).

61. Although I arrived at the term 'immanent mimesis' independently, I have since discovered a number of existing usages in a variety of contexts. For example, in his 2007 book on Jorge Luis Borges, Alfonso de Toro considers the idea of language as a form of 'immanent mimesis' in the sense that 'language has some sort of an intrinsic connection with the universe' (de Toro 2007: 109). In turn, Zornitsa Dimitrova appealed to the concept of 'immanent mimesis' at a 2011 conference in Copenhagen. In her abstract for this paper, Dimitrova connects the notion of mimesis to the concept of expression in Deleuze.

62. As Martin Puchner has discussed, Plato developed a specific account of mimesis as it relates to the performance of poetry. For Plato, 'mimesis is the direct presentation of different voices and the types of impersonation that happen not just in theatre but also when rhapsodes recite Homeric poetry, doing the lines in different voices' (Puchner 2010: 32). This is contrasted with the more distanced mode of presentation, which Plato called 'diegesis'.

63. Shibusawa and Hijikata 2000: 53–4. 'HIJIKATA: ... I think I've always been mad about implements. I love it when a human being almost becomes a thing or part of a human completely turns into a thing, for example, an artificial leg. My intuition tells me that the wolf boy was the same.'

64. In the same way, the composer Olivier Messiaen found it necessary to 'transcribe the bird's song in a slower tempo if it is to be played at all' (see Bogue 2003c: 29).

65. *Sparrowhawk Bait* was made while Coates was doing an artists' residency at Grizedale Arts in Grizedale Forest, so although I can find no evidence either way, one might hope that the birds in question were not killed *for* the work, but were found already dead. Interested readers can watch the video work online: http://www.digitalartlab.org.il/ArchiveVideo.asp?id=451&is_submit=1.

66. Again, an excerpt of the video can be watched online at http://www.digitalartlab.org.il/ArchiveVideo.asp?id=450.

67. Interestingly, as Dylan Evans has discussed, Lacan's original concept of the mirror stage – first presented in 1936 – was in part a response to a 1931 experiment performed by his friend, the French psychologist Henri Wallon, in which Wallon compared the reactions of a human child to those of a chimpanzee when both were faced with their own reflection in a mirror (Evans in Gottschall and Wilson 2005: 47). The experiment found that 'around the age of six months both humans and chimpanzees begin to recognize that the image in the mirror is their own. However, Wallon claimed that there was an important difference between the subsequent reactions of the human infant and the chimpanzee. The human infant becomes fascinated with his reflection and leans forward to examine it more closely ... The chimp, on the other hand, quickly loses interest and turns to look at other things' (Gotschall and Wilson 2005: 48). In turn, Evans suggests that the early Lacan was more willing to admit a continuity between human and nonhuman animals than his subsequent writings suggest.

68. At other times, though, Read seems to seek to maintain a special place for the human, a uniqueness and qualitative 'distinction from other animals' that will not be sustained here. For instance, Read begins his book by stating that 'Humans are unique in their ability to sustain a controlled unbroken breath' (Read 2008: 1), and goes on to admit that he is 'less interested ... in the appearance of the animal' in performance and more interested in what he sees as 'the strangeness of the human animal' (Read 2008: 8).

69. Following his death in 2006, Kaprow's work has received significant international attention, most notably perhaps in the major retrospective exhibition *Allan Kaprow: Art as Life*, curated by Stephanie Rosenthal and Eva Meyer-Hermann, which toured a number of global art institutions during 2007–08, at the same time as it sought to preserve Kaprow's 'synthesis of art and everyday life' (Leddy and Meyer-Hermann 2008: 57). That is, the curators appreciated the irony of the very notion of a major retrospective of an artist who had 'an ambivalent attitude towards exhibitions' (to say the least) and spent much of his life pursuing the participatory practices he called 'nonart' (Leddy and Meyer-Hermann 2008: 57). In 1967, Kaprow remarked: 'I am put off by museums in general, they reek of a holy death which offends my sense of reality'; even when museums try to acknowledge the relationship between art and life, 'they provide canned life, an aestheticized illustration of life'. '"Life" in the museum is like making love in a cemetery,' he argued (Leddy and Meyer-Hermann 2008: 77). Curators of Lygia Clark's work face comparable problems; indeed, the art historian Yve-Alain Bois 'wrote that he knew of no other artist whose oeuvre a curator would find more difficult to present' (Larsen and Rolnik 2009: n.p.). Nevertheless, 1997–98 saw the *Lygia Clark* retrospective exhibition, curated by the Fundacio Antoni Tapies in Barcelona, while in 2005 Suely Rolnik curated *Lygia Clark. From Work to Event (Lygia Clark, de l'œuvre à l'événement)* for the Nantes Musée des Beaux-Arts. However, Rolnik's exhibition did not present the documentary remnants of Clark's practice in conventional ways, but focused on the production and display of interviews with 66 people who had been directly and indirectly involved in Clark's work, life and times. As Rolnik puts it: 'it was a matter of producing a memory of the bodies that the experience of Lygia Clark's proposals had affected and where it was inscribed, to give it a chance of pulsating in the present, since this ground, transformed over the course of thirty years by the successive generations of institutional critique, was once again potentially fertilizable' (Rolnik 2007: n.p.).

70. At this point, we might also wish to note the importance of participation as a concept in the context of arts and cultural policy. Here, it is broadly understood to connote an inclusive attitude towards arts engagement and can encompass a wide range of modalities, from supporting a new visitor to step over the threshold of a local arts institution through to the establishment of educational programs that can serve as an alternative point of public access both to the works on show and to the arts more generally. Participation is a buzzword for funding applications in both academic and professional contexts, the term that indicates the applicant's understanding of and interest in the need for galleries and theatres alike specifically to reach out to those who might not otherwise participate in the arts, as audiences, visitors or co-creators.

71. Mischa Twitchin of the Shunt Collective has also noted the misguided attribution of a sense of freedom with respect to audience participation in the company's work. For instance, in a 2009 interview, Twitchin emphasized the constructed nature of the participation in works such as *Tropicana*, saying, 'I suspect that this "freedom" is rather spurious. It's the way you describe the experience, but the part of the experience that you're calling "freedom" is no less conventionalized and constructed than the part of the experience that you're calling traditional. There are a whole set of accidents that compose these possibilities as well as the decisions, of course; but, as I said before, one of the main interests of the company is to consider the journey of the audience. The work includes "an audience", distinct from a group of people wandering randomly. How they are included is our responsibility; we are making an experience for an audience, in an environment that we are constructing. It's not a Happening, it's a rehearsed show and even if it's not apparent to anybody – even ourselves sometimes! – there is a narrative structure' (Twitchin in Eglinton 2009: n.p.).

72. Rolnik has argued that many of 'the proposals that have been qualified and theorized as "relational"', and one might add many performances that claim to be participatory or immersive, have tended to 'reduce themselves to a sterile exercise in entertainment contributing to the neutralization of aesthetic experience – the affair of *engineers of leisure*, to paraphrase Lygia Clark ... Such practices establish a relationship of exteriority between the body and the world, where everything remains in the same place and the attention is *entertained*, immersed in a state of *distraction* that renders subjectivity insensible to the effects of the forces shaking up the environment around it' (Rolnik 2007: n.p.. emphasis in original).

73. Excerpt from the score of *Meters*, an unrealized Activity by Allan Kaprow from 1972 (Kaprow in Leddy and Meyer-Hermann 2008: 225).

74. Excerpt from the score of *Baggage*, an Activity by Kaprow from 1972, sponsored by Rice University, which took place in various locations in Houston (Kaprow in Leddy and Meyer-Hermann 2008: 225).

75. Excerpt from the score of *Satisfaction*, an Activity by Kaprow from 1976, sponsored by the M.L.D'Arc Gallery New York (Kaprow in Leddy and Meyer-Herman 2008: 261).

76. According to the timelines published in *Allan Kaprow: Art as Life*, the last, new Activity that Kaprow created before his death was entitled *Postal Regulations* and was realized in June–July 2001 (Leddy and Meyer-Hermann 2008: 330).

77. Although we cannot address this work here, we might wish to note that, towards the end of her life, from the mid to late 1970s until the mid to late 1980s, Clark's work moved even further away from what could be recognized as 'art' in *The Structuring of the Self*. At this point, Clark began to see individual 'patients' 'for

one-hour sessions, one to three times a week, over a period of months, and, in certain cases, for more than one year', performing a series of actions on the bodies of participants using 'Relational Objects' – shells, air-filled bags and other created objects. Of this work, Clark said: 'it is not psychoanalysis, it is not art' (in Borja-Villel and Mayo 1998: 344). And, in turn, Rolnik has argued that in this final phase, Clark did not operate on the border between art and therapy, but created an 'entirely new territory' in which 'Art effectively reconnects itself to life [the utopian ambition of modern art per se according to Rolnik], and the existence of psychotherapeutic treatment loses any meaning' (Rolnik in Ruiz and Martin 1999: 99). Art and therapy 'cease to exist as such', Rolnik argues (Ruiz and Martin 1999: 100), so rather than call Clark an 'artist' or a 'therapist', we might concur that 'her discoveries call for a new name which has not yet been found' (Brett in Borja-Villel and Mayo 1998: 17).

78. One might argue that the labelling of these events as 'performer only' Happenings was arguably aspirational rather than descriptive on Kaprow's part. In particular, we might note the large, if impromptu, audience that gathered to watch the aspects of *Calling* that took place in New York's Grand Central Station. Indeed, we might suggest that there is an attention-seeking, spectacular quality to Kaprow's decision to have the cloth-wrapped bodies of participants dropped off at Grand Central and propped up against an information booth. Looking like dead bodies or packages awaiting collection, the mummified participants call out to other volunteers, before unwrapping themselves and leaving the station.

79. There is conflicting evidence as to exactly when Kaprow began to use the term 'Activity' and when the first Activity might be said to have taken place, but it seems to have been around 1968–69. For instance, there is terminological confusion over whether certain events such as *Runner* (1968) and *Charity* (1969) should be called 'Activities' or 'Happenings'. Kaprow's own essay, 'The Education of the Un-Artist, Part II' (1972), provides a score for both works that categorizes them as Activities (Kaprow 2003: 115, 122). However, in *Allan Kaprow: Art as Life*, both *Runner* and *Charity* are listed as Happenings (Meyer-Hermann 2008: 197, 207). The recent and very comprehensive catalogue *Allan Kaprow: Art as Life*, which draws heavily on the Kaprow papers in the Getty Archive, suggests that several of Kaprow's early Activities remained unrealized, and that the first actually presented Activity was an event entitled *Moon Sounds*, realized in December 1969 at the wedding of Heidi and Richard Blau, son of the eminent performance theorist Herbert Blau (Meyer-Hermann 2008: 210). In correspondence with the author, Herbert Blau has said of *Moon Sounds*: 'It was a marvellous affair that started at our house in Silver Lake, went out onto the desert landscape between Cal Arts & the Livermore atomic energy research headquarters, and ended with a dinner back at the house' (Blau 2008: n.p.).

80. We might remind ourselves here of the relevance to Performance Studies of the ethnographic research method of 'participant observation', as discussed by Dwight Conquergood among others. Generally claimed to have been developed by Malinowski during the 1920s and 1930s, participant observation might be broadly defined as a form of research in which data is gathered by a researcher who takes part in the activities of the people s/he is studying. In his recent guide, H. Russell Bernard (2011) differentiates between three different roles that a researcher might play during fieldwork. Firstly, there is the 'complete participant', where the researcher becomes a member of a group without revealing that this participation is research. Secondly, there is the 'complete observer', who

observes his object of study without pursuing any interaction with that object. And then there is the participant observer, who lies between the two. However, Bernard goes on to differentiate within this category too, depending on whether or not the participant is an 'insider' or an 'outsider' in relation to the activity or community that they are observing; if they are an insider, they are an 'observing participant'. As a method for conducting fieldwork, particularly prevalent in cultural anthropology, participant observation is conventionally understood as a means to accumulate 'experiential knowledge' through immersion in a particular environment. The participant observer collects data on their subject by directly experiencing the life of that subject as it unfolds. In this way, participant observation was originally staked on the claim that an observer can observe a phenomenon without altering its behaviour; the act of observation itself is thought to have become transparent (at least when one gets it right).

81. According to Anthony Uhlmann, Bergson suggests that 'we can become unconscious when our actions correspond with our idea of them: that is, when we perform perfectly mechanical or habitual actions. When this happens we are not conscious of what we are doing: we become the act of doing itself and this nullifies any thoughts we might have about the action itself' (Uhlmann in Jun and Smith 2011: 162).

82. The Living Theatre's *Paradise Now*, for example, was structured in such a way as to make room for the audience to generate creative responses to an invitation from the company. However, the company's desire to communicate their own political agenda often seemed to prevent them from affirming the diverse forms that an audience's creativity might take. That is, the performance consisted of a series of eight of what the company called 'Rungs', incorporating a 'Vision' performed by the actors, a 'Rite' that aimed to establish contact between audience and performers and an 'Action' to be initiated and conducted by the audience. Yet there seem to have been occasions when the company felt the need to 'steer' *Paradise* back on course. For example, during 'Rung II' the actors are instructed to give support to any kind of movement, dialogue or scene that members of the public might decide to enact. But, tellingly, the instruction then continues: 'If this *digresses from the revolutionary theme* or from the plateau to which we have been brought by the Rite and the Vision, the actors then try to *guide the scene back to the meaning* of the Rung' (Beck and Malina 1971: 45, emphasis added). This quote is emblematic of a recurring problem for the Living Theatre: the incompatibility of the desire to generate an audience experience of creative, participatory presence and the ambition to communicate or transmit a single political message or final meaning.

83. There are many instances of this use of repetition in the late Happenings as well as the Activities. For example, we might note the repeated 'bucketing' and pouring of water in the Happening *Course* (1969); the repetition of carrying and placing down cement blocks in the Activity *Scales* (1971); or the turning on and off of multiple light bulbs in another Activity *Message Units* (1972).

84. As Beth Lord explains in her very clear and helpful book, *Spinoza's Ethics*, Spinoza himself inherited this vocabulary from earlier thinkers such as Aristotle and Descartes. As Lord recounts, Aristotle, for instance, divided the world up into 'substances and their attributes. For Aristotle, substances are the basic, independently existing things of the universe, and attributes are their changeable properties. Whereas attributes depend on substances for their existence, substances do not *logically* depend on anything beyond themselves' (Lord 2010: 16, emphasis in original). That is, Aristotle suggests that while a substance like the human body

does not depend on anything outside itself to exist, a property or attribute like 'weight' must be 'the weight of some body'.

85. Zepke himself quotes Kelley a number of times in his essay, recognizing his expertise on Kaprow's relationship to Zen. However, he still seems to associate Zen in general with mysticism and transcendence rather than immanence and the political.

86. The koan is a Zen form of study that involves the student being given a 'problem with no logical solution', such as a paradoxical statement or question. Kaprow was not interested in the koan because of the Rinzai school's belief in it as a means to produce 'instant enlightenment'. Rather, Kelley suggests, Kaprow appreciated Zen for its emphasis on practice, on 'paying attention to what we are doing' rather than trying, purely intellectually, to make sense of what we do from a transcendent point of view (Kelley 2004: 204).

87. Part of the problem, or limitation with Duchamp's gesture for Kaprow, is that by insisting on using the gallery it excludes 'most of life' on account of size if nothing else. One might be able to put a urinal on show, but one cannot exhibit the LA freeway at rush hour, Kaprow complains (Kaprow 2003: 207). Kaprow sees Duchamp as taking nonart and setting it in a 'conventional art context', or what he also calls 'an art-identifying frame', which 'confers "art value" or "art discourse" upon the nonart object, idea, or event'. Despite the forceful effect of Duchamp's initial gesture, Kaprow argues that the readymade strategy later became 'trivialised, as more and more nonart was put on exhibit by other artists' (Kaprow 2003: 219).

88. It is partly for this reason that I have devoted a chapter to the temporal aspect of theatres of immanence, while there is no such chapter devoted to spatiality. However, the chapter will question the dichotomy between the time's creativity and inert space that one can find in aspects of Bergson's early work.

89. The notion of the 'well-made play' (or *pièce bienfaite*) is generally attributed to the French dramatist Eugène Scribe (1791–1861). For Martin Banham, 'the well made play is skillfully crafted to arouse suspense. An outgrowth of the comedy of intrigue, its action is propelled through a concatenation of causally related events' (Banham 1995: 1191). As well as reinforcing notions of causality, the temporality of a well-made play is characterized by 'a clear beginning, middle, and end' and by the careful organization of points of crisis and climax, in ways that other nineteenth- and twentieth-century dramatists like Chekvov and Bernard Shaw would criticize as overly constructed and artificial (Cody and Sprinchorn 2007: 1119).

90. In fact, the concept of presence in Féral's important 1982 article is more complex than I have suggested in these brief remarks. For instance, she talks about the performance of gestures in Vito Acconci's practice as rendering Derrida's *différance* perceptible in a manner that suggests that hers is by no means a binary logic (Féral 1997: 292).

91. As John Mullarkey has pointed out, Bergson's account of the nature of spatiality and its relation to time changes across his oeuvre beyond this straightforwardly negative depiction of space as pure homogeneity that is primarily put forward by Bergson in *Time and Free Will* (Mullarkey 1999: 12–13). However, it is outside the scope of this book to explore the nuances of Bergson's thinking; suffice it to note that Deleuze presents a particular and partial account of Bergsonism that should not be taken as identical with Bergson's philosophy per se (as Deleuzians often tend to do).

92. Among the works of Deleuzian Virtualism, Mullarkey cites Manuel de Landa's *Intensive Science and Virtual Philosophy* (2002) and Keith Ansell Pearson's *Philosophy*

and the Adventure of the Virtual (2001) (Mullarkey 2004: 488). In these interpretations of Deleuze, Mullarkey argues that 'the actual is normally aligned ... with the merely possible, the molar, the spatial, the phenomenological, and the psychological, while the virtual alone has privileged access to reality, that is, to ontology' (Mullarkey 2004: 488).

93. As Mullarkey acknowledges, his Actualist critique of the ethical and political implications of the prioritization of the virtual over the actual to some extent reflects the feminist critiques of Deleuze put forward by theorists like Luce Irigaray and Alice Jardine. As he puts it, 'we could point initially to the feminist critique of Deleuze's key notion of "becoming woman" as one attempt to rehabilitate the actual, by pointing out the need to regard fully the molar being of individual women, as political agents or as biological mothers, beyond any indifferent flow of pure "atoms of womanhood" heading towards imperceptibility'. For an essay connecting this feminist critique to aspects of Goat Island, see Cull and Goulish (2007).

94. However, it would be a mistake to think that Mullarkey is simply reversing the virtual/actual hierarchy here, dismissing the virtual as a 'merely' psychological phenomenon rather than an ontological reality. Although it is beyond the remit of this project to discuss such a position in full, Mullarkey's view is essentially that the virtual is 'a function of the actual', but one that has 'real effects on the actual rather than being merely epiphenomenal' or illusory; both psychology and actuality are ontological. The actual is not a self-identical presence that needs a hidden power of virtual difference to render it creative and, as such, real. The actual was always already real as differential presence without the need for the concept of the virtual as 'the pure difference ontologically subtending our actual world' (Mullarkey 2004: 471).

95. It is perhaps worth reminding ourselves here that this 'otherness' can equally be what we conventionally consider to be a part of 'ourselves', not just the otherness of another person or individuality. For instance, Mullarkey discusses the example of the tendency to 'virtualize' parts of one's self – such as the unconscious, the body or memory – from the perspective of consciousness. Rather than appropriate the difference of these parts as 'mine' or label their reality as 'virtual', Actualism encourages us to conceive of each part as its own actual world, with its own actuality, which may or may not be visible to other parts such as conscious thought, but can be felt or intuited (Mullarkey 2004: 479).

96. Mullarkey suggests that 'One way to capture the two dominant approaches to time in contemporary Continental philosophy is by depicting them as either futurist or pastist. Where (the early) Heidegger demotes the present in favour of the future, Deleuze attacks it from its flank of the past. In both cases, though, any depth that might be thought to belong to other broader presents, to thick presents, is stolen for the future or past' (Mullarkey 2004: 487). In this sense, this final chapter is pointing to a consideration of differential presence *beyond Deleuze* and partly developed by Matthew Goulish, whose perspective – particularly in recent writing – is arguably closer to Bergson and Mullarkey than Deleuze, to the extent that we are willing to label the current orthodoxy on Deleuze as more 'Virtualist' than 'Actualist'.

97. The AV Festival Welcome by Festival Director Rebecca Shatwell reads as follows: 'In the run-up to London 2012 with its motto of "Faster, Higher, Stronger" we propose an alternative slower pace and relaxed rhythm to counter the accelerated speed of today' (Shatwell 2012: 3).

98. Many contemporary companies now report taking over a year to create a performance. In this regard we might think of Elevator Repair Service as well as Goat Island; and of emerging companies such as the New York-based duo Cupola Bobber and the UK-based group Gecko.

99. Each of these branches of the Slow Movement is explained on the website (http://www.slowmovement.com/). Of particular interest perhaps is the discussion of Stradbroke Island, near Brisbane, the tourist economy of which has successfully profited from rebranding itself as 'the world's first Slow Island'.

100. Deleuze conceives of habit as one aspect of our way of being in time, through his articulation of the notion of 'synthesis': essentially, a concept concerned with the durational aspects of material relationships such as sensation, metabolism, perception, representation, imagination and memory. Or again, we might suggest that the concept of synthesis – which Deleuze follows Hume in dividing up into 'active' and 'passive' forms – is another way to think about what we have hitherto conceived of in terms of affective encounter. As Keith Faulkner explains, for Deleuze, 'the organism seeks to sustain its unity in time' and, as such, synthesis necessarily occurs when organic bodies confront the multiple speeds of the world that seem to threaten this unity. 'The simple organism senses a changing environment and, because it appears discontinuous, the senses must *synthesize it into a durational schema* to stabilize the object' (Faulkner 1995: 61, emphasis in original).

101. In fact this molar account is particular inadequate in Earhart's case given the uncertainty surrounding her time and place of death. Earhart went missing on 2 July 1937 and was declared dead on 5 January 1939.

102. Bergson's original example was about sugar dissolving in water, since sugared water was a popular drink in the late nineteenth and early twentieth centuries. Goulish's (mis)quotation of the example – in which water becomes tea – is not so much a mistake as a deliberate translation of Bergson's observations into a more ordinary, contemporary example.

103. At this point, we might also think of the singling out of a particular gesture in *September Roses*. Here, it is Lito Walkey's gesture of trying to stand still on one leg, while the other leg is bent and raised to waist height.

104. For instance, Mullarkey states that 'the average shot length for the *Bourne Supremacy* (2004)' is 2.4 seconds, in contrast to the 9–10 second average of 1940s films (Mullarkey 2009: 153).

105. Lehmann cites *Difference and Repetition* in a footnote to this statement; see Lehmann 2006: 197n.

106. Contra Deleuze's emphasis on Bergson's specifically metaphysical contributions to the philosophy of difference, Mullarkey suggests that 'Bergsonism may best be read as an ethics of alterity fleshed out in empirical concerns' (Mullarkey 1999: 107).

107. This is how viewers will see the film if they watch it on the recently released DVD. As Theron Schmidt notes, the four films that make up *A Last, A Quartet* are in fact intended to be screened as four adjacent projections (Schmidt in Goat Island 2012: 17).

108. For instance, in a tape recording made as part of the Activity *Take Off*, participant Gerald Piltzer said: 'I usually don't have any feelings while making a bed. I don't think about it but now I have to think because Allan told me to ... This bed isn't a bed anymore. It's just a process in a Happening ...' (Piltzer *et al.* 1975: 90). The certainty with which Piltzer identifies the process of making the bed as art and his reinforcement of 'Allan' as the 'author' of the work indicate the

difficulty of actually experiencing a dissolution of the distinction between the usual situations of life and the unusual situations of art.

109. According to the article, two women put together in the first group met each other the day before the Activity and became friends. They objected to the invitation to deceive one another built into Kaprow's instructions and 'decided it was an authoritative imposition that sought to destroy their relationship'. The man who was the third in the group wanted to continue to follow the rules of the Activity, so during a group lunch the women 'symbolically killed him with a pistol and photographed the action' (Piltzer *et al.* 1975: 90).

110. 'A body can be anything; it can be an animal, a body of sounds, a mind or an idea' (Deleuze 1988: 127).

111. For this work, Sierra paid six unemployed men in Cuba $30 to participate in the tattoo image/action. In the related work, *160 cm Line Tattooed on 4 People* (2000), Sierra paid four prostitutes, who were already addicted to heroin, the price of a shot of heroin in exchange for consenting to being tattooed.

112. In Alys's work, 500 volunteer labourers were employed by the artist in order to move a sand dune situated on the outskirts of the city of Lima in Peru. Working in a line, and moving sand with shovels, the labourers managed to move the dune 4 inches from its original position.

113. An 'ethico-aesthetic paradigm' is the subtitle of Guattari's sole-authored text *Chaosmosis*, which was originally published in French in 1992.

114. See Joshua Abrams in Kattwinkel (2003), Erickson (1999), Sherman in Cull and Gritzner (2011), Bayly (2011).

115. Indeed, as Bayly points out, Deleuze directly discusses the idea of the face of the Other in *Difference and Repetition* and *What is Philosophy?*

116. According to Mullarkey, 'it is Bergson's metaphysics that is said to have influenced Levinas most' (Mullarkey 1999: 108). This is particularly evident in Levinas's *Time and the Other*, in which he explicitly acknowledges the importance of Bergsonism for his ethical philosophy.

117. For example, it is well known that some concepts from *A Thousand Plateaus* have been appropriated by the Israeli Defence Force (IDF). As Shimon Naveh, 'a retired Brigadier-General, [who] directs the Operational Theory Research Institute, which trains staff officers from the IDF and other militaries in "operational theory"', explains: 'Several of the concepts in *A Thousand Plateaus* became instrumental for us ... allowing us to explain contemporary situations in a way that we could not have otherwise. It problematized our own paradigms. Most important was the distinction they have pointed out between the concepts of "smooth" and "striated" space [which accordingly reflect] the organizational concepts of the "war machine" and the "state apparatus". In the IDF we now often use the term "to smooth out space" when we want to refer to operation in a space as if it had no borders. ... Palestinian areas could indeed be thought of as "striated" in the sense that they are enclosed by fences, walls, ditches, roads blocks and so on' (Weizman 2006: n.p.).

118. As Jeff Bell has discussed, 'In their book Boltanski and Chiapello single out Deleuze as among the vanguard whose critique of transcendent power and affirmation of immanence exemplifies the new spirit of capitalism, and thus Deleuze's philosophy, on their view, is simply the most recent ideology that has, as they put it, "opened up an opportunity for capitalism to base itself on new forms of control and commodify new, more individuated and 'authentic' goods" (Boltanski and Chiapello 2007: 467)' (Bell in Jun and Smith 2011: 7).

119. In this way, we might also wish to note that Kirby's scale is based on a particular definition of acting that differs from the less representationalist concepts developed by some of the practitioners whose work is said to exemplify particular points along the continuum, such as the Living Theatre and Grotowski, for instance, who are categorized as doing 'simple' and 'complex acting' respectively.

120. The open whole is a Bergsonian idea that Deleuze develops most fully in the *Cinema* books. Here, he argues that 'Movement in space expresses a whole which changes, rather as the migration of birds expresses a seasonal variation. Everywhere that a movement is established between things and persons, a variation or a change is established in time, that is, in an open whole which includes them and into which they plunge' (Deleuze 1989: 237).

Bibliography

Allain, P. and Harvie, J. (2006) *The Routledge Companion to Theatre and Performance*, London: Routledge.

Alliez, Eric (2004) 'Anti-Oedipus: Thirty Years On', *Kein Theater* website, http://theater. kein.org/node/145, accessed 8 December 2009.

Almenberg, Gustaf (2010) *Notes on Participatory Art*, Milton Keynes: AuthorHouse.

Aloi, Giovanni (2007a) 'Marcus Coates – Becoming Animal', *Antennae* 4: 18–21.

Aloi, Giovanni (2007b) 'In Conversation with Marcus Coates', *Antennae* 4: 31–5.

Aloi, Giovanni (2011) 'Different Becomings', *Art & Research: A Journal of Ideas, Contexts and Methods*, 4(1): 1–10.

Aloi, Giovanni (2012) *Art and Animals*, London: I. B. Tauris.

Andrews, Max (2009) 'Marcus Coates and Other Animals', *Picture This*, http://www. picture-this.org.uk/library/essays1/2007/marcus-coates-and-other-animals, accessed 26 May 2012.

Ansell-Pearson, Keith (1999) *Germinal Life: The Difference and Repetition of Deleuze*, London: Routledge.

Apple, Jacki (1991) 'The Life and Times of Lin Hixson: The LA Years', *The Drama Review*, 35(4, Winter): 27–45.

Armitage, John (ed.) (2001) *Virilio Live: Selected Interviews*, London: Sage.

Aronson, Arnold (2000) *American Avant-Garde Theatre: A History*, New York: Routledge.

Aronson, Arnold Elvin and Bless, Diane (2009) *Clinical Voice Disorders*, New York: Thieme Medical Publishers.

Artaud, Antonin (1977) *The Theatre and Its Double*, trans. Victor Corti, London: John Calder.

Artioli, U. (2004) 'Production of Reality or Hunger for the Impossibility?' in Scheer, E. (ed.) *Antonin Artaud: A Critical Reader*, London: Routledge.

Attebury, Jeffrey (2000) 'Reading Forgiveness and Forgiving Reading: Antonin Artaud's "Correspondance avec Jacques Rivière"', *MLN*, 15(4): 714–40.

Auslander, Phillip (1997) *From Acting to Performance: Essays on Modernism and Postmodernism*, London: Routledge.

Auslander, Phillip (1999) *Liveness: Performance in a Mediatized Culture*, London: Routledge.

Auslander, Phillip (ed.) (2003) *Performance: Critical Concepts in Literary and Cultural Studies*, London: Routledge.

Auslander, Phillip (2006) 'The Performativity of Performance Documentation', *PAJ: Performing Arts Journal*, 84: 1–10.

Badiou, Alain (1997) *Deleuze: The Clamor of Being*, trans. Louise Burchill, Minneapolis: University of Minnesota Press.

Bailes, Sara Jane (2007) 'Some Slow Going: Considering Beckett and Goat Island', *Performance Research*, 12(1): 35–49.

Bailes, Sara Jane (2010) *Performance Theatre and the Poetics of Failure: Forced Entertainment, Goat Island, Elevator Repair Service*, London: Routledge.

Baird, Bruce (2012) *Hijikata Tatsumi and Butoh: Dancing in a Pool of Gray Grits*, Basingstoke: Palgrave Macmillan.

Baker, S. (2000) *The Postmodern Animal*, London: Reaktion Books.

Banham, Martin (1995) *The Cambridge Guide to Theatre*, Cambridge: Cambridge University Press.

Barber, Stephen (2010) *Hijikata: Revolt of the Body*, Washington, DC: Solar Books.

Barish, J. A. (1981) *The Anti-Theatrical Prejudice*, Berkeley: University of California Press.

Barnes, Sara and Patrizio, Andrew (2009) 'Darwin on the Threshold of the Visible', in Barbara Jean Larson and Fae Brauer (eds) *The Art of Evolution: Darwin, Darwinisms and Visual Culture*, Lebanon, NY: Dartmouth College Press, pp. 288–312.

Bayly, Simon (2011) *A Pathognomy of Performance*, Basingstoke: Palgrave Macmillan.

Beaulieu, Alain (2011) 'The Status of Animality in Deleuze's Thought,' *Journal for Critical Animal Studies*, IX(1/2): 69–88.

Beck, J. (1964) 'How to Close a Theatre', *Tulane Drama Review*, Post War Italian Theatre, 8(3): 180–90.

Beck, J. (1972) *The Life of the Theatre: The Relation of the Artist to the Struggle of the People*, San Francisco: City Lights Books.

Beck, J. (1992) *Theandric: Julian Beck's Last Notebooks*, ed. Erica Bilder, notes by Judith Malina, Philadelphia: Harwood Academic Publishers.

Beck, J. and Malina, J. (1971) *Paradise Now, Collective Creation of the Living Theatre*, New York: Random House.

Beck, J., Malina, J. and Ryder, P. (1971) 'The Living Theatre in Brazil', *The Drama Review*, 15(3): 21–9.

Becker, C. (1991) 'From Tantrums to Prayer: Goat Island's Can't Take Johnny to the Funeral', *The Drama Review*, 35(4): 63–5.

Becker, C. (1996) *Zones of Contention: Essays on Art, Institutions, Gender and Anxiety*, New York: State University of New York Press.

Beech, Dave (2008) 'Include Me Out', *Art Monthly*, 315: 1–4.

de Beistegui, M. (2010) *Immanence: Deleuze and Philosophy*, Edinburgh: Edinburgh University Press.

Bell, J. (2006) *Philosophy at the Edge of Chaos: Gilles Deleuze and the Philosophy of Difference*, Toronto: University of Toronto Press.

Bentley, Eric (1987) *Thinking about the Playwright: Comments from Four Decades*, Evanston, IL: Northwestern University Press.

Bergson, H. (1911) *Creative Evolution*, trans. Arthur Mitchell, New York: Henry Holt.

Bergson, H. (1946) *The Creative Mind: An Introduction to Metaphysics*, trans. Mabelle L. Andison, New York: Philosophical Library.

Bergson, Henri (2004) *Matter and Memory*, trans. Nancy Margaret Paul and W. Scott Palmer, New York: Dover.

Bergson, H. (2007) *An Introduction to Metaphysics*, trans. T. E. Hulme, Basingstoke: Palgrave Macmillan.

Bernard, H. Russell (2011) *Research Methods in Anthropology*, Lanham, MD: Alta Mira Press.

Bernstein, David W. and Hatch, Christopher (eds) (2001) *Writings through John Cage's Music, Poetry, and Art*, Chicago: Chicago University Press.

Best, Sue (2006) 'Lygia Clark (1920–1988). Bodily Sensation and Affect: Expression as Communion', *Australian and New Zealand Journal of Art*, 6/7(2/1): 82–104.

Bigsby, C. W. E. (1985) *A Critical Introduction to Twentieth-Century American Drama*, Cambridge: Cambridge University Press.

Biner, P. (1972) *The Living Theatre*, New York: Horizon Press.

Bishop, Claire (2004) 'Antagonism and Relational Aesthetics', *October*, 110(Fall): 51–79.

Bishop, Claire (2006) 'The Social Turn: Collaboration and Its Discontents', *Artforum*, February: 179–85.

Blau, H. (1983) 'Universals of Performance; or, Amortizing Play', *SubStance*, Special Issue from the Center for Twentieth Century Studies, 11(4): 140–61.

Blau, Herbert (2008) Unpublished correspondence with the author.

Bleeker, M. (2004) 'The A, B, C's of Differance: Jan Ritsema and the Relationality of Theatrical Presence', in J. de Bloois, S. Houppermans and F. Korsten (eds) *Discernements: Deleuzian Aesthetics/Esthetiques deleuziennes*, Amsterdam: Rodopi.

Bloom, Alexander (ed.) (2001) *Long Time Gone: Sixties America Then and Now*, Oxford: Oxford University Press.

Bogue, R. (1989) *Deleuze and Guattari*, London: Routledge.

Bogue, Ronald (1991) 'Word, Image and Sound: The Non-Representational Semiotics of Gilles Deleuze', in *Mimesis in Contemporary Theory: An Interdisciplinary Approach, Volume 2: Mimesis, Semiosis and Power*, Amsterdam: John Benjamins, pp. 77–98.

Bogue, R. (2003a) *Deleuze on Literature*, London: Routledge.

Bogue, R. (2003b) *Deleuze on Cinema*, London: Routledge.

Bogue, R. (2003c) *Deleuze on Music, Painting and the Arts*, London: Routledge.

Bogue, Ronald (2007) *Deleuze's Way: Essays in Transverse Ethics and Aesthetics*, Farnham: Ashgate.

Boltanski, Luc and Chiapello, Eve (2007) *The New Spirit of Capitalism*, London: Verso.

Borja-Villel, Manuel J. and Mayo, Nuria Enguita (1998) *Lygia Clark*, Barcelona: Fundació Antoni Tàpies.

Bottoms, S. J. (1998) 'The Tangled Flora and Fauna of Goat Island: Rhizome, Repetition, Reality', *Theatre Journal*, 50(4): 421–46.

Bottoms, S. J. (2006) *Playing Underground: A Critical History of the 1960s Off-Off-Broadway Movement*, Ann Arbor: University of Michigan Press.

Bottoms, S. J. and Goulish, M. (2007) *Small Acts of Repair: Performance, Ecology and Goat Island*, London: Routledge.

Boundas, C. V. (1996) 'Deleuze-Bergson: An Ontology of the Virtual' in P. Patton (ed.) *Deleuze: A Critical Reader*, Oxford: Blackwell.

Bourg, J. (2007) *From Revolution to Ethics: May 1968 and Contemporary French Thought*, Montreal: McGill-Queens University Press.

Bradby, D. (2008) 'Book Review: The Performance of Shakespeare in France since the Second World War. By Nicole Fayard,' *French Studies*, 62(1): 110–11.

Briginshaw, V. and Burt, R. (2009) *Writing Dancing Together*, Basingstoke: Palgrave Macmillan.

Broglio, Ron (2011) *Surface Encounters: Thinking with Animals and Art*, Minneapolis: University of Minnesota Press.

Brown, K. H. (1964) 'The Brig', *Tulane Drama Review*, Post War Italian Theatre, 8(3): 222–59.

Buchanan, Ian (2011) 'Desire and Ethics', *Deleuze Studies*. 5: 7–20.

Cage, John (1978) *Silence: Lectures and Writings*, London: Marion Byars.

Carlson, Marvin (1996) *Performance: A Critical Introduction*, London: Routledge.

Carlson, Marla (2011) 'Furry Cartography: Performing Species', *Theatre Journal* 63: 191–208.

Carroll, N. (1994) 'Cage and Philosophy', *Journal of Aesthetics and Art Criticism*, 52(1): 93–8.

Caygill, Howard (1995) *The Kant Dictionary*, Oxford: Blackwell.

Caygill, Howard (2013) 'Hyperaesthesia and the Power of Perception', in John Mullarkey and Charlotte De Mille (eds) *Bergson and the Art of Immanence: Painting, Photography, Film, Performance*, Edinburgh: Edinburgh University Press.

Champagne, L. (1984) *French Theatre Experiment since 1968*, Ann Arbor: University of Michigan Research Press.

Charny, B. (2001) 'Birds Sing a New Tune in Wireless Era', *CNET News* website, May 17, http://news.cnet.com/Birds-sing-a-new-tune-in-wireless-era/2100-1033_3-257826.html, accessed 26 May 2012.

Chaudhuri, Una (2005) 'Animal Geographies: Zooësis and the Space of Modern Drama', in G. Giannachi and N. Stewart (eds) *Performing Nature: Explorations in Ecology and the Arts*, Bern: Peter Lang, pp. 103–18.

Chaudhuri, Una (2007) '(De)Facing the Animals: Zooësis and Performance', *The Drama Review*, 51: 8–20.

Chaudhuri, Una and Enelow, Shonni (2006) 'Animalizing Performance, Becoming-Theatre: Inside Zooësis with The Animal Project at NYU', *Theatre Topics* 16: 1–17.

Clark, Lygia and Bois, Yve-Alain (1994) 'Nostalgia of the Body', *October*, 69(Summer): 85–109.

Cody, Gabrielle and Sprinchorn, Evert (2007) *The Columbia Encyclopedia of Modern Drama*, New York: Columbia University Press.

Cohn, R. (1979) 'Artaud's "Jet de Sang": Parody or Cruelty?', *Theatre Journal*, 31(3): 312–18.

Colebrook, C. (2000) "Questioning Representation", *SubStance*, 29(2): 47–67.

Colebrook, C. (2002a) *Gilles Deleuze*, Routledge Critical Thinkers Series, London: Routledge.

Colebrook, C. (2002b) *Understanding Deleuze*, Crows Nest: Allen & Unwin.

Colebrook, Claire (2002c) *Irony in the Work of Philosophy*, Lincoln, NE: University of Nebraska.

Colebrook, C. (2005) 'How Can We Tell the Dancer from the Dance? The Subject of Dance and the Subject of Philosophy', *Topoi*, 24: 5–14.

Colebrook, C. and Buchanan, I. (eds) (2001) *Deleuze and Feminist Theory*, Edinburgh: Edinburgh University Press.

Connor, Steven (1999) 'The Ethics of the Voice', in Dominic Rainsford and Tim Woods (eds) *Critical Ethics: Text, Theory and Responsibility*, Basingstoke: Palgrave Macmillan, pp. 220–37.

Copeland, R. (1990) 'The Presence of Mediation', *The Drama Review*, 34(4): 28–44.

Counsell, Colin (1996) *Signs of Performance: An Introduction to Twentieth Century Theatre*, London: Routledge.

Coveney, Michael (2010) 'Stage Directions: Immersive Theatre', *Prospect*, 174, http://www.prospectmagazine.co.uk/2010/08/you-me-bum-bum-train-one-on-one-theatre/, accessed 26 May 2012.

Cox, Christoph and Warner, Daniel (2004) *Audio Culture: Readings in Modern Music*, London: Continuum.

Crary, Jonathan (1990) *Techniques of the Observer: On Vision and Modernity in the Nineteenth Century*, Cambridge, MA: MIT Press.

Cull, L. (2009a) (ed.) *Deleuze and Performance*, Edinburgh: Edinburgh University Press.

Cull, L. (2009b) 'How Do You Make Yourself a Theatre without Organs? Deleuze, Artaud and the Concept of Differential Presence', *Theatre Research International*, 34: 243–55.

Cull, Laura (2011) 'While Remaining on the Shore: Ethics in Deleuze and Guattari's Use of Artaud', in *Deleuze and Ethics*, Edinburgh: Edinburgh University Press.

Cull, Laura and Daddario, Will (2012) *Manifesto Now! Instructions for Performance, Philosophy, Politics*, Bristol: Intellect.

Cull, Laura and Goulish, Matthew (2007) 'A Dialogue on Becoming', in Daniel Watt and Daniel Meyer-Dinkgrafe (eds) *Theatres of Thought: Theatre, Performance and Philosophy*, Newcastle: Cambridge Scholars Publishing.

Cull, Laura and Gritzner, Karoline (eds) (2011) 'On Philosophy and Participation', *Performance Research*, 16(4, December).

Dachy, Marc (ed.) (1995) 'Introduction', in the accompanying booklet to the CD *Pour en finir avec le jugement de dieu [To have done with the judgment of god]*, Ed. and intro. Marc Dachy, Paris: Radiodiffusion Française.

Dale, C. (2001a) 'Falling from the Power to Die', in G. Genosko (ed.) (2001) *Deleuze and Guattari: Critical Assessments of Leading Philosophers*, London: Taylor and Francis, pp. 69–81.

Dale, C. (2001b) 'Knowing One's Enemy: Deleuze, Artaud, and the Problem of Judgement', in M. Bryden (ed.) *Deleuze and Religion*, London: Routledge, pp. 126–37.

Dale, C. (2002) 'Cruel: Antonin Artaud and Gilles Deleuze', in B. Massumi (ed.) *A Shock to Thought: Expression after Deleuze and Guattari*, Minneapolis: University of Minnesota Press, pp.85–100.

De Toro, Alfonso (2007) *Jorge Luis Borges: Ciencia y filosofía*, Hildesheim: Georg Olms Verlag.

DeKoven, M. (2004) *Utopia Limited: The Sixties and the Emergence of the Postmodern*, Durham, NC: Duke University Press.

Deleuze, G. (1978) 'Gilles Deleuze, Lecture Transcripts on Spinoza's concept of affect – Cours Vincennes – 24/01/1978', *Les Cours de Gilles Deleuze*, http://www.webdeleuze.com/php/texte.php?cle=14&groupe=Spinoza&langue=2, accessed 26 May 2012.

Deleuze, G. (1981) *Francis Bacon: The Logic of Sensation*, London: Continuum.

Deleuze, Gilles (1983) *Nietzsche and Philosophy*, trans. Hugh Tomlinson, London: Athlone Press.

Deleuze, G. (1986) *Cinema 1: The Movement-Image*, trans. Barbara Habberjam and Hugh Tomlinson, Minneapolis: University of Minnesota Press.

Deleuze, G. (1988a) *Bergsonism*, trans. Barbara Habberjam and Hugh Tomlinson, New York: Zone Books.

Deleuze, Gilles (1988b) *Spinoza: Practical Philosophy*, trans. Robert Hurley, San Francisco: City Lights Books.

Deleuze, Gilles (1989) *Cinema 2: The Time-Image*, London: Athlone Press.

Deleuze, G. (1990) *The Logic of Sense*, trans. Charles Stivale and Mark Lester, New York: Columbia University Press.

Deleuze, G. (1994) *Difference and Repetition*, trans. Paul Patton, London: Athlone Press.

Deleuze, G. (1995) *Negotiations 1972–1990*, trans. Martin Joughin, New York: Columbia University Press.

Deleuze, G. (1997) 'One Less Manifesto', trans. Timothy Murray and Eliane dal Molin, in Murray, T. (ed.) *Mimesis, Masochism and Mime: The Politics of Theatricality in Contemporary French Thought*, Michigan: University of Michigan Press.

Deleuze, G. (1998) *Essays Critical and Clinical*, trans. Daniel W. Smith and Michael A. Greco, London and New York: Verso.

Deleuze, Gilles (1999) 'Bergson's Conception of Difference', in John Mullarkey (ed.) (1999) *The New Bergson*, Manchester: Manchester University Press, pp.42–65.

Deleuze, Gilles (2001) *Pure Immanence: Essays on a Life*, New York: Urzone.

Deleuze, Gilles (2002) 'Manfred: An Extraordinary Renewal', in Carmelo Bene (2002) *Manfred*, recorded live at La Scala Milan, 1980, Wiesbaden: Breitkopf and Hartel.

Deleuze, G. (2004a) 'Thirteenth Series of the Schizophrenic and the Little Girl', in E. Scheer (ed.) *Antonin Artaud: A Critical Reader*, London: Routledge.

Deleuze, G. (2004b) *Desert Islands and Other Texts 1953–1974*, ed. D. Lapoujade, trans. M. Taormina, Los Angeles: Semiotext(e).

Deleuze, G. (2004c) *Francis Bacon: The Logic of Sensation*, trans. Daniel W. Smith, London: Continuum.

Deleuze, Gilles (2005) 'Ethology: Spinoza and Us', in Mariam Fraser and Monica Greco (eds) *The Body: A Reader*, New York: Routledge), pp. 58–61.

Deleuze, G. (2006 [1962]) *Nietzsche and Philosophy*, trans. Hugh Tomlinson, New York: Columbia University Press.

Deleuze, Gilles and Guattari, Félix (1983) 'What Is a Minor Literature?', *Mississippi Review*, Essays Literary Criticism, 11(3): 13–33.

Deleuze, G. and Guattari, F. (1984) *Anti-Oedipus: Capitalism and Schizophrenia*, trans. R. Hurley, M. Seem and H. R. Lane, London: Athlone Press.

Deleuze, G. and Guattari, F. (1986) *Kafka: Toward a Minor Literature*, Minneapolis: University of Minnesota Press.

Deleuze, G. and Guattari, F. (1988) *A Thousand Plateaus: Capitalism and Schizophrenia*, trans. Brian Massumi, London: Athlone Press.

Deleuze, G. and Guattari, F. (1994) *What Is Philosophy?*, trans. Graham Burchell and Hugh Tomlinson, London: Verso.

Delord, Frédéric (2006) *"La Rose et la hache [The Rose and the Axe]*, directed by Georges Lavaudant, production Odéon-Théâtre de l'Europe, Théâtre des Treize Vents, Montpellier, 12 November 2005', *Cahiers Elisabethains* 69: 77–80.

Derrida, J. (1973) *Speech and Phenomena: And Other Essays on Husserl's Theory of Signs*, trans. David B. Allison, Evanston, IL: Northwestern University Press.

Derrida, J. (1995) 'I'll Have to Wander All Alone', trans. David Kammermann, http://evans-experientialism.freewebspace.com/derrida4.htm, accessed 8 October 2007.

Derrida, J. (1997) 'The Theatre of Cruelty and the Closure of Representation', trans. Alan Bass, in T. Murray (ed.) *Mimesis, Masochism and Mime: The Politics of Theatricality in Contemporary French Thought*, Ann Arbor: University of Michigan Press.

Dolan, A. (2011) 'Are Mobile Ringtones Confusing Birds? Twitchers' Imitation Apps "Putting Chicks in Peril"', *Mail Online*, http://www.dailymail.co.uk/news/article-1386344/iPhone-apps-putting-chicks-peril-Twitchers-immitation-ringtones-blamed-confusing-birds.html, accessed 26 May 2012.

Dolan, J. (2005) *Utopia in Performance: Finding Hope at the Theatre*, Ann Arbor: University of Michigan Press.

Dosse, François (2011) *Gilles Deleuze and Félix Guattari: Intersecting Lives*, New York: Columbia University Press.

Egginton, W. (2004) 'Performance and Presence, Analysis of a Modern Aporia', *Journal of Literary Theory*, 1(1): 3–18.

Eglinton, Andrew (2009) 'Mischa Twitchin on the History of SHUNT and Their New Show Money', *London Theatre Blog*, http://www.londontheatreblog.co.uk/mischa-twitchin-on-the-history-of-shunt-and-their-new-show-money/, accessed 4 June 2012.

Erickson, J. (1985) 'The Language of Presence: Sound Poetry and Artaud', *Boundary* 214(1/2): 279–90.

Erickson, J. (1995) 'A Critique of the Critique of Presence', unpublished paper delivered at *Performance Studies International* conference, New York.

Erickson, J. (1999) 'The Face and the Possibility of an Ethics of Performance', *Journal of Dramatic Theory and Criticism*, 13(2): 5–22.

Erickson, J. (2006) 'Presence', in D. Krasner and D. Saltz (eds) *Staging Philosophy: Intersections of Theatre, Performance and Philosophy*, Ann Arbor: University of Michigan Press, pp. 142–59.

Erickson, J. (2007) Unpublished correspondence with the author.

Etchells, T. (1999) *Certain Fragments: Contemporary Performance and Forced Entertainment*, London: Routledge.

Evans, Dylan (2005) 'From Lacan to Darwin', in Jonathan Gottschall and David Sloan Wilson (eds) (2005) *The Literary Animal: Evolution and the Nature of Narrative*, Evanston, IL: Northwestern University Press, pp. 38–55.

Evans, Fred (2008) 'Deleuze, Bakhtin, and the "Clamour of Voices"', *Deleuze Studies*, 2(2): 178–200.

Fancy, David (2011) 'Geoperformativity: Becoming, Performance and the World', in Laura Cull and Karoline Gritzner (eds) 'On Philosophy and Participation', *Performance Research* 16(4): 62–72.

Farrell, Joseph (2004) 'Carmelo Bene: Revolutionizing Tradition', in Brian Richardson, Simon Gilson and Catherine Keen (eds) *Theatre, Opera, and Performance in Italy from the Fifteenth Century to the Present: Essays in Honour of Richard Andrews*, Society for Italian Studies, Occasional Papers, London: Maney Publishing.

Faulkner, Keith W. (1995) *Deleuze and the Three Syntheses of Time*, Oxford: Peter Lang Publishing.

Fayard, Nicole (2003) 'The Last Bastion of Resistance: Georges Lavaudant's *Theatrum Mundi*', *Contemporary Theatre Review* 13(3): 37–46.

Fayard, N. (2006) *The Performance of Shakespeare in France since the Second World War*, Lewiston, ME: Edwin Mellen Press.

Féral, J. (1997) 'Performance and Theatricality: The Subject Demystified' in T. Murray (ed.) *Mimesis, Masochism and Mime: The Politics of Theatricality in Contemporary French Thought*, Ann Arbor: University of Michigan Press.

Fetterman, W. (1996) *John Cage's Theatre Pieces: Notations and Performances*, London: Routledge.

Fieser, J. (2006) 'Ethics', *Internet Encyclopedia of Philosophy* website, http://www.utm.edu/research/iep/e/ethics.htm, accessed 8 December 2009.

Finter, H. and Griffen, M. (1997) 'Antonin Artaud and the Impossible Theatre: The Legacy of the Theatre of Cruelty', *The Drama Review*, 41(4, Winter): 15–40.

Forbes Black, Hannah (2011) 'Marcus Coates at Kate McGarry', *murmurART*, http://www.murmurart.com/dialogue/marcus-coates-at-kate-mcgarry, accessed 9 December 2011.

Fortier, M. (1996) 'Shakespeare as "Minor Theatre": Deleuze and Guattari and the Aims of Adaptation', *Mosaic*, 29(1, March): 1–18.

Fraleigh, Sondra Horton (1999) *Dancing into Darkness: Butoh, Zen and Japan*, Pittsburgh: University of Pittsburgh Press.

Fraleigh, Sondra (2010) *Butoh: Metaphoric Dance and Global Alchemy*, Champaign: University of Illinois Press.

Fraleigh, Sondra and Nakamura, Tamah (2006) *Hijikata Tatsumi and Ohno Kazuo*, London: Routledge.

Fricker, Karen (2009) 'Warhol and Hamsters at the Europe Theatre Prize', *The Guardian* website, 14 April, http://www.guardian.co.uk/stage/theatreblog/2009/apr/14/europe-theatre-prize, accessed 4 June 2012.

Fried, M. (1998) *Art and Objecthood: Essays and Reviews*, Chicago: University of Chicago Press.

Fuchs, E. (1985) 'Presence and the Revenge of Writing: Re-Thinking Theatre after Derrida', *Performing Arts Journal*, 10th Anniversary Issue: The American Theatre Condition, 9(2/3): 163–73.

Fuller, Matthew (2007) 'Art for Animals', *SPC Boggled*, http://www.spc.org/fuller/texts/8/, accessed 27 May 2012.

Gaiser, C. (2006) 'That Dangerous Automaton: The Construction of the "Human" in 60's Minimalist Dance', unpublished paper delivered at Performance Studies International conference, *PSi#12: Performing Rights*, Queen Mary, University of London, 15–18 June.

Garcin-Marrou, F. (2011) 'Gilles Deleuze, Felix Guattari and Theatre. Or, Philosophy and Its "Other"', *TRAHIR*, August, http://www.revuetrahir.net/2011-2/trahir-garcin-marrou-theatre.pdf, accessed 27 May 2012.

Garoian, C. R. (1999) *Performing Pedagogy: Toward an Art of Politics*, New York: State University of New York Press.

Gebauer, G. and Wulf, C. (1995) *Mimesis: Culture, Art, Society*, Berkeley: University of California Press.

Genosko, Gary (ed.) (1996) *The Guattari Reader*, Oxford: Blackwell.

Genosko, G. (2001) (ed.) *Deleuze and Guattari: Critical Assessments of Leading Philosophers*, London: Routledge.

Giannachi, G. (2006) 'Etymologies of Presence', *Performing Presence* website, http://presence.stanford.edu:3455/Collaboratory/497, accessed 8 December 2009.

Goat Island (1996) 'Illusiontext', *Performance Research*, 1(3, Autumn): 6–10.

Goat Island (1999a) 'Our Simplest Gestures: 6 Short Lectures by Goat Island', unpublished.

Goat Island (1999b) 'The Incredible Shrinking Man Essay and Board Game: A Collaborative Publication Project', *The Drama Review*, 43(1, Spring): 13–45.

Goat Island (2001) 'Lecture in a Stair Shape Diminishing', Goat Island Performance Group, www.goatislandperformance.org/writing_stair.htm, accessed 23 May 2007.

Goat Island (2006a) 'Part 1 – Reflections on the Process: Goat Island's When will the September roses bloom? Last night was only a comedy', *Frakcija*, 32.

Goat Island (2006b) 'Part 2 – Reflections on the Performance: Goat Island's When will the September roses bloom? Last night was only a comedy', *Frakcija*, 35.

Goat Island (2009) 'Goat Island', *Goat Island Performance Company* website, http://www.goatislandperformance.org/goatisland.htm, accessed 4 June 2012.

Goat Island (2012) *Goat Island: A Last, A Quartet*, DVD plus accompanying booklet.

Goh, I. (2007) 'The Question of Community in Deleuze and Guattari: After Friendship', *symploke*, 15(1-2): 218–43.

Goodall, J. (1994) *Artaud and the Gnostic Drama*, Oxford: Oxford University Press.

Goodall, J. (2008) *Stage Presence*, London: Routledge.

Goodchild, P. (1996) *Deleuze and Guattari: An Introduction to the Politics of Desire*, London: Sage.

Gottlieb, S. (1966) 'The Living Theatre in Exile: "Mysteries, Frankenstein"', *Tulane Drama Review*, 10/4: 137–52.

Goulish, M. (2000a) *39 Microlectures: In Proximity of Performance*, London: Routledge.

Goulish, M. (2000b) 'Memory Is This', *Performance Research*, On Memory, 5(3): 6–17.

Goulish, M. (2004) 'Peculiar Denotation. The Incomplete History and Impermanent Manifesto of the Institute of Failure', in Judith Helmer and Florian Malzacher (eds) *Not Even a Game Anymore: The Theatre of Forced Entertainment*, Berlin: Alexander Verlag.

Goulish, M. (2005) 'A transparent lecture', in Gavin Butt (ed.) *After Criticism: New Responses to Art and Performance*, New Interventions in Art History Series, Oxford: Blackwell.

Goulish, M. (2007a) 'The Strain of the Ordinary', paper delivered at *Performing Literatures* conference at University of Leeds, July.

Goulish, M. (2007b) Unpublished correspondence with the author.

Goulish, M. (2008) 'The Time of the Ordinary', paper delivered at *Performance Studies International #14* conference in Copenhagen, August.

Goulish, M. (2009) Unpublished correspondence with the author.

Goulish, M. and Hixson, L. (2007) 'A Lasting Provocation', *The Drama Review*, 51(4): 2–3.

Gracieuse, Marjorie (2012) 'Expressive Bodies and Imaging Desire: Deleuze's Vitalist Spinozism', unpublished paper, courtesy of the author.

Graham-White, A. (1976) 'Ritual', in Contemporary Theatre and Criticism, *Educational Theatre Journal*, 28(3): 318–24.

Griffin, Jonathan (2007) 'Marcus Coates – Focus', *frieze*, 108, http://www.frieze.com/issue/article/focus_marcus_coates/, accessed 9 December 2011.

Grotowski, J. (1968) *Towards a Poor Theatre*, New York: Simon and Schuster.

Guattari, F. (1995) *Chaosmosis: An Ethico-Aesthetic Paradigm*, trans. Paul Bains and Julian Pefanis, Bloomington: Indiana University Press.

Guattari, F. (1998) 'Pragmatic/Machinic: Discussion with Felix Guattari (19 March 1985)', in C. J. Stivale (ed.) *The Two-Fold Thought of Deleuze and Guattari: Intersections and Animations*, London: Guildford, pp. 191–224.

Guillaume, L. and Hughes, J. (2011) *Deleuze and the Body*, Deleuze Connections Series, Edinburgh: Edinburgh University Press.

Gumbrecht, H. U. (2004) *Production of Presence: What Meaning Cannot Convey*, Stanford: Stanford University Press.

Hallward, P. (2006) *Out of This World: Deleuze and the Philosophy of Creation*, London: Verso.

Hallward, P. (2010) 'You Can't Have It Both Ways: Deleuze or Lacan', in Leen de Bolle (ed.) *Deleuze and Psychoanalysis: Philosophical Essays on Deleuze's Debate with Psychoanalysis*, Leuven: Leuven University Press, pp. 33–50.

Harding, J. M. and Rosenthal, C. (2006) *Restaging the Sixties: Radical Theaters and Their Legacies*, Ann Arbor: University of Michigan Press.

Hardt, Michael and Negri, Antonio (2000) *Empire*, Cambridge, MA: Harvard University Press.

Heathfield, A. (2001) 'Coming Undone', *Goat Island Performance Group* website, www.goatislandperformance.org/writing_comingUndone.htm, accessed 23 May 2007.

Heathfield, A. (ed.) (2004) *Live: Art and Performance*, London: Tate Publishing.

Henri, A. (1974) *Environments and Happenings*, London: Thames and Hudson.

Herwitz, D. (1996) *Making Theory/Constructing Art: On the Authority of the Avant-Garde*, Chicago: University of Chicago Press.

Higgins, D. (1976) 'The Origin of Happening', *American Speech*, 51(3/4): 268–71.

Higgins, D. (2001) 'Intermedia', *Leonardo*, 34(1): 49–54.

Hijikata, T. (2000) 'Inner Material/Material', *The Drama Review* 44: 36–42.

Hijikata, T. and Kurihara, N. (2000) 'Wind Daruma', *The Drama Review* 44: 71–9.

Hindman, J. T. (1979) 'Self-Performance: Allan Kaprow's Activities', *The Drama Review*, Autoperformance Issue, 23(1): 95–102.

Hixson, L. (1990) 'Soldier, Child, Tortured Man: The Making of a Performance', *Contact Quarterly*, Summer: 12–19.

Hixson, L. (2008) 'How Do You Want to Say Goodbye? A Choreography for a Last Performance', *Performance Research*, 13(1, March): 49–54.

Holland, E. (1999) *Deleuze and Guattari's Anti-Oedipus: Introduction to Schizoanalysis*, London: Routledge.

Holland, E. (2006) 'Nomad Citizenship and Global Democracy', in M. Fuglsang and B. M. Sørensen, *Deleuze and the Social*, Edinburgh: Edinburgh University Press.

Holland, John H. (1998) *Emergence: From Chaos to Order*, Oxford: Oxford University Press.

Holledge, J. and Tompkins, J. (2000) *Women's Intercultural Performance*, London: Routledge.

Hollier, D. (1989) '1968, May: Actions, No! Words, Yes!, in D. Hollier (ed.) *A New History of French Literature*, Cambridge, MA: Harvard University Press.

Holmberg, Arthur (1996) *The Theatre of Robert Wilson*, Cambridge: Cambridge University Press.

Honore, Carl (2010) *In Praise of Slow: How a Worldwide Movement is Challenging the Cult of Speed*, London: Orion Books.

Hornblow, M. (2006) Bursting Bodies of Thought: Artaud and Hijikata, *Performance Paradigm*, 2(March): 26–44, http://www.performanceparadigm.net, accessed 10 May 2007.

Hurley, Erin and Warner, Sara (2011) Call for papers for 'Affect, Performance, Politics', special issue of *Journal of Dramatic Theory and Criticism* XXVI: 2 (Spring 2012), available at: http://www.jdtc.ku.edu/callforpapers.shtml, accessed 4 June 2012.

Huxley, M. and Witts, N. (eds) (1996) *The Twentieth Century Performance Reader*, London: Routledge.

Innes, C. (1981) *Holy Theatre: Ritual and the Avant Garde*, Cambridge: Cambridge University Press.

Innes, C. (1993) *Avant-Garde Theatre, 1892–1992*, New York: Routledge.

Jackson, S. (2004) *Professing Performance: Theatre in the Academy from Philology to Performativity*, Cambridge: Cambridge University Press.

Jackson, Shannon (2011) *Social Works: Performing Art, Supporting Publics*, New York: Routledge.

Jaeger, S. M. (2006) 'Embodiment and Presence: The Ontology of Presence Reconsidered', in D. Krasner and D. Saltz (eds) *Staging Philosophy: Intersections of Theatre, Performance and Philosophy*, Ann Arbor: University of Michigan Press.

Jannarone, Kimberly (2005) 'The Theater before Its Double: Artaud Directs in the Alfred Jarry Theater', *Theatre Survey* 46(2): 247–73.

Jannarone, Kimberly (2010) *Artaud and His Doubles*, Ann Arbor: University of Michigan Press.

Jardine, A. (1984) 'Woman in Limbo: Deleuze and his Br(others)', *SubStance* 13(3–4): 46–60.

Jaremba, T. (1991) 'Lin Hixson: An Interview', *The Drama Review*, 35(4, Winter): 66–74.

Johnson, Steven (2001) *Emergence: The Connected Lives of Ants, Brains, Cities and Software*, New York: Touchstone.

Jones. A. (1997) '"Presence" in Absentia: Experiencing Performance as Documentation', *Art Journal*, 56(4): 11–18.

Jun, Nathan and Smith, Daniel (2011) *Deleuze and Ethics*, Edinburgh: Edinburgh University Press.

Jürs-Munby, K. (2006) '"There's a Hole in This Performance": Tracing the Real in Goat Island's *When will the September roses bloom? Last night was only a comedy*',

paper given at *Beyond Drama: Postdramatic Theatre Symposium*, University of Huddersfield, February.

Kahn, D. (1999) *Noise, Water, Meat: A History of Sound in the Arts*, Cambridge, MA: MIT Press.

Kaprow, A. (1963) "The Effect of Recent Art upon the Teaching of Art", *Art Journal*, Vol. 23, No. 2. (Winter, 1963–1964), pp. 136–138.

Kaprow, A. (1965) 'Calling', *Tulane Drama Review*, 10(2, Winter): 203–11.

Kaprow, A. (1966) *Assemblages, Environments and Happenings*, New York: Harry N. Abrams.

Kaprow, A. (1968) 'Self-Service: A Happening', *The Drama Review*, Architecture/ Environment, 12(3, Spring): 160–64.

Kaprow, A. (1975a) *2 Measures*, Turin: Martano Editore.

Kaprow, A. (1975b) *Echo-logy*, New York: D'Arc Press.

Kaprow, A. (1976a) *Maneuvers*, Naples: Framart Studio.

Kaprow, A. (1976b) *Satisfaction*, New York: M.L.D'Arc Gallery.

Kaprow, A. (1984) 'Once Again, Learning Life', *Journal of Education*, 166(2): 196–8.

Kaprow, A. (1986) 'Tail-Wagging Dog', *Inventivity* website, http://www.inventivity. com/PP/TAIL_WAGGING_DOG.html, accessed 8 December 2009.

Kaprow, A. (1991) 'Interview with Robert C. Morgan', *Journal of Contemporary Art*, 4(2), http://www.jca-online.com/kaprow.html, accessed 9 September 2009.

Kaprow, A. (1992) *7 Environments*, Naples: Studio Morra.

Kaprow, A. (1993) 'Right Living: John Cage, 1912–1992', *The Drama Review*, 37(2, Summer): 12–14.

Kaprow, A. (1997) 'Just Doing', *The Drama Review*, 41(3, Autumn): 101–6.

Kaprow, A. (1998) *Allan Kaprow*, Como: Fondazione Antonio Ratti.

Kaprow, A. (2003) *Essays on the Blurring of Art and Life*, ed. Jeff Kelley (expanded edn), Berkeley: University of California Press.

Kaprow, A. (2004a) 'Some Recent Happenings', Ubu Classics, www.ubu.com, accessed 3 August 2007.

Kaprow, A. (2004b) 'Untitled Essay and Other Works', Ubu Classics, www.ubu.com, accessed 7 May 2008.

Kaprow, A. (2004c) 'Once the Task...', in *Manifestos*, Ubu Classics, www.ubu.com, accessed 7 May 2008.

Kaprow, A. and Lee, M. (1966) 'On Happenings', *Tulane Drama Review*, 10(4, (Summer): 281–3.

Kaprow, A. with Marranca, Bonnie, Monk, Meredith, Foreman, Richard *et al.* (1994) *Performing Arts Journal*, Bodies of Work, 16(1): 9–57.

Kattwinkel, S. (2003) *Audience Participation: Essays on Inclusion in Performance*, Westport, CT: Greenwood.

Kaye, N. (1994) *Postmodernism and Performance*, London: Macmillan.

Kelley, J. (2004) *Childsplay: The Art of Allan Kaprow*, Berkeley: University of California Press.

Kershaw, B. (2007) *Theatre Ecology: Environments and Performance Events*, Cambridge: Cambridge University Press.

Kerslake, C. (2002) 'The Vertigo of Philosophy: Deleuze and the Problem of Immanence', *Generation Online* website, http://www.generation-online.org/p/fpdeleuze8.htm, accessed 31 October 2009.

Kerslake, C. (2009) *Immanence and the Vertigo of Philosophy: From Kant to Deleuze*, Edinburgh: Edinburgh University Press.

Kester, Grant H. (2004) *Conversation Pieces: Community and Communication in Modern Art*, Berkeley: University of California Press.

Khalfa, J. (2003) (ed.) *An Introduction to the Philosophy of Gilles Deleuze*, New York: Continuum.

Kirby, M. (ed.) (1965) *Happenings. An Illustrated Anthology*, New York: E. P. Dutton.

Kirby, Michael (1972) 'On Acting and Not-Acting', *The Drama Review* 16(1): 3–15.

Knapp, G. P. (2003) 'Lenz', *Literary Encyclopedia*, http://www.litencyc.com/php/sworks. php?rec=true&UID=10378, accessed 30 December 2008.

Knowles, Ric (2008) 'The Structures of Authenticity: Collective and Collaborative Creations', in Bruce Barton (ed.) *Collective Creation, Collaboration and Devising, Critical Perspectives on Canadian Theatre in English*, Toronto: Playwrights Canada Press.

Kourilsky, F. and Champagne, L. (1975) 'Political Theatre in France since 1968', *The Drama Review*, Political Theatre Issue, 19(2, June): 43–52.

Kowsar, M. (2001) 'Deleuze on Theatre: A Case Study of Carmelo Bene's Richard III', in G. Genosko (ed.) *Deleuze and Guattari: Critical Assessments of Leading Philosophers*, Vol. 1, London: Routledge.

Kwon, Miwon (2004) *One Place after Another: Site-Specific Art and Locational Identity*, Cambridge, MA: MIT Press.

Lacan, J. (2001 [1966]) *Écrits: A Selection*, London: Routledge.

Lampert, J. (2006) *Deleuze and Guattari's Philosophy of History*, London: Continuum.

Larsen, Lars Bang and Rolnik, Suely (2007) 'On Lygia Clark's Structuring the Self', *Afterall*, 15(Spring/Summer), http://www.afterall.org/journal/issue.15/lygia.clarks. structuring.self, accessed 4 June 2012.

Lavery, Carl (2011) 'Practising Participation: A Conversation with Lone Twin', in Laura Cull and Karoline Gritzner (eds) 'On Philosophy and Participation', *Performance Research*, 16(4, December): 7–14.

Lawlor, L. (2006) *The Implications of Immanence: Toward a New Concept of Life*, New York: Fordham University Press.

Lawlor, L. (2008) 'Auto-Affection and Becoming: Following the Rats', paper delivered at *International Association for Environmental Philosophy*, Twelfth Annual Meeting, 18–20 October, Pittsburgh.

Lecercle, J.-J. (2002) *Deleuze and Language*, New York: Palgrave Macmillan.

Leddy, A. and Meyer-Hermann, E. (eds) (2008) *Allan Kaprow: Art as Life*, London: Thames and Hudson.

Lefebvre, Alexander (2008) *The image of law: Deleuze, Bergson, Spinoza*, Palo Alto, CA: Stanford University Press.

Lehmann, H.-T. (2006) *Postdramatic Theatre*, trans. Karen Jurs-Munby, London: Routledge.

Leibniz, G. W. (1989) *Philosophical Essays*, trans. Roger Ariew and Daniel Garber, Indianapolis: Hackett.

Lepecki, A. (ed.) (2004a) *Of the Presence of the Body: Essays on Dance and Performance Theory*, Middletown, CT: Wesleyan University Press.

Lepecki, A. (2004b) 'Concept and Presence: The Contemporary European Dance Scene', in A. Carter (ed.) *Rethinking Dance History: A Reader*, London: Routledge.

Lepecki, André (2007) 'Machines, Faces, Neurons: Towards an Ethics of Dance', *The Drama Review*, 51(3): 118–23.

Levy, Alastair, J. (2007) 'Marcus Coates at Whitechapel', *Artvehicle* 20, http://www. artvehicle.com/events/94, accessed 9 December 2011.

Ley, G. and Milling, J. (2001) *Modern Theories of Performance: From Stanislavski to Boal*, Basingstoke: Palgrave.

Living Theatre, The (1969) '"Paradise Now"': Notes', *The Drama Review*, 13(3, Spring): 90–107.

Living Theatre, The (1971) *The Living Book of the Living Theatre*, intr. Richard Schechner, Greenwich, CT: New York Graphic Society.

Loayza, M. (2000) 'Strobe Light Consciousness and Body Technology in the Theatre of Antonin Artaud', *Body, Space, Technology Journal*, 1(1): n.p.

Lopez, A. (2004) 'Deleuze with Carroll: Schizophrenia and Simulacrum and the Philosophy of Lewis Carroll's Nonsense', *Angelaki: Journal of the Theoretical Humanities*, 9(3): 101–20.

Lord, B. (2010) *Spinoza's Ethics*, Edinburgh: Edinburgh University Press.

MaGee, Chris (2010) 'Criminal Dance: The Early Films of Butoh Master Tatsumi Hijikata', *Midnight Eye*, http://www.midnighteye.com/features/criminal-dance-the-early-films-of-butoh-master-tatsumi-hijikata.shtml, accessed 9 December 2011.

Malina, J. (1972) *The Enormous Despair*, New York: Random House.

Malina, J., Brown, K. and Schechner, R. (1964) 'Interviews with Judith Malina and Kenneth Brown', *Tulane Drama Review*, Post War Italian Theatre, 8(3, Spring): 207–19.

Manning, Erin (2009) *Relationscapes: Movement, Art, Philosophy*, Boston, MA: MIT Press.

Mantegna, G. with Beck, J. and Malina, J. (1970) *We, The Living Theatre*, New York: Ballantine Books.

Marks, John (1998) *Gilles Deleuze: Vitalism and Multiplicity*, London: Pluto Press.

Marks, John (2006) 'Introduction', *Paragraph*, 29(2, July): 1–18.

Martin, B. (2001) 'Politics as Art, Art as Politics: The Freedom Singers, the Living Theatre, and Public Performance', in A. Bloom (ed.) *Long Time Gone: Sixties America Then and Now*, Oxford: Oxford University Press, pp. 159–88.

Martin, B. (2004) *The Theater Is in the Street: Politics and Performance in Sixties America*, Amherst, MA: University of Massachusetts Press.

Massumi, B. (ed.) (2002a) *A Shock to Thought: Expression after Deleuze and Guattari*, London: Routledge.

Massumi, B. (2002b) *Parables for the Virtual: Movement, Affect, Sensation*, Durham, NC: Duke University Press.

May, T. (2003) 'When Is a Deleuzian Becoming?', *Continental Philosophy Review*, 36(2, June): 139–53.

May, T. (2005) *Gilles Deleuze: An Introduction*, Cambridge: Cambridge University Press.

Mee, C. L., Jr (1962) 'The Becks' Living Theatre', *Tulane Drama Review*, 7(2, Winter): 194–205.

Midgelow, V. (ed.) (2007) *Reworking the Ballet: Counter Narratives and Alternative Bodies*, London: Routledge.

Mitchell, D. T. and Snyder, S. L. (eds) (1997) *The Body and Physical Difference: Discourses of Disability*, Ann Arbor: University of Michigan Press.

Moore, S. (2006) 'Ghosts of Premodernity: Butoh and the Avant-Garde', *Performance Paradigm* 2(March): 45–53.

Morfee, A. (2005) *Antonin Artaud's Writing Bodies*, Oxford: Oxford University Press.

Mullarkey, J. (1999) *Bergson and Philosophy*, Edinburgh: Edinburgh University Press.

Mullarkey, J. (2004) 'Forget the Virtual: Bergson, Actualism and the Refraction of Reality', *Continental Philosophy Review* 37: 469–93.

Mullarkey, J. (2006) *Post-Continental Philosophy: An Outline*, London: Continuum.

Mullarkey, J. (2009) *Refractions of Reality: Philosophy and the Moving Image*, Basingstoke: Palgrave Macmillan.

Mullarkey, John (2012) 'Animals Spirits: Philosomorphism and the Background Revolts of Cinema', in Ron Broglio and Frederick Young (eds) *Angelaki*, special edition on The Animality Revolutions to-come: Between Techne and Animality, forthcoming.

Murray, Timothy (1997) 'Introduction: The Mise-en-Scène of the Cultural', in *Mimesis, Masochism and Mime: The Politics of Theatricality in Contemporary French Thought*, Ann Arbor: University of Michigan Press, pp. 8–28.

Nelson, Cary and Grossberg, Lawrence (eds) (1988) *Marxism and the Intepretation of Culture*, Illinois: University of Illinois Press.

Newman, Fred, Wilson, Robert and Schechner, Richard (2003) 'Robert Wilson and Fred Newman: A Dialogue on Politics and Therapy, Stillness and Vaudeville', *The Drama Review*, 47(3): 113–28.

Nicholls, D. (ed.) (2002) *The Cambridge Companion to John Cage*, Cambridge: Cambridge University Press.

Nietzsche, Friedrich W. (1954) *The Portable Nietzsche*, trans. Walter A. Kaufmann, New York: Viking Press.

Olf, J. M. (1981) 'Acting and Being: Some Thoughts about Metaphysics and Modern Performance Theory', *Theatre Journal*, 33(1): 34–45.

Olkowski, D. (2000) 'Eluding Derrida: Artaud and the Imperceptibility of Life for Thought', *Angelaki*, 5(2): 191–9.

Orozco, Lourdes (2012) 'Manifesting the Animal: Human-Animal Interactions in Contemporary Theatre', in Laura Cull and Will Daddario (eds) *Manifesto Now!*, forthcoming.

O'Sullivan, S. (2005) 'Notes towards a Minor Art Practice', *Drain: Journal of Contemporary Art and Culture*, Issue on 'Syncretism', 5, www.drainmag.com, accessed 4 April 2007.

O'Sullivan, S. (2006) *Art Encounters Deleuze and Guattari*, Basingstoke: Palgrave Macmillan.

O'Sullivan, Simon and Zepke, Stephen (eds) (2008) *Deleuze, Guattari and the Production of the New*, London: Continuum.

Osthoff, Simone (1997) 'Lygia Clark and Hélio Oiticica: A Legacy of Interactivity and Participation for a Telematic Future', *Leonardo*, 30(4): 279–89.

Owens, C., Bryson, S., Kruger B., Tillman, L. and Weinstock, J. (eds) (1992) *Beyond Recognition: Representation, Power and Culture* (Berkeley: University of California Press.

Parker-Starbuck, J. (2006) 'Becoming-Animate: On the Performed Limits of "Human"', *Theatre Journal*, 58(4, December): 649–68.

Parr, A. (ed.) (2005) *The Deleuze Dictionary*, Edinburgh: Edinburgh University Press.

Patton, P. (ed.) (1996) *Deleuze: A Critical Reader*, Oxford: Blackwell.

Patton, P. and Protevi, J. (eds) (2003) *Between Deleuze and Derrida*, London: Continuum.

Paull, Jennifer (2007) *Cathy Berberian and Music's Muses*, Vouvry: Amoris.

Pavis, P. (1998) *Dictionary of the Theatre: Terms, Concepts, and Analysis*, trans. Christine Shantz, Toronto: University of Toronto Press.

Pavis, Patrice (2003) *Analyzing Performance: Theatre, Dance and Film*, trans. David Williams, Ann Arbor: University of Michigan Press.

Pecora, V. P. (1986) 'Deleuze's Nietzsche and Post-Structuralist Thought', *SubStance*, 14(3): 34–50.

Perloff, M. and Junkerman, C. (eds) (1994) *John Cage: Composed in America*, Chicago: University of Chicago Press.

Piltzer, Gerald, Radice, Barbara, Carla de Miro, Ester and Nes Kirby, Victoria (1975) "Take Off: An Activity in Genova by Allan Kaprow", *The Drama Review*, 19(1, March): 87–94.

Plato (1991) *The Republic*, trans. Benjamin Jowett, Vintage Classics Edition, New York: Random House.

Potolsky, Matthew (2006) *Mimesis*, London: Routledge.

Power, C. (2008) *Presence in Play: A Critique of Theories of Presence in the Theatre*, Amsterdam: Rodopi.

Protevi, J. (2001) *Political Physics: Deleuze, Derrida and the Body Politic*, London: Athlone Press.

Protevi, J. (2005) *A Dictionary of Continental Philosophy*, Edinburgh: Edinburgh University Press.

Protevi, John (2006) 'Deleuze, Guattari and Emergence', *Paragraph*, 29(2, July): 19–39.

Protevi, John (2011) 'Larval Subjects, Autonomous Systems and E. Coli Chemotaxis', in Laura Guillaume and Joe Hughes (2011) *Deleuze and the Body*, Edinburgh: Edinburgh University Press, pp. 29–52.

Puchner, M. (2002) 'The Theater in Modernist Thought', *New Literary History*, 33(3): 521–32.

Puchner, M. (2010) *The Drama of Ideas: Platonic Provocations in Theater and Philosophy*, Oxford: Oxford University Press.

Quick, A. (1996) 'Approaching the Real: Reality Effects and the Play of Fiction', *Performance Research*, 1(3): 12–22.

Rabkin, G. (1984) 'The Return of the Living Theatre: Paradise Lost', *Performing Arts Journal*, 8(2): 7–20.

Rae, P. (2002) 'Presencing', *ePAI* (electronic journal *Performing Arts International*), Presence, an experimental issue, http://www.mdx.ac.uk/www/epai/presencesite/index.html, accessed 3 May 2007.

Rancière, Jacques (2009) *The Emancipated Spectator*, London: Verso.

Read, Alan (1995) *Theatre and Everyday Life: An Ethics of Performance*, New York: Routledge.

Read, A. (2008) *Theatre, Intimacy and Engagement: The Last Human Venue*, Basingstoke: Palgrave Macmillan.

Reinelt, J. (2002) 'The Politics of Discourse: Performativity Meets Theatricality', *SubStance*, Special Issue: Theatricality, 13(2/3): 201–15.

Reinelt, Janelle and Roach, Joseph (eds) (1992) *Critical Theory and Performance*, Ann Arbor: University of Michigan Press.

Richie, D. (2006) *Japanese Portraits: Pictures of Different People*, Vermont: Tuttle Publishing.

Ridout, N. (2006) *Stage Fright, Animals, and Other Theatrical Problems*, Cambridge: Cambridge University Press.

Roach, J. (2007) *It*, Ann Arbor: University of Michigan Press.

Robinson, R. and Tormey, S. (2010) 'Living in Smooth Space: Deleuze, Postcolonialism and the Subaltern', in Simone Bignall and Paul Patton (eds) *Deleuze and the Postcolonial*, Edinburgh: Edinburgh University Press, pp. 20–40.

Rokem, Freddie (2010) *Philosophers and Thespians: Thinking Performance*, Stanford: Stanford University Press.

Rolnik, Suely (2007) 'The Body's Contagious Memory: Lygia Clark's Return to the Museum', trans. Rodrigo Nunes, *Transversal*, http://eipcp.net/transversal/0507/rolnik/en, accessed 4 June 2012.

Rolnik, Suley (2011) 'Archive for a Work-event: Activation of the Bodily Memory of the Poetics of Lygia Clark and its Context', *Manifesta*, 13(3): 72–81.

Rosenthal, C. (1998) 'Living on the Street: Conversations with Judith Malina and Hanon Reznikov, Co-directors of the Living Theatre', in J. Cohen-Cruz (ed.) *Radical Street Performance: An International Anthology*, London: Routledge, pp. 150–59.

Ruiz, Alma and Martin, Susan (1999) *The Experimental Exercise of Freedom: Lygia Clark, Gego, Mathias Goeritz, Hélio Oiticica*, Los Angeles: Museum of Contemporary Art.

Ryan, P. R. (1974) 'The Living Theatre's "Money Tower"', *The Drama Review*, Rehearsal Procedures and Berlin Dada Issue, 18(2): 9–19.

Sandford, M. R. (ed.) (1995) *Happenings and Other Acts*, London: Routledge.

Sarlós, R. K. (1982) *Jig Cook and the Provincetown Players: Theatre in Ferment*, Amherst, MA: University of Massachusetts Press.

Sawyer, R. Keith (1999) 'The Emergence of Creativity', *Philosophical Psychology*, 12(4): 447–69.

Sayre, H. (1989) *The Object of Performance: The American Avant-Garde since 1970*, Chicago: University of Chicago Press.

Sayre, H. (2004) 'In the Space of Duration', in A. Heathfield (ed.) *Live: Art and Performance*, London: Tate Publishing.

Schechner, R. (1999) 'Jerzy Grotowski: 1933–1999', *The Drama Review*, 43(2, Summer): 5–8.

Schechner, R. (2000) 'Post-Poststructuralism?', *The Drama Review*, 44(3): 4–7.

Schechner, Richard (2002) *Performance Studies: An Introduction*, New York: Routledge.

Schechner, R. and Appel, W. (ed.) (1990) *By Means of Performance: Intercultural Studies of Theatre and Ritual*, Cambridge: The Press Syndicate of the University of Cambridge.

Schechner, R., Beck, J. and Malina, J. (1969) 'Containment Is the Enemy', *The Drama Review*, 13(3): 22–44.

Schechner, Richard and Friedman, Dan (2003) 'Robert Wilson and Fred Newman: A Dialogue on Politics and Therapy, Stillness and Vaudeville', The Drama Review, 47(3): 113–28.

Schechner, R. and Kaprow, A. (1968) 'Extensions in Time and Space: An Interview with Allan Kaprow', *The Drama Review*, Architecture/Environment, 12(3, Spring): 153–9.

Schechner, R. and Wolford, L. (eds) (1997) *The Grotowski Sourcebook*, Worlds of Performance Series, London: Routledge.

Scheer, E. (ed.) (2000) *100 Years of Cruelty: Essays on Artaud*, Sydney: Power Publications.

Scheer, E. (ed.) (2004) *Antonin Artaud: A Critical Reader*, London: Routledge.

Scheer, Edward (2009) 'I Artaud BwO: The Uses of Artaud's To have done with the judgement of god', in Laura Cull (ed.) *Deleuze and Performance*, Edinburgh: Edinburgh University Press, pp. 37–53.

Schumacher, C. (1989) *Artaud on Theatre*, London: Methuen.

Semetsky, I. (2006) *Deleuze, Education and Becoming*, Rotterdam: Sense Publishers.

Shank, T. (1972) 'Collective Creation', *The Drama Review*, Directing Issue 16(2, June): 3–31.

Shank, T. (2002) *Beyond the Boundaries: American Alternative Theatre*, Amherst: University of Michigan Press.

Shatwell, Rebecca (2012) 'Welcome', in *AV Festival 2012: As Slow as Possible* programme, http://www.avfestival.co.uk/programme/2012?category=all, accessed 4 June 2012.

Shevtsova, Maria (2007) *Robert Wilson*, Routledge Performance Practitioners, London: Routledge.

Shibusawa, Tatsuhiko and Hijikata, Tatsumi (2000) 'Hijikata Tatsumi: Plucking Off the Darkness of the Flesh', *The Drama Review*, 44: 49–55.

Shukin, N. (2009) *Animal Capital: Rendering Life in Biopolitical Times*, Minneapolis: University of Minnesota Press.

Sidiropoulou, Avra (2011) *Authoring Performance: The Director in Contemporary Theatre*, Basingstoke: Palgrave Macmillan.

Smith, D. W. (2003) 'Excerpts from the Translator's Introduction. Deleuze on Bacon: Three Conceptual Trajectories in *The Logic of Sensation*', *University of Minnesota Press* website, http://www.upress.umn.edu/excerpts/Deleuze.html, accessed 8 December 2009.

Smith, D. W. (2004) 'The Inverse Side of the Structure: Žižek on Deleuze on Lacan', *Criticism*, 46(4, Fall): 635–50.

Smith, D. W. (2007) 'Deleuze and the Question of Desire: Toward an Immanent Theory of Ethics', *Parrhesia*, 2: 66–78.

Smith, M. (1987) 'The Living Theatre at Cooper Union: A Symposium with William Coco, Jack Gelber, Karen Malpede, Richard Schechner, and Michael Smith', *The Drama Review*, 31(3, Autumn): 103–19.

Sokel, Walter (1966) *Franz Kafka*, New York: Columbia University Press.

Sontag, S. (ed.) (1976) *Antonin Artaud: Selected Writings*, New York: Farrar, Straus and Giroux.

Spivak, G. C. (1988) 'Can the Subaltern Speak?', in Cary Nelson and Lawrence Grossberg (eds) *Marxism and the Interpretation of Culture*, Chicago: University of Illinois Press, pp. 217–316.

Stanier, P. (2005) 'Process, Repair and the Obligations of Performance', *Dance Theatre Journal*, 20(4): 37–40.

Stanier, P. and Christopher, K. (2004) '7 Questions for Goat Island on "When will the September roses bloom/Last night was only a comedy" (with 7 Footnotes of Varying Relevance Prompted by the Performance and the Questions Themselves) and 7 Answers from Karen Christopher', *Strange Names Collective*, http://www.strangenamescollective.co.uk/writings/Questions%20for%20Goat%20Island.htm, accessed 23 May 2007.

Stastny, Peter (1998) 'From Exploitation to Self-Reflection: Representing Persons with Psychiatric Disabilities in Documentary Film', *Literature and Medicine*, 17(1): 68–90.

Stiles, Kristine (1999) 'Beautiful, Jean-Jacques': Jean-Jacques Lebel's Affect and the Theories of Gilles Deleuze and Félix Guattari, in Jean-Jacques Lebel (1999) *Jean-Jacques Lebel*, Milan: Edizioni Gabriele Mazzotta, pp. 7–30.

Stivale, Charles (1993) 'Pragmatic/Machinic: A Discussion with Felix Guattari (19 March 1985)', *Pre-Text: A Journal of Rhetorical Theory*, 14(3–4): 215–50, http://topo-logicalmedialab.net/xinwei/classes/readings/Guattari/Pragmatic-Machinic_chat.html, accessed 4 June 2012.

Stivale, C. (2000) 'Summary of *L'Abécédaire de Gilles Deleuze*, avec Claire Parnet', http://www.langlab.wayne.edu/CStivale/D-G/ABCs.html, accessed 8 December 2009.

Stivale, C. (ed.) (2005) *Gilles Deleuze: Key Concepts*, Chesham: Acumen.

Stravinsky, Igor (2003) *Poetics of Music in the Form of Six Lessons*, Cambridge, MA: Harvard University Press.

Syssoyeva, K. (2012) *Negotiations of Power: A History of Collective Creation*, Basingstoke: Palgrave Macmillan.

Tanaka, Min (2006) Min Tanaka's Butoh, Theme, http://www.thememagazine.com/stories/min-tanaka/, accessed 27 May 2012.

Thévenin, P. (1993) Antonin Artaud, ce désespéré qui vous parle, Paris: Editions du Seuil.

Thompson, James (2009) Performance Affects: Applied Theatre and the End of Effect, Basingstoke: Palgrave Macmillan.

Thurschwell, Pamela (2009) Sigmund Freud, New York: Routledge.

Trilling, Ossia (1973) 'Robert Wilson's "Ka Mountain and Guardenia Terrace"', The Drama Review, Visual Performance Issue, 17(2): 33–47.

Tsatsos, I. (1991) 'Talking with Goat Island: An Interview with Joan Dickinson, Karen Christopher, Matthew Goulish, Greg McCain and Tim McCain', The Drama Review, 35(4, Winter): 66–74.

Turetsky, Philip (1998) Time, London, Routledge.

Uhlmann, Anthony (2009) 'Expression and Affect in Kleist, Beckett and Deleuze', in Laura Cull (ed.) Deleuze and Performance, Edinburgh: Edinburgh University Press, pp. 54–70.

Uhlmann, Anthony (2011) 'Deleuze, Ethics, Ethology, and Art', in Nathan Jun and Daniel Smith (eds) Deleuze and Ethics, Edinburgh: Edinburgh University Press, pp. 154–70.

Vanden Heuvel, M. (1991) Performing Drama/Dramatizing Performance: Alternative Theater and the Dramatic Text, Amherst: University of Michigan Press.

Wallis, M. and Shepard, S. (2004) Drama/Theatre/Performance, London: Routledge.

Watt, D. and Meyer-Dinkgräfe, D. (2007) Theatres of Thought: Theatre, Performance and Philosophy, Newcastle: Cambridge Scholars Press.

Wehle, P. (1984) 'A History of the Avignon Festival', The Drama Review, French Theatre, 28(1, Spring): 52–61.

Weimann, R. (1992) '(Post)Modernity and Representation: Issues of Authority, Power, Performativity', New Literary History, Papers from the Commonwealth Center for Literary and Cultural Change, 23(4): 955–81.

Weizman, Eyal (2006) 'The Art of War: Deleuze, Guattari, Debord and the Israeli Defense Force', Frieze Magazine, 99(May), http://www.frieze.com/issue/article/the_art_of_war/, accessed 27 May 2012.

Wiles, D. (2003) A Short History of Western Performance Space, Cambridge: The Press Syndicate of the University of Cambridge.

Williams, David (2000) 'Performing Animal, Becoming Animal', in Peta Tait (ed.) Body Show: Australian Viewings of Live Performance, Amsterdam: Rodophi, pp. 44–59.

Williams, David (2005) 'L'ombre de ton chien: On Dogs and Goats and Meanwhile', Art Surgery, http://www.artsurgery.org/contributors.html, accessed 19 July 2008.

Williams, James (2003) Gilles Deleuze's 'Difference and Repetition': A Critical Introduction and Guide, Edinburgh: Edinburgh University Press.

Williams, James (2008) Gilles Deleuze's 'The Logic of Sense': A Critical Introduction and Guide, Edinburgh: Edinburgh University Press.

Williams, James (2010) 'Immanence and Transcendence as Inseparable Processes: On the Relevance of Arguments from Whitehead to Deleuze Interpretation', Deleuze Studies, 4: 94–106.

Wilson, Robert and Eco, Umberto (1993) 'Robert Wilson and Umberto Eco: A Conversation', Performing Arts Journal, 15(1, Jan): 87–96.

Witmore, M. (2008) Shakespearean Metaphysics, Shakespeare Now! series, London: Continuum.

Wolford, Lisa and Schechner, Richard (2001) The Grotowski Sourcebook, Worlds of Performance Series, London: Routledge.

Zepke, S. (2005) *Art as Abstract Machine: Ontology and Aesthetics in Deleuze and Guattari*, London: Routledge.

Zepke, Stephen (2009) 'Becoming a Citizen of the World: Deleuze between Allan Kaprow and Adrian Piper', in Laura Cull (ed.) *Deleuze and Performance*, Edinburgh: Edinburgh University Press, pp. 109–25.

Žižek, Slavoj (2004) *Organs without Bodies: On Deleuze and Consequences*, New York: Routledge.

Index